STEICHEN'S LEGACY

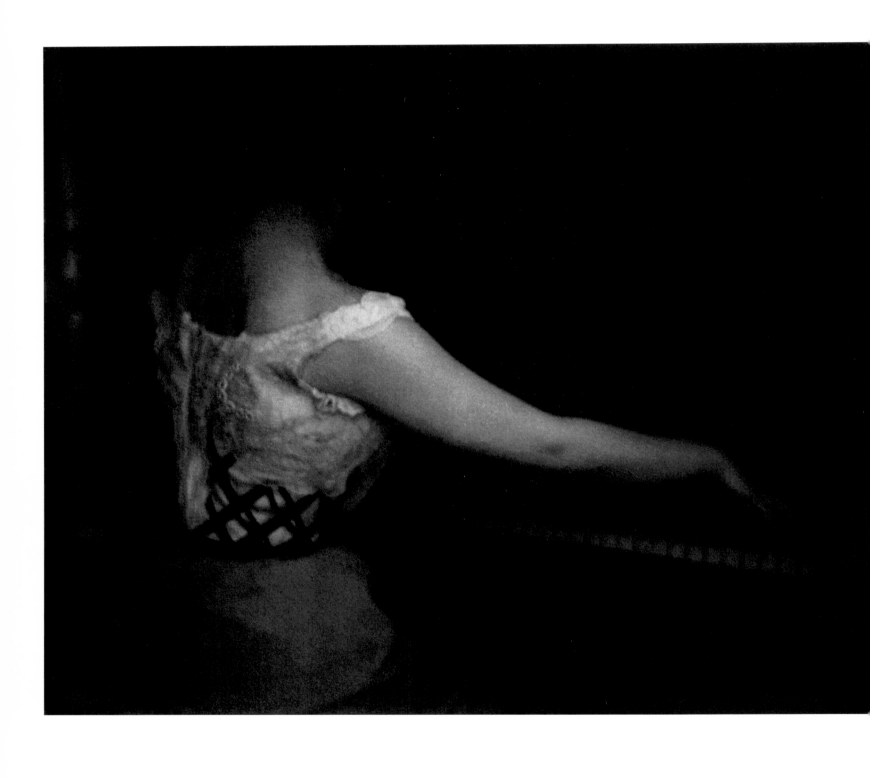

STEICHEN'S LEGACY

PHOTOGRAPHS, 1895–1973

EDITED AND WITH TEXT BY

JOANNA STEICHEN

ALFRED A. KNOPF

NEW YORK | 2000

THIS IS A BORZOI BOOK
PUBLISHED BY ALFRED A. KNOPF

Copyright © 2000 by Joanna Steichen

www.aaknopf.com

Knopf, Borzoi Books, and the colophon are
registered trademarks of Random House, Inc.

The poem "Topstone" and the inscription by Carl Sandburg are
quoted with permission of the Carl Sandburg Family Trust.

ISBN 0-679-45076-9

Manufactured in Italy
First Edition

Frontispiece: *At the Piano*, 1900–1903.
Gum platinum print with watercolor wash around image

To the memory of E.N.T. and W.J.T., ambition's innocents

CONTENTS

ACKNOWLEDGMENTS

I am grateful to many people for their contributions to this book.

To George Tice, photographer and master printer, for his perfectionist drive and dedication, and to Jean Elizabeth Poli for her careful assistance.

To Victoria Wilson, Charlotte Sheedy and Jack Lenor Larsen for their encouragement and faith in the project and the author.

To Nichole Frocheur and Fairlee Shattuck Benson for diligent and enthusiastic work in research and organization.

To Laurie Platt Winfrey of Carousel Research, Jean Back of the Luxembourg Department of Cultural Affairs, Ronald Zitver of Ken Taranto Labs, Grant Rohmer of George Eastman House, Francesca Calderone-Steichen, Joel Stahmer, Helga Sandburg Crile and the Carl Sandburg Family Trust, Jonathan Thomas, Mia Westerlund-Roosen and Mack Lee for material, information, support and technical advice.

To Pam Roberts of the Royal Photographic Society, Marianne Fulton and Janice Madhu of George Eastman House, and Peter Galassi and Susan Kismaric of New York's Museum of Modern Art for access to their collections and the loan of photographs.

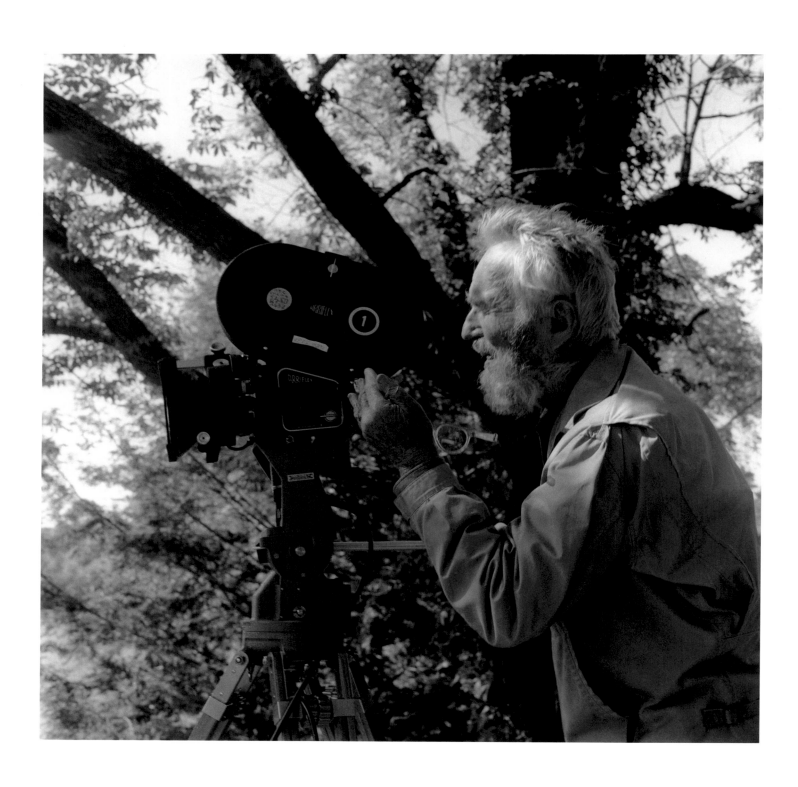

Edward Steichen with Movie Camera, Umpawaug Farm, 1959. | PLATE 1
Photograph by Joanna Steichen under Edward Steichen's direction

EXPERIENCING STEICHEN

At last, a rose among the thorns!" These are the first words Edward Steichen said to me. The expression has been around since at least the third century B.C., but context is everything. His voice was soft and thick. He was an inch or two taller than I, lean, big boned, with a peppery gray beard, a substantial nose, fine silver-white hair brushed loosely back from a broad, high forehead. He wore a light gray wool suit and plain black necktie. (I didn't know it then, but at the end of World War II, in honor of his service in that war, he had vowed to wear only the black neckties of a naval officer's uniform. This kind of dramatic gesture was typical: a sincere noble sentiment that also served a practical private purpose—in this case, simplifying the choices in his wardrobe.) One arm rested in a sling made of heavy, pebble-textured silk. His blue eyes, behind big square glasses framed in clear plastic, were wide set and crinkling at the outer corners. We were indoors, but his face seemed dappled with sunlight. I knew nothing about his work.

I was twenty-six, tall, broad shouldered, slim but sturdy, well groomed down to my clean white cotton gloves. In a haphazard transition from parent-subsidized college student with theatrical ambitions to self-supporting New Yorker, I had stumbled into an advertising career and had just become the chief television copywriter on the American Airlines account. My appearance and credentials gave no clue to my limited social experience or to the isolation in which I had been reared. The agency I worked for, Young & Rubicam, was a famously paternalistic organization in those days, an agreeable and safe place for a naïve young woman to begin to try out adult life.

It was July 20, 1959. The setting was a private dining room upstairs at "21." American Airlines executives were giving a lunch to launch a series of recordings by Carl Sandburg for use on an all-night radio program called *Music Till Dawn.* It had been my idea to use a distinguished American poet's thoughts on aviation in order to establish a dignified and dependable image for the airline's brand-new jet passenger service. At that time, most commercial planes were still pulled through the air by propellers. Jet engines offered exhilarating new travel prospects. I had put together the writing and worked with Sandburg on the recordings, and we had become friends. At "21," his face, a combination of crafty Swedish peasant and monumental ancient visionary, had been recognized, and he had been ushered to a room full of airline and agency executives in conservative summer suits and ties. Carl, in a wool suit that looked too big and a bow tie clipped onto a drip-dry shirt collar, with long underwear peeking out between pants cuffs and scuffed shoes, was introduced all around. I was the only woman present.

The official reason for inviting Edward Steichen to this celebratory luncheon was that both Steichen and Sandburg were leaving for Moscow later that afternoon. My private reason was that I wanted to meet Steichen. During our work together on the recordings, Carl had made frequent, intriguing references to his widowed brother-in-law. (Carl had married Steichen's sister, Lillian, called Pausl by the family, in 1910.) I did not know then that Edward Steichen was referred to as the "dean of American photographers." Only in working with Carl had I learned that he was responsible for the extraordinary photography exhibition *The Family of Man.*

I had seen the exhibition not long after its opening at New York's Museum of Modern Art in 1955. *The Family of Man* was a dramatic hymn to life celebrating the needs, pleasures, griefs and transitions common to people of many different classes and cultures all over the world. The work of photographers from sixty-eight countries was included. Mural-size images illustrating major themes anchored clusters of small prints. Pithy captions taken from the world's literature led the viewer through thematic sections. Joy and sorrow, destruction and birth, all the shadings of human experience were there, lush and stark and wonderful with the immediacy of the photograph. The exhibition was Steichen's plea for world peace based on the premise that the similarities among human beings mattered more than their differences.

The paperback version of *The Family of Man* had become a bible for advertising copywriters like myself. We tore out pages to show art directors what we meant by real people. But I had paid no attention to the name of *The Family of Man*'s creator. Carl made the connection for me. During our recording sessions, he referred several times to a passage he might like to include, something from a new introduction he had written for the show's Moscow opening. *The Family of Man* would be part of the American Exhibition there, marking a thaw in the Cold War. Sandburg hesitated to use the passage because, he said, "Steichen hasn't seen it yet. He might not approve." I was astonished. Who was this Steichen, who had the power to approve the great poet's copy?

He stood in front of me, a year younger than his brother-in-law. While Carl at eighty-one clearly projected a rumpled old grandfather, careless and forgetful, needing to be looked after by indulgent friends and admirers, Steichen at eighty was something else. The sling, improvised from a Japanese scarf to rest an arm he had injured recently in a skating accident, advertised vitality, not frailty. He stood straight, moved quickly, crackled with energy. We exchanged innocuous verbal pleasantries, but the contact between our eyes was a supercharged, sexual infusion of zest for life. I arranged to sit next to Steichen at the table.

There were speeches and applause and food and wine, but all I remember is the intense field of energy between Steichen and myself. After lunch, he was impatient to return to his office around the block at the Museum of Modern Art, where he was director of the Photography Department. He was fiercely proud of MOMA for being the first major art museum to give photography equal status with painting and sculpture. I didn't know then what a rarity he was in a museum's bureaucracy: a man whose formal schooling had ended in high school and who, for decades, had earned his living and achieved fame as a work-

Edward Steichen and Joanna Taub at "21"—American Airlines lunch for Carl Sandburg, New York, July 20, 1959. Photograph courtesy of American Airlines

ing artist. I didn't know that in 1947, when he took the museum job, he had basically given up his own photography in order to be objective in assessing other photographers' portfolios.

Sandburg asked me to accompany him for some shopping. Steichen charged me with getting Carl back in time for their departure for the airport and mumbled something about coming up to see where he worked. Then he walked away briskly. The poet, with my arm in his, moved at the measured pace of a man who weighs his balance carefully with each step.

Carl wanted to buy some short-sleeved shirts for the journey. The nearest store was DePinna's, a dignified establishment at which Carl, always the country boy, professed awe. He selected two shirts in a fine, silky cotton, one a brilliant slate blue, the other a gray of the same intensity. One was to be a present for Steichen. He asked me to choose which man should get which color. I thought of Steichen's gray suit and told Carl he should keep the blue because of his own blue eyes. He laughed, a characteristic long, intermittent bark. Slowly, he withdrew a checkbook from his pocket. In the sonorous, carefully spun out syllables into which Carl poured his lilting baritone on and off the performance platform, he asked if a personal check would be acceptable. It would. Eventually it was written and taken off with the package to be wrapped. With sly pleasure, he confided his trick. Sometimes the store manager never cashed the check but kept it for the autograph.

Slowly, with pauses as Carl stood still to track one thought or another, we proceeded up the block to Fifty-third Street and turned left. The Museum of Modern Art was housed in Edward Durell Stone's original glass building in those days but used several adjacent town houses for office space. The Photography Department was in Number 19, a minor mansion in carved limestone with

heavy double doors in the center of the ground floor. At the doorstep, Carl rang the bell. I prepared to say good-bye, but Carl insisted that I come up. A staff member let us in and escorted us up the broad central suitcase to the parlor floor. There, in one large space across the back of the building, gray paint, over-head fluorescent lights, composition floors, freestanding steel shelves and rows of plain worktables obscured every trace of elegance that might have been built into the mansion's interior. This was where Steichen worked.

The dreary space took on a new aura when the great man emerged from an inner cubbyhole and greeted us. I had never felt so welcomed or so important. There were introductions to the staff, all women: Patricia Walker, the shy and gentle secretary; Grace Mayer, the curator and life-professed Steichen votary. They were a blur behind the current that sizzled between Steichen and myself. There was some explanation of projects spread out on the worktables, some opening of large, flat, black boxes to bring out treasured prints, then a reminder that the time to leave for the airport was near. Just as the good-byes began, Steichen had an inspiration. He asked one of the assistants to find something. Quickly. It was produced, an eight-by-ten glossy print of Steichen's best-known portrait of Sandburg, a sequence of overlapping profiles (plate 154). He muttered something about the quality of the print, then dismissed the thought as not important. With the glee of a child planning a surprise, he wrote all the way down one margin and had Carl do the same in the other.

"Carl Sandburg—love & blessings for Joanna Taub 1959." "This, with admiration of a beautiful wise girl—Steichen." He handed me the print with the sense of ritual befitting an historic event. Then, gently, he kissed me on the forehead. Someone found an envelope for the print, and I was ushered out, my head full of cartwheels, floating, it seemed, down the broad staircase and into the sunny street.

I had raced a bicycle no-hands around a downhill corner with roller skates on my feet, acted with movie stars in summer stock, ridden with Saumur-trained cavalry officers in Haiti, survived two emergency landings in my own single-engine airplane. I had been dazzled by the musicals of Kurt Weill and Rodgers and Hammerstein and the plays of Tennessee Williams on Broadway. I had shaken Paul Robeson's hand after his politically controversial 1947 concert in Albany. But the most thrilling event of my life had just happened. I could not simply let it go.

I knew the time and number of their flight. Back at 285 Madison Avenue, I closed my office door and began to compose a telegram, my style still colored by months of immersion in Sandburg's. This is the telegram:

CARL SANDBURG AND EDWARD STEICHEN
EN ROUTE PARIS FRANCE PAN AMERICAN JET FLIGHT 114
LEAVING 600 PME IDLEWILD AIRPORT NY=
A HEART FILLED WITH NEW WARMTH WISHES FOR TWO DEAR
TRAVELERS A BEAUTIFUL JOURNEY THROUGH FRIENDLY SKIES A
WINDFALL OF WONDERFUL PEOPLE AND A MERRY HOMECOMING=
JOANNA TAUB

When the brothers-in-law returned in September, Carl stayed with friends in New York for several weeks. I saw him frequently, took him to dinner at my friends' apartments, sometimes found him waiting on my stoop when I returned from work. I played a few simple chords for him on the lute-shaped guitar he had bought me, one of twelve made by the Lyon and Healey Company in Chicago; they had given him six and, ending with mine, he had given them all away. He wrote inscriptions in all my copies of his books, like this one in *Rootabaga Stories:*

> Joanna Taub
> who has a luminous
> child heart & will
> be at home among
> these pages, says her
> collaborator or here-
> with the scrivener
> Carl Sandburg

He never made a pass, seemed content just to be around, but the attention began to worry me enough so that one evening I made a speech on the order of "I'm happy to be your friend, but I don't want to have a footnote in history as Carl Sandburg's last mistress." His reaction was astonishment. Soon after that, he mentioned being invited to "Ed's place" in Connecticut for the weekend and having to take the train. I picked up the cue, saying I could borrow a car and drive him there.

We arrived at Umpawaug Farm in the middle of a sunny September afternoon. On the way to a magical setting where the interlocking rectangles of a contemporary house nestled with deceptive simplicity into the bank of a pond, the driveway wound past two acres of plant-breeding fields. There, Steichen, shirtless, in baggy corduroys, rubber boots and a wide-brimmed hat, was striding, notebook in hand, between rows of delphinium, attending to his plant-breeding records, checking the progress of the crosses he had made and planning new ones. At the house, while Carl protested that he had been looking for it for weeks, Steichen, with an expression of sly triumph, produced the telegram I had sent to the plane. His gestures were expansive, brimming with life and warmth. I stayed for dinner. In the middle of the following week, Carl called to invite me to repeat the trip and to stay overnight. He insisted on giving me the larger of the two guest rooms, which had big corner windows close to the pond. I woke to the sight of a rosy gold autumn hillside emerging through rising mist and the sound of a breakfast tray being deposited at my door. Steichen was an early riser.

Ten days later, I answered the phone and heard a hoarse, hesitant voice say "This is . . . uh . . . Connecticut." Steichen never invited anyone to use his first name. Carl and Pausl and their children, who called him Uncle Ed, were the only people I ever heard do so. Dana, his second wife, his patient, undemanding, good wife whose death from cancer in 1957 left him devastated, called him by his first two initials, E.J. Agnes Meyer, the widow of his close and powerful friend Eugene Meyer, and a distinguished presence in her own right, had known him

since the first decade of the century; she always called him Steichen. Other people resorted to military rank. He had two: Colonel from the U.S. Army in World War I and Captain from the Navy in World War II. The length of a person's acquaintance with him usually could be gauged from the title they used. However, some people were not even that bold. Grace Mayer, his most devoted acolyte in later years, always called him, respectfully, Mr. Steichen. I never arrived at a satisfactory solution but hovered between standard terms of endearment for direct address and Captain for third-party reference.

Steichen had been attractive to women all his life and had enjoyed a variety of sexual liaisons between and during his first two marriages, but his approach was delicate. It's hard to imagine him making advances to a woman who had not given him clear signals of invitation. I tended to be awkward and cautious with men, even if I liked them, so the relationship might have ended after two hours of polite, evasive tension the first time he took me to dinner in New York. However, with Steichen, I felt freed as magically as in a fairy tale to give him the right signals. Soon after that first New York date, Steichen began to spend a night or two at my apartment every week, and I spent almost every weekend in Connecticut, always careful to muss up the sheets on the guest room bed before Helen, the housekeeper, arrived in the morning. Although he had little patience for the rituals of ordinary social life, a respectable appearance mattered to him. It was he who insisted that we get married.

I had not intended to marry. I was an only child, born in New York City and transplanted farther and farther upstate as my parents tried to outmaneuver the disappointments of lives from which commitment to each other, and to me, required the sacrifice of individual interests and drained the possibility of joy. My father, a silent, unhappy dentist who had meant to be a civil engineer, withdrew into recurring illness and solitary, all-night sessions tinkering with inventions that almost worked. My mother, volatile and anxious, trained only to be the lady of the house and a volunteer for polite philanthropies, found herself juggling the tasks of perfectionist housewife, financial planner, nurse to my father and manager of his office. They were attractive, honorable people who maintained their sense of superiority and concealed their troubles from outsiders by deliberately isolating our unit of three from most of the social rituals and memberships through which people define their place in the world. For me, there were no solid roots or appealing role models. My grandparents all died early. My parents' tiny circle of friends and the aunts and uncles from whom we maintained a prickly distance reinforced my impression of marriage as a vise for bending women's lives into shapes determined entirely by their husbands' strengths and failings.

The settings in which I grew honored achievement but squelched many of the processes that foster it. I was outstanding but not popular in a succession of schools. To this day, many of the social signals and preoccupations of my peers remain a foreign language. Comfortable with active solitude, I plunged without guidance or discipline into the piano, drawing, theater, horses and reform politics. There was talent on both sides of my family, but the combinations of genes and environment that propel individuals into single-minded, high-risk careers

occurred only in the orchestra conductor Eugene Ormandy, my father's second cousin. We never knew him. In contrast, while they espoused many of the same decent, humanitarian values as my parents, the Steichen family, from Marie, the matriarch, on down, bred a sense of entitlement bordering on arrogance and demanded notable achievement. This heady stance certainly was part of Steichen's appeal for me.

Although I preferred the idea of a series of interesting love affairs to marriage, one brief experiment proved I was nice, naïve, middle-of-the-middle class in the buttoned-down 1950s, very much aware that I would have nowhere to turn if I "got into trouble." Somehow, without the help of a social network or traditional feminine wiles, I met several tall young men who wanted to marry me, but I was uneasy with young men. They were as needy and unformed as myself. While both body and spirit acknowledged a yearning for connection, the prospective fiancés were not compelling enough to overcome my wariness of marriage.

Steichen was different. With the validation of experience behind him, he exuded confident pleasure in life and its possibilities. All his long life, he had been restless, inquisitive, searching for meaning, driven to master technical processes and the workings of nature. The perspective of those many years was part of the attraction. So was his ability to retain qualities we associate with youth: awe, zest, rapture over the tallest tree or the biggest dog, a fine face or a sleek convertible, a musical phrase, a new use for a particular slant of light. Best of all, his capacity for perpetual wonder was balanced by a healthy irreverence for pretension and cant. Steichen appeared to offer the grounding of warm certainty and gentle wisdom that I had always unconsciously sought. What's more, I absolutely delighted him.

We were opposites in metabolism and personality. Life pulsed insistently through him, exploding into activity that he had the good fortune or the genius to have steered early and permanently into productive purposes. I was sluggish, slow to focus, pessimistic about outcomes. But we had values in common. Steichen was an irrevocably lapsed Catholic who grew up in an area west of the Great Lakes where optimistic, democratic socialism flourished at the turn of the century. I was the grandchild of thoroughly secular, nineteenth-century Jewish immigrants and the heir to their children's populist New York City liberalism. We both poured our capacities for worship into aesthetic and ethical concerns. In the America of my youth as in his, ethnic, economic and social injustices were rampant, but faith in progress included high hopes for the ways in which human beings would learn to treat one another. We shared righteous patriotism and the wish to make something beautiful, concepts considered admirable in the first two thirds of the twentieth century, not consigned, as they seem now, to the superficial and cosmetic or to the jingoistic and paranoid, but broad and respectable expressions of appreciation and hope. Passion, too, was an acceptable phenomenon then.

Steichen knew how to exercise discretion in the company of patrons, but his heart was with the underdog. Conviction sparked his cooperation with the local Connecticut chapter of the Urban League on a photography exhibition in Dan-

bury in the 1960s. At MOMA in 1962, at a time when the subject of poverty in America was politically unpopular, he persisted in staging his last big thematic exhibition, *The Bitter Years: 1935–1941, Rural America as Seen by the Photographers of the Farm Security Administration*. He had hoped that this powerful document on the Great Depression, consisting of photographs initiated by a temporary federal agency, would inspire the funding of a permanent, government-sponsored unit for making an ongoing photographic record of American life.

It was through politics that he taught me to trust my eyes. When "the new Richard Nixon," bolstered by convincing rhetoric, ran for president, we watched his speeches on television. Steichen said, "Look at that face. It's all there in the face, the eyes. No matter what that man says, he's the same Tricky Dick. He can't be trusted." (However, even Steichen's eye was not infallible. He and the opera singer Eileen Farrell received honorary degrees from the University of Hartford on the same June day in 1960. The soprano was more than amply proportioned, and her face's small features were buried in flesh. Steichen, who never had heard her sing, could not believe that the soul of an artist lay behind that mask.)

To a man who could charm almost anyone and master any task that engaged his imagination, courtship came easily. He began cautiously to introduce me to his world, inviting me to a panel discussion in which he starred at the Museum of Modern Art and to lunch with his old friend Agnes Meyer, in her great stone château at Seven Springs Farm. On Sundays, with the house at Umpawaug to ourselves, we made leisurely love on the big living room sofa and basked in each other's attention. It became difficult to imagine a life without him. He invented a project, a book about the making of *The Family of Man*, as a cover for spending so much time together and even had relevant research material sent out from the museum, but neither of us had any intention of working on it.

Steichen decided we must marry secretly to avoid the kind of tabloid publicity that a May-December marriage would attract. He asked his nearest neighbor, Elmo Roper, the pollster, to research the best location. It turned out to be at home in Connecticut. The ceremony could be performed by the town justice, Hjalmar Anderson, and the necessary papers slipped quietly into an anonymous stack of others waiting to be sent to the state capital at the end of the month. Steichen counted on journalistic pride to keep old news from making headlines, and he was right. Steichen also decided I had to inform my parents of our plans to marry. He did not offer to take on the task himself. My announcement was greeted with raging horror and resulted in a rupture with my family that never entirely healed. Steichen's daughters accepted the news in more positive tones. It took time for me to understand all the nuances in their trained voices.

We were married on Saturday afternoon March 19, 1960, with two of Steichen's friends and two of mine, Steichen's younger daughter, Kate, and the housekeeper and gardener, Helen and Sergei Milaschewitsch, in attendance and all sworn to secrecy. The living room was decked with every flowering plant available from the greenhouse. We celebrated with Steichen's favorite brand of champagne, Lanson, and one of Helen's rich walnut cakes with mocha icing. After the guests left, Helen served our dinner. For the first time in my six months of weekends at Umpawaug, Steichen turned on the television before we sat down. I

protested. Impatiently, he muttered that he always watched the news during dinner. And that was that. Courtship was over. My education in Steichen's work was about to begin.

It never occurred to Steichen or me to discuss our individual hopes and plans before we married. In dealing with other people, I had been trained to observe, consider their needs first and ask for nothing for myself. (The misguided assumption, straight out of Dickens novels and Hans Christian Andersen fairy tales, was that humility and generosity ultimately would be rewarded.) Steichen had been accustomed all his life to concentrate fiercely, proudly, on his own interests. He had run a big commercial studio, military units and a museum department, all full of willing assistants. He once told me, long after we were married, that what he wanted from any person in his household was quiet, dog-like devotion. I had done some freelance writing while working in advertising, and I had assumed I would continue this independent work, but Steichen exploded with rage the first time I was offered an assignment. He informed me that his excellent part-time secretary was planning a move to a full-time job in another town. He expected me to take over the bookkeeping and other paper-work and to be available all day, every day, to assist him on his projects. If I took an hour longer than usual for household errands, he would transpose his anxiety into gruff reproaches that, at first, reduced me to tears.

The projects at hand were a retrospective exhibition at New York's Museum of Modern Art and a pictorial autobiography. A Steichen retrospective in 1961 had to cover a multifaceted career begun in the 1890s and not yet ended. I learned its range while I worked with him. He had started in his teens as a nineteenth-century romantic determined to prove that a photograph could be a work of art, and he was going strong in his eighties as the high priest of photography's mission to enhance human life through understanding. In his twenties, he became known for moody, mysterious photographs designed to compete with paintings and printed in time-consuming, multilayered techniques. Some observers had found their innovative compositions shocking, and others had hailed them as the emergence of a new genius. They attracted attention in major exhibitions in Europe and America.

Steichen was in demand as a portraitist in the first decade of the twentieth century and again in the 1930s, when the higher he raised his fees, the greater the demand for bookings became. In his early forties, after World War I, he decided the work for which he was known had become pointless. Profoundly shaken by firsthand experience with war's indiscriminate destruction and stung by a scandal preceding his divorce from his first wife, he chafed at the self-absorbed concerns of artists and patrons. He wanted to reach a much larger public and to say something that mattered. He decided to learn everything there was to know about the technical aspects of photography. He assigned himself a new apprenticeship in technical precision, photographed a white cup and saucer a thousand times and went on to symbolic still lifes and intense studies in scale. He also studied the proportions of the golden mean in an attempt to find a discipline based on

nature. After three self-imposed years of retooling, he decided to redirect his energy to the photograph's potential as a medium for mass communication. From that period on, he referred to his fine individual prints, as well as to his paintings, as "expensive wallpaper for rich people's houses."

After that, he raised fashion photography to a high plane of elegance for *Vogue*, set up improvisations for *Vanity Fair* designed to transmit the essence of a play or a personality in a single image, made photomurals for Radio City's Center Theatre and, at considerable profit to himself, pioneered the use of lively, naturalistic photographs in advertising. Most of this work did not offer opportunity for the kind of philosophical communication that had inspired his career shift, but his photographs did appear in publications with large circulations. He moved closer to his higher goal in the 1940s, when powerful photo-essays on social issues began to appear in *Life* and elsewhere. Steichen produced their large-scale equivalent, dramatically mounted thematic exhibitions, on the walls of museums. These paved the way for *The Family of Man.* In 1960, he had begun working on a 35-millimeter film of a single shadblow tree across the pond from his house.

In the first half of his life, photography brought Steichen more fame than income. He was a star of the avant garde, but both the general public and the majority of connoisseurs considered photography a utilitarian, relatively low-cost means of obtaining likenesses rather than a viable art form. Steichen's claim that his photographs were art carried a little more weight because he was respected as a painter. In fact, painting provided most of his livelihood. But in 1923, he took another of the grand risks that shaped his career. Innovative and proficient as he might be, he decided he did not have the imagination of a great painter. In a characteristic dramatic gesture, he made a bonfire of all the paintings in his studio on the property he leased in Voulangis, in France, from 1908 to 1923. Of course, most of his best work was already installed in other people's houses.

Between 1905 and 1914, Steichen served as European art scout for Alfred Stieglitz and the Photo-Secession. First, he convinced Stieglitz to show other media along with photography. Then he designed the Little Galleries of the Photo-Secession in his former studio at 291 Fifth Avenue. And then he made 291 the first gallery in America to show many of the seminal painters and sculptors of the twentieth century. Among the exhibitions Steichen arranged were works by Matisse in 1908, Alfred Maurer and John Marin in 1909, Cézanne in 1910, E. Gordon Craig in 1910, Max Weber in 1911, Picasso in 1911, Arthur B. Carles in 1912 and Constantin Brancusi in 1914. It was Steichen's passion for discovery that allowed Stieglitz and the Photo-Secession to play a major role in the introduction to America of radical, contemporary art.

Some of the moves that he justified on philosophical grounds were also expedient for a variety of reasons. For example, there was his wartime service, which ranged from using open-cockpit biplanes for accurate information gathering in his thirties to documenting life on aircraft carriers under fire in his sixties. He joined the Army Signal Corps and ended up in charge of aerial photography for the Air Force in France in World War I. Well past retirement age by the start of

The Lotus Screen, oil painting by Edward Steichen. Collection of Joanna Steichen

World War II, he maneuvered his way into the Navy and eventually was put in charge of combat photography in the Pacific. While both periods of military service were inspired by the old-fashioned patriotism of the naturalized citizen, they also were undertaken at times when it became attractive to get away, first from a troublesome marriage and uneasiness about his vocation, then from the remnants of a commercial career that had ceased to interest him.

The 1961 retrospective and the 1963 autobiography were planned, like this book, to concentrate on Steichen's photographs. While museum staff would handle many important aspects of the exhibition, including procuring loans of early works from other museums, most of the prints were to be new enlargements made from the original negatives in Steichen's possession. The work of selection and printing would be done at home, first in a three-room lab built into a barn on the property and then in the house. Although some negatives had been destroyed in a lab fire in 1952 and many of those made before World War I had succumbed during that war to neglect and climatic conditions in Steichen's house in France, the material at Umpawaug represented at least four of the most productive decades of his photographic work. There were thousands of negatives. Rolf Petersen, the master printer in charge of the photography lab at the Museum of Modern Art, estimated well over fifty thousand. They were in a variety of formats: eight by ten, five by seven, four by five glass plates and negatives from his big studio cameras, and roll film negatives and slides from his Kodak Medalist, Rolleiflex, Robot, Kodak Bantam and other cameras. There were autochromes made before 1914. Although many of the negatives were on the volatile, self-consuming nitrate film that began to be phased out in 1924, most of them were still intact and could be used for printing. Steichen set about examining everything.

As he reviewed the larger negatives, he made piles of those he decided had no artistic merit or historic interest. Petersen has described the process as a frantic one in which Steichen made too many hasty decisions and destroyed many great works. Petersen was an extraordinarily skilled technician and a dedicated helper, but he did not necessarily share Steichen's vision. I was not invited to participate in the preliminary sorting but was called in eventually to help dispose of the discards. In a spirit of clandestine adventure, we tied up these piles of negatives in bundles about two feet high and carted them to an aluminum rowboat beached on the bank of one of the two big ponds on the property. I rowed out to the deepest part, and Steichen and I dumped the bundles of negatives overboard. They lay anchored in the mud at the bottom of the pond, where the constant flow of water washed away the emulsion. The remainder of the larger negatives were returned to their file folders with guide prints, many of them vintage prints, and stored in the two four-drawer metal file cabinets in which I still keep them.

To make new prints for both the exhibition and the book, Steichen arranged for Petersen to come to Umpawaug with his wife, Eva, and live in a cottage next door to the lab there. Although much of Steichen's early reputation was based on the luscious prints he produced himself through complex, time-consuming techniques, his methods had changed along with his priorities in the 1920s. Since 1923, when he went to work for the Condé Nast publications, he had become

accustomed to having someone else in the lab, printing, usually over and over again, making minute corrections, under his exacting supervision. A Steichen photograph intended for large-scale reproduction still had to have beauty, power, subtlety, the perfect balance of light and dark, all the authentic brilliance of the artist's vision. This time it was Pete's turn to make any number of prints before Steichen declared one satisfactory. "Make the light sing, Pete," he would say. We took several of the best versions of each image to the house and filed them in big gray folders on crude plywood shelves in a storeroom reserved for his work. Steichen apparently had given Pete permission to make or take some prints for himself, but, unfortunately, we paid too little attention to the disposition of the prints Steichen rejected. Years later, after Petersen had retired to Europe, prints that Steichen never would have approved began turning up at sales galleries and auctions.

In 1960, Steichen still handled certain finishing touches himself, touches such as a toning bath, often a double toning process, to heighten permanence and effect slight changes in gradation. My only job in the lab was to hang the toned prints up to dry, but for the final selection process, when the work moved to the all-purpose main room of the house, I was intensely involved. For weeks, we laid out prints on every surface: cabinets, tables, sofa and floor. Steichen compared, rejected, reclaimed, grunted dissatisfaction and aaahed with approval or nostalgia, and, as the pictures evoked memories, came up with fragments of stories and opinions about the subjects: the charming actresses who so completely enchanted him that his eye faltered and the sitting had to be rescheduled, the pompous or critical sitters on whom he took revenge in his portrayal or by delays in filling their orders for prints, the ideal symbolic father he had found in Auguste Rodin, his artist-to-artist deal with Brancusi for the first cast of *Bird in Space.*

Questions from me made him impatient, and attempts to argue angered him. Later, silently, with no trace of acknowledgment, he might agree with one of my suggestions and remove or replace a print. He had learned his technique on his own through painstaking practice and absorbed it at a level deeper than words. He had little patience for explaining things and no interest in didactic teaching. I had had some training in art and design, but with Steichen's work, I learned by being there, going over and over the pictures, soaking up their unique combinations of boldness and delicacy, intensity and elegance, allowing my mind to take in slowly, thoroughly, what my eyes encountered.

René d'Harnoncourt, the director of the Museum of Modern Art, installed the 1961 retrospective exhibition. Very tall, bulky but light on his feet, he was a courtly and delightful man and probably one of the finest directors any museum ever will have. D'Harnoncourt brought to museum life a rare combination of creative talent, diplomatic charm and a wide-ranging, respectful knowledge of art. His showmanship matched Steichen's. And, like Steichen's, his expertise came from experience rather than academic credentials. For me, watching him install became a seminar in exhibition design. He grouped pictures of similar intensity in fours and sixes, marched them singly up and down walls, punctuated them with mural-size enlargements, draped swatches of silk fabric designs

behind glass, made a patch of color with photographs of delphinium and another with the Oochens, a series of tempera paintings of triangular figures devised in the proportions of the golden mean. The result was an exhibition that offered all the drama and sparkle associated with Steichen.

After the retrospective opened, our focus shifted to the pictorial autobiography, *A Life in Photography.* The process of winnowing out photographs began again. For the text, I became the dragon of the tape recorder, demanding a block of words before he could go out to work in the garden or turn on the television. Though he could be eloquent, Steichen was a reluctant writer. His voice was muffled and hoarse from a lifetime of nonstop smoking. His thoughts wandered, and he had to be coaxed to produce phrase by fragmented phrase. After each dictation, I would transcribe the tape and then reorganize the typescript for clarity and continuity. Steichen's intentions, satisfactions and disappointments became part of my own history. At our final meeting at Doubleday before the book was to be printed, T. O'Connor Sloane, the editor, drew Steichen's attention to the acknowledgment page, on which he had thanked the staff of the Museum of Modern Art for their assistance and particularly the Photography Department's curator, Grace M. Mayer, and the book's designer, Kathleen Haven. Tom Sloane, who knew the extent of my participation, suggested that Steichen add the following sentence: "I owe a very special acknowledgment to my wife, Joanna, who participated with me in preparing the material and encouraged me at every step." Steichen looked startled, then, without enthusiasm, said, "Yes, I suppose so."

In 1970, we watched a television program celebrating the Beethoven bicentennial in Vienna. Leonard Bernstein conducted. In between musical sections, he talked about Beethoven, the glory of his work and the dyspeptic disorder of his life. I understood that Bernstein was attempting to teach audiences to consider the work separately from the life and to accept that, no matter how earnestly we try to turn them into flawless idols, geniuses are even less perfect than ordinary people. Pausl, my sister-in-law, took another approach and tried for years to discourage Sandburg biographies, insisting that the warts and peccadilloes of the life were private and the work was all anyone needed to know about the man. In the novella "Tonio Kröger," Thomas Mann wrote that "good work comes only out of a bad life." Individuals with a consuming need to reach a particular goal seldom concern themselves with the Freudian ideal of a life balanced reasonably between love and work.

When we married, I understood none of this. I was angry at Steichen for years for his single-minded attention to his own projects and his indifference to anything about me and our time together that did not serve his purposes. His daughters resented him most of their lives for the same reason. (However, in the last decade of his life, they found some relief by transferring their malice to me and acting out in my direction the vengeful rage that hit a stone wall when aimed at him.) Even though I fumed, I began to understand that his stubborn priorities were essential to Steichen's existence. He was not a monster, not a Picasso driven

to deliberate, cruel domination of the women he hated and feared in proportion to his need for them. Steichen had a conscience and room for compassion, but he also had an urgent, lifelong mandate for accomplishment. To the investigative fervor of genius were added the compelling hopes of a vigorously supportive mother. In 1963, at eighty-four, when he received the telegram announcing that John F. Kennedy would be awarding him America's highest civilian honor, the Presidential Medal of Freedom, his first words were "If only my mother could have lived to see this day!"

Edward Steichen was the firstborn, favorite child of a mother absolutely convinced that the son who emerged from her womb was destined for greatness. Marie Kemp Steichen, a working-class Luxembourger with a few years of convent education, was a woman of reckless determination, willing to risk everything, including her husband's health, and turn her hand to anything in order to provide her son with the best possible opportunities for achievement. Her moral teachings were strict, but her cheerful encouragement of every risky artistic project her boy undertook—once art had been identified as his talent—was unwavering.

Steichen was born in Luxembourg in 1879, grew up in Milwaukee after a stay in the Upper Michigan Peninsula and, in 1900, headed for Paris to prove himself as a professional artist. The American audience for photography had already seen his entries in salon exhibitions in Philadelphia and Chicago and considered

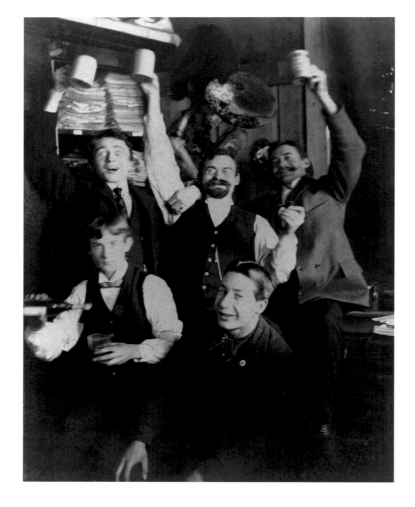

Staff of the American Fine Arts Company, Milwaukee, c. 1886. Steichen is at far left in the top row. Photographer unknown (possibly Steichen)

them original and provocative. On his way through New York, he made a favorable connection with Alfred Stieglitz, the indefatigable promoter of photography as an art form, who bought some of his prints. In Milwaukee, Steichen had helped found the Art Students' League and had parlayed his apprenticeship in a lithography studio into a job paying twice the going wage. He learned early the importance of attracting attention and patronage by producing something astonishing. He was first recognized as an artist of exceptional ability at age nine, when he traced a complex drawing and presented it as his original work.

All his life, he seized the advantage of being the first to use a new technique or to apply an old one in a new way. As a schoolboy, it occurred to him to put his new bicycle to work and become the fastest Western Union messenger in Milwaukee. At fifteen, as a lowly apprentice, he persuaded his employer that lithographs of livestock based on his own photographs of local examples would attract more customers than the stylized illustrations then used to publicize farm products. When the Lumière brothers, the inventors of an early and beautiful color process, made their autochrome plates available for sale for the first time in 1907, Steichen came close to cornering the market in Paris and arranged quickly to show the successful results. In the 1920s, when most advertisers still relied on drawings for illustration, Steichen convinced the J. Walter Thompson agency that the photograph offered greater immediacy and connection with the consumer.

In his youth, Steichen soaked up through reproductions in periodicals the major visual styles of his times. He was drawn to the sun-dappled colors of the impressionists and the massive heroics of Rodin's sculpture. Whistler's dark tones and compositions also turn up in early Steichens. The panache of the era's most popular portraitist, John Singer Sargent, reappears with bold elegance in Steichen's striking studies of fashionable women and in his later fashion photographs. His moody, mysterious landscapes and reveries have been linked, arguably, by other writers to the Symbolists. For his early landscapes, he evolved painterly results out of technical accidents such as raindrops on the lens or a foot jiggling the tripod. In the darkroom, he became a master manipulator, often spending days combining several difficult processes in one print. He would brush a platinum print with several layers of gum bichromate, then would overprint in color. Or he might print two negatives together before adding layers of other processes.

He remained alert and welcoming throughout his life to new talent and new modalities. Once in a while, he enjoyed a daring bluff. When he brought a show of Cézanne watercolors to 291 in 1910, he added a watercolor of his own, done in Cézanne's style, to test the acuity of the New York connoisseurs and, perhaps, to measure his own skill against that of an original master about whose work he was initially skeptical. At that time, Cézanne was ridiculed for his outrageous abstractions. Steichen believed that his "Cézanne" was slightly less free, more literal, than the authentic paintings, and that was why his fake became the public's overwhelming favorite. He withdrew it quickly and quietly.

At twenty-one, when he went to Paris for the first time, traveling in steerage class and bringing his bicycle for transportation on land, his only financial assets

were savings from his earnings in Milwaukee supplemented by a little of his mother's profits from her millinery shop. He had other assets: talent, voracious curiosity, inexhaustible energy; a sensitive, handsome face and an agile frame; an instinct for dramatic self-presentation; a deep-seated sense of entitlement; and the timing of an expansive, optimistic era ruled by fascination with progress and dotted with opportunity for a bright, ambitious young white man of northern European extraction. By his midforties, he had to provide for a wife, an ex-wife, his parents and the periodic needs of his grown daughters. Until he went to work for Condé Nast in 1923, his income usually lagged precariously behind his fame, but it could be supplemented with different kinds of help—commissions, housing, long-term child care—from influential and well-to-do friends. Steichen accepted such assistance as his due.

In turn, Steichen offered moral support to other artists. In the right mood, he radiated benevolence. Charles Sheeler (plate 138), a painter of precise, haunting American images, has written, "In those days, Steichen was like a great hearth around whom we all gathered for warmth." He spoke proudly of having changed John Marin's palette from somber Whistlerian tones to vibrant, sunlit-flower colors when they painted side by side in Steichen's garden at Voulangis and Steichen kept urging Marin to try pigments from his own brighter, more varied palette. Dorothea Lange, best known for her stark, compassionate photographs of migrant farm families during the Great Depression, visited us in Connecticut to start planning her retrospective exhibition. She saw that I was unhappy. When we traveled to New York together by train, she fixed me with a look as powerful as if she were shaking me by the shoulders and said, "Nothing but good has ever come to me through this man."

In the 1960s, Steichen photographed sporadically. He concentrated on the landscape he had hewn out of woods and rocks and hollows at Umpawaug, on the new race of delphinium he had bred and on the sunflowers he raised for optimal growth. He bought a professional-quality tape recorder to capture natural sounds—grass, wind, insects, birds—for the soundtrack of his shadblow film. To finish the film visually, he was waiting for one magnificent storm, but it never came.

He allowed our solitude at Umpawaug to be broken occasionally by a few close friends and held court for distinguished visitors from the past, for new talents like Paul Winter, and for the photographers Lartigue, Cartier-Bresson, Karsh, Harry Callahan, Paul Caponigro. As director emeritus, he still turned up weekly at the Museum of Modern Art. His own prints were in demand for exhibitions in many places. He lectured and received awards at photography conferences in Florida and California, camped out with his friends Wayne and Joan Miller in the coastal redwood forests north of Mendocino, lined up for snapshots with Rudolf Serkin and Pablo Casals between rehearsals at the Marlboro Music Festival in Vermont and, in 1966, visited Picasso at Notre-Dame-de-Vie. Steichen had arranged for the first showing of Picasso's work in America, at 291,

Edward and Joanna Steichen with Tripod and Fintan, 1966. Photograph by Jacques-Henri Lartigue, © Ministère de la Culture— France/AAJHL

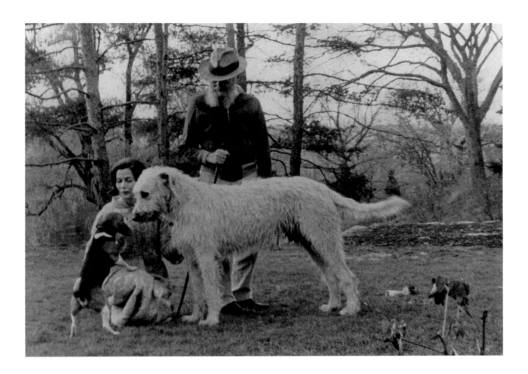

but the two never had actually met face to face. Both showmen to the core, they exclaimed their pleasure at "meeting again" and embraced like dear old friends.

These were years of attending formal ceremonies and collecting honors: the Presidential Medal of Freedom, conferred in a somber rite by Lyndon Johnson just weeks after the Kennedy assassination; the Family of Man Award sponsored by the Protestant Council of the City of New York; a sheaf of honorary doctorates and international medals; a red-carpet tour of Luxembourg as guests of the state; a half week of VIP treatment at the gala festivities in Washington for Lyndon Johnson's 1965 presidential inauguration; a white-tie dinner at the Kennedy White House for Charlotte, the Grand Duchess of Luxembourg. She was fine featured and white haired, gowned in cascading tiers of white chiffon, the image of an old-fashioned fairy godmother, minus the wand. For that event, Steichen practiced for weeks the phrase *"Ech sin e lëtzebuerger Jong"* (I am a Luxembourg boy). Agnes Meyer gave him a grand eighty-fifth birthday party at her mansion on Crescent Place in Washington. Another devoted old friend, Tom Maloney, publisher of *U.S. Camera*, gave him a ninetieth birthday party at the Plaza Hotel in New York. That evening, Steichen stood erect, shoulders back, in his perfect size-forty dinner jacket, but, except for a brief, rousing speech on the purpose of photography, his mind drifted in soft focus.

Steichen faded gradually over the years, then rapidly in the last two. His face, once a kaleidoscope of expression, settled into a single, solemn tone, his purposeful step and expansive gestures shrunk to a shuffle. Time blended into a stream without landmarks, and all but the three or four most familiar faces blurred into anonymity. There were moments of clarity when he became miserably aware of his condition. He had not meant to allow this slow subsiding into useless stillness. Edward Steichen died of congestive heart failure at home at Umpawaug on March 25, 1973, two days before his ninety-fourth birthday.

Steichen had considered trying to exercise permanent control over his work's integrity by instructing that his negatives be destroyed after his death. Alfred Stieglitz had done this, and Georgia O'Keeffe had obliged by scratching an X on the surfaces of some of them. But Stieglitz, who dedicated his life to photography as art, pure art—and who did not have to earn a living—considered the fine individual print made by the photographer its only valid expression. Therefore, once the photographer was dead, the negative never should be used. Steichen had a long falling-out with Stieglitz, partly over the pure-art issue. Steichen's midlife shift to photography as a medium of mass communication led him to consider that his negatives might have a useful life beyond his own. He decided they should be preserved as part of the record of his own work and as a source of historical information. He also decided that I should be their guardian and left his negatives to me outright.

The arrangement for his prints was more complicated. There were thousands in those gray folders on the plywood shelves of the Umpawaug storeroom. Steichen wanted them distributed to museums around the world at his executor's discretion, and I was sole executor. Confronted with the complexity of the art world, I decided to offer one museum first choice for its own collection in exchange for taking on the task of allotting the remainder appropriately. While communications with institutions in New York City foundered, the young staff of the George Eastman House at Rochester, New York, led by Marianne Fulton, organized an excellent Steichen centennial exhibition in 1979. They were so enthusiastic and thorough that they earned for their museum the combined privilege and burden of the Steichen print collection. Eastman House estimated that the New York institutions had lost the leverage implicit in three to four million dollars worth of negotiable Steichen prints.

I have lived with Steichen photographs for forty years. I've given slide lectures, written essays for exhibition catalogues, participated in producing a set of limited edition portfolios and, at different times, hung as few as six and as many as thirty-six prints in my home. I know Steichen's dynamic tricks with background panels; his ways of using an armchair to sculpt a sitter; his powerful diagonals worked in gestures or in groupings of people or by a sudden fall of shadow; the startling way he emphasizes bold postures in elegant women; the tingling joy he evokes in shards and dapples of brilliant light; the soft mystery of his deep velvet shadings into moody darkness; the tactile intimacy of flower petals or apples or birch bark in close-up; the hovering anticipation in a landscape; the rich, haunting sense of more than two dimensions in even the plainest still life. I can close my eyes and summon hundreds of his pictures in detail. They continue to amaze me. Whether it's a person, a grove of trees, a frog or a cigarette lighter, a successful Steichen photograph has an inevitable rightness that makes me believe he has penetrated the heart of his subject.

To select pictures for this book, I lived for months surrounded by portable panels filled with examples of that special Steichen intensity. That came after many more months spent reviewing everything in my collection and agonizing over the difficult choices required to narrow the selection down merely to twice as many as I could use.

The selection was complicated further by the range of variations in size, tone and finish that Steichen himself chose for the prints he exhibited. The variety of manipulations that he employed in printing from the same negative at different times or even in the same darkroom session makes it difficult to call any one vintage print the definitive version of that photograph. For example, in both early and later works, Steichen sometimes chose to add color or not depending on practical considerations, but just as often the decision was based on his mood and the purpose or context for which the print was intended. The portraits made for reproduction in magazines usually are strongest as untinted black-and-white prints, but sometimes, for contrast or emphasis, he toned them brown or green or blue for exhibitions and books.

In the Metropolitan Museum's collection of early Steichen prints there are three prints made from the same negative: *The Flatiron Building, Evening*, photographed in 1905 (plate 143). One is a gum bichromate over gelatin silver print in a reddish sepia tone made in 1905. The other two, gum bichromate over platinum prints made in 1909, are green-toned, one slightly yellower, one bluer. The three-color halftone reproduction in the 1906 number 14 edition of *Camera Work* has a subdued yellowish green tone. And in the first edition of the 1963 *A Life in Photography*, in which he had the option to use color, Steichen chose to have the same image reproduced in the subtle grays of pure black and white. The 1920 *Wheelbarrow with Flower Pots* (plate 144) is reproduced in this book from a rare color print made from two separation negatives. Although this print was in Steichen's possession when he prepared his 1961 retrospective exhibition, and he found the print important enough to write an explanation of the printing process on the back of its mount, he chose to use a straight black-and-white print for the exhibition.

In preparing this book, I was fortunate to be able to enlist George Tice to print from Steichen's negatives for reproduction in the book and to supervise the digital reproduction of those photographs for which there was no usable negative. Tice, the chief of a dying tribe of master printers, was one of Steichen's young discoveries at MOMA forty years ago. He also was the last person to print for Steichen in his lifetime. We examined it all: prints; the large-format negatives in at least a thousand folders, each containing from one to a dozen negatives from one or more sittings; boxes and looseleaf notebooks full of smaller negatives and 35-millimeter slides; autochromes; three-color process glass plates; first editions of *Camera Work*. Although I did borrow, gratefully, from museums several images I particularly wanted, I found that I could, if necessary, illustrate the tremendous range of Steichen's work entirely by drawing on the legacy he left me.

Not every frame that Steichen shot is a masterpiece, of course. I have files a foot thick of negatives and prints from the Max Reinhardt–Franz Werfel–Kurt Weill extravaganza *The Eternal Road*, two sittings, one at the theater, one in the studio, all full of waxen actors grimacing in biblical costume. There are enough portraits of fur-draped singers renowned for moving portrayals and legendary voices to cast a major opera house's entire season, but most of them stand rooted to the floor with all the vivacity of a taxidermist's display. There are

sequences of dancers and athletes suspended in obvious imitation of motion and some faces from which no wizardry of caressing light or expressive composition could evoke either beauty or character.

More difficult to eliminate were wonderful photographs of people who affected history or mattered personally to Steichen or myself but whose images, compared with the very best of his work, did not quite measure up. No picture appears in this book simply because of its subject's fame. Hardest of all was the decision to reject some pictures that Steichen had favored when we worked together. However, three extra decades of perspective made it clear when nostalgia for the subject or pride in a technique had colored his judgment. I was tempted to include atypical photographs—trees in a swampy Florida jungle, a panorama of the Grand Canyon, colorful scenes of life in Mexican villages— just to prove that Steichen could do them, but ultimately, priority went to photographs that it would be difficult to imagine being made by anyone other than Steichen.

Some of the work in this book is less well-known than it should be. This includes some of the powerful close-ups of fruit and objects and insects made in that intensely productive, exploratory period between 1920 and 1923, as well as Steichen's later color work with flowers and landscape. Many of the latter have not been published before. In composition and tone, the later landscapes flow naturally from the earlier ones. The midcareer, black-and-white close-ups of natural objects are as emotional and subjective as the earliest romantic studies. The techniques, the equipment, the subjects changed over the years, but the artist's sensibility did not. For Steichen, heightened clarity did not eliminate drama, beauty or the search for meaning.

There is an emotional dialectic in Steichen's work well beyond the facts of light and shadow. A romantic moralist, he seems always aware of the tug between good and evil. I am reminded of the darker fairy tales of Oscar Wilde and their theme: beauty, splendor, happiness have a secret, ghastly price, often paid elsewhere, by others, behind the scenes. I see it lurking in the gorgeous settings of his photographs of Marion Morehouse in Chanel and Cheruit gowns (plates 96 and 97), in the hothouse languor of the portrait of Mrs. Philip Lydig with a cyclamen plant (plate 71), in *Heavy Roses* (plate 308), in the nighttime scene of crew members scattered and tiny against the massive decks of the U.S.S. *Lexington* (plate 180).

Scholars and curators have tended to concentrate on chronology or a particular phase. They generate detailed arguments why this one or that is the best or most important or most influential period of Steichen's photography, and they assign it to a particular school. Some still make a distinction between "pure art" and photographs made for commercial purposes. I prefer a variation on the reasoning of the federal judge who ruled that Steichen did not have to pay customs duties when he imported Brancusi's *Bird in Space*, then a bewildering abstraction, to America. Art, wherever it is found, and for whatever purpose it was conceived, is a work that only the artist could have made.

Academic theories and curatorial categories had little appeal for Steichen. He used to tell a story about walking through the Museum of Modern Art and see-

ing a pair of well-dressed matrons clucking in distress in front of a large abstract canvas. They were trying so hard to "get it," sure there was a key to its meaning, one correct interpretation, if only they could find it. He suggested that they sit down, relax, give up trying to understand the painting and simply look at it, take in its colors and shapes, its overall effect. If any associations or reactions emerged, that was fine. If they found they liked something about it or they hated it, that was all right, too. In preparing this book, I have considered many rationales, but ultimately, I have taken Steichen's advice and trusted my eyes.

Because I remain fascinated with the underlying continuity in Steichen's entire body of work. I have grouped the photographs in sections chosen to emphasize visual theme and emotional communication over chronology and initial function. I want the reader to have optimal opportunity to experience the images simply as images. For example, portraits of actors turn up in several sections. The one called "Improvisation" includes actors in particular roles, composites and single shots set up to convey the major themes of a play, and images made to promote products or to raise money for charitable causes. Their common ground is that they are all scenes composed by the photographer to bring a particular story to life on the printed page. In the section called "On Stage," portraits of actors are treated more formally and with deeper, more psychological scrutiny.

The section called "Style" includes advertisements, fabric designs, fashion photographs made to sell class along with clothing, gleaming close-ups of objects and privately commissioned portraits of dazzling elegance. Among the celebrity portraits, I have segregated people by field of influence because Steichen emphasized different characteristics in each one. Even when their expressions are animated, the writers have an inward-turning look, while the subjects in "Artists" appear to be responding to visions outside of themselves. Composers, conductors, instrumentalists and dancers are grouped together because Steichen usually found a way to suggest powerful motion in the makers of music, even when they were in repose.

Steichen's importance to twentieth-century art both includes and transcends his own photographs. From his teens through his old age, he remained passionate about the visual image and its effect on the spectator. Part of his genius lay in his ability to spot and seize new possibilities in many different media. With the work of others, such as Cézanne's and Matisse's paintings and Brancusi's sculpture, he relished being the clever and valuable fellow who pointed out new wonders to the rest of the world. In photography, he opened doors with a flourish, threw himself ardently into mastering every millimeter of the new venue, then moved on and applauded those who passed through to their own achievements.

There were disappointments and regrets. While it was always secondary to fascination with the process of the work at hand, he took a kind of innocent delight in his fame and the ability to get what he wanted, and that elicited envy and spite. He could be hurt by critics and fellow artists who misunderstood his professional aims and his altruistic intentions, particularly by those whose own ambitions and self-esteem depended on defining and defending specific pigeonholes. In personal life, his first wife caused him tremendous anguish and embar-

rassment, which left permanent scars. While accepting it privately, he never could face public acknowledgment of his daughter Kate's lesbian relationship.

He never learned everything he wanted to know about color printing. On principle, he encouraged photographers who were experimenting with abstraction even when he was not enthusiastic about their results. In all his work, he always felt there were more discoveries, more possibilities, if only he could grasp them. In late middle age, he felt trapped by commercial success, stuck doing other people's bidding when he wanted to be out exploring his own interests. He was known for his sincere and respectful attention to every photographer who brought a portfolio to him at MOMA, and he produced many small exhibitions that launched careers. But when he perceived that they were really explorers of new horizons, he advised them to earn their livings as plumbers or carpenters, anything but photographers, and leave their work with the camera free to roam wherever their eyes and hearts might take them.

He was full of contradictions. He thought of himself as the son of peasants, but he accepted royal treatment as his due. He had a fierce temper and a beatific smile. He broke promises. He demanded truth from others but manipulated his own. He never could repeat a story without embellishing it a little more each time. He loved beauty, and he could find it in worn faces and insects, tenement fire escapes and dying begonia stalks. He hoarded his time and his attention with a selfishness that infuriated wives and children, but, when he chose, he could enter fully into the moment, any moment, whether painful or joyful, dig in wholeheartedly to the task at hand, hold nothing back. Meeting the daily needs of individuals was not his concern. His capacity for connecting truly and intensely operated on a grander scale.

As he aged, Steichen became more and more fervent about the photograph's ability to communicate. He called the job of the camera that of explaining mankind to himself. He never stopped believing that seeing led to understanding and understanding could transform suspicion, hatred and violence into tolerance, peace and love. In that sense, Steichen's capacity to love was tremendous. And that is what his pictures are about. They never entirely forget the danger in the shadows, but they demonstrate the passion and the connection that make life worth living.

STEICHEN'S LEGACY

PLATE 2 | *Portrait of a Young Man* (self-portrait), 1905

The Young Photographer (self-portrait), Milwaukee, 1898 | PLATE 3

PLATE 4 | *Young Tycoon* (self-portrait)

At the Garden Wall (self-portrait) | PLATE 5

PLATE 6 | *With Studio Camera* (self-portrait), 1917

With Photographic Paraphernalia (self-portrait), 1929 | PLATE 7

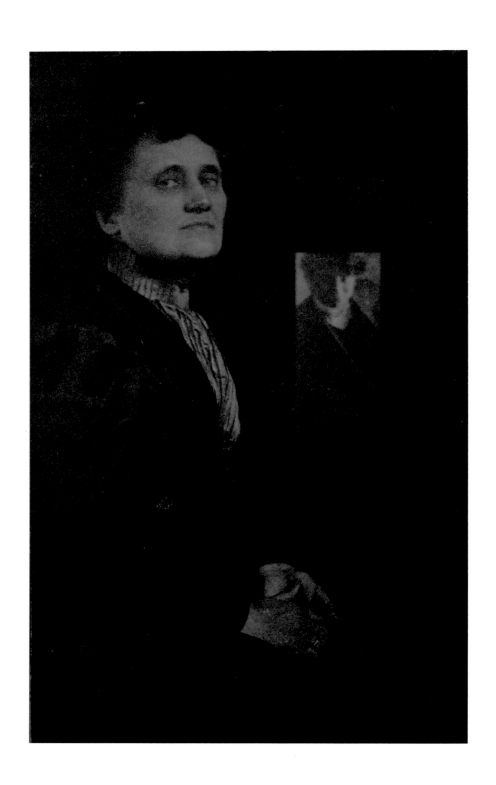

Portrait of My Mother (Marie Kemp Steichen), Milwaukee, 1908 | PLATE 8

NEXT OF KIN

To the individual, knowledge remains an abstraction until it is related to his experiences. Knowledge needs to be fertilized by experience or vice versa to become alive, effective, useful, and the experience must be penetrating, or it also [remains] an abstraction.

—E.S., private notes

When Marie Kemp and Jean-Pierre Steichen married, Luxembourg was a poor, precariously independent grand duchy, 998 square miles of sloping meadows, iron mines and steep hills topped by crumbling castles. The official language was French; the language of the people was Lëtzebuergesch, a low German dialect. Steichen is a very common name there. When we visited in 1966, as guests of the state, with red carpets, black-suited mayors and little girls offering bouquets of flowers to greet us in each town, he was polite but not interested in the hordes of Steichen relatives who presented themselves. He felt that all the strength and encouragement in his life had come from his mother, but her line of Kemps had disappeared. He told me that in the Luxembourg of his parents' youth, a person's worth was determined by the size of the manure pile in front of his house, and Marie's in-laws, who had a large manure pile, looked down on her. She vowed to rear her children in an environment that offered equality and opportunity.

I imagine Marie as unselfconsciously ambitious, fired with the rightness of her way, a little too fierce to be an easy companion—all traits she passed on to her descendants. She had no fear of risky ventures. As soon as she became pregnant, she began making plans to immigrate to America. When their son, christened Eduard [*sic*] Jean, was born, she packed Jean-Pierre off and then followed with the child eighteen months later. They ended up in Hancock in the Upper Michigan Peninsula, where Jean-Pierre worked in the copper mines until his health failed. Marie, who had some experience as a seamstress, became a milliner overnight. She ordered a large supply of hatboxes to fill the shelves, a few hats and a variety of trim, and turned the front room of their rented house into a shop.

The millinery shop supported the family, even though most of the neighborhood women covered their heads with kerchiefs. Marie decided that the poor, working-class population of Hancock did not offer the right examples for her boy. So she found a boarding school for him, Pio Nono College, in Milwaukee, a prosperous city where the streetcar conductors might refuse to speak any language other than German but where the beer barons built mansions on the bluffs overlooking Lake Michigan and stocked the local library with literature and art

periodicals. Sent off to boarding school at age nine, Steichen was much younger than the other students, so the monks in charge occupied him with art classes. In one of them, in a skewed echo of his mother's bravado with the empty hat-boxes, he produced the traced drawing that he presented, to much acclaim, as an original.

The announcement of her son's artistic talent propelled Marie into moving the whole family to Milwaukee, where she opened another successful millinery shop. In his teens, he began experimenting with cameras. When only one picture in his whole first roll of film was considered fit to print, Marie praised it, and Jean-Pierre complained about the waste. Though she worried about keeping dangerous chemicals in the house, Marie allowed her talented son to set up a darkroom in the basement, where he could print from individual plates. As his work in photography became more intense and, with portrait work, even prof-itable, his father enjoyed referring to him as that "long, lean, lazy lout of a poor pitiful photographer."

His mother was consistently encouraging about his work and relentlessly strict about other issues. When he charged some neighbors twice the agreed-on amount for vegetables from Jean-Pierre's garden, Marie made him go back and return the extra money. When, as he entered the house, he yelled back into the street to another child, "You dirty little kike," Marie excused herself from the customers, closed the shop and sat down to lecture him for what seemed like hours on the evils of bigotry and intolerance and on the basic equality of people of all races, creeds and colors. He always claimed that this lecture sowed the seed for *The Family of Man.*

Marie had the courage of her convictions. She had begun life as a devout Catholic, but in middle age, volunteering in her church's soup kitchen, she saw some neighborhood children being turned away because they did not belong to the parish. According to her son, she marched over to the rectory immediately to ask the rector whether he had made that rule. When the priest replied that he had, she took off her apron, flung it in his face and never returned to church. Steichen reported that, on her deathbed, she adamantly refused all offers to sum-mon a priest.

The only image considered fit to print on the first roll of film Steichen shot with his first camera was *My Little Sister* (plate 9). Born in America four years after her brother, christened Lillian and called Pausl, she was short, with a sharp, pretty face and a cloud of hair that turned white before she was thirty. Pausl was as energetic, bright and determined as her brother, and she shared with him an aptitude for genetic tampering. While he steered that aptitude into plant breed-ing, she directed hers toward goats. Pausl bought a goat one day to supply milk for a neighbor's lactose-intolerant child. The single goat multiplied into three champion milking herds: Saanens, Toggenburgs and Nubians, those elegant beauties with aquiline noses and long ears like wigs that turn their heads into masks suggesting all the wisdom of ancient Egypt.

Pausl insisted on becoming one of the rare women of her generation who went to college. She emerged a Phi Beta Kappa, found a teaching job, got involved in socialist politics and met a young poet, Carl Sandburg, definitely a

Eduard and Lillian Steichen, Hancock, Michigan, c. 1884. Photograph by F. C. Haefer

Mary and Kate Steichen, Voulangis,
1913. Mary is at left, Kate at right; girl
in center unknown. Photograph by
Edward Steichen

diamond in the rough. She followed the model her mother
had provided of woman's role as nurturer of a male genius.
She protected and encouraged Carl, arranged the house-
hold activities around his work, brought up their three
daughters and managed the goat farm. Pausl served as the
stable rock for her children and her wandering-poet hus-
band, and her fierce loyalties never wavered. When Stei-
chen's daughters turned their lifelong frustration with their
father into spiteful accusations against me, Pausl refused to
listen, telling them I would always be the angel who had
come into her brother's life when he was most in need.

By the time the twenty-one-year-old Steichen installed
himself in Paris, he was a dashing figure. He made friends
easily, and he attracted women. His first wife was Clara
Smith, a coldly chiseled beauty from Missouri whose
mother had brought her to Paris to seek her fortune. The
couple married in New York in 1903 and in 1906 returned
to Paris, where life as the wife of a rising, ambitious artist
turned out to be much less attractive than Clara had imag-
ined. The portrait of Mr. and Mrs. Steichen on their hon-
eymoon—she with her chin up and her mouth turned
down, he wide-eyed and hopeful—could have been used
to predict the course of the marriage (plate 12). Clara, dif-
ficult from the start, became increasingly acrimonious as
the years went on. Steichen acknowledged to me that he
had contributed to their problems. He had been short-
tempered and preoccupied with his own goals. When the
struggling young family finally moved into an apartment
equipped with the luxury of a bathtub, Clara expected to
bathe her babies in it, but Steichen immediately appropriated the bathtub for
darkroom use.

Steichen claimed that he never had wanted children and would only marry a
woman who did not want them. He worshiped the sight of a pregnant belly
when it did not belong to his wife, but a baby closer to home offered too much
competition with his own creative efforts. Despite his preference, Mary was
born in 1904 and Kate in 1908. Clara discharged her own unhappiness onto her
firstborn, whom she subjected to vicious physical and mental abuse. In later
years, Kate, her second and favorite daughter, described her as a devil. In 1914,
the family fled France just barely ahead of the advancing German army. Back in
New York, Clara found life with Steichen so disagreeable that she returned to
France in the middle of the war. She took Kate with her, but Mary refused to go.

After the war, Clara filed a suit in New York for alienation of affection
against a young heiress, Marion Beckett, who had been a guest in the house at
Voulangis. Steichen told me he had had an affair, but with a different visitor.
Eventually, Clara admitted that she had accused Miss Beckett because she was
rich. Even though Clara lost, the suit caused an embarrassing scandal for Stei-

Proud of her soldier: Edward Steichen
and his mother during World War I,
c. 1917. Photographer unknown

chen. When it ended, he returned to France for his last extended period of resi-
dence in the house at Voulangis and filed for a divorce. He did not go to France
alone. At the New York Camera Club, he had met a pretty young actress called
Dana Desboro.

She was born Goldie Glover on a hardscrabble midwestern farm. Her mother
named each of her daughters after a jewel or a precious metal, raised them alone
and warned them never to fall into the trap of having children. Goldie-Dana had
a smiling, dimpled face and masses of red-gold hair. From 1923 on, when she was
not on tour with a play, Dana and Steichen made a thin pretense of not living
together. A door in the back of the closets connected their separate bedrooms in
the first, temporary cottage at Umpawaug. In New York, Steichen rented a room
in Dana's mother's apartment on the Upper West Side. After his experience with
Clara, Steichen was wary of marriage, and Dana, who claimed she had married
and divorced one of her stage managers some years before, could not produce
the papers. So they never got a license or had an official ceremony. By 1929, both
Steichen and Dana were tired of her long absences on the road. She retired from
the stage, and they announced that they had been married secretly in France
in 1923.

Steichen's photographs of Clara are cool and distant. Often, she is identified
only as Mary's mother (plate 16). The photographs of Dana are intimate, full of
pleasure and warmth (plates 18 and 150). Dana was the best of his three wives,
devoted and undemanding. She accepted Steichen's priorities, raised the Irish

wolfhounds, was genuinely kind to his children and grandchildren, became a champion bird-watcher, cooked and baked in the big kitchen that was the one concession to her wishes. In the back of a cupboard in the house at Umpawaug, I discovered penciled floor plans and notes in Dana's handwriting. She had imagined a very different house, one with room for a greater variety of people and activities than the dramatic and egocentric statement Steichen built.

By the late 1940s, Dana had become a virtual recluse. She believed she had found a musical theme that ran through Beethoven's works and provided the key to the identity of his mysterious "beloved." Before advancing cancer claimed her in February 1957, she completed a manuscript, called *Beethoven's Beloved*, to support her theory. Doubleday published it posthumously. As they had agreed, Steichen sprinkled Dana's ashes in the middle of the pond in front of the house. Every Memorial Day, for as long as he could handle the boat, he rowed out to the middle of the pond and strewed flowers over its surface.

For two years, he was inconsolable. He arranged a rendezvous with at least one beautiful, available woman and found he was not interested. He spent months with friends in California, considered building a cabin among the tall coastal redwoods and spending days of contemplation in the natural temple formed by their soaring trunks. But projects and invitations beckoned, and he was not geared to sitting still. He was on his way to Moscow for the American Exhibition and then on to visit friends in Sweden and France when we met at the airline lunch in 1959.

I was the only one of Steichen's wives who was not a natural, photogenic beauty. Except for some vacation snapshots which are lost, he photographed me only once, and the inspiration to do so came from the accident of my being present when a reflection of the pond and hillside in a window offered an irresistibly puzzling composition (plate 19). I met the no-children qualification, since I had decided in my teens that, without a clear idea how to make a child feel welcome in the world, it would be wiser never to have one. Eventually I realized that with my broad shoulders and failure to develop either cute, girlish mannerisms or knowing, seductive ones, I appealed mostly to men looking for the ideal caretaker I never wanted to be. Steichen was too proud to admit that he was one of those men, and I was too blindly infatuated to notice until after we were married. We pitched our relationship on the romance of sexual passion and shared ideals. Later, slowly, we learned to accommodate our mutual disillusionment.

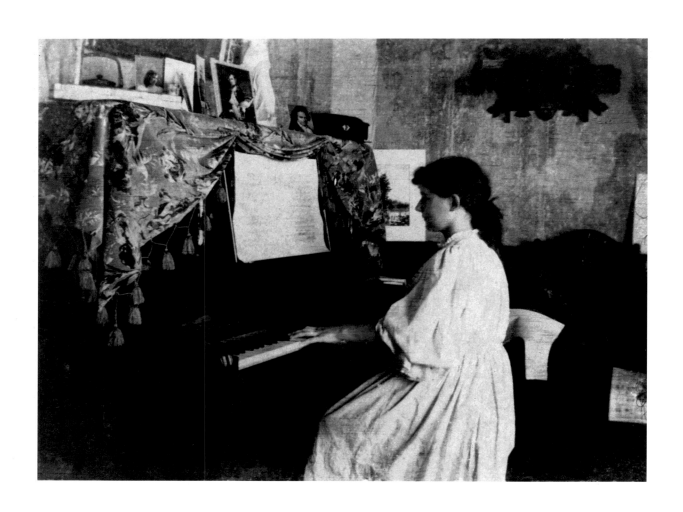

My Little Sister (Lillian [Pausl] Steichen), 1895 | PLATE 9

PLATE 10 | *Lillian Steichen,* Menomonee Falls, Wisconsin, 1907

Marie and Jean-Pierre Steichen | PLATE 11

PLATE 12 | *Mr. and Mrs.——Edward and Clara Steichen on Their Honeymoon,*
Lake George, New York, 1903

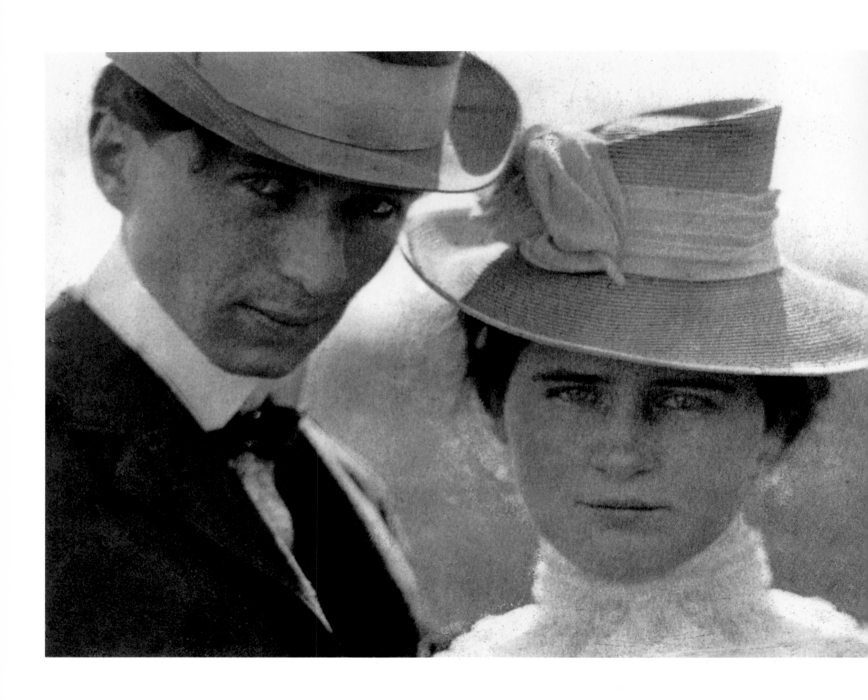

Brother and Sister—Edward and Lillian Steichen, Milwaukee, 1900 | PLATE 13

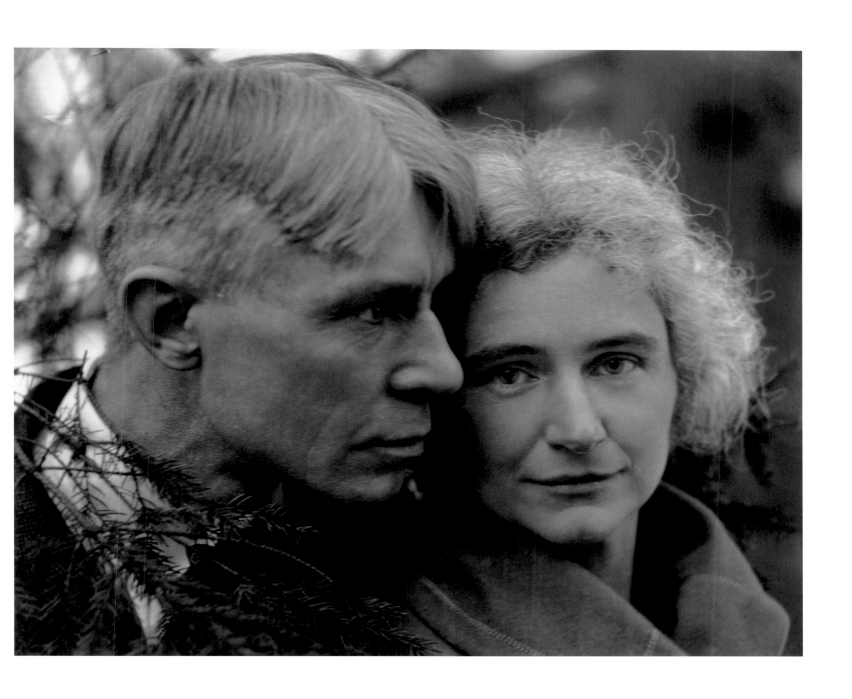

PLATE 14 | *Mr. and Mrs.—Carl and Lillian Sandburg, 1923*

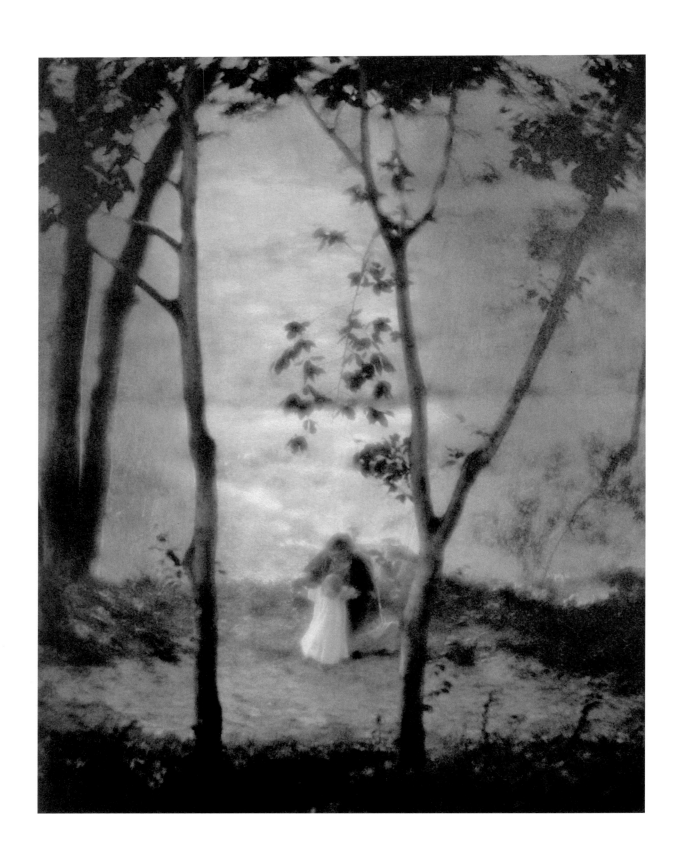

Mary Learns to Walk, 1906 | PLATE 15

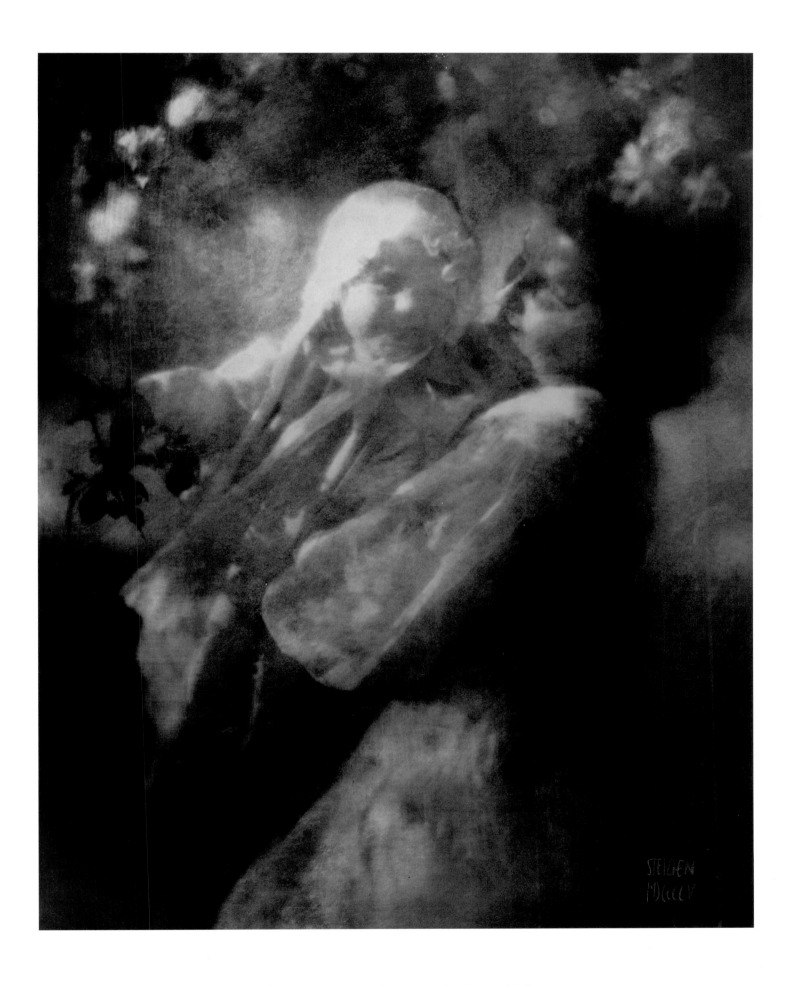

PLATE 16 | *Mary and Her Mother*, Long Island, New York, 1905

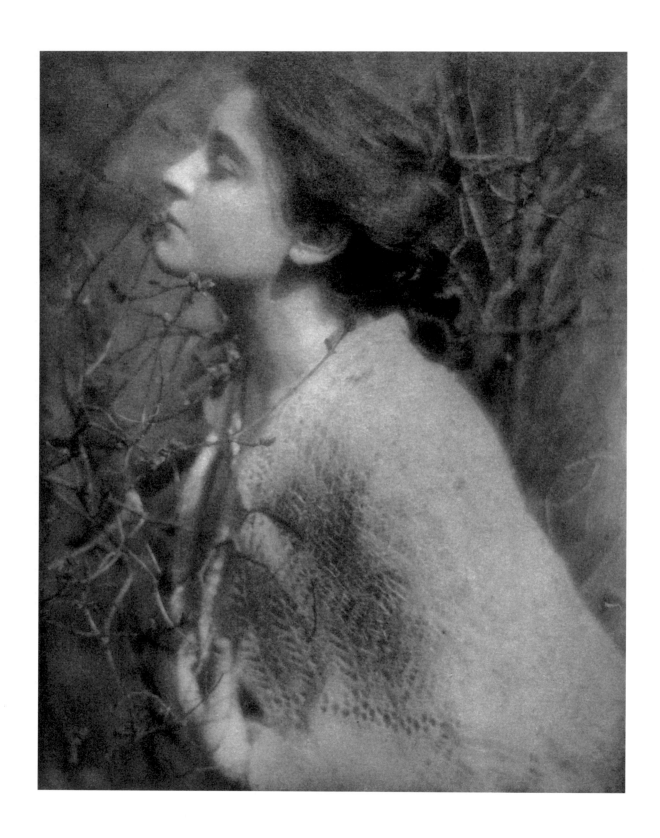

Lilac Buds—Clara, Long Island, New York, 1906 | PLATE 17

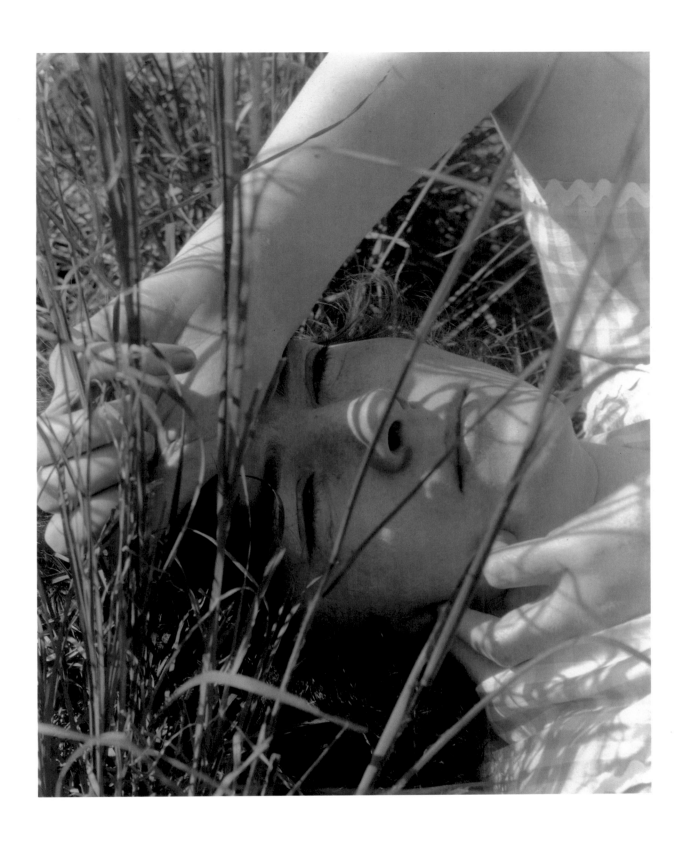

PLATE 18 | *The Blue Sky—Dana,* 1923

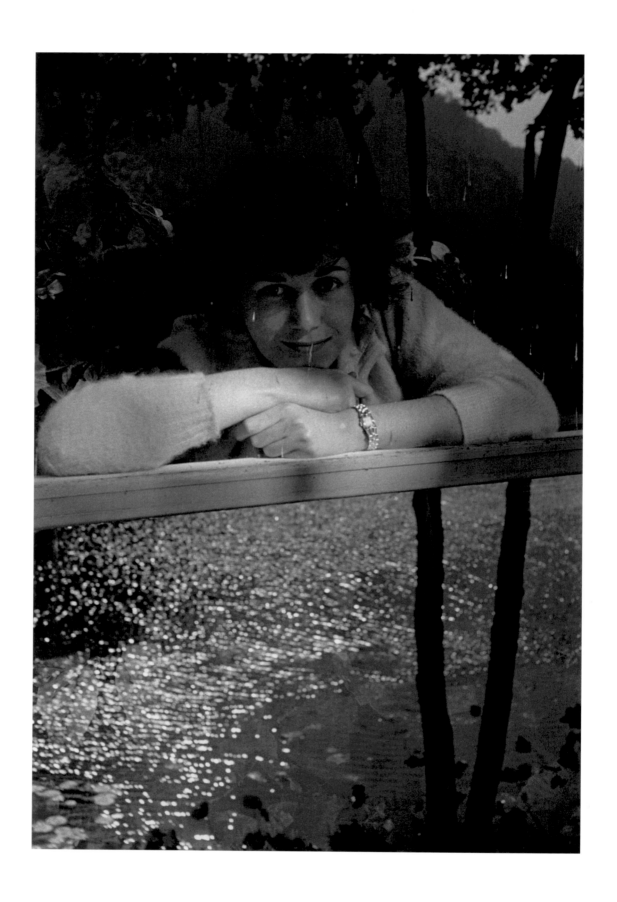

Joanna, Umpawaug Farm, 1959 | PLATE 19

The Lady in the Doorway, Milwaukee, 1897 | PLATE 20

OF WOODS
AND WATER

In art, the dynamic is the result of the contemplative.

<div align="right">—E.S., private notes</div>

While Steichen made friends easily and directed a succession of peers and subordinates with galvanizing spirit, he needed solitude for learning, growing and creating. All his life, he found challenge and regeneration in landscape. In both painting and photography, he loved particularly the feelings induced in him by what he called "the haunting, elusive quality of landscapes" at twilight and in moonlight. Such scenes were never far from his home in Milwaukee. When his mother retired from the millinery business, he bought his parents a small farm in what is now a near suburb, Menomonee Falls. In Paris in 1908, a struggling artist with a young family, he scraped together enough money to lease an alternative to his city studio, a house with a garden in the tiny farming village of Voulangis. Through all his transatlantic moves, he kept that lease until 1923. As soon as he had accumulated some money working for Condé Nast in New York, he began scouring the territory in an expanding radius from the city, looking for a few hundred acres that he could afford to buy.

Steichen became interested in photography at sixteen, first as a practical aid to illustration and as a source of extra income through photographic portraits and group pictures for local social organizations. Soon the desire to photograph things that had personal meaning took over. His first camera was a relatively small box camera selected because it was cheap and its name appealed to him: the "detective camera." But he could not see the results of his work until the dealer sent the whole roll of film back to Eastman Kodak to be developed. This was frustrating and expensive. He traded the detective camera for a four-by-five-inch Primo Folding View Camera that used single plates he could learn to develop himself.

To improve their skill in painting, he and a group of friends hired a studio, a live model and a local painter, Richard Lorence, to instruct them, and that was the beginning of the Milwaukee Art Students' League, but for photography, Steichen was on his own. While the library stocked books on painting, and he absorbed the style of the impressionists there, he could find nothing on photography. Except for some advice from a friendly camera dealer, he learned his techniques by trial and error. It took him three years to feel in control of the effects he wanted then, but fascination with the mastery of technique continued all his life.

He realized that the most important and magical element of a photograph

was light and that light could determine the mood and the subject. He began the impressionistic photograph called *The Lady in the Doorway* (plate 20) as a study of sunlight coming through the door of the summer quarters of the Milwaukee Art Students' League. A young woman, a fellow student, appeared, and Steichen asked her to stay there. He deliberately shifted the image on his ground glass in and out of focus several times and decided he liked the quality of the light better out of focus. That decision also kept the photograph a landscape, while sharp focus might have turned it into a portrait.

In Steichen's adolescence, a photograph was considered good if it offered a clear, recognizable image. But he was drawn to mood and lyricism. He would take his camera and tripod to a vacant woodlot to try out many different combinations of focus and exposure. Several accidents contributed to his repertoire. On one heavily overcast day, while he was setting up his camera, a few raindrops fell on the lens and made the scene in his ground glass mysteriously diffuse. He liked it. Later, he found he could repeat the effect by spitting on the lens. At another time, during an exposure that lasted several seconds, he accidentally kicked the tripod. The resulting vibration in the camera produced a different kind of diffusion. When he showed the results of these found techniques to his friends at work or in the art class, they pronounced them "artistic." He was delighted to get approval for going beyond the literal. In his own words, "Emotional reaction to the qualities of places, things and people became the principal goal in my photography."

As an artist, he understood how much composition contributed to setting the mood of a picture. At first, he relied on cropping his photographs to produce the effect he wanted, but eventually, he learned to compose in the ground glass viewer of his camera. *The Pool—Evening* (plate 22) and *Woods—Twilight* (plate 24) are early examples of successful initial composition. *Woods—Twilight* also illustrates the diffusion produced by wetting the lens. In discussing *The Pool—Evening*, he described how he transformed a puddle of water with protruding mud clots into something that seems much larger and deeper by setting the focus on the foreground and regulating the diffusion in the trees in the background through opening or closing the diaphragm of the lens.

Except for the autochromes, Steichen produced his early color photographs through hand toning, multiple printing and brushing different colors on the printing paper in combined platinum, ferroprussiate and gum bichromate processes (plates 32, 143, 152). He also used mechanical processes to add color in the print that did not exist in the negative (plate 31). But the mystery, rapture and enchantment of his early color landscapes reappear in the 35-millimeter color photographs he made from the late 1930s through the 1950s (plates 34–43). In these, the effects come not from manipulation of the lens or the printing process but from brilliant use of natural phenomena: shadow, sunlight on water, reflection and mist. Most of them were made on his own land at Umpawaug Farm.

In 1928, Steichen bought this abandoned farm in West Redding, Connecticut. Only the barns, set traditionally close to the road, remained standing. Steichen put up a prefab house for his own temporary use on the foundation of the old farmhouse. He converted the barn next door into a photography lab and a gar-

dener's apartment and added a greenhouse. He found two places where the land was naturally depressed and had two ponds dug out. The upper pond, reached by a narrow path through the woods, formed a wide oval that bulged into a bay on one side. It was deep, a private seventeen-acre swimming hole bordered by dense woods and contained at one end by a long concrete dam that also served as a footbridge. (This pond is now the official swimming hole and recreation center for the Town of Redding. Steichen had considered making a grand gesture and giving the pond to the town, but, in the 1960s, living on dwindling investment income, he needed to recapitalize and began the process of selling it to the town instead.) A thin sheet of water flowed from a small opening at the bottom of the dam and splashed and gurgled over natural rocks in a zigzag stream until it vanished in the smooth, sleepy surface of the lower pond.

The lower pond was smaller, long and shallow like a tranquil English river floating wide aprons of water lily and lotus, as well as the invading cow lily weed with its puny yellow bud. One bank of this pond, bordered by the stiltlike trunks and bushy pates of swamp maples, sloped gently down from a wooded hill and the end of a level field. It has an eerie resemblance to a different pond that Steichen photographed in 1906 (plates 33 and 34). The other bank was dotted with the beak-leaved, drooping branches of weeping willow and sinuous clusters of shadblow. Behind them, the ground rose abruptly in a bold pink sweep of dogwood, which Steichen had planted, to a bare, jagged rock cliff towering above the surrounding woods and fields. The cliff was known in the neighborhood as Topstone. Charles Sheeler made a drawing of it, and Carl Sandburg wrote a poem about it:

> Sometimes old men sitting near
> the exits of life say there were giants in those days!
> they wanted stones to sit on,
> stones to throw at each other,
> great stones for companions,
> for loneliness, all giants be-
> ing lonely.

Steichen took ten years to decide where to build his house. He considered placing it over the upper pond's dam with the constant music of running water below, like Frank Lloyd Wright's Falling Water. He considered a stark extension thrust up from the rocks of Topstone cliff, a fortress from which to survey the countryside. He considered a site halfway up a gentler hill, where he might incorporate into the house walls a massive outcropping of boulders. He decided to build in the bottom of a bowl. From there, he could control everything he would see from his house. He designed the house himself and had it constructed next to the lower pond, facing Topstone cliff.

The house was built into the bank of the pond, most of it on one floor, the guest bedrooms down below, invisible from the entrance. The materials were fieldstone and glass and naturally battered, brown-gray pecky cypress wood. Approaching it by car, beyond a screening grove of pines, one saw a flat-roofed

Steichen's house at Umpawaug Farm (designed by Steichen, built in 1940). Photograph probably by Steichen

structure just tall enough to contain a garage door. On the right were a hedge and a low stone wall broken by a few stone steps leading up to a long, perfect lawn bordered by flower beds. A flagstone path beside one of the beds led to a simple trellis of beams hung with pots of fuchsia. These shaded a plain brown door and the wide windows of what appeared to be a low, one-story house of modest dimensions.

But inside, beyond the sheltering entrance hall, lay the grand expanse of a room almost two stories high. Three of its walls were panels of glass set into two bays whose corners were joined by slender posts. Dividing the glass bays was an asymmetrical center fireplace with no mantel, just a vertical panel of rough white plaster edged in fieldstone around a corner opening. The thin posts where the glass walls joined at the corners were barely noticeable against the mixture of foliage outside mingling visually with the jumble of plants set in gravel trays on a polished brick floor flanking the glass inside. It was difficult to tell where the room ended and the landscape began. That was as Steichen had planned it.

Out of once abandoned Umpawaug Farm, he created a magic bowl and, in it, a singular, dramatic house considered shocking for 1940 in a countryside dotted discreetly with traditional, center-hall colonials. A guest waking in a room downstairs close to the pond on a late September morning, as I had on my first visit, would see through a loose scrim of mist rising from the water a dream landscape, a haze of yellow and rosy gold and garnet and tender green (plate 37). Years later, on a visit to Kyoto, I learned about the Japanese use of foreground and background in an aesthetic that makes it impossible to distinguish between features that nature had put in the landscape decades ago and those a gardener had arranged earlier in the day. That was Steichen's landscape. Through it roamed a series of wheaten-colored Irish wolfhounds, noble, gentle giants whose short, rough coats almost disappeared against late autumn grasses or snow. It's

not surprising that Steichen chose as his canine companions the tallest breed in the world (plate 30).

In the 1950s, he became fascinated with a single tree. The shadblow tree or bush, usually an upright cluster of twisting trunks, is the first of the native species in the northeast to put out its mass of white blossoms in spring. (The name "shadblow" comes from its timing. It blooms when the shad fish begin to swim upriver to spawn.) Across the pond from the house, directly opposite the deck off the master bedroom, one shadblow stood apart from its sisters. It had only two trunks, which seemed to come not from the bank, but from the water of the pond itself. To Steichen, it looked like a little girl standing on one foot, shyly twisting one leg around the other. He began photographing this special tree on 35-millimeter color film in every season and at all hours (plate 40).

Stories evolved. A paper-white birch growing uphill from the shadblow began bending toward her. The birch became a lovesick suitor. And when the birch had bent so far that it snapped its trunk and died, that was the classic ending of a great romance. After he had completed his shadblow series with thousands of 35-millimeter slides, Steichen decided against putting together the still pictures. He wanted motion. So he began all over again with the Arriflex movie camera. Except for a silent sample a few minutes long, the film was never completed. I moved to the city after Steichen's death, but I have been told that the shadblow did not outlive him very long. The roots weakened, and the little tree succumbed, like Ophelia, to the water.

Woods in Rain, Milwaukee, 1899 | PLATE 21

PLATE 22 | *The Pool—Evening,* Milwaukee, 1899

Melting Snow, Milwaukee, 1899 | PLATE 23

PLATE 24 | *Woods—Twilight, 1898*

Moonlight — Winter, Milwaukee, 1902 | PLATE 25

PLATE 26 | *The Big White Cloud,* Lake George, New York, 1903

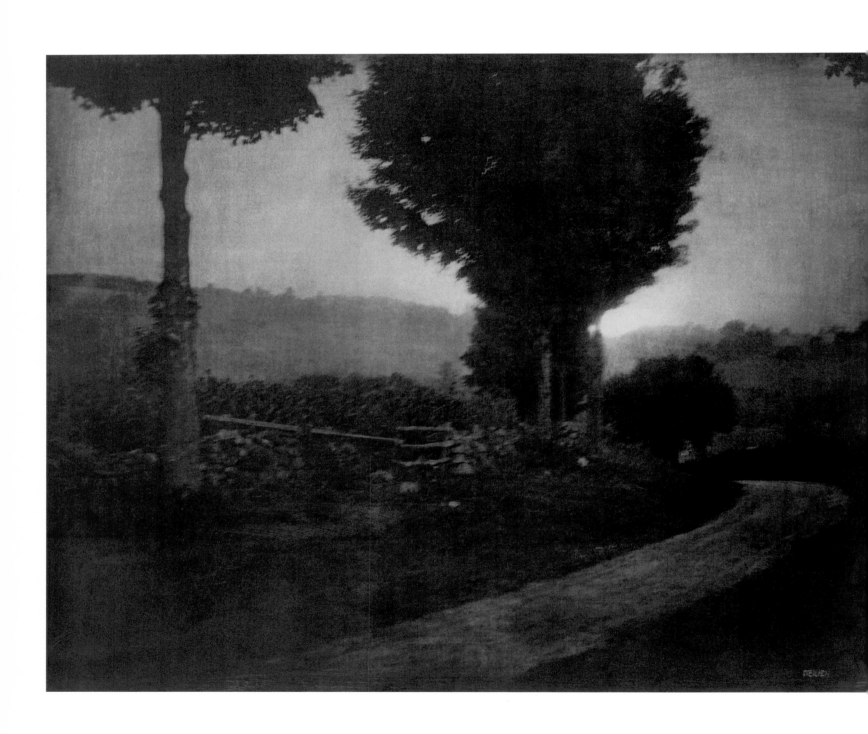

Moonrise, New Milford, Connecticut, 1904 | PLATE 27

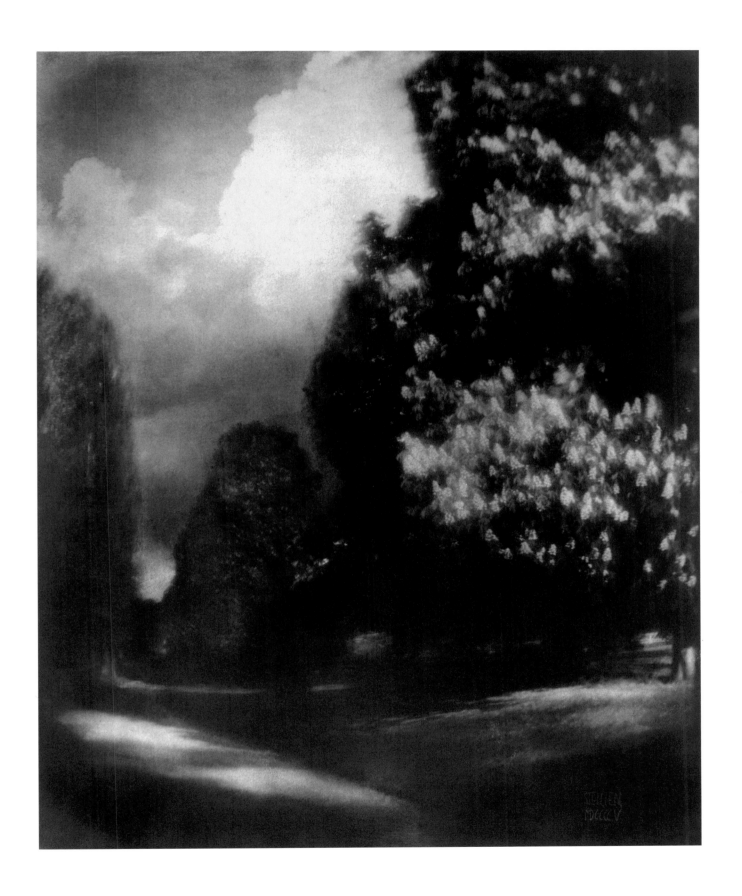

PLATE 28 | *Horse Chestnut Trees,* Long Island, New York, 1904

Clouds from an Airplane | PLATE 29

PLATE 30 | *Irish Wolfhound,* Umpawaug Farm, 1940s

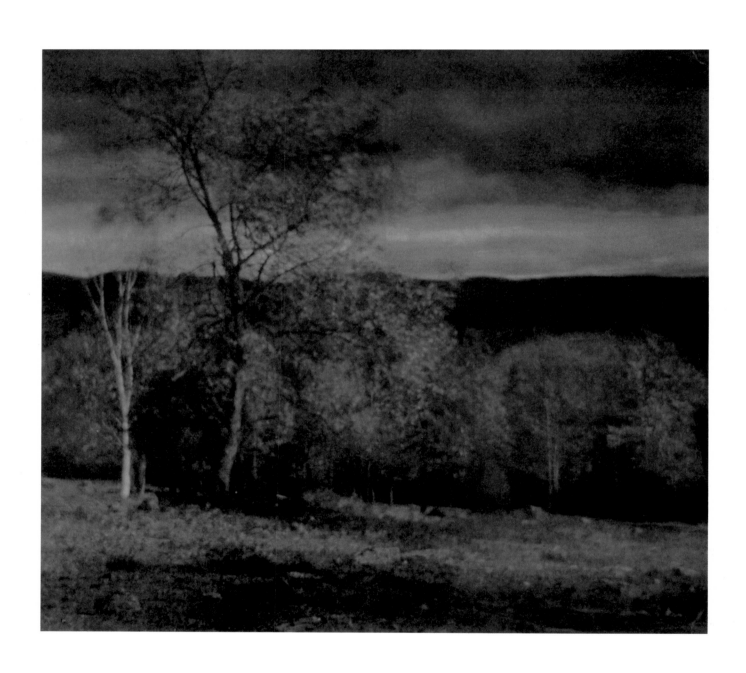

Landscape in Two Colors, 1906 | PLATE 31

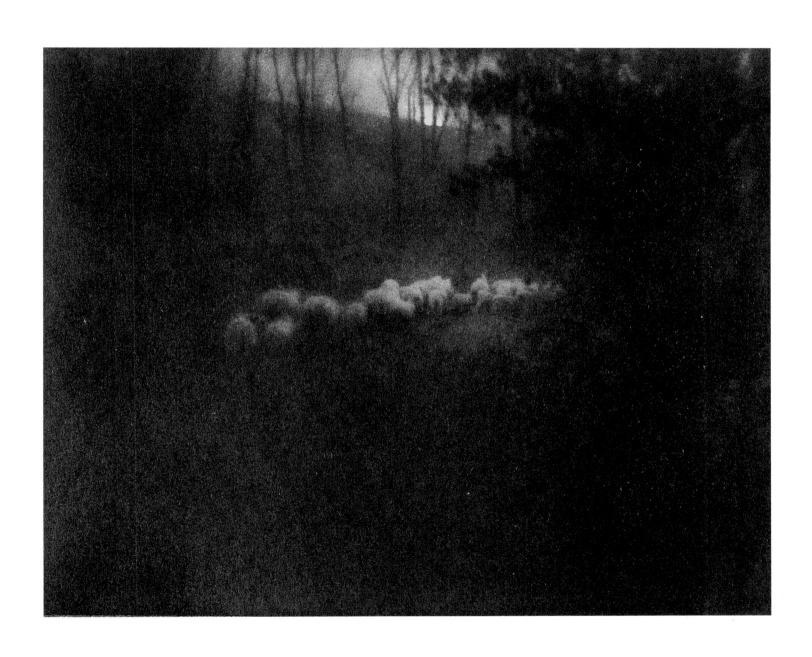

PLATE 32 | *Pastorale—Moonlight,* 1907. Hand-toned gravure

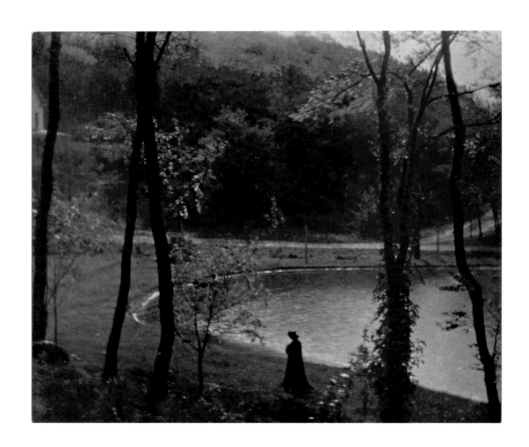

Around the Pond—Experiment in Three-Color Photography, 1906 | PLATE 33

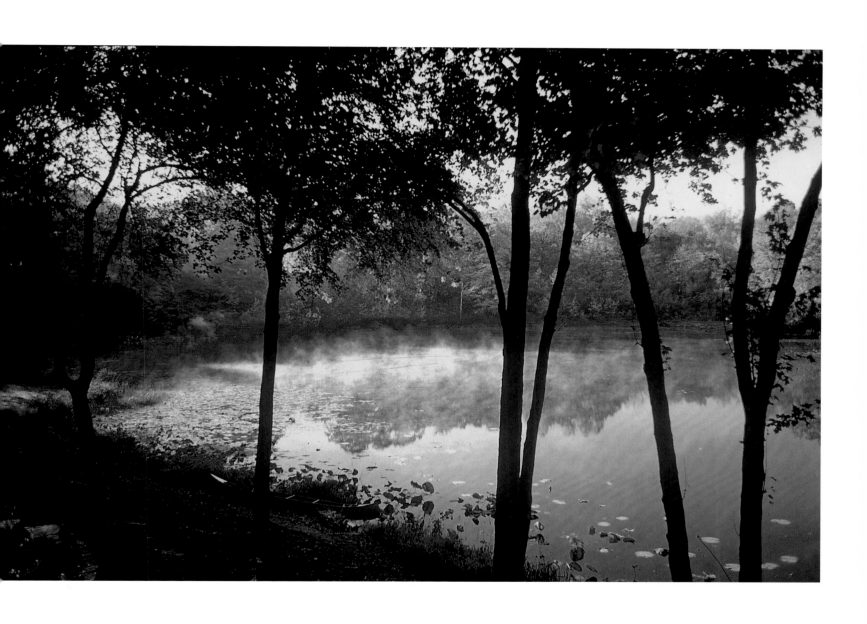

PLATE 34 | *Around the Pond — Umpawaug Farm,* 1950s

Xochimilco, Mexico City, 1938 | PLATE 35

PLATE 36 | *Weeping Willow*, Umpawaug Farm, 1950s

The Pond—Morning, Umpawaug Farm, 1950s | PLATE 37

PLATE 38 | *The Pond—Autumn*, Umpawaug Farm, 1950s

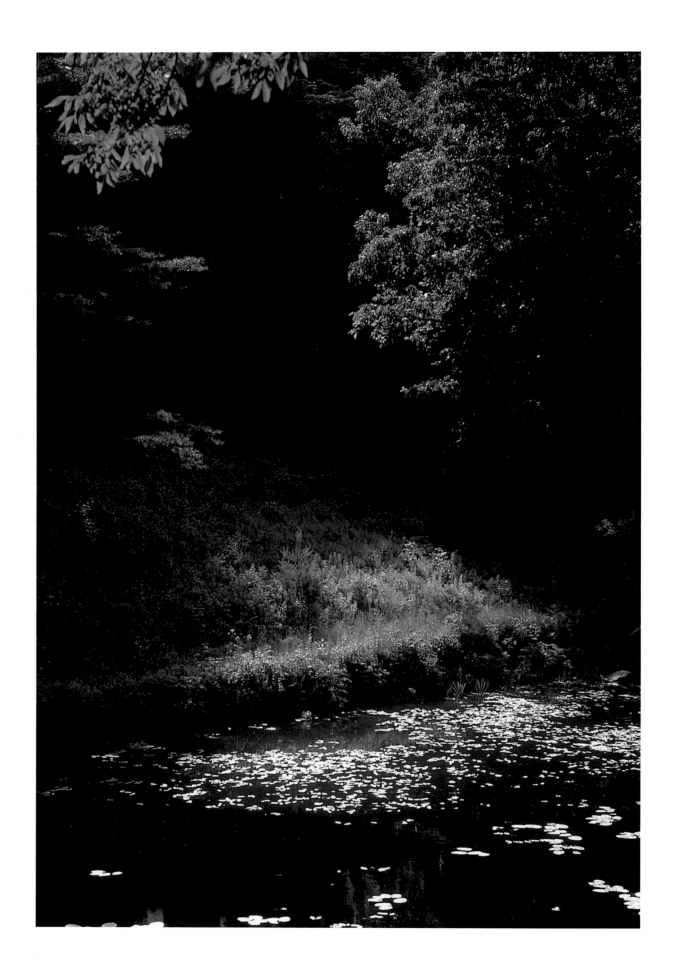

The Sunny Bank, Umpawaug Farm, 1950s | PLATE 39

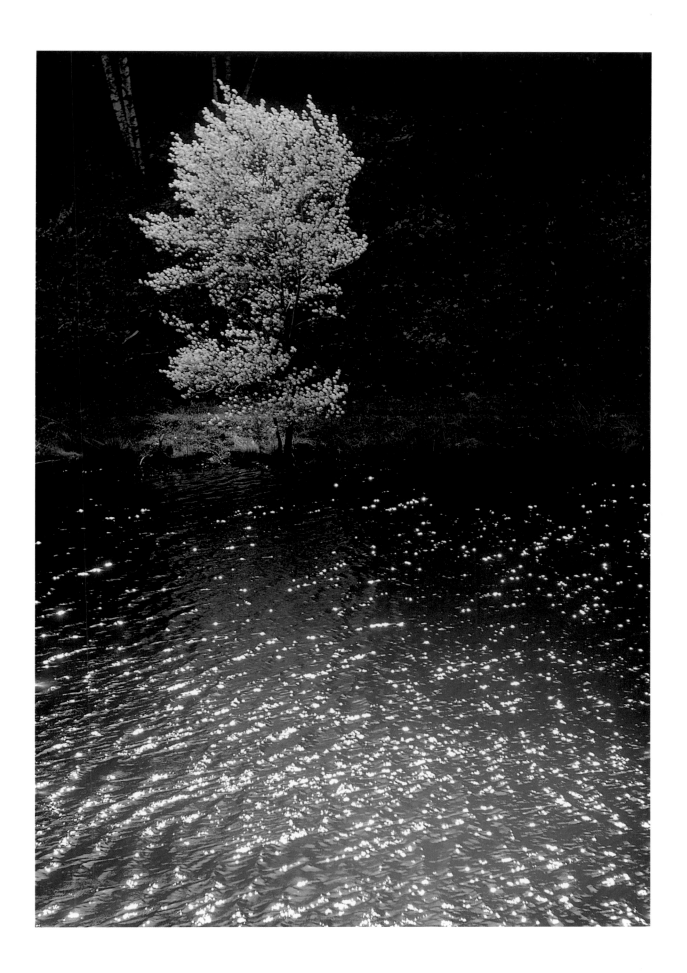

PLATE 40 | *Shadblow*, Umpawaug Farm, 1950s

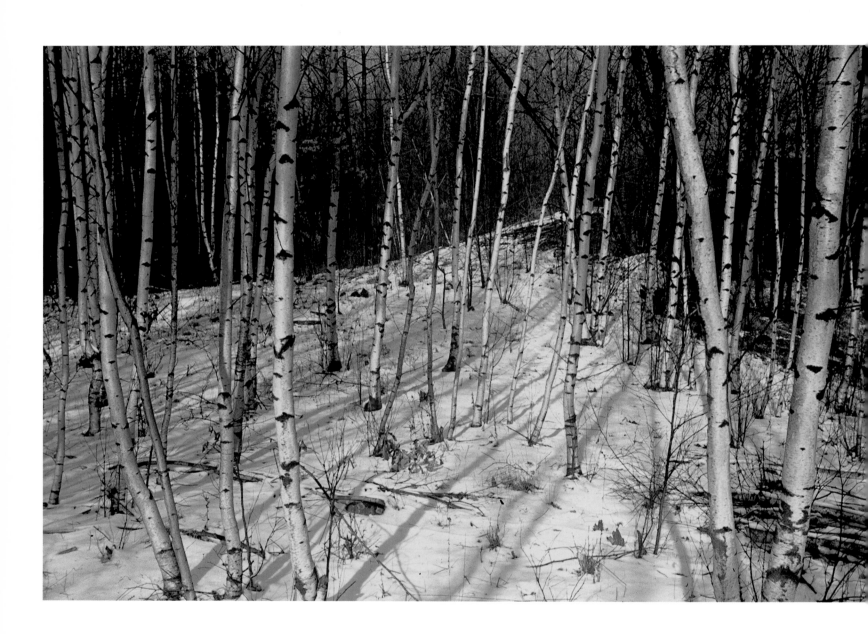

Winter Birches, Umpawaug Farm, 1950s │ PLATE 41

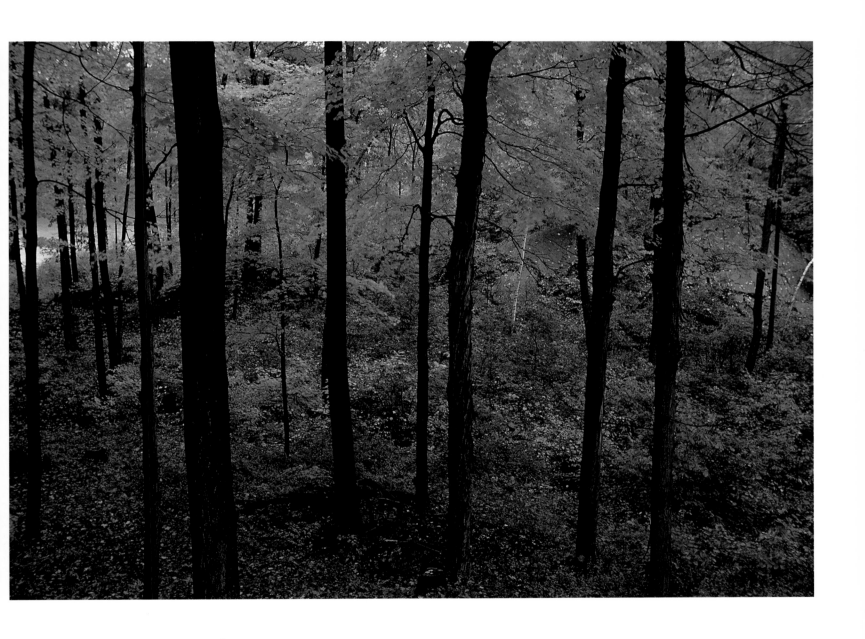

PLATE 42 | *Autumn Trees,* Umpawaug Farm, 1950s

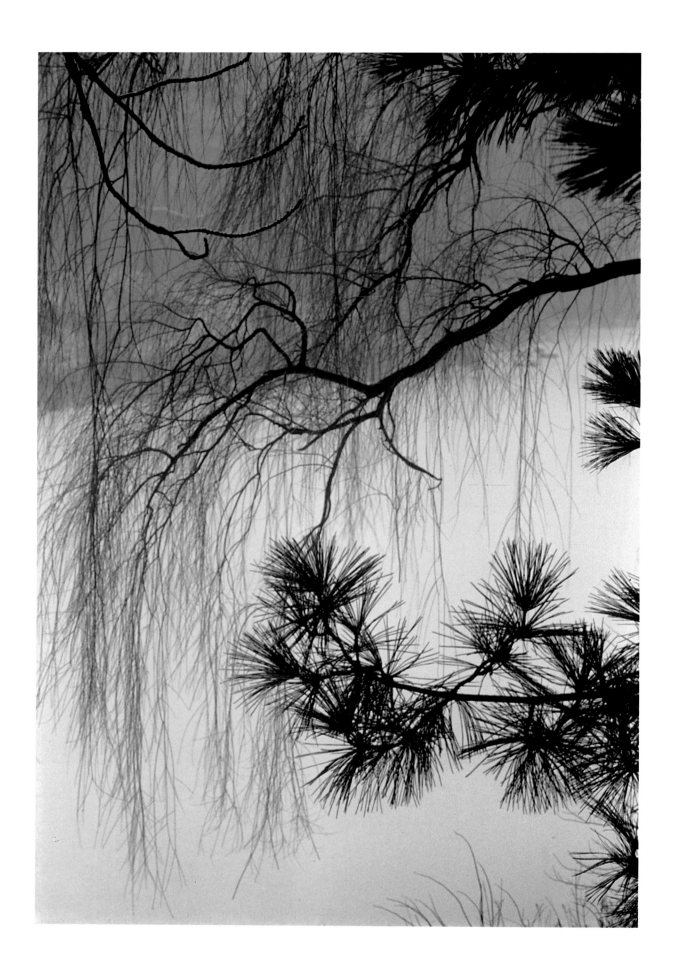

Winter, Umpawaug Farm, 1950s | PLATE 43

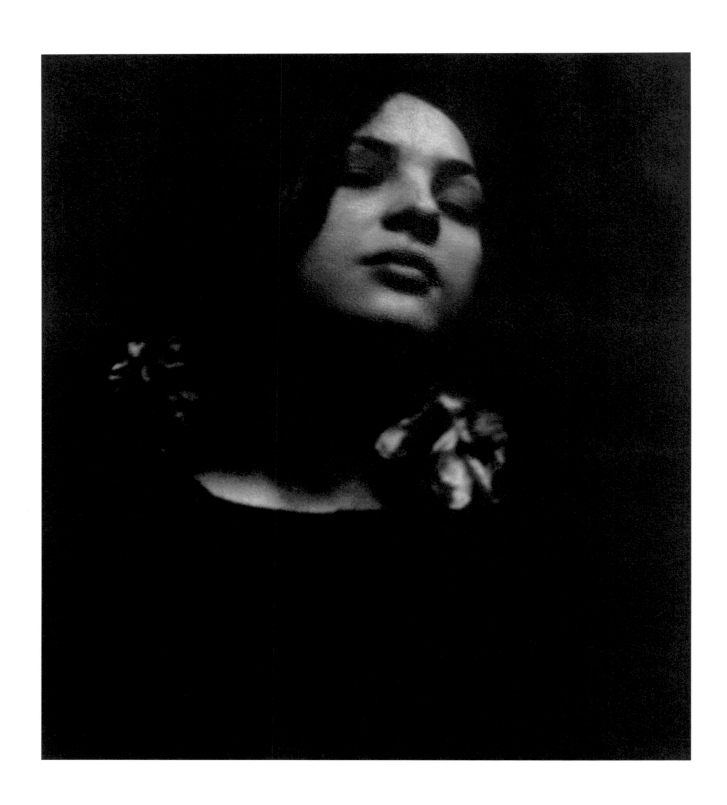

La Rose, 1900–1903. | PLATE 44
Gum platinum print with watercolor wash around image

REVERIE

[The] painter creates, evolves, produces texture. [The] photographer represents *texture.*

—E.S., private notes

When he began photographing, Steichen was a nineteenth-century teenager ardently exploring the aesthetic conventions of his time. Melancholy, graceful, evocative, his earliest work is clearly that of a romantic whose message was mood. In his idealism, his reverence for nature, his belief in humanitarian principles and his reliance on emotion, he remained a romantic all his life. His romanticism is most obvious and conventional in the black-and-white landscapes and in the dreaming figures that follow.

As a young man determined to germinate his own ideas while experimenting with the methods in fashion among the art photographers of the day, Steichen often tried expressly to make photographic images that might be mistaken for paintings or, at least, charcoal drawings. *Miss Polly Horter* (plate 46) and *A Smile in Shadow* (plate 47) are examples. The portrait of Miss Horter was one of his first experiments with the gum bichromate process. Instead of buying paper already coated with silver or platinum, he coated the paper himself, brushing on a water-color tint mixed with gum arabic. The sensitizing agent was bichromate of potash. The thickness of the mixture determined the grain of the print. This was an economical way to prepare paper for printing photographs, and it also offered the photographer striving for artistic effect the greatest flexibility. (The gum bichromate mixture could also be applied to papers already coated with silver or platinum.) To get the effect of a charcoal drawing, Steichen printed the negative of Miss Horter twice on the same piece of rough-textured charcoal paper. Later, he went on to many combinations of tints and multiple printings.

In this section, even when the printing process was less complex, one can find many references to the styles of painters. There are echoes of Degas in *At the Piano* (plate 50) and *The Mirror* (plate 51) and of art nouveau composition in *The Brass Bowl* (plate 53) and *The Black Vase* (plate 55). *The Man Who Resembled Erasmus* (plate 52) might be a Rembrandt. Like Rembrandt, Steichen used his mastery of chiaroscuro to convey mood. Steichen learned from Whistler the technique of using a small picture behind the subject to establish a very simple background, as in *The Lady in a Plumed Hat* (plate 49), but he went on experimenting with the technique by using one of his own large paintings or mural-size enlargements of his own photographs in the background. In the ultimate refinement, he simply set up a plain white panel against a darker wall.

The images here, like the black-and-white landscapes and the still lifes, present a variety of dreamy states—pensive, brooding, wistful, expectant—all remote and mysterious and all evoked through the masterly arrangement of light and shadow. Only one, the 1925 portrait of the opera singer Maria Jeritza (plate 57), was made with the help of artificial light, which Steichen never used until 1923, when he went to work for Condé Nast. Carl Sandburg seated at the edge of the Lake Michigan dunes (plate 45) is a tour de force of focus and contrast; opposing evocations of light and shadow are the point. The faces of the individual dreamers scarcely matter. Some of the sitters are famous. One or two may have had amorous attachments to Steichen. Many of their names have not been recorded. The subject in all these photographs is mood.

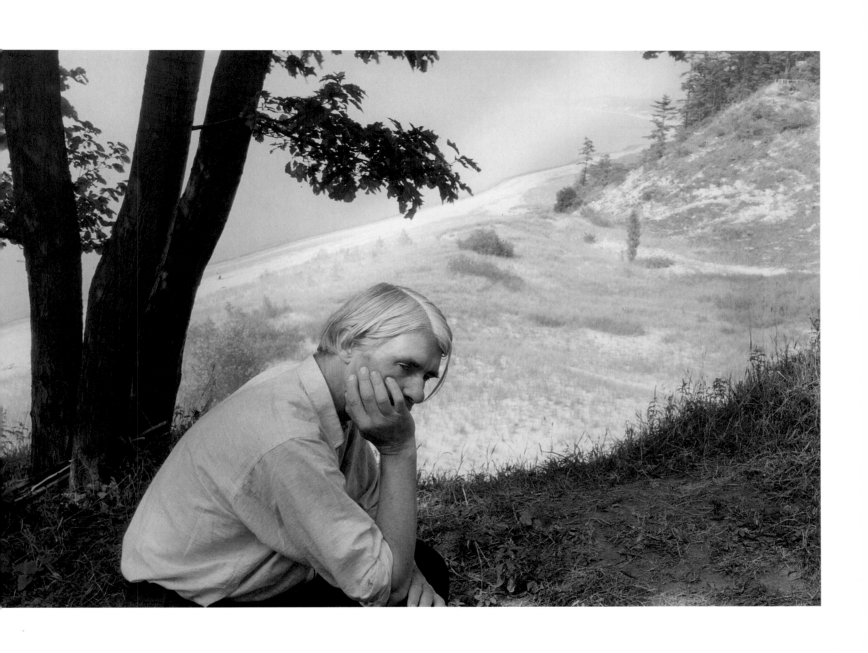

PLATE 45 | *Carl Sandburg at the Michigan Dunes,* 1930

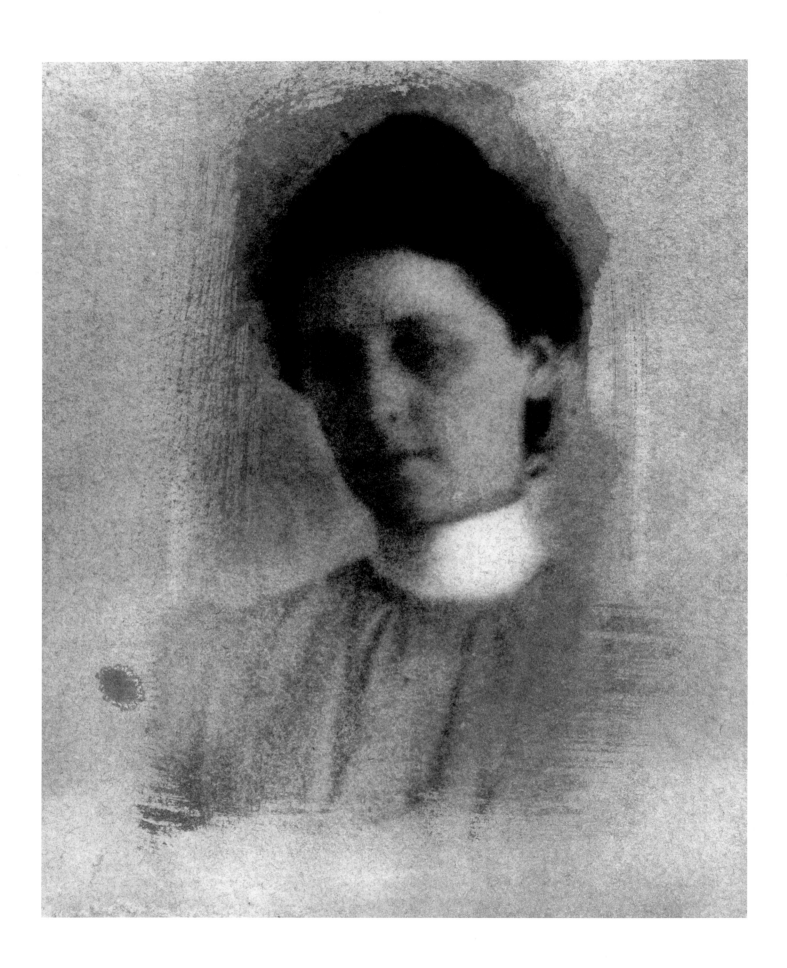

Miss Polly Horter, Milwaukee, 1899 | PLATE 46

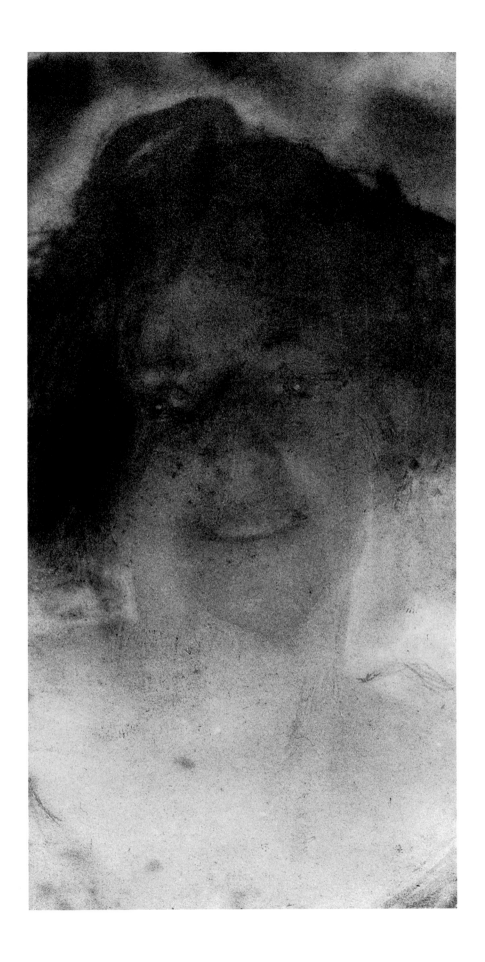

PLATE 47 | *A Smile in Shadow*, 1900–1903. Glycerine platinum print

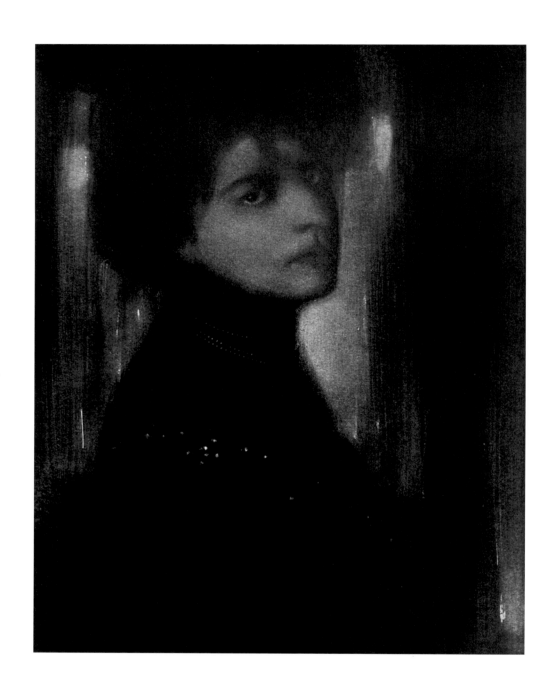

Portrait, 1903 | PLATE 48

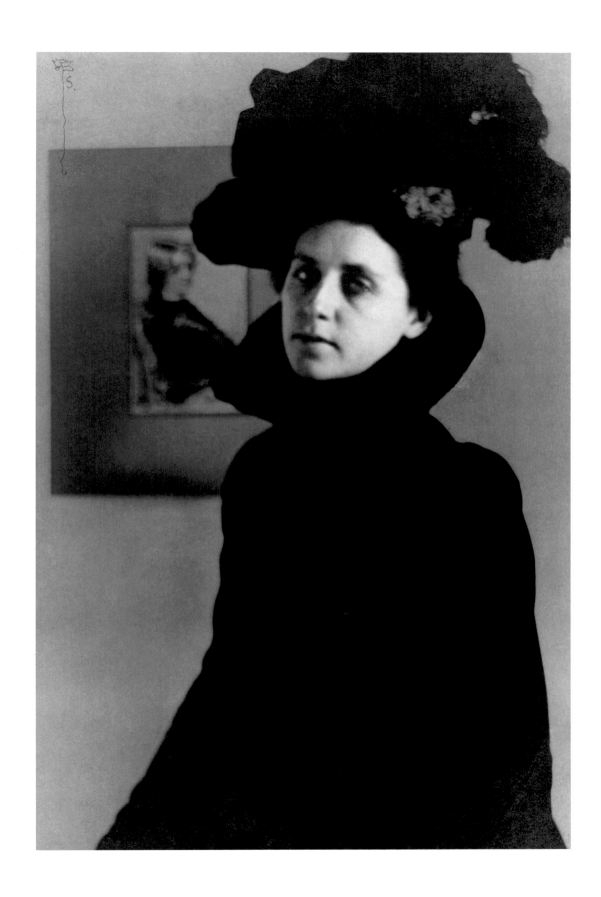

PLATE 49 | *The Lady in a Plumed Hat,* c. 1898

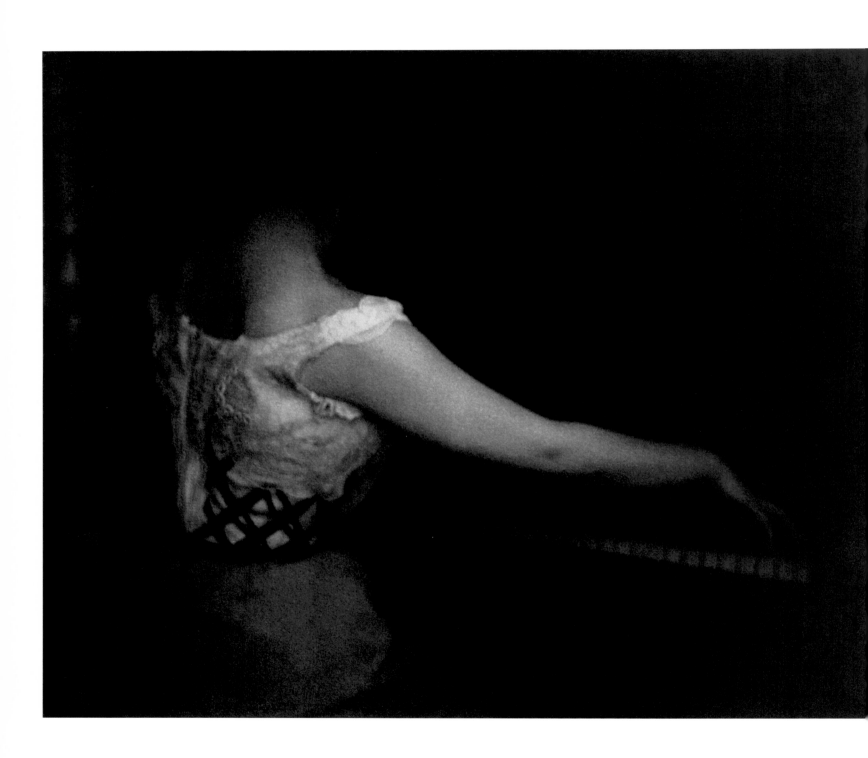

At the Piano, 1900–1903. Gum platinum print with watercolor wash around image | PLATE 50

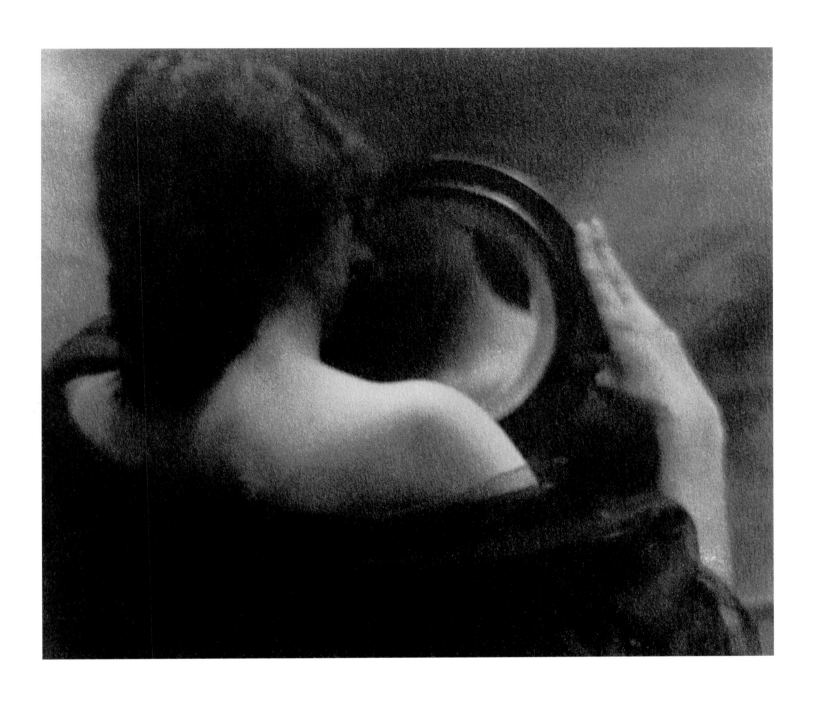

PLATE 51 | *The Mirror,* 1901. Gum platinum print with watercolor wash around image

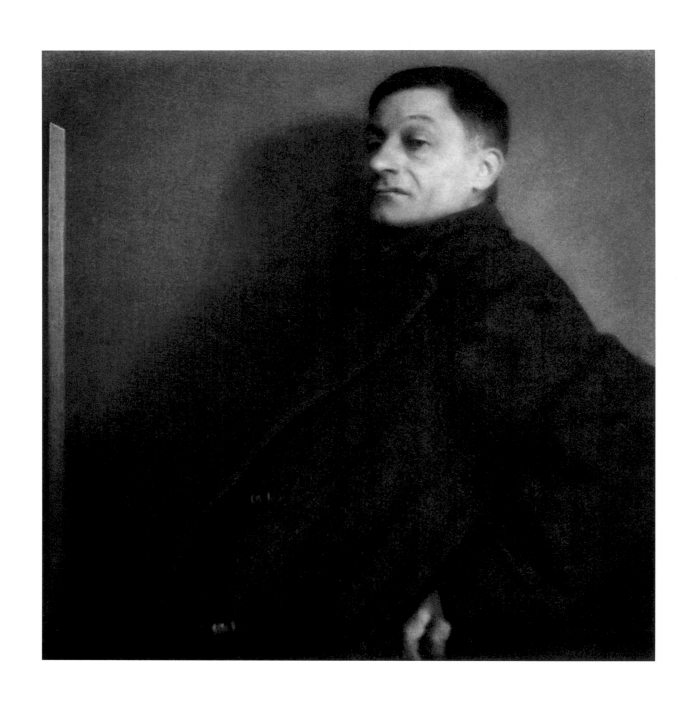

The Man Who Resembled Erasmus, 1913 | PLATE 52

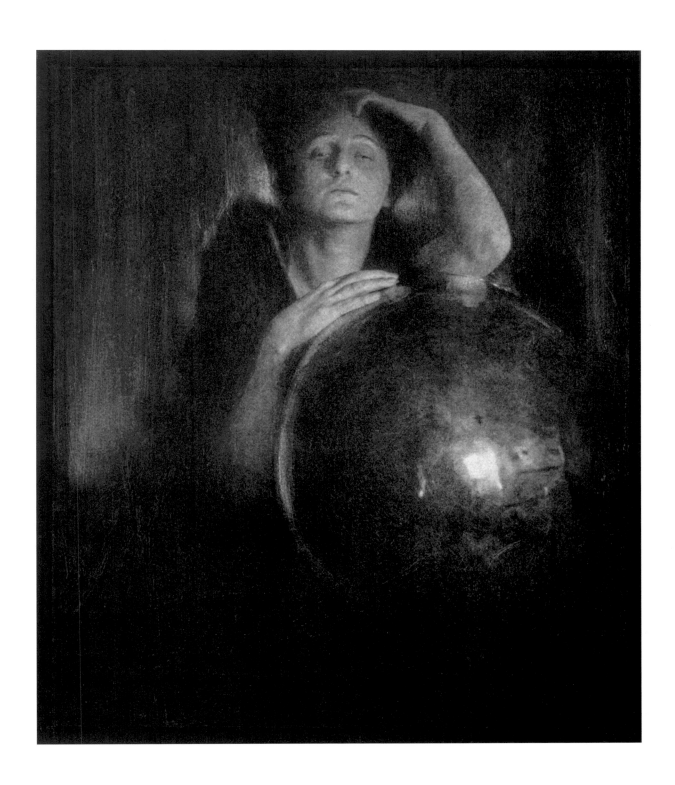

PLATE 53 | *The Brass Bowl*, 1904

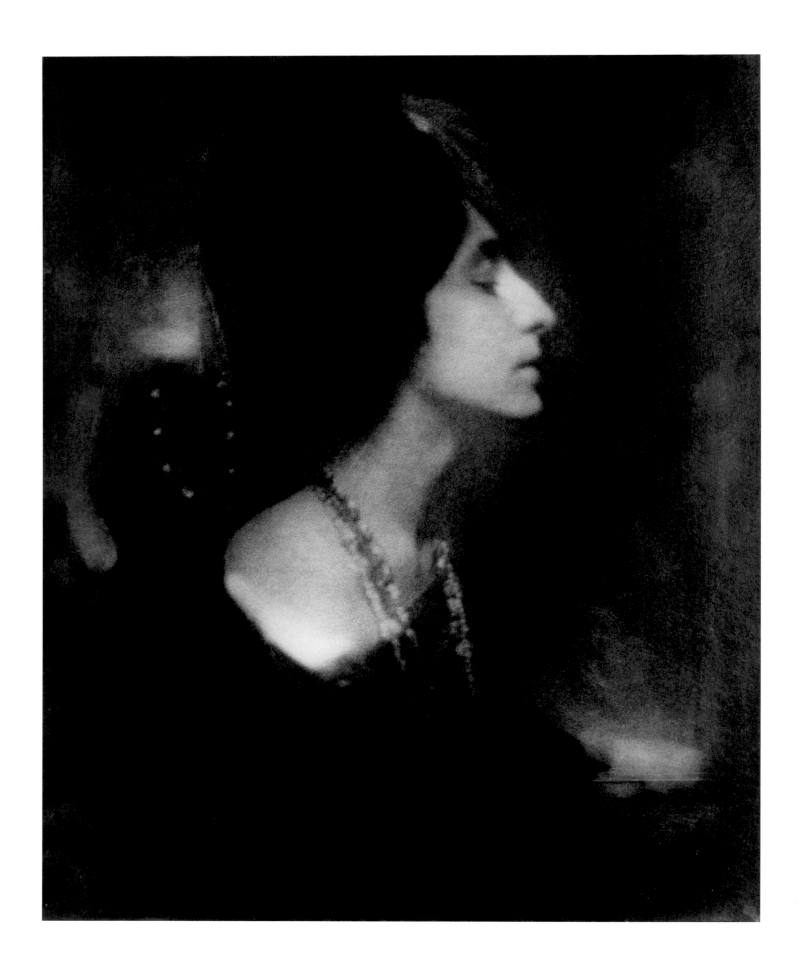

Mercedes de Cordoba (Mrs. Arthur Carles), New York, 1904 | PLATE 54

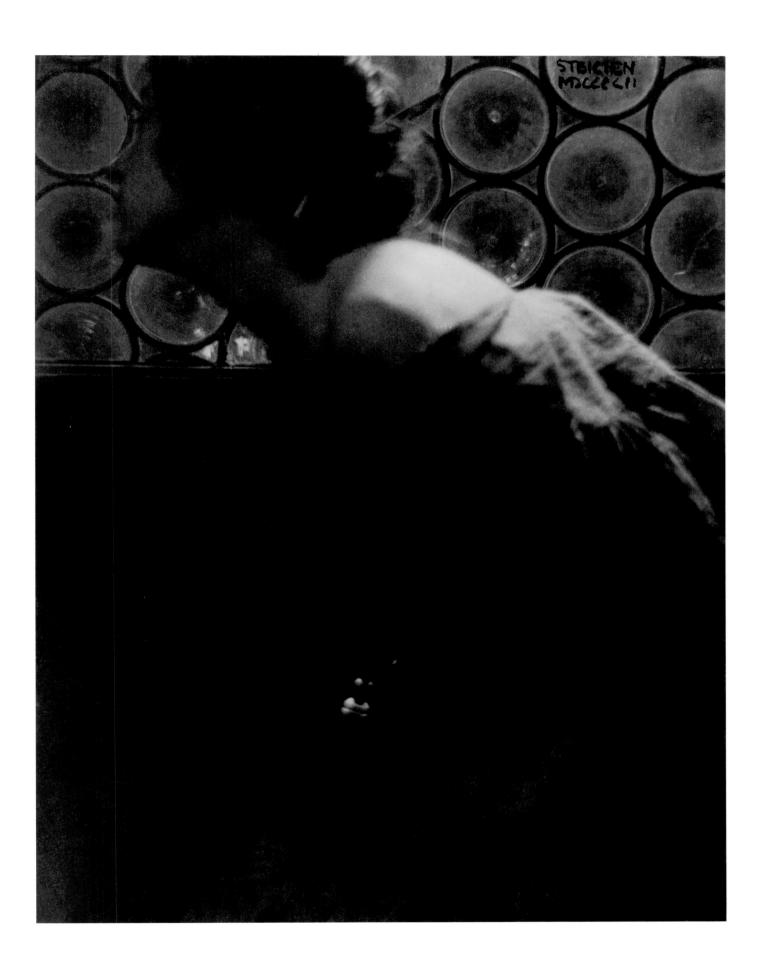

PLATE 55 | *The Black Vase,* 1901

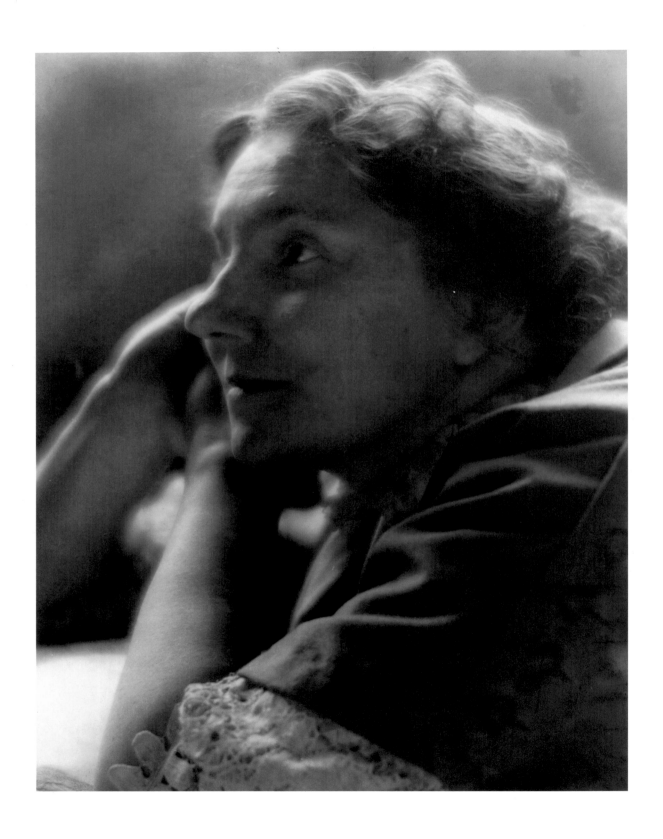

Yvette Guilbert, Paris, 1901 | PLATE 56

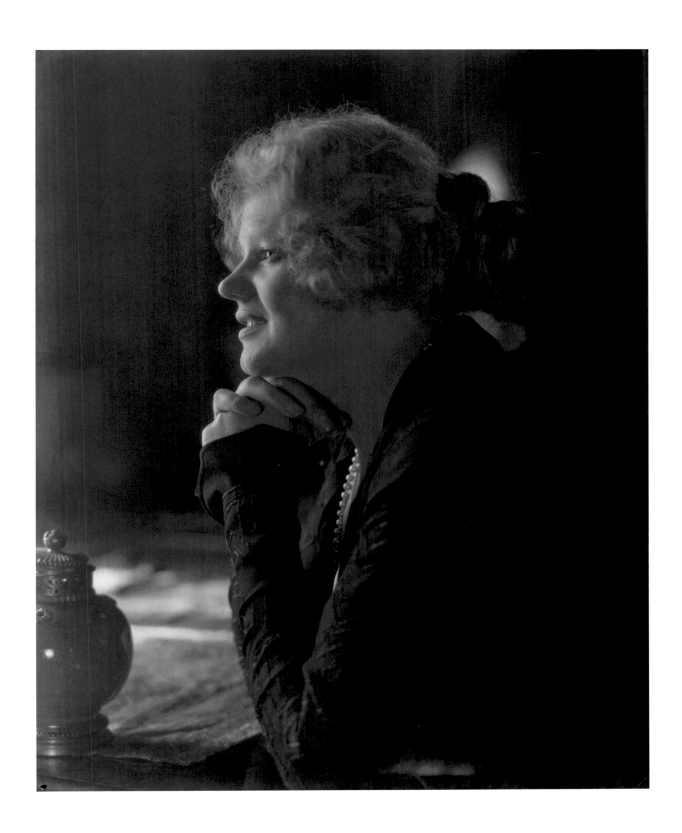

PLATE 57 | *Maria Jeritza, 1925*

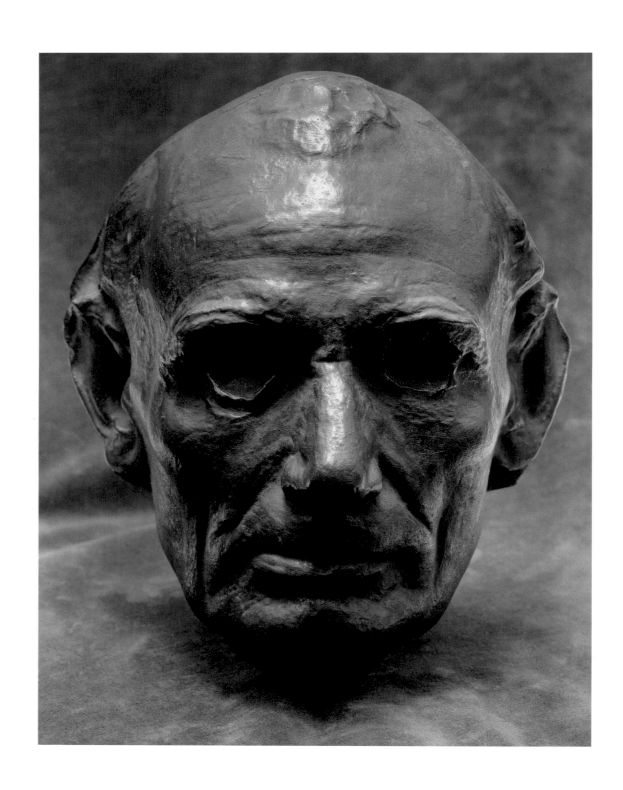

Life Mask of Abraham Lincoln by Leonard W. Volk, | PLATE 58
Chicago, March 1860, photograph 1936

POWERFUL
PEOPLE

Look at the subject, think about it before photographing, look until it becomes alive and looks back into you.

—E.S., private notes

In the course of Steichen's lifetime, photography firmly replaced painting and drawing as the medium for literal representation. Portraiture was one of photography's first strongholds, and Steichen made himself known as the portraitist in demand early on. His thick files of photographs of leaders and shapers started long before he went to work as a magazine photographer. They led the editor of *Vanity Fair*, Frank Crowninshield, to proclaim in print that Steichen was the greatest portrait photographer in the world. On the basis of that statement, Steichen demanded what was considered an astronomical salary in 1923 when he was offered the job of photographer in chief of Condé Nast. For *Vanity Fair* and *Vogue*, he photographed almost everyone in the public eye in New York and Hollywood and, periodically, in Paris. Whole books can be devoted to Steichen portraits of the famous, but they still represent only one aspect of his photographic virtuosity, so I have chosen a small selection of the images in several categories that illustrate best how Steichen zeroed in on a salient feature of each individual.

Bernard Baruch (plate 63), the financial wizard, shown half in light, half in shadow that suggests deep secrets, wears a benign but sly smile, the cat that swallowed the canary. Steichen devised a more predatory shadow and added the tiny flicker of a match's flame to suggest that the powerful, politically reactionary gossip columnist Walter Winchell might be the devil incarnate (plate 64). Robert Moses, the long-term czar of New York's highways and bridges, a man who always got his way, seems made of steel springs, poised to strike any opponent (plate 65). Amelia Earhart's soft pose suggests a shyness in face-to-face situations that was not uncommon in pioneering aviators; determination lies in the strong, straight arm braced against a square shoulder (plate 66).

Steichen spent weeks approaching the life mask of Abraham Lincoln, studying it from all angles in every kind of light before he found the combination that brought the strong, grave character of that face to life on paper (plate 58). The portrait of Franklin Delano Roosevelt (plate 67) is an example of Steichen's own choice to crop a negative. The uncropped negative shows a standard pose, the decisive leader erect in his chair, but Steichen preferred to emphasize the sad and serious face of a visionary personally acquainted with suffering. Although the picture was made when FDR was governor of New York, I believe Steichen chose to crop it much later in response to FDR's record as president.

Steichen photographed four presidents, but none after FDR. During Lyndon Johnson's presidency, LBJ employed a photojournalist whom we knew, Yoichi Okamoto, as his personal photographer to accompany him everywhere and make a full-time pictorial record of his term in office. Oke made the mistake of giving an interview to *Newsweek* in which he mentioned making thousands and thousands of negatives. That volume of shooting is standard for photojournalists, but, at a time when Johnson was going around the White House personally turning off lights to emphasize the need for economy, such figures stated in public marred the image. The photographer was fired. Several months later, the day after Agnes Meyer's party for Steichen's eighty-fifth birthday, we were invited to tea at the White House. Steichen took advantage of his introduction to the President to tell him he had made a terrible mistake in firing "that young man." I have a memory of Steichen grasping the lapels of Johnson's jacket, but this may be simply a visual translation of the force of his argument. "Just think," Steichen concluded, "what it would mean if we had such a photographic record of Lincoln's presidency." Okamoto was rehired promptly.

One could do a whole study on Steichen's use of the armchair. Writers loll in them, relaxed. Actors are draped over them in preposterous character. But bankers and financiers invariably assume a stiffer pose, backs straight, arms planted firmly on the chair's arms. Here, an almost identical pose serves to emphasize contrasts in character and relationship. Steichen's fierce, richly shadowed portrait of J. P. Morgan (plate 62) was commissioned merely as an aid to the memory of a portrait painter, Frederick Encke, who found the financier — probably the most powerful financier America has ever known—an impossibly impatient sitter. In order to complete the photographic sitting in just three minutes, Steichen had the janitor of his building sit in the portrait position while he arranged the chair in exactly the right light. Morgan arrived and sat down in the portrait pose. Steichen snapped the shutter, then put in another plate and asked the financier to shift his position. Morgan was irritated, moved, returned spontaneously to the requested position, and Steichen, having engineered a moment of real emotion, snapped again. He always claimed that the chair arm's resemblance to a dagger was purely accidental.

Morgan had a hideously diseased nose that was never shown in painted portraits. When Steichen brought the finished prints to Morgan, he completely retouched the nose, as the painters did, in the official pose, but he left the other very close to its natural state. Morgan, incensed, tore up the unretouched print. Later, when Morgan's librarian, Belle Greene, saw a print of the rejected photograph, she declared it the best portrait of Morgan that ever had been made, and Morgan ordered some prints. In revenge, Steichen kept him waiting three years.

It's no accident that the chair's arm in the portrait of Eugene Meyer (plate 61) did *not* look like a dagger. Meyer, an investment banker, government adviser and publisher of the *Washington Post,* was the man Steichen called his best friend. Sympathetic noncompetitors, they could share their troubles equally in long night walks and enhance each other's lives with very different talents. Steichen encouraged the Meyers to buy four Cézanne paintings that have long since become priceless and now hang in the National Gallery in Washington. The Meyers fre-

quently came to Steichen's aid. They financed the packing and shipping of Brancusi's sculptures for the 1914 exhibition at 291. They sent the telegram that warned the Steichen family to leave France barely ahead of the German troops in the same year. In the 1920s and '30s, Eugene Meyer's insistence on always investing a little more money than the busy photographer had saved made it possible for Steichen to have a comfortable, well-attended old age.

Theodore Roosevelt, The White House, 1908. Pigment print for *Everybody's Magazine* | PLATE 59

PLATE 60 | *William Howard Taft,* Washington, D.C., 1908.
Pigment print for *Everybody's Magazine*

Eugene Meyer, New York, 1932 | PLATE 61

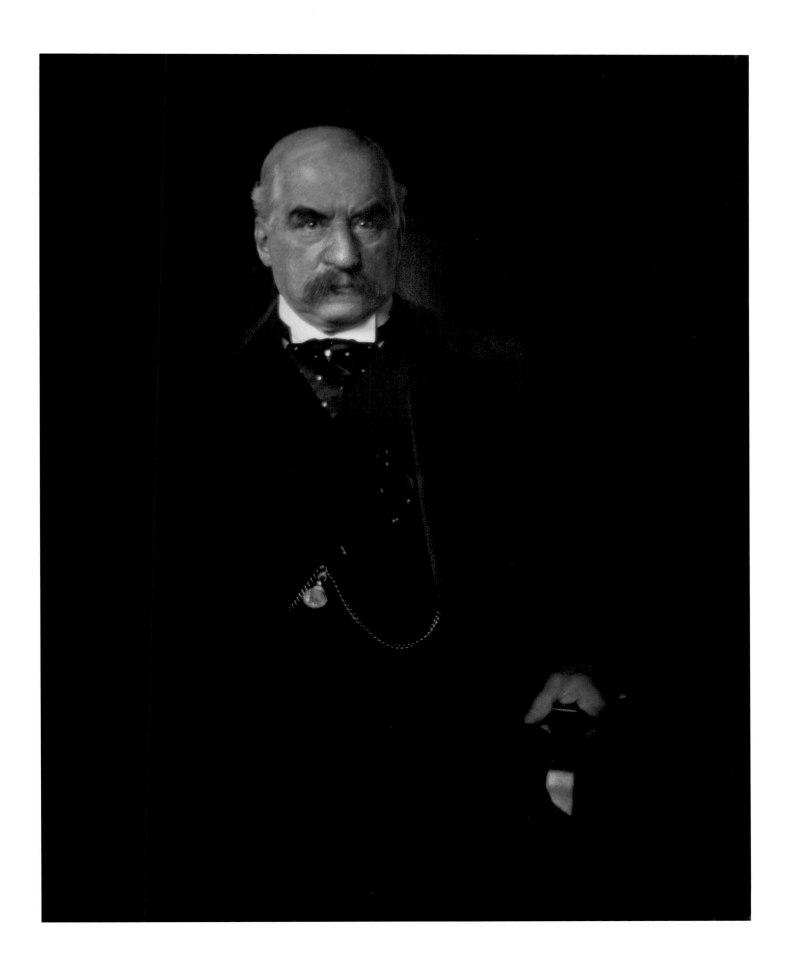

PLATE 62 | *J. P. Morgan*, New York, 1903

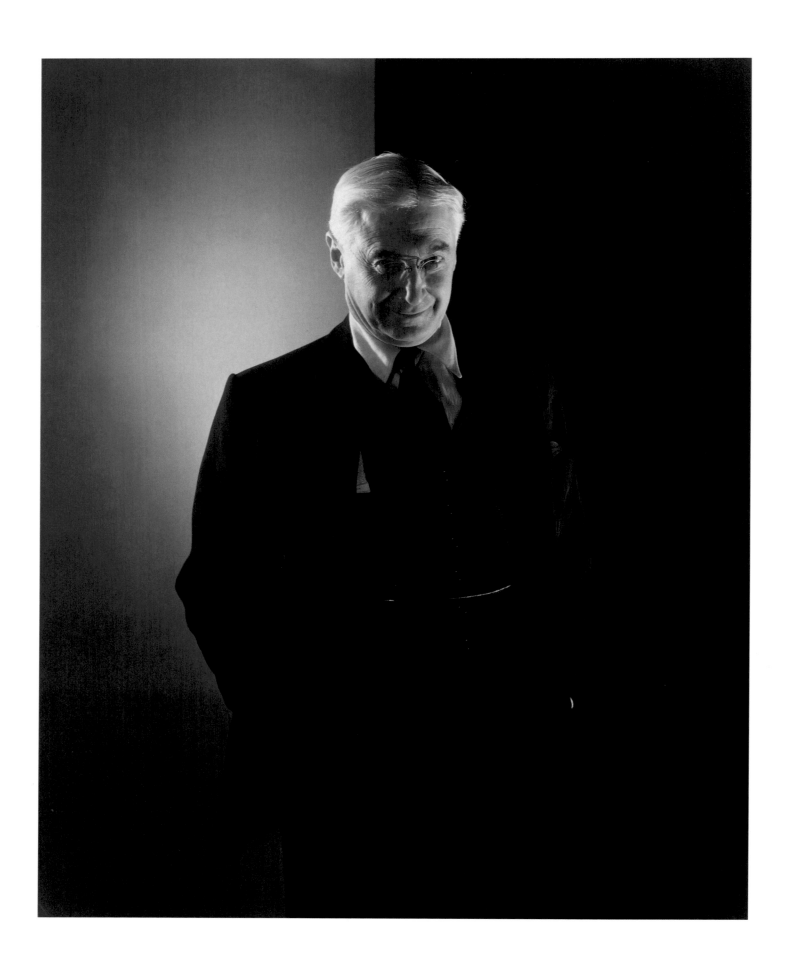

Bernard Baruch, New York, 1932 | PLATE 63

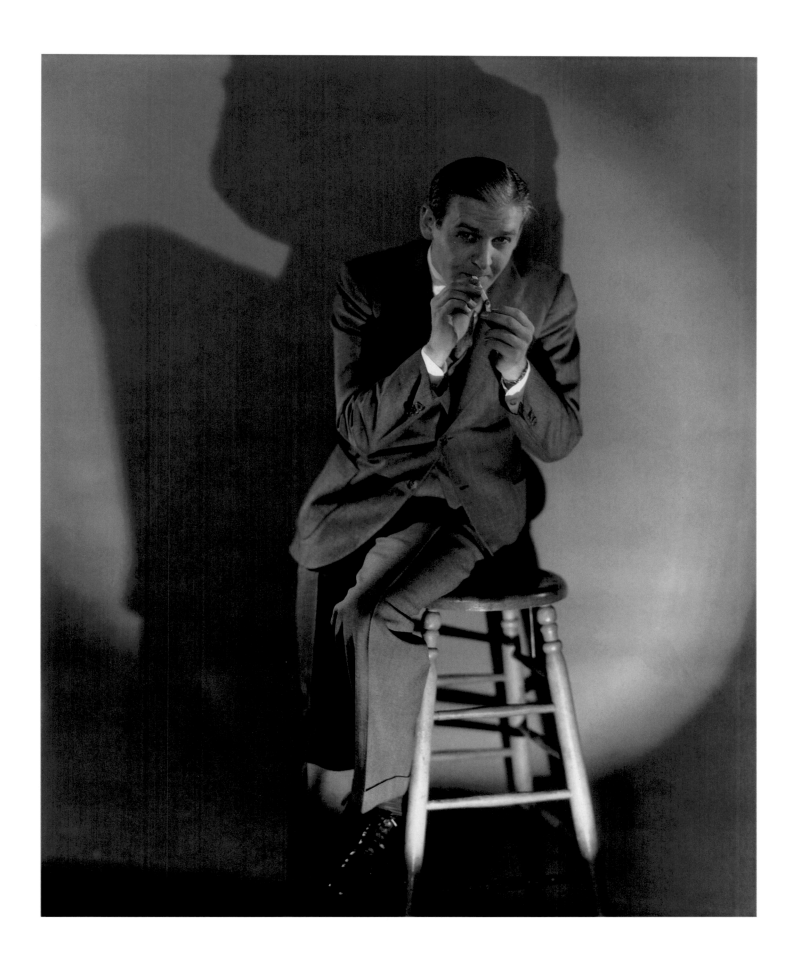

PLATE 64 | *Walter Winchell*, New York, 1929

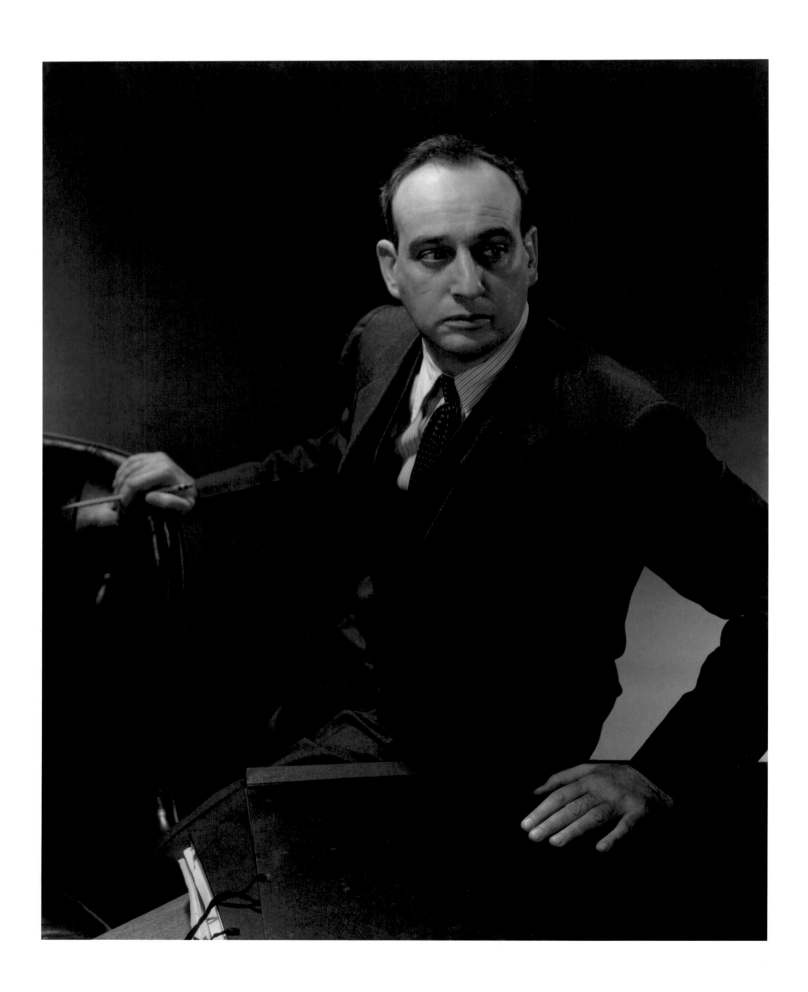

Robert Moses, New York, 1935 | PLATE 65

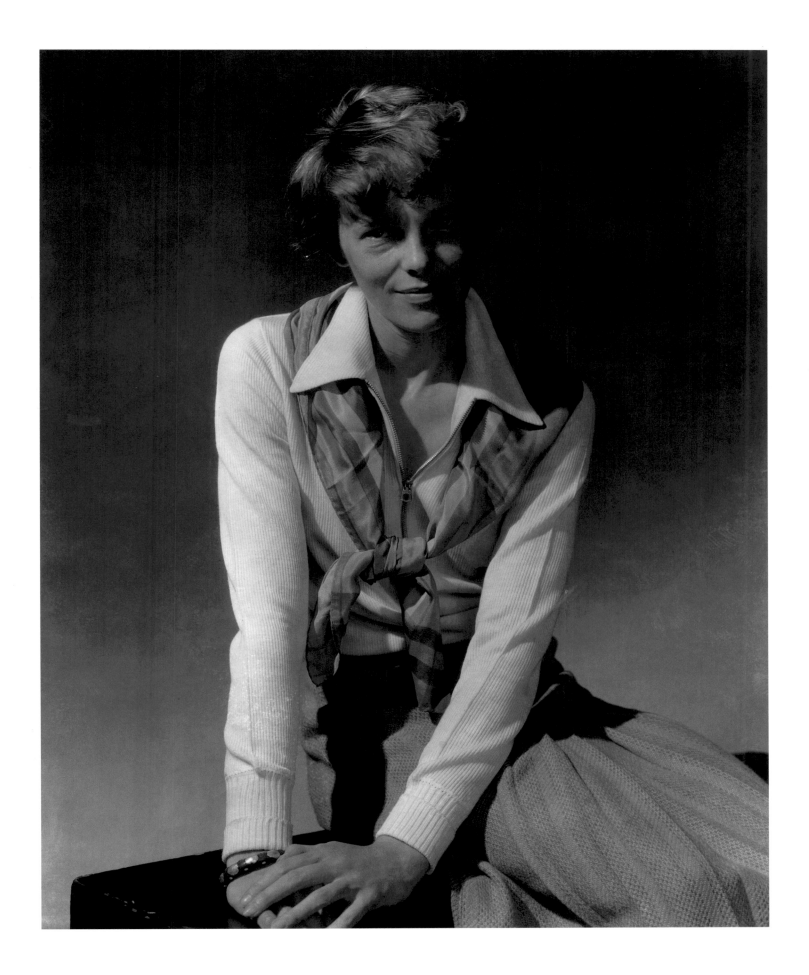

PLATE 66 | *Amelia Earhart, 1931*

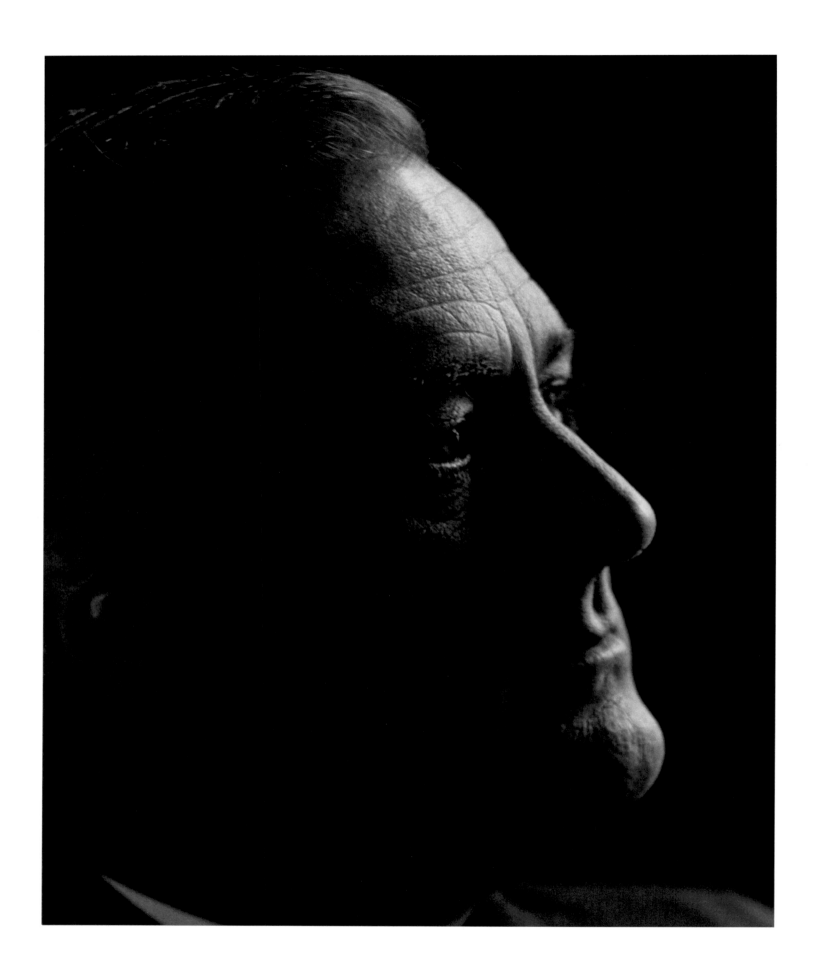

Franklin D. Roosevelt, 1929 | PLATE 67

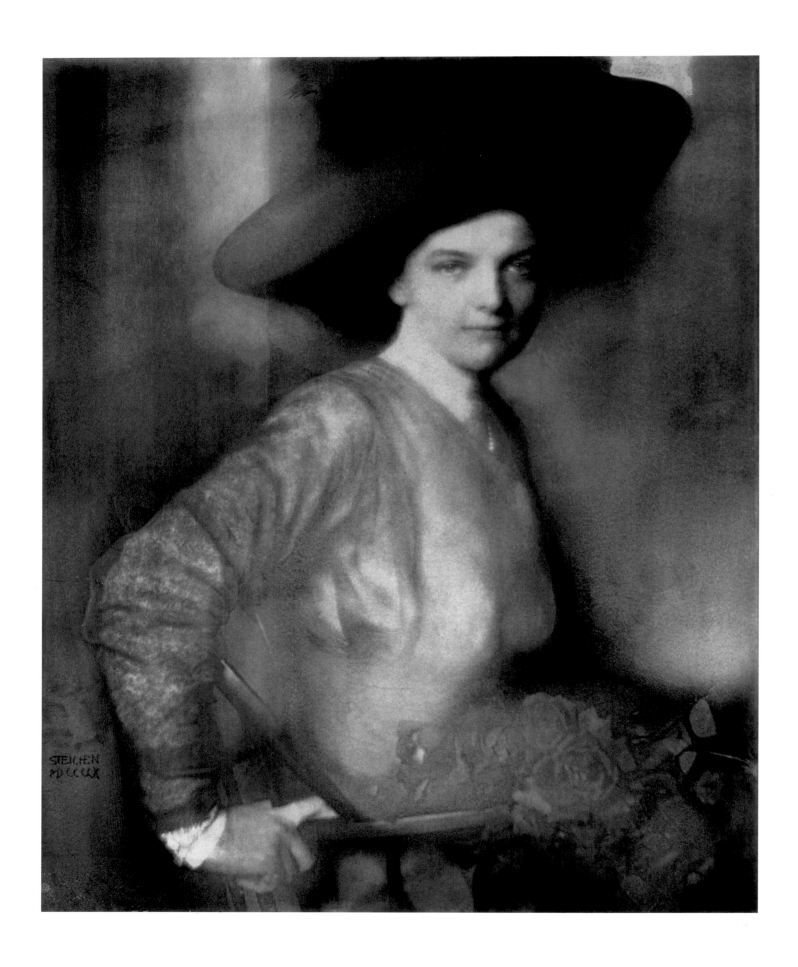

Agnes Ernst Meyer (Mrs. Eugene Meyer), 1910 | PLATE 68

CHALLENGING
WOMEN

Perception is a mental process that merely registers just as the lens registers. The good photographer not only sees—he looks and in the process of looking, insight is developed to the point where the object looks back at the photographer—and together they make the photo.

—E.S., private notes

Steichen could hardly be called a feminist. He admired powerful women but preferably from a slight distance. Up close, he found them exhausting. However, he never lost the capacity to exclaim in appreciation of beautiful and talented women. He claimed to be the only male friend of Isadora Duncan who never quarreled with her because he was the only one who did not have an affair with her; for earthy romance, he chose one of her pupils. When he went to photograph the legendary actress Eleanora Duse, on the same day he photographed J. P. Morgan, he was so captivated by her enchanting personality that his camera eye lost its objectivity, and the sitting had to be redone. The same thing happened years later at his first session with Lillian Gish. I've always wondered if his telling of these incidents concealed but hinted at another kind of encounter. In the 1960s, at separate times, two aging, grandly costumed divas, Lillian Gish and Maria-Theresa Duncan (whom Steichen called Thérèse), each accompanied by an entourage, swept into Umpawaug for what appeared to be a sentimental farewell visit.

In studying the prints I was considering for this book, I became aware of a particular look that kept turning up in Steichen's portraits of women from the very beginning of the twentieth century. Finally, I grouped the most outstanding examples together. Four of the women are movie actresses, one a coloratura soprano, two are artists' wives, two society matrons, two are children and one is a studio employee, name forgotten, who turned up for work one morning with a severe sunburn (plate 77). In all these pictures, no matter what the pose, the era, the woman's age or position in the world, her eyes confront the camera directly, holding their own, challenging the observer. Even in the soft focus of the Duse portrait (plate 72), the pensive poses of Agnes Meyer (plate 68) and Isadora Duncan (plate 70), and the sidelong gazes of Lillian Gish (plate 78) and Mercedes de Cordoba (plate 74), the eyes are steely, indomitable.

Some of these women were Steichen's friends; some were extraordinary achievers; and some were both. Steichen met Agnes Ernst several years before her 1910 marriage to Eugene Meyer. She was a regular visitor to 291, where, because of her Valkyrean beauty, her intellect and her newspaper reporter's job with the *New York Sun,* she was known as the Girl from the Sun. After her marriage she

became a discerning art collector, an active supporter of political and educational causes, an important hostess and a close, generous friend to outstanding artists and intellectuals. She welcomed me and remained a kindly friend from the first time Steichen brought me to lunch at Seven Springs Farm in 1959. Whenever we were invited to events in Washington, we stayed at her grand, well-staffed house on Crescent Place. Her daughter Elizabeth (plate 80), later Mrs. Pare Lorentz, was the most artistically talented of Eugene and Agnes's children and the one who remained closest to Steichen throughout his life.

Steichen was proud of his portraits of Garbo (plates 73 and 213). Again, it was a question of having to shoot fast. He was given only a few minutes in a small space behind a movie set between takes. Garbo straddled the chair he had covered with a black cloth and pushed back her hair in angry agreement when Steichen complained about the curly hairdo she had been given for the movie (plate 73). Evelyn Brent (plate 75) and Gloria Swanson (plate 79) were famously sultry movie sirens. Mercedes de Cordoba (plate 74) was an actress and the wife of the American painter Arthur Carles. Rose Covarrubias, standing here in front of Brancusi's *Endless Column* in Steichen's garden in Voulangis (plate 76), was the wife of the Mexican painter Miguel Covarrubias. Other photographs made on the same day show her romping with Brancusi himself in the branches of a tree.

In his mideighties, Steichen started talking about putting together one more thematic exhibition. The subject was Woman, and his ideas were impassioned, filled with awe, and too alarmingly sentimental for the raised consciousness that began gathering momentum in the 1960s. Although he tended to think about women in worshipful, mythic terms, the eye behind the camera lens found a hard truth that the conscious mind was less willing to confront. Steichen captured the challenge in the faces of women who resolutely knew their own minds.

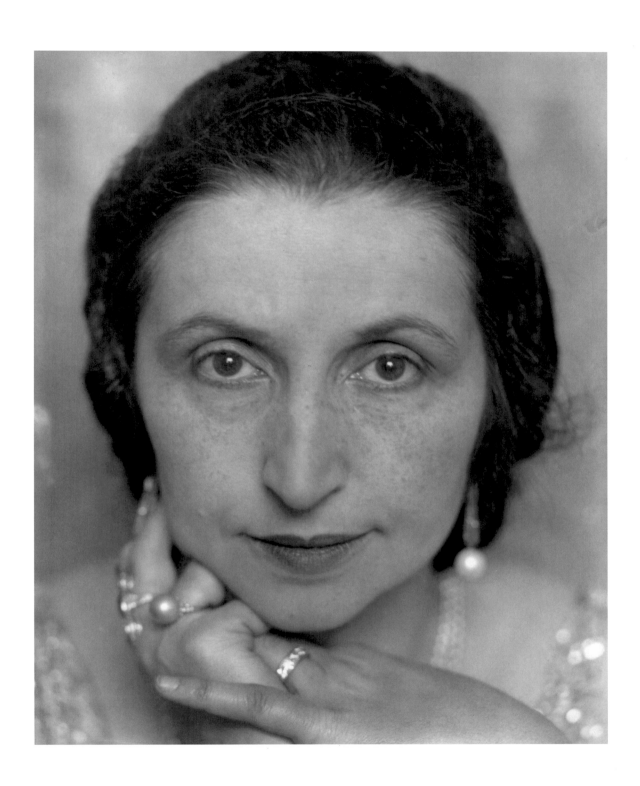

PLATE 69 | *Amelita Galli Curci, 1924*

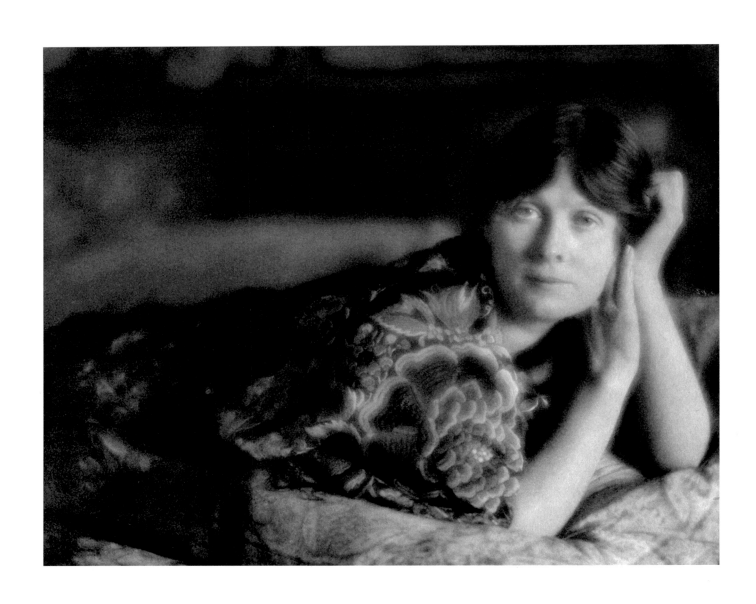

Isadora Duncan, 1913 | PLATE 70

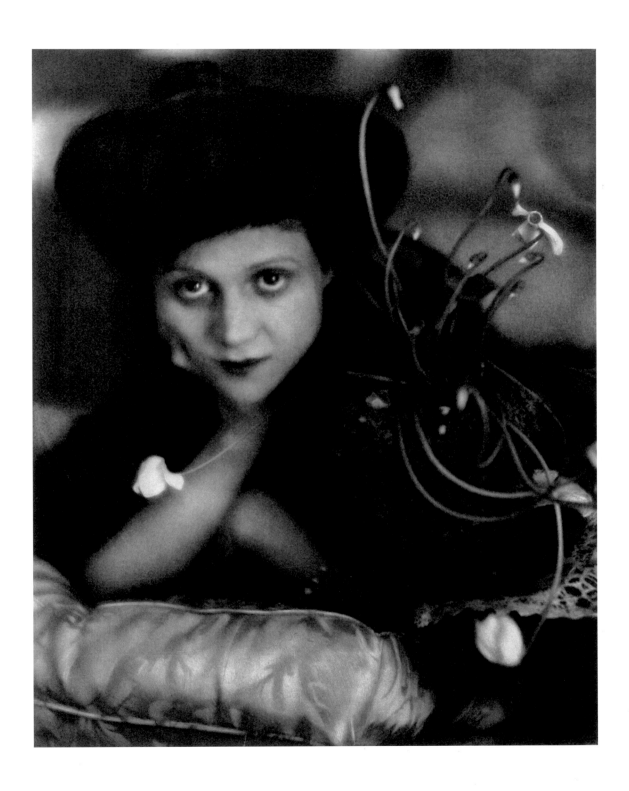

PLATE 71 | *Cyclamen—Mrs. Philip Lydig* (Rita de Acosta Lydig), New York, 1905

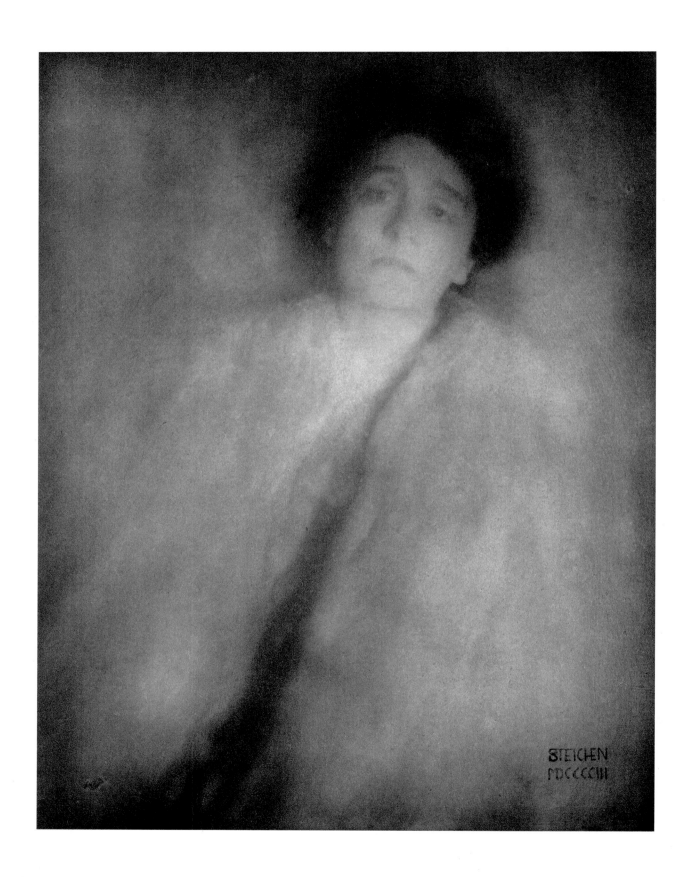

Eleanora Duse, New York, 1903 | PLATE 72

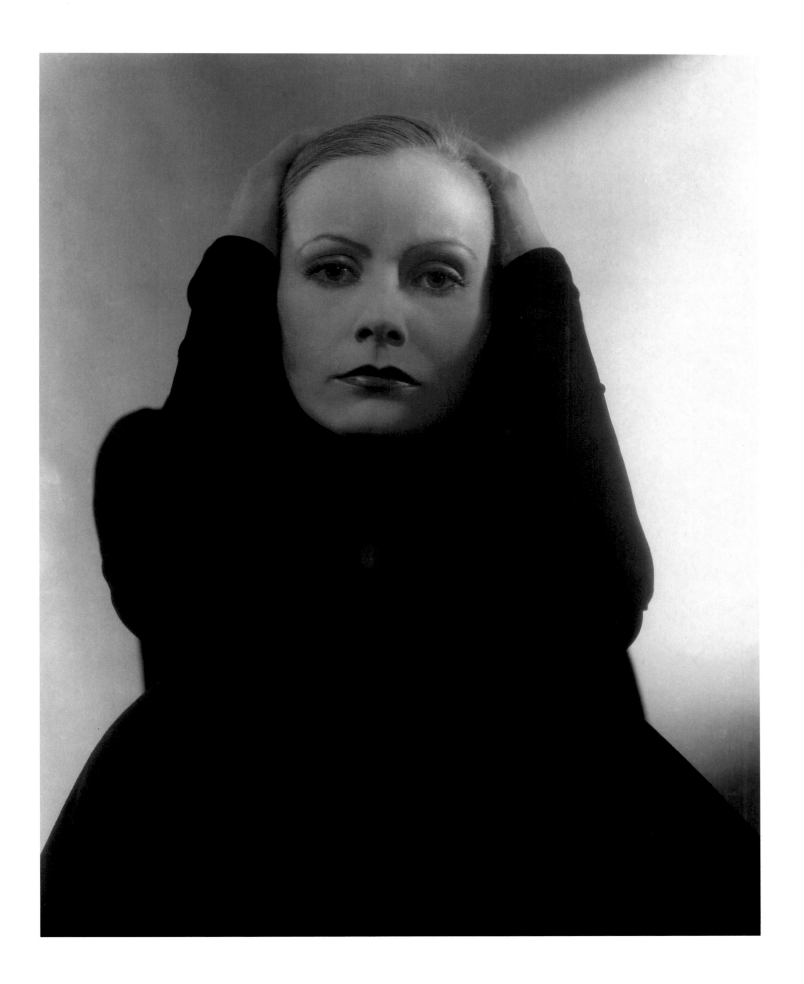

PLATE 73 | *Greta Garbo*, Hollywood, 1928

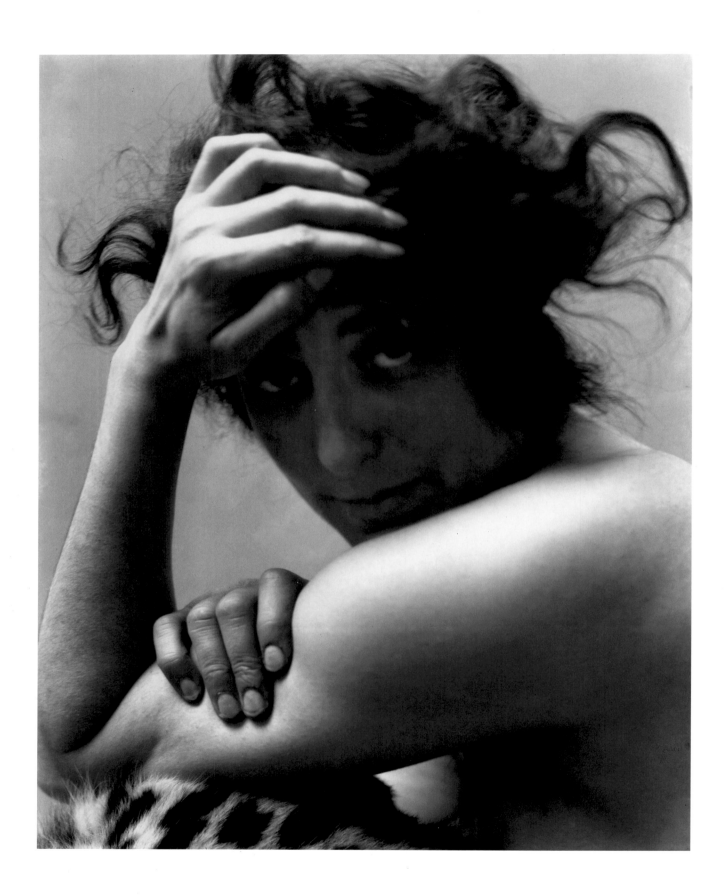

Mercedes de Cordoba (Mrs. Arthur Carles) | PLATE 74

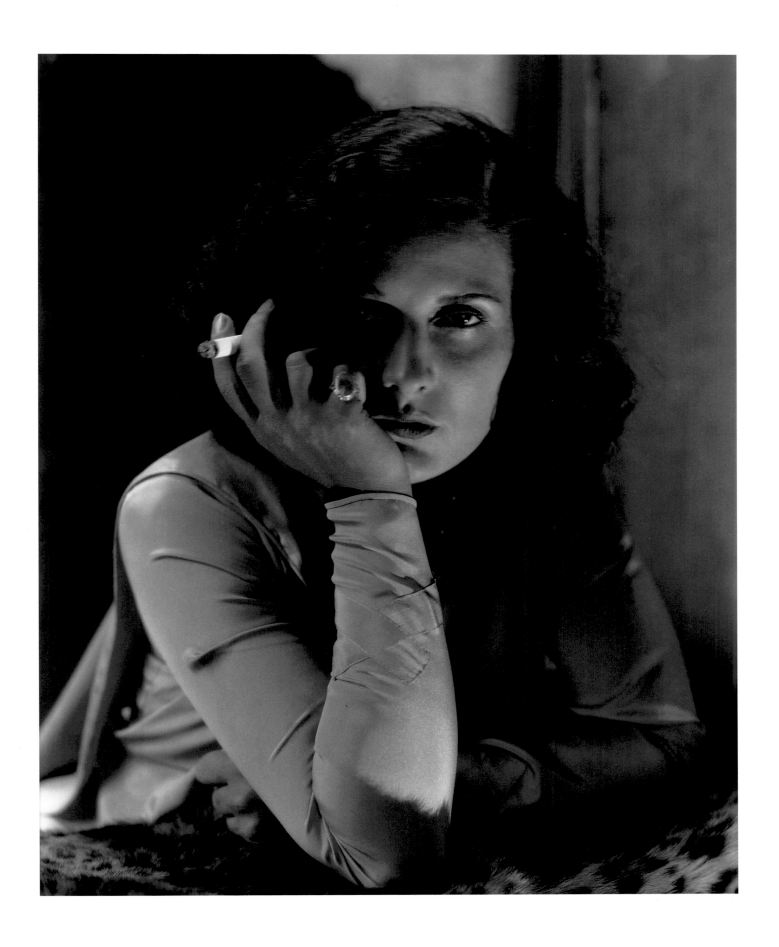

PLATE 75 | *Evelyn Brent, 1928*

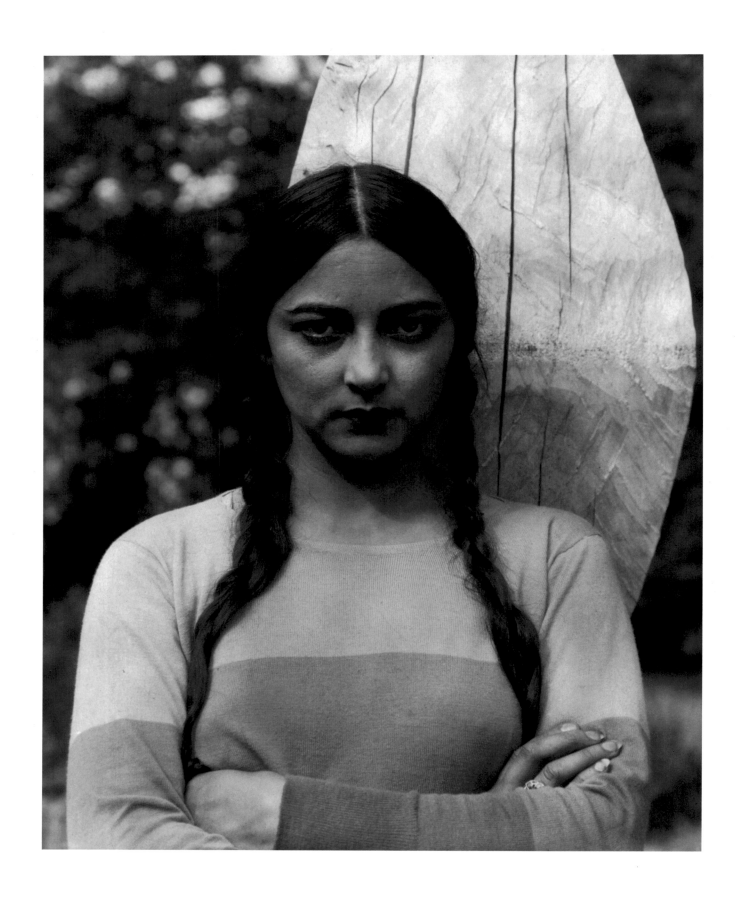

Rose Covarrubias in Front of Brancusi's "Endless Column" | PLATE 76
in the Garden at Voulangis, c. 1922

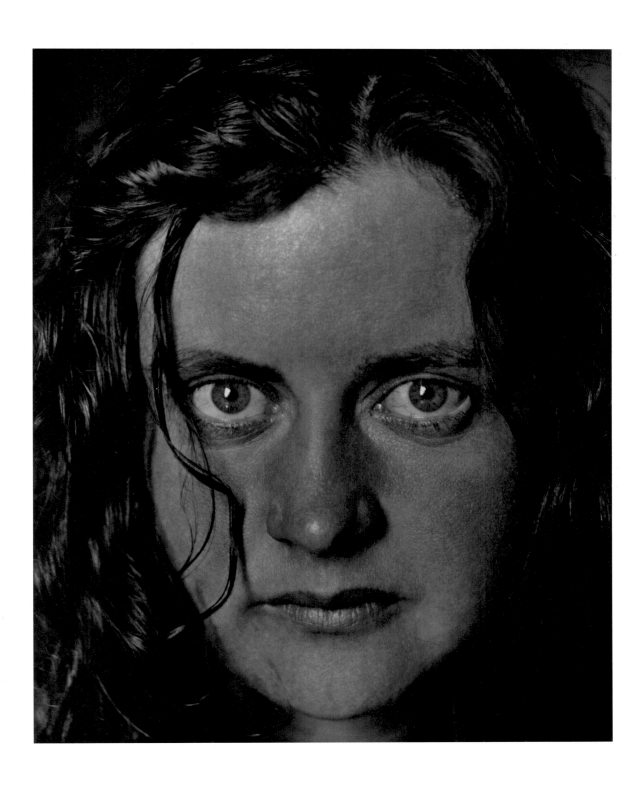

PLATE 77 | *Sunburn*, New York, 1925

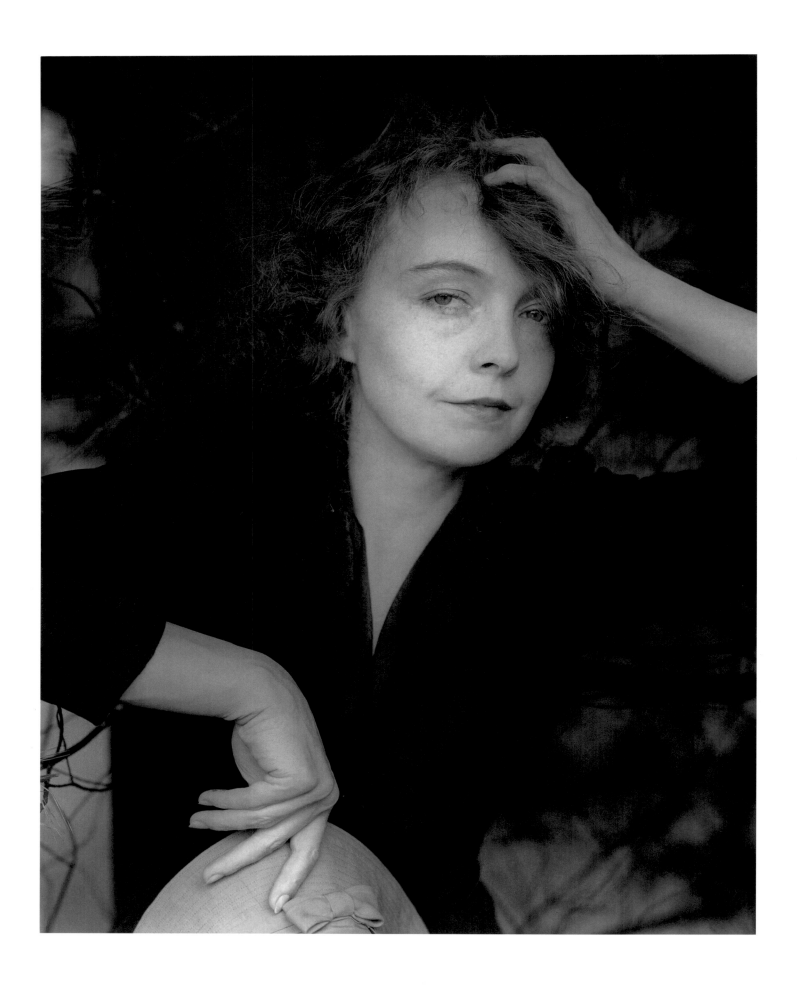

Lillian Gish in "The Green Hat," 1934 | PLATE 78

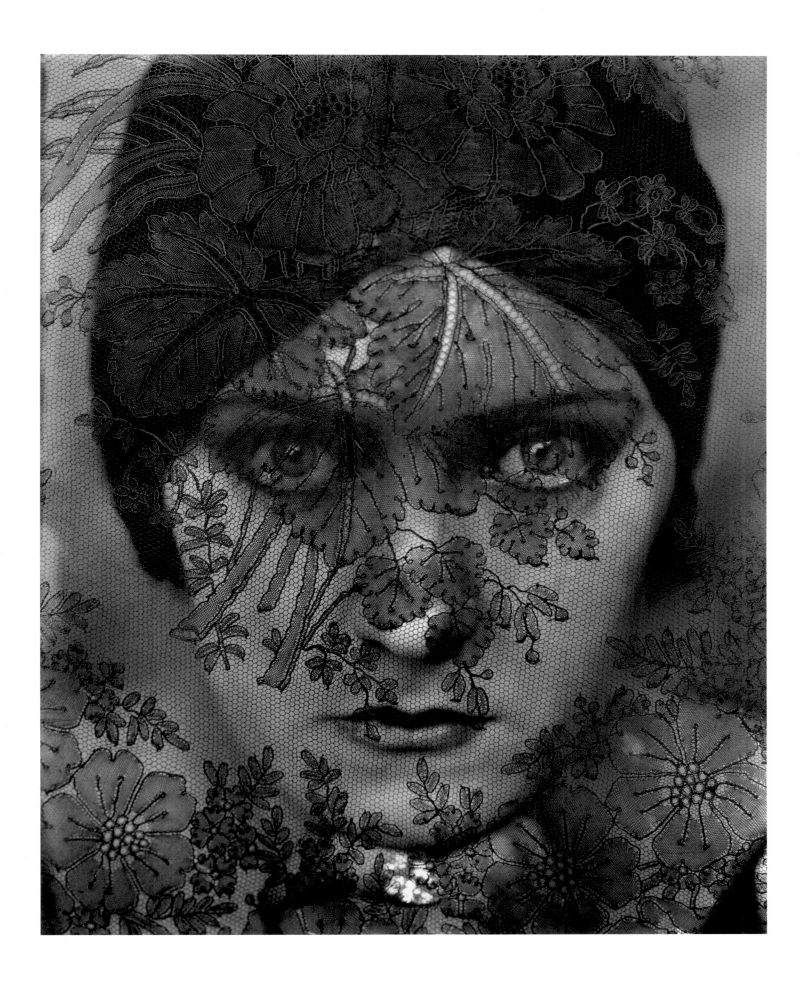

PLATE 79 | *The Cat—Gloria Swanson, 1924*

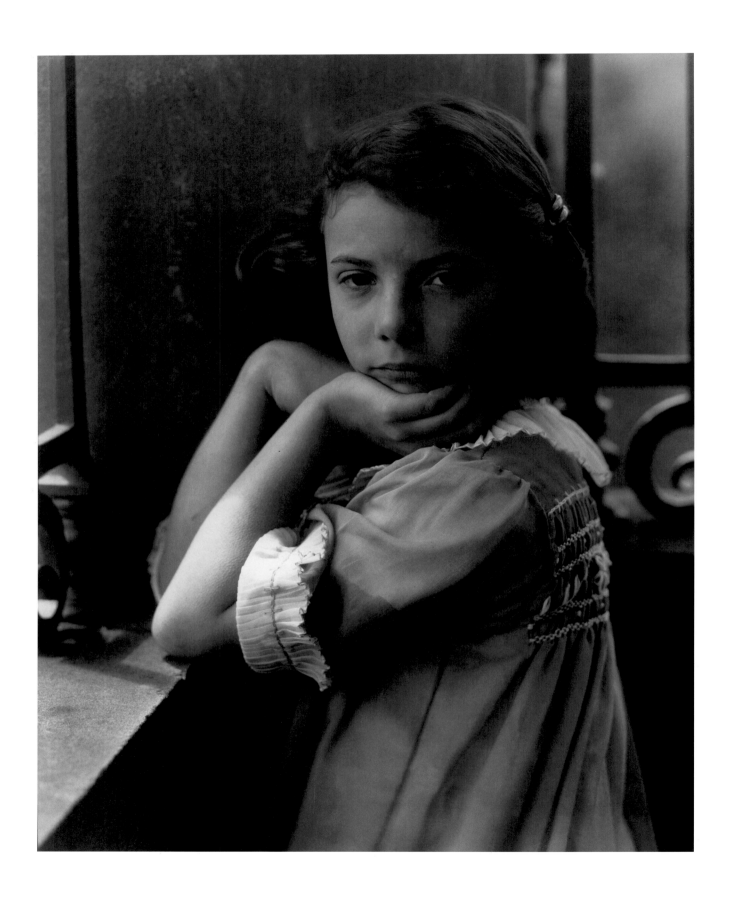

Elizabeth Meyer, c. 1920 | PLATE 80

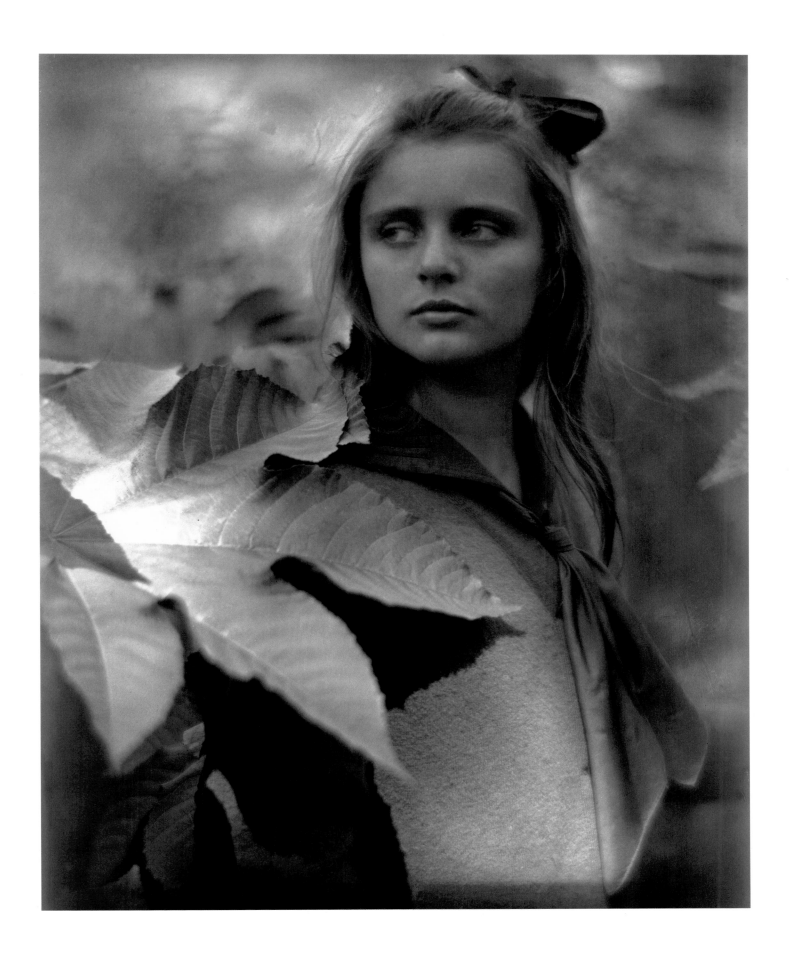

PLATE 81 | *Mary Steichen*, 1917

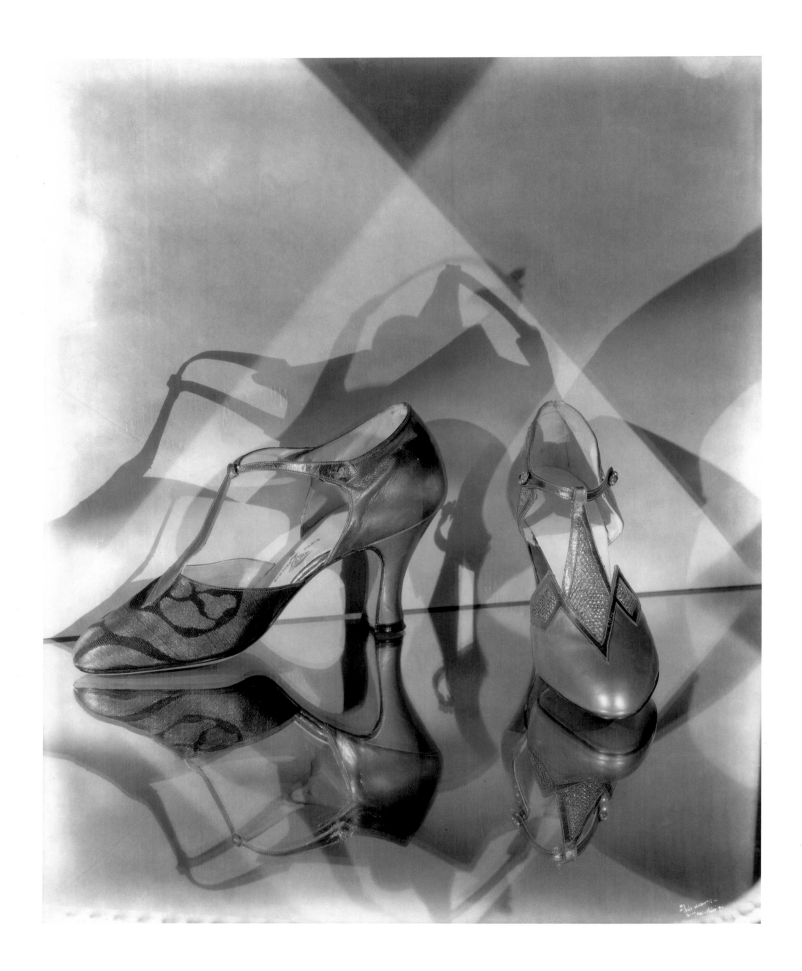

Shoes, 1927 | PLATE 82

STYLE

A good photographer not only builds his own concepts but, out of the style he has created in the process, he also builds or creates receptivity of the audience for his work. . . . The audience may have become so belligerently appreciative of his work as to become bigoted and seek to crucify the next generation with the ideas or ideals of their hero.

—E.S., private notes

When Steichen was first hired as photographer in chief of Condé Nast Publications to photograph the celebrities of the day for the original *Vanity Fair* magazine, he was asked whether he would mind making some fashion photographs for *Vogue* as well. He replied that he had already made fashion photographs in 1911 for the Parisian publication *Art et Décoration* (plates 88–91). Steichen's predecessor at Condé Nast, Baron de Meyer, produced precious, frilly images. Both the women and the clothes appeared giddy and trivial. Steichen, in contrast, had an innate sense of style that already served him well in portraits and was ideally suited to the impression of upper-class authority that *Vogue* tried to project. Steichen's women, from Edwardian grandes dames to sophisticated habitués of the salon and the speakeasy, were bold, graceful and elegant.

So were his photographs of objects: shoes (plate 82), silverware (plate 100), cigarette lighters (plate 99), tour de forces of composition and special lighting effects. Some of these are fashion photographs, some were advertisements. And at least one was a joke. Each year, as the children grew, he lined up the Meyer family in the same pose and made a family portrait. One year, he asked them to stand at the edge of the lily pond while he photographed just their feet above its edge (plate 83). Certain fashion photographs, such as the one called *White* (plate 103), also required a sense of humor.

In photographing fashions for *Vogue,* Steichen learned on the job. He credited Carmel Snow, the editor, with teaching him what was important about the clothes. He wanted his photographs to show the reader how each garment worked, as well as to suggest the kind of life appropriate to the clothes. First, he had to learn how to use artificial light. At his initial *Vogue* sitting, he found an electrician standing by with banks of klieg lights. Nonplussed but maintaining command, he ordered all the lights turned off while he studied the scene. Then he had the lights massed together, coming from one direction only. He called for several layers of bedsheets to be hung in front of the lights, diffusing them to produce something like the natural daylight with which he was comfortable. The

astonished editors and their assistants clucked and cooed over his innovative genius.

Month after month, he managed to come up with fresh images for increasingly similar subjects. To achieve variety, he used mirrors, stark black-and-white contrast, geometry, background panels, jolting shafts of light, crinkling swirls of fabric and the assured, regal grace of his sitters and models. Sometimes he used props in the studio to imply luxurious and aristocratic backgrounds, and sometimes he took his models on location, in Condé Nast's apartment, on steamships, in stables, in expensive automobiles.

His favorite model was Marion Morehouse. According to Steichen, she cared as little about fashion as he did in private life, but she had a fine actress's capacity to become whichever person the clothes she modeled required. Once, Steichen suggested making a series of nude photographs. Morehouse agreed and posed wearing only long black gloves and stockings. Later, Steichen heard that she had married. To save her any possibility of future embarrassment, he destroyed the negatives of the nude sitting. Then he learned that she had married the avant garde bohemian poet e. e. cummings, who, Steichen believed, would have relished the pictures.

The Stehli Silk Company asked Steichen to make some photographs that could be translated into designs for fabric. He accepted the assignment on the condition that he would not be required to make traditional flower prints. He devised arrangements of sugar cubes, matches, thumbtacks, eyeglasses and thread, as well as a few bold groupings of flowers. The results (plates 106–113) rank among his finest abstractions. The designs were reproduced on rayon fabric and made into moderately priced dresses.

Steichen claimed that it pleased him to know that women of modest means could wear his designs. He could be gracefully at home among the rich and the socially prominent, people whose attention is necessary to an artist's success, but he never wasted time striving to be one of them. He knew that the aristocracy to which he belonged was one of talent and creative achievement.

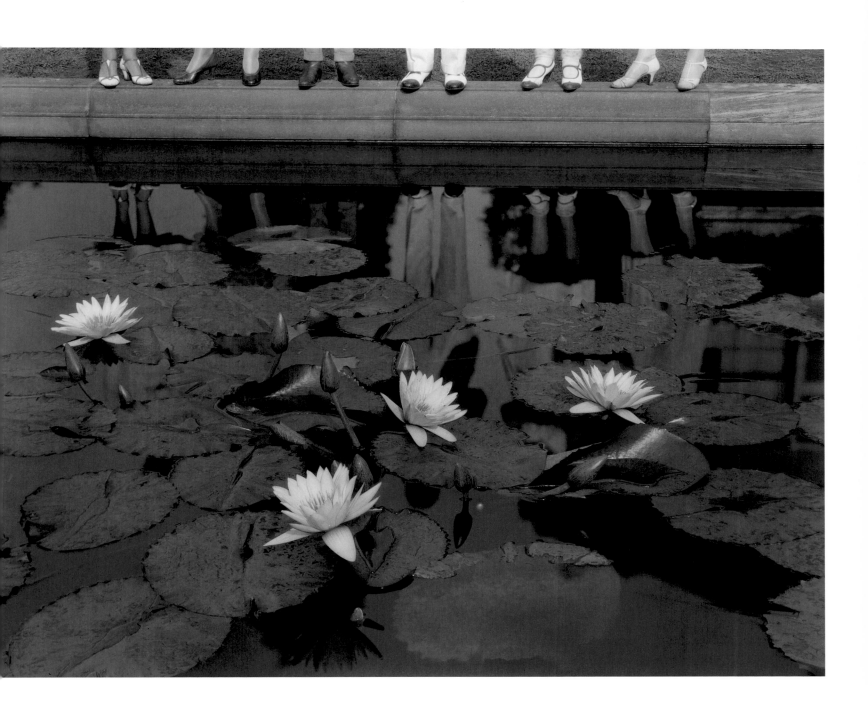

PLATE 83 | *The Lily Pond at Seven Springs Farm,* Mount Kisco, New York, 1935

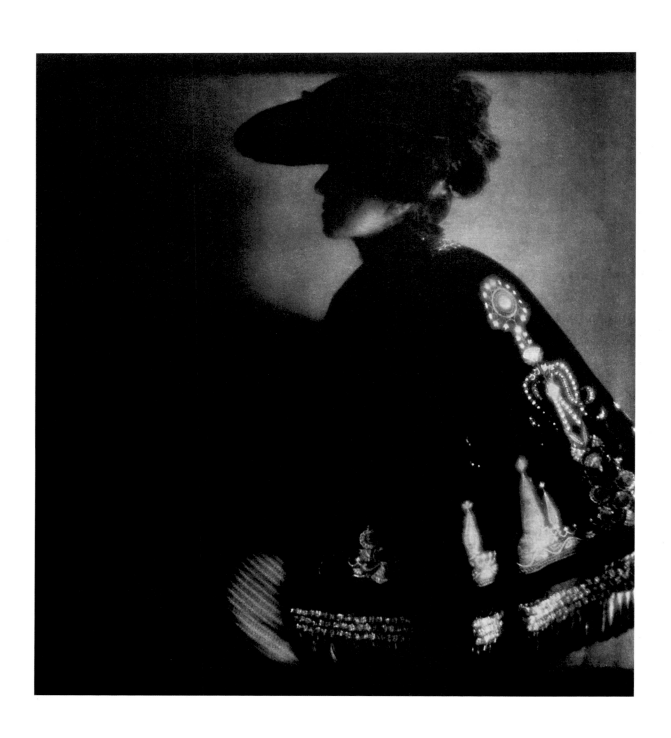

Poster Lady, 1906 | PLATE 84

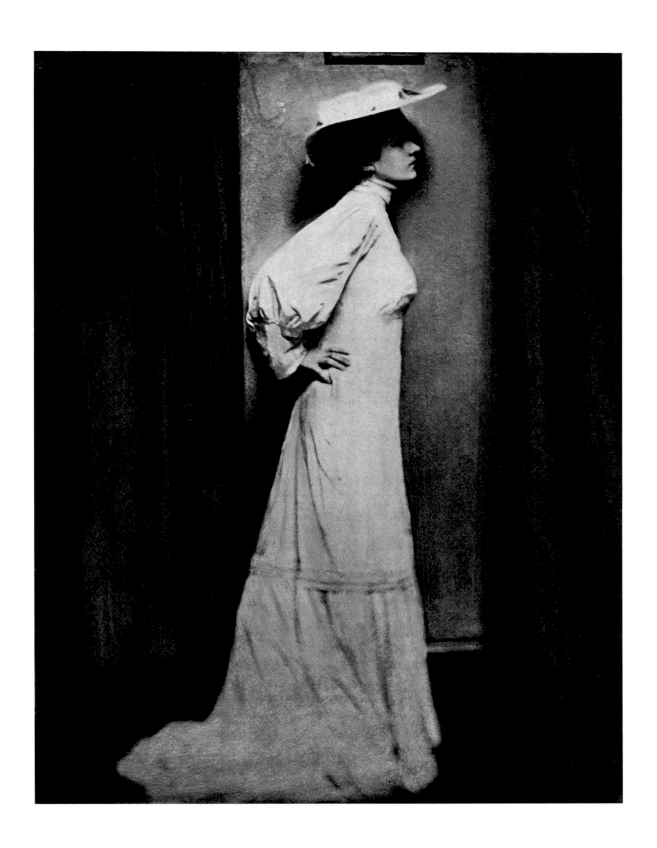

PLATE 85 | *The Lady in White*, 1906

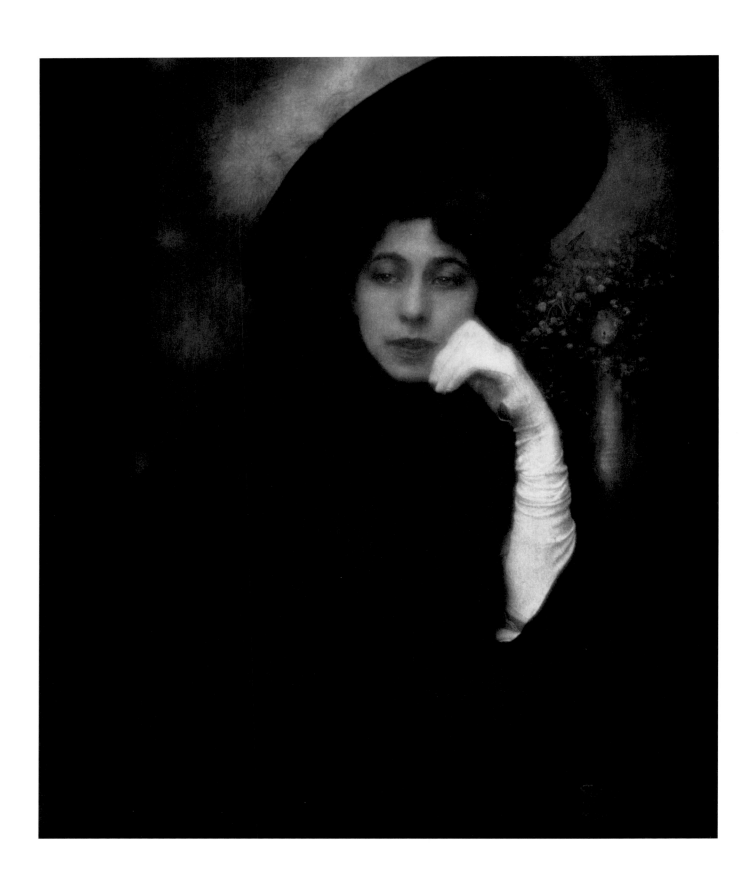

Mrs. Condé Nast, Paris, 1907 | PLATE 86

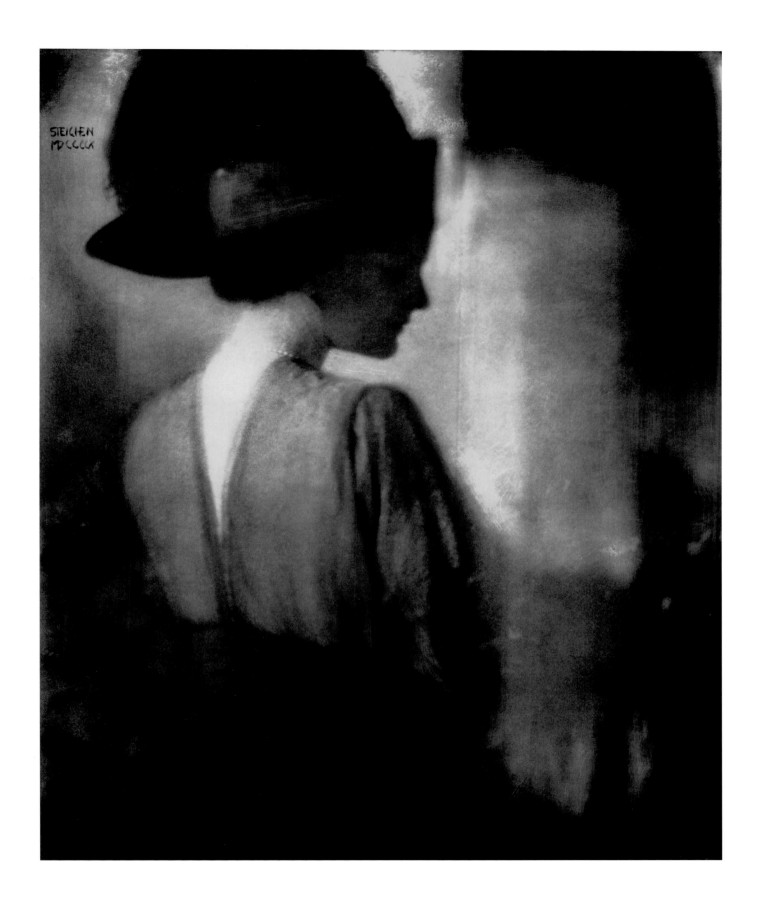

PLATE 87 | *Agnes Ernst Meyer* (Mrs. Eugene Meyer), New York, 1910

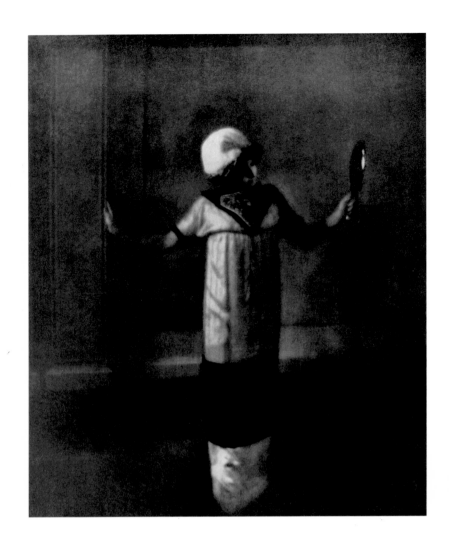

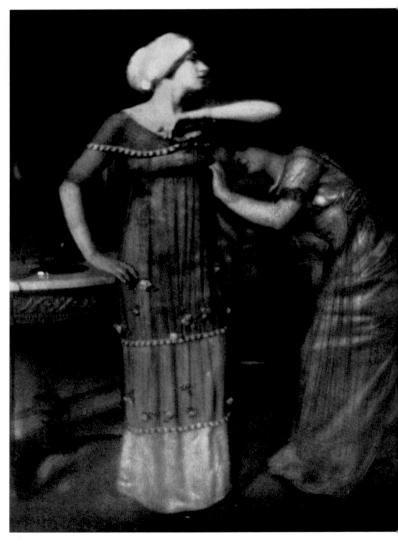

Poiret Fashions for *Art et Décoration*, Paris, April 1911 | PLATES 88–89
TOP: *"Babou"*; BOTTOM: *"Pompon"*

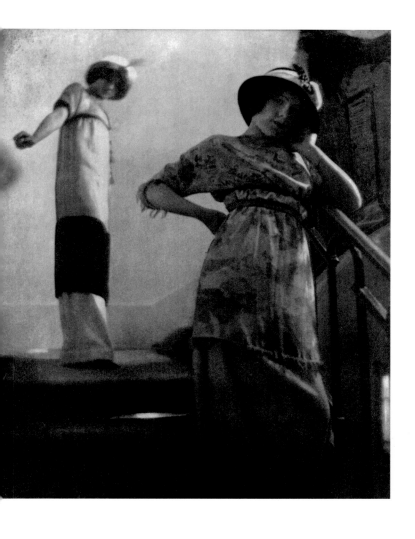

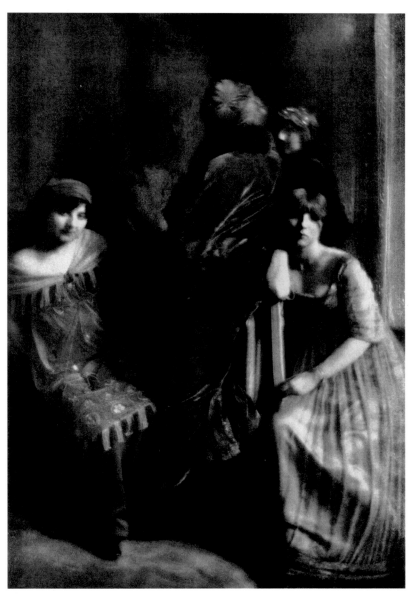

PLATES 90–91 | Poiret Fashions for *Art et Décoration*, Paris, April 1911
TOP: *"Babou" and "Patre"*; BOTTOM: *"Byzance"*

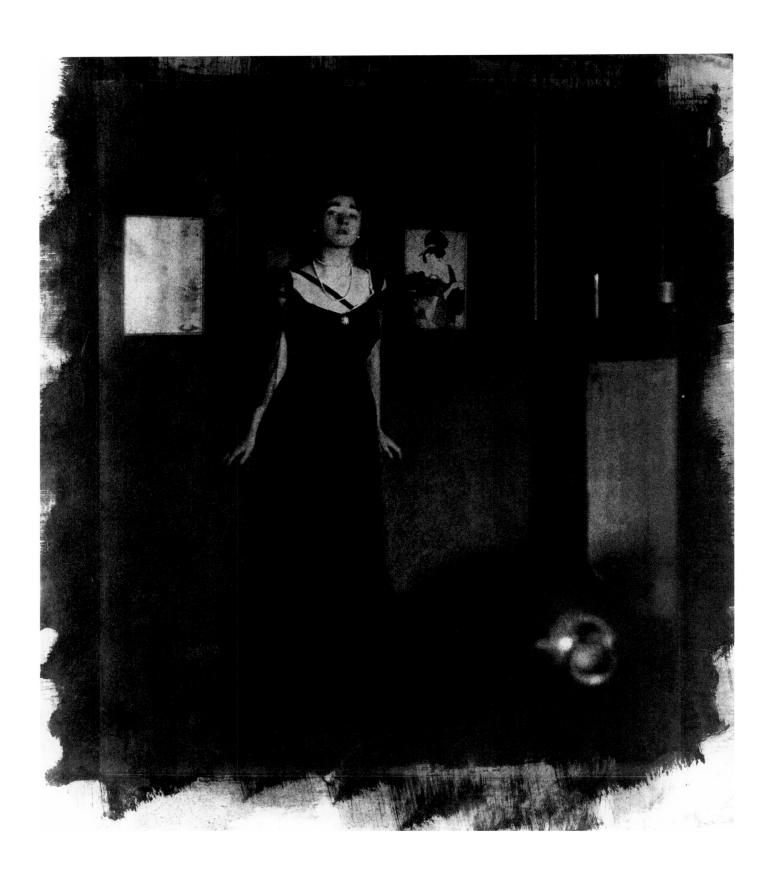

The Lady in Black, 1904. Experiment in multiple gum printing | PLATE 92

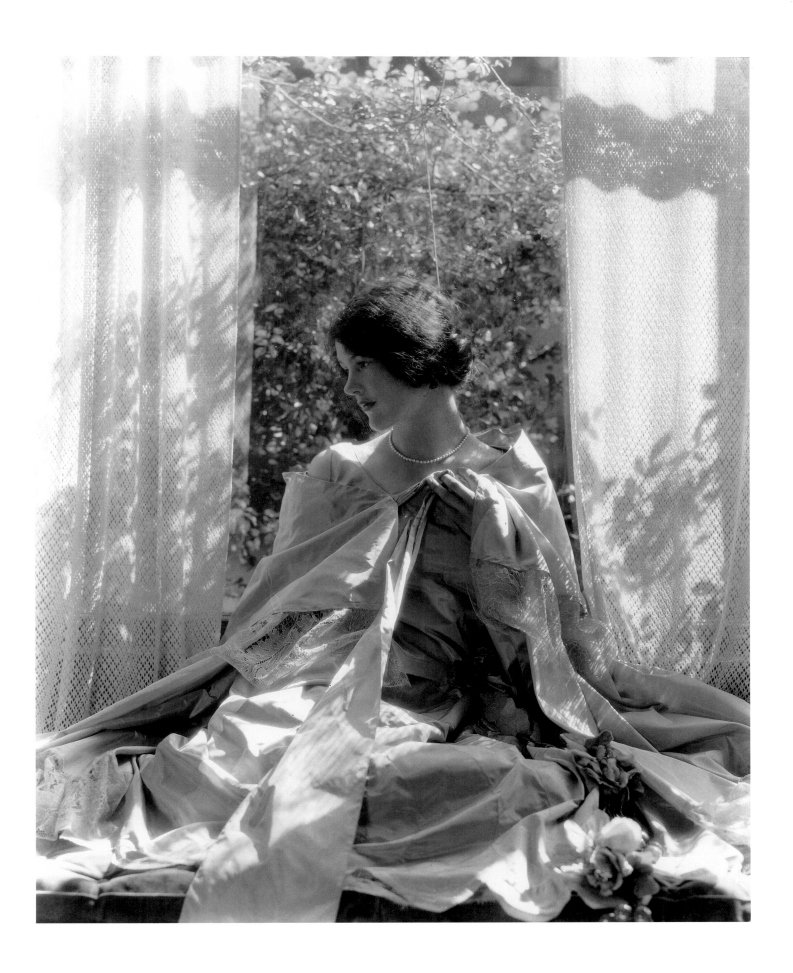

PLATE 93 | *Miss Fanny Wickes, 1924*

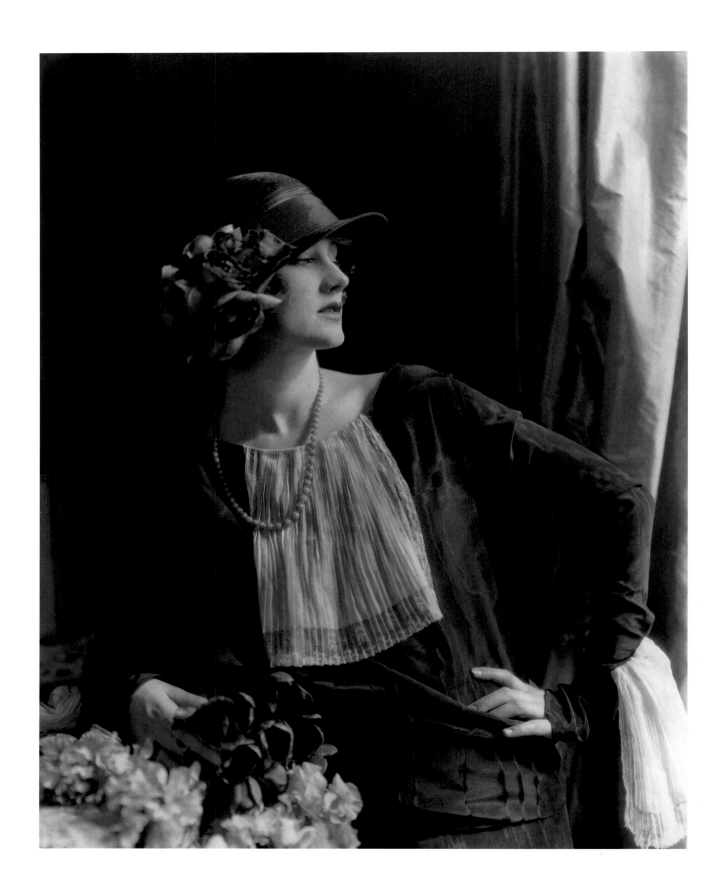

Flapper, 1923 | PLATE 94

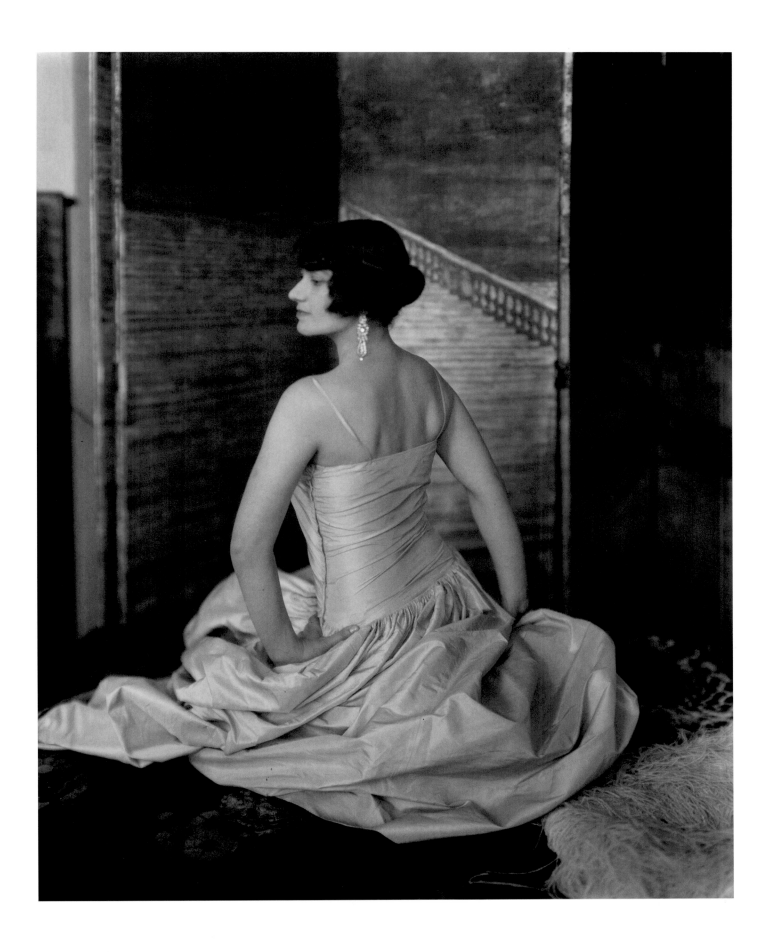

PLATE 95 | *La Duchesse de Gramont*, Paris, 1924

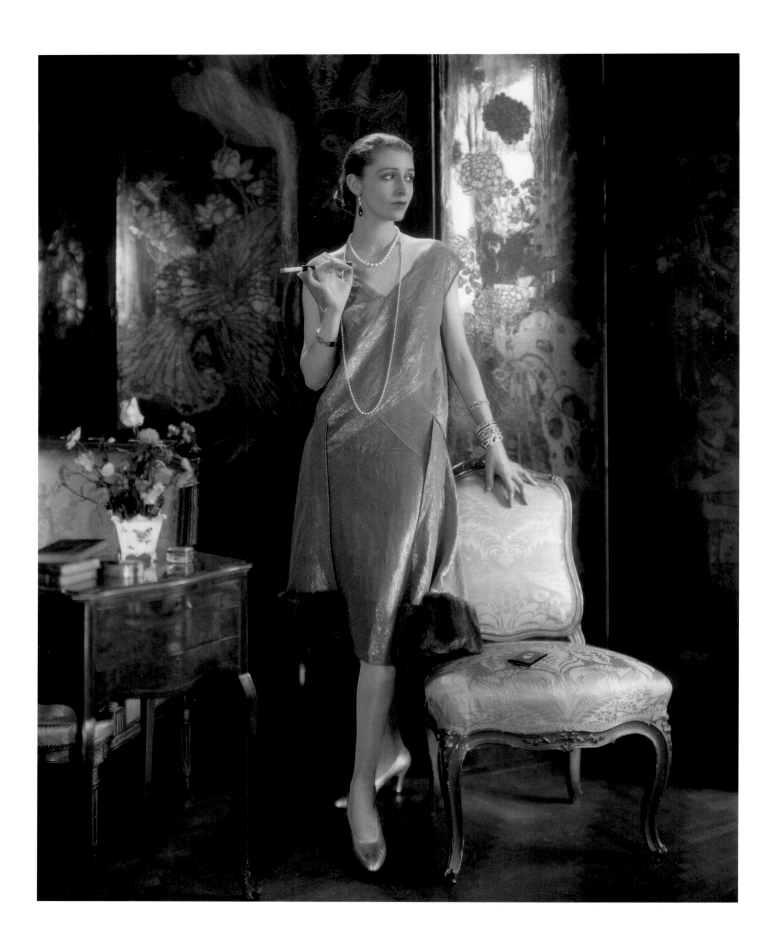

Marion Morehouse in a Chanel Gown, 1925 | PLATE 96

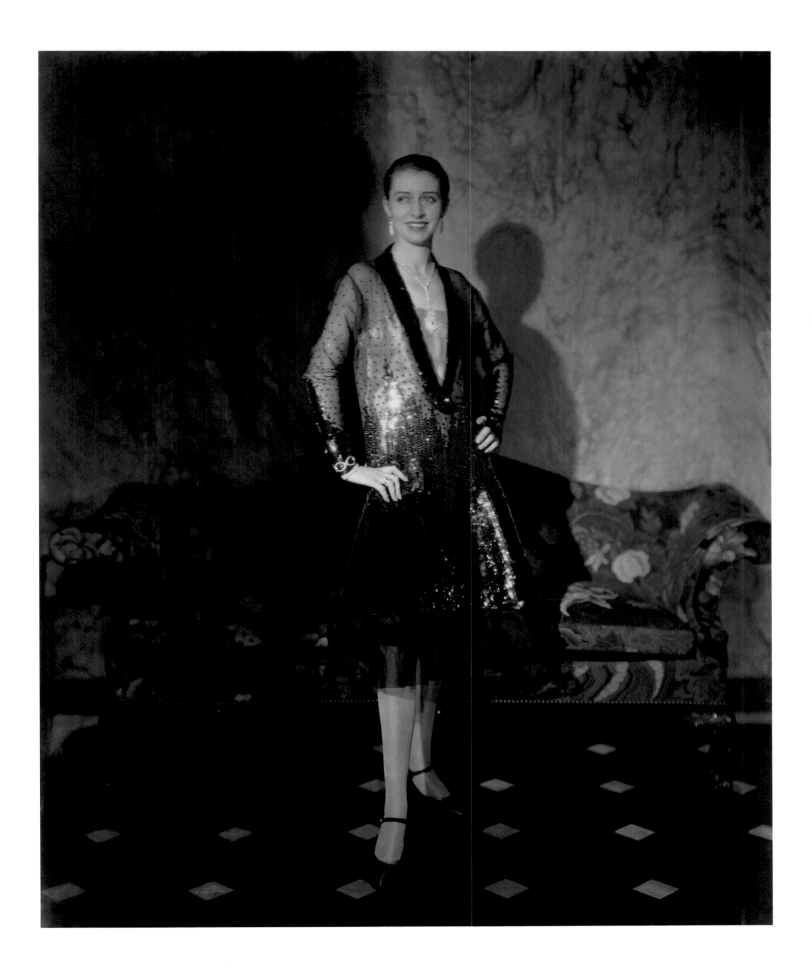

PLATE 97 | *The Photographer's Favorite Model, Marion Morehouse, in a Cheruit Gown*, New York, 1927

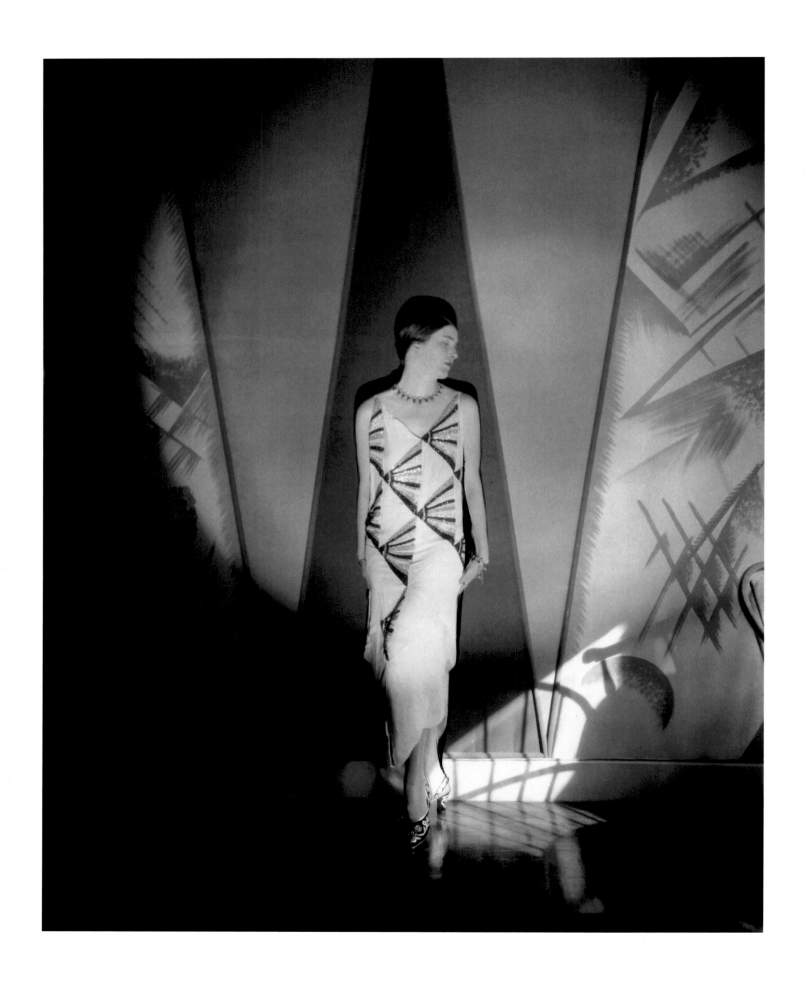

Anita Chase in a Vionnet Gown, 1925 | PLATE 98

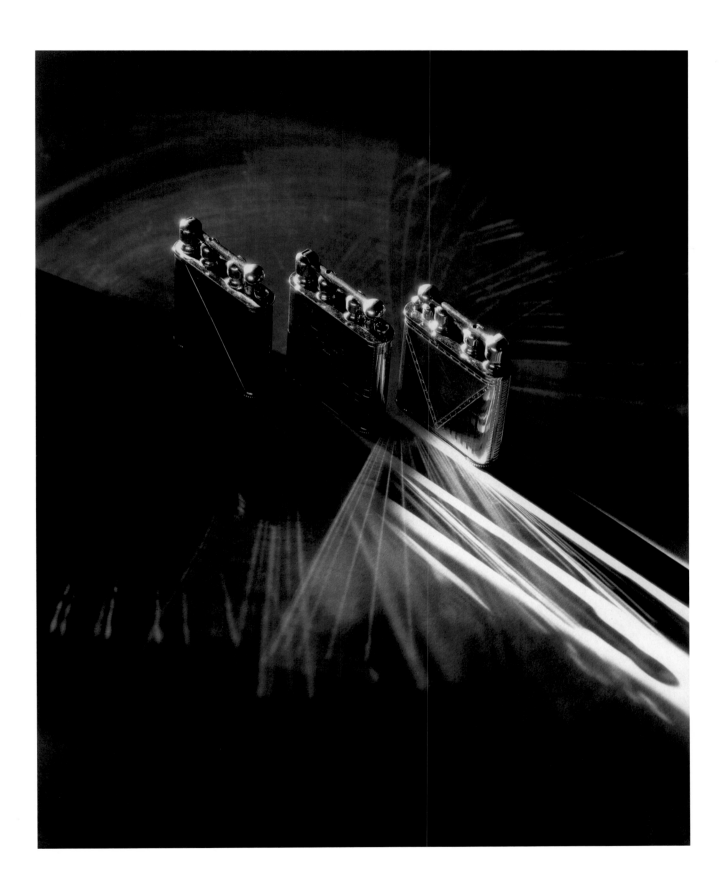

PLATE 99 | *Douglass Lighters,* 1928

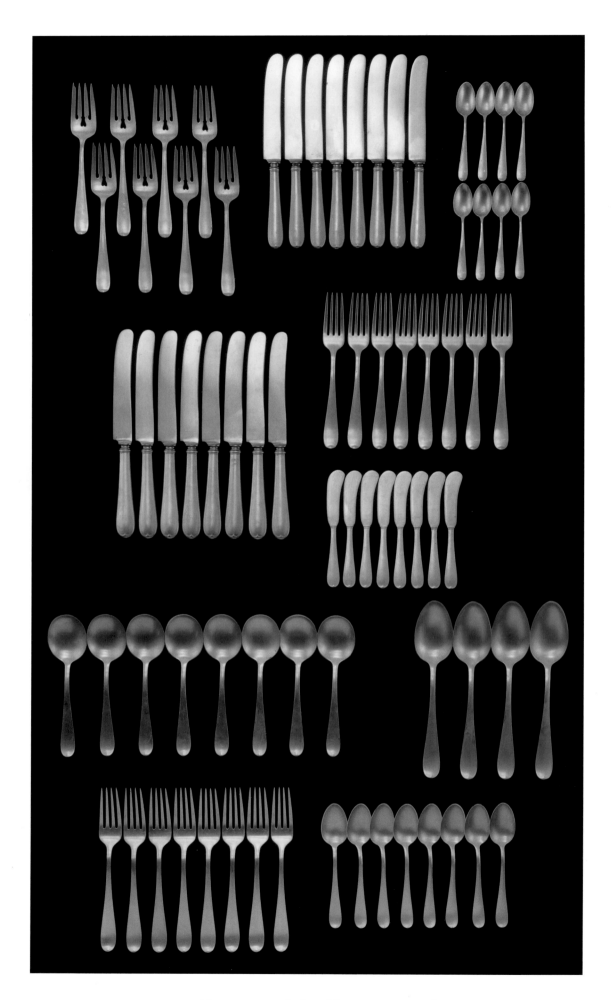

Advertisement for Gorham Silver, 1929–1930. | PLATE 100
The J. Walter Thompson Agency

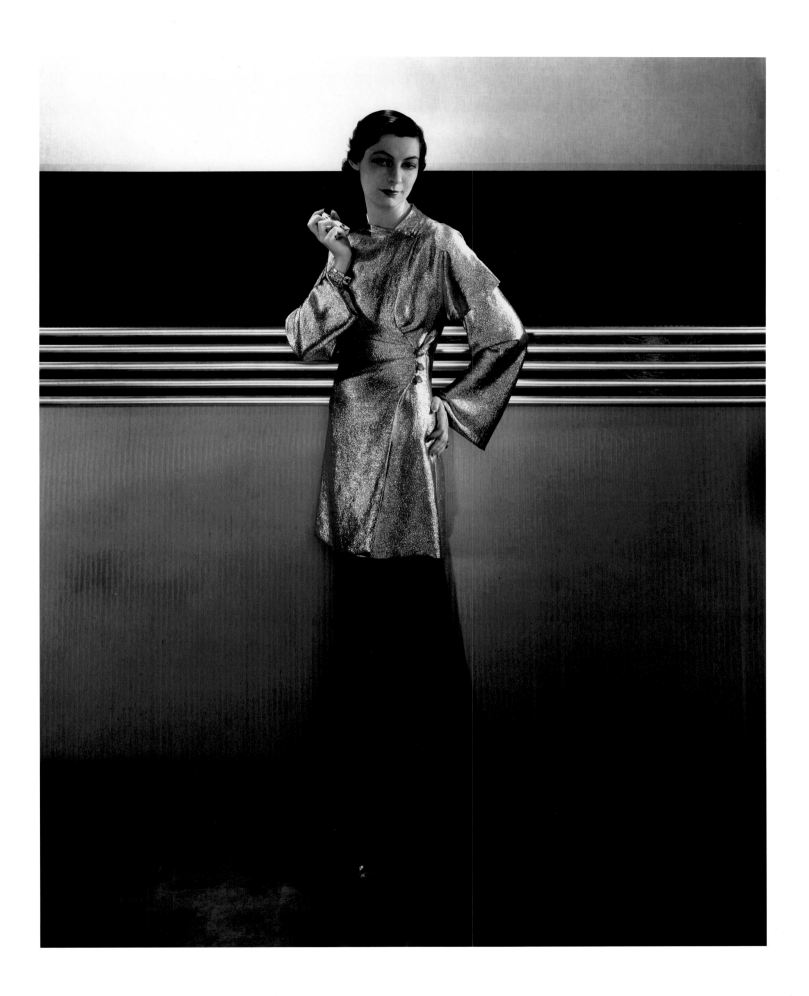

PLATE 101 | *Ilka Chase, 1933*

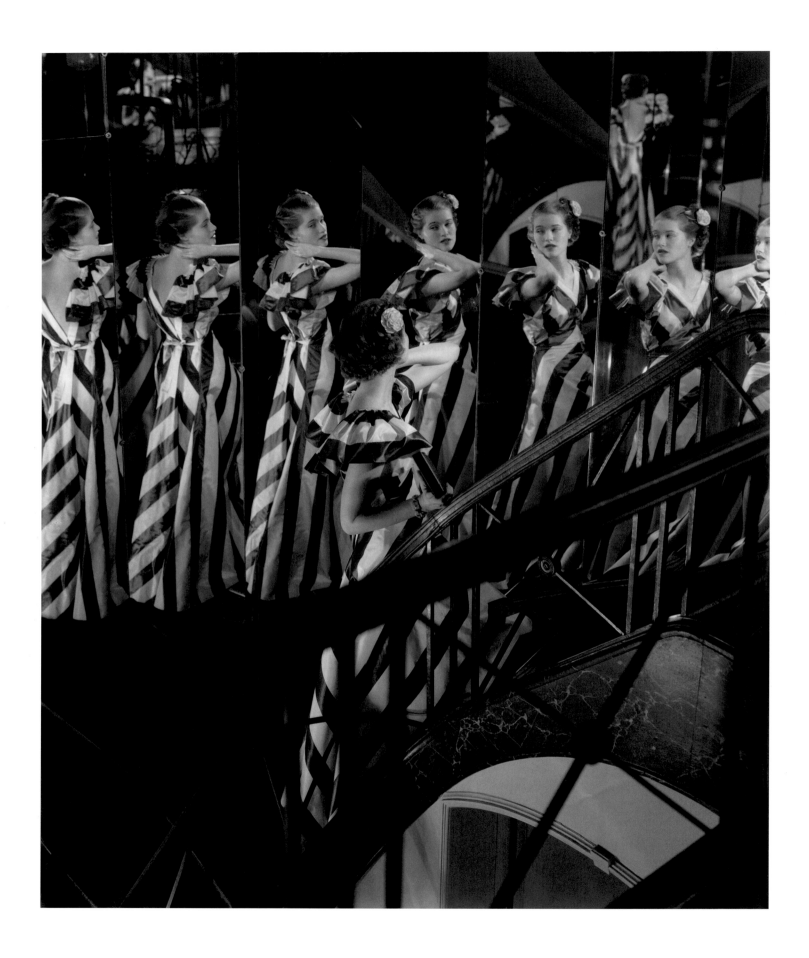

Striped Gown, 1935 | PLATE 102

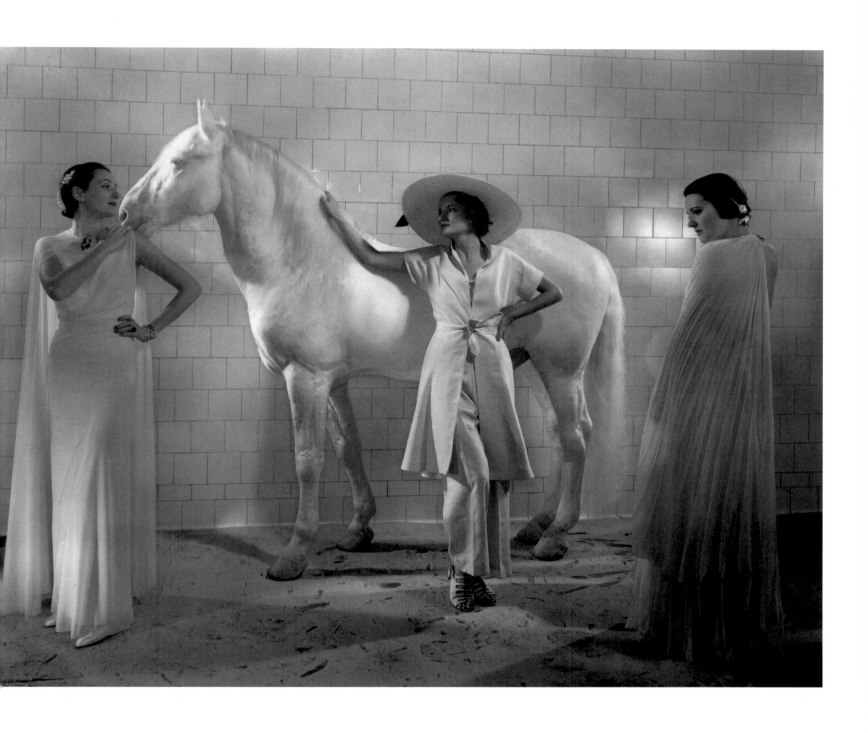

PLATE 103 | *White, 1935*

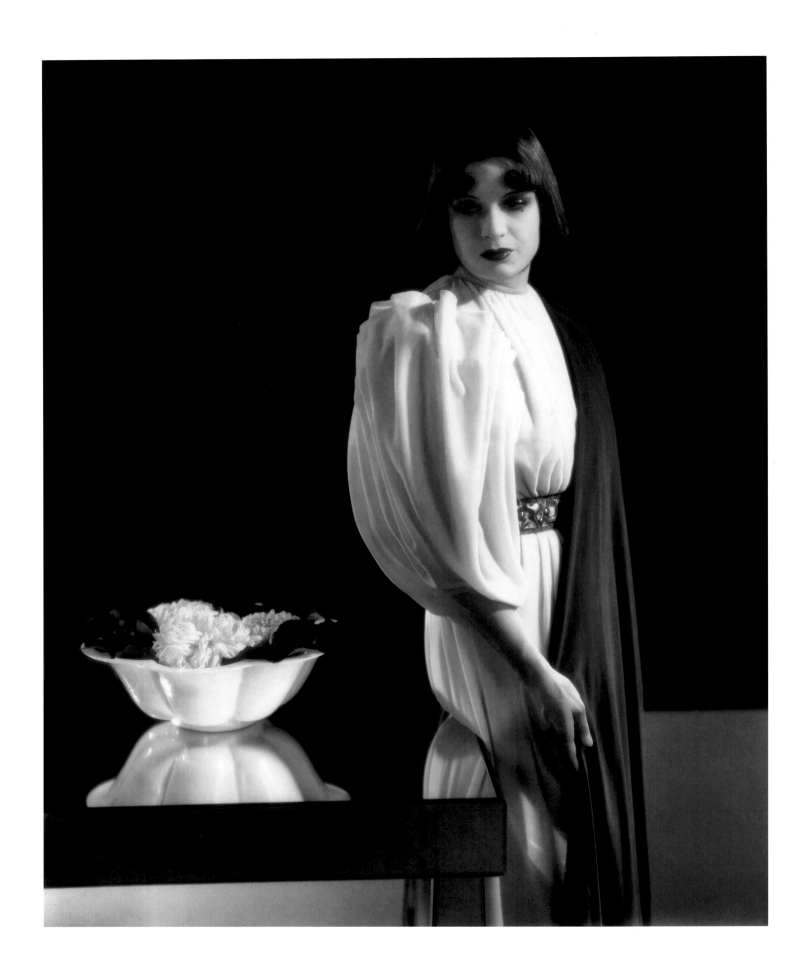

Lili Damita, New York, 1928 | PLATE 104

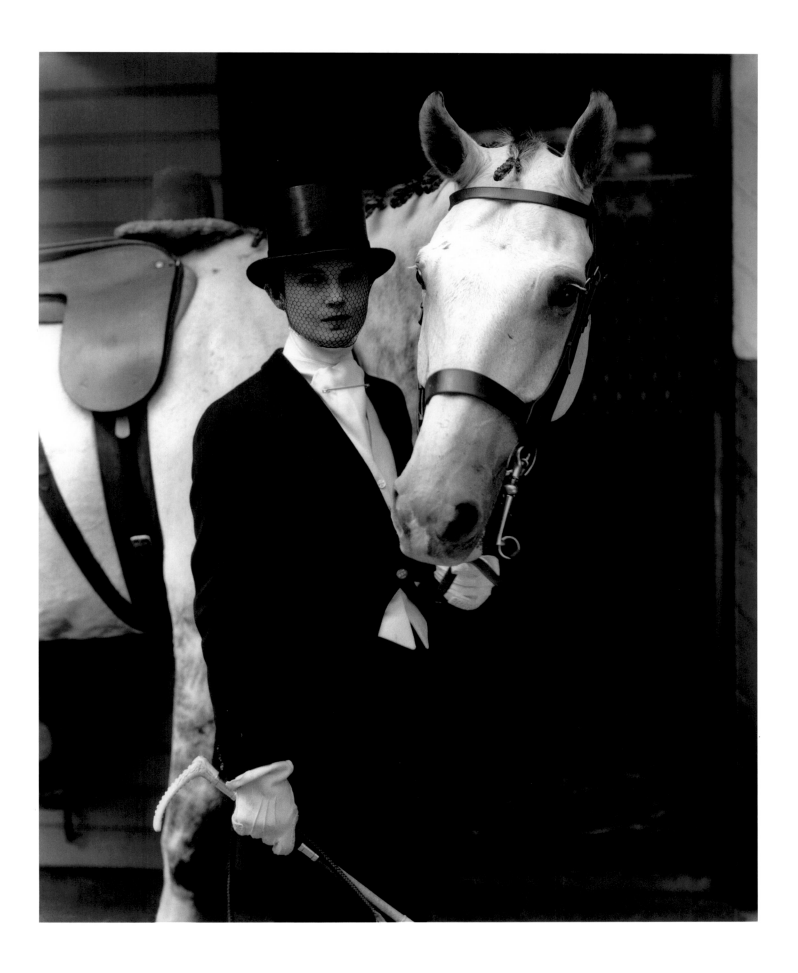

PLATE 105 | *Equestrienne, 1930*

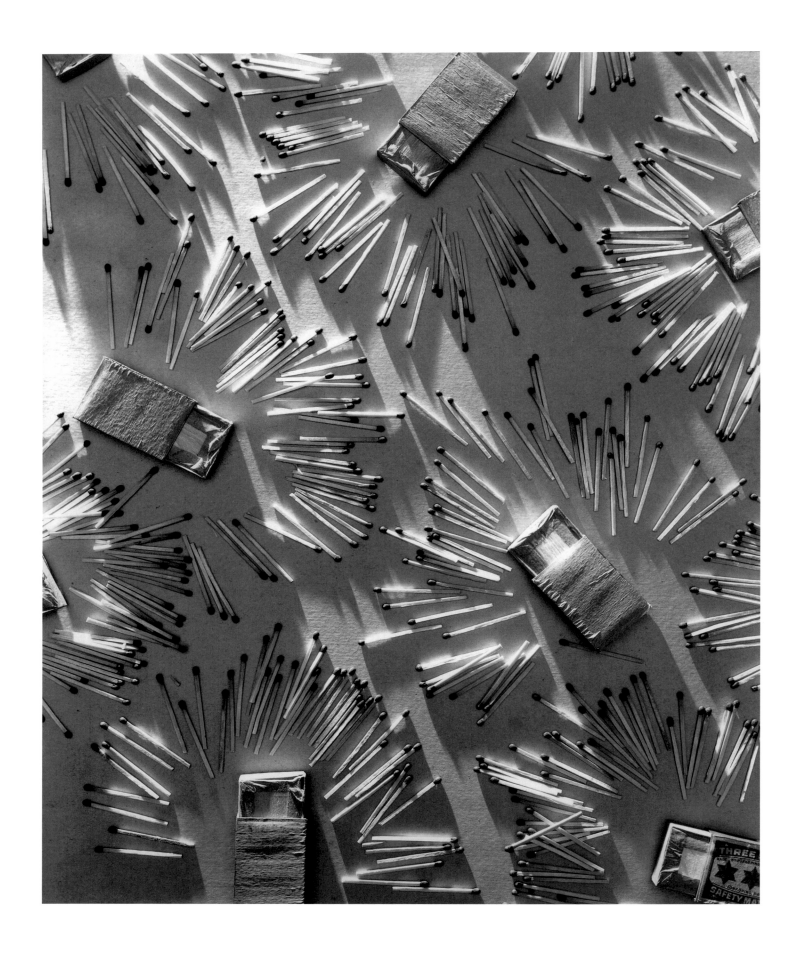

Matches and Match Boxes, 1926. Fabric design for Stehli Silks | PLATE 106

PLATE 107 | *Thumbtacks*, 1926–1927. Fabric design for Stehli Silks

The Wandering Thread, 1927. Fabric design for Stehli Silks | PLATE 108

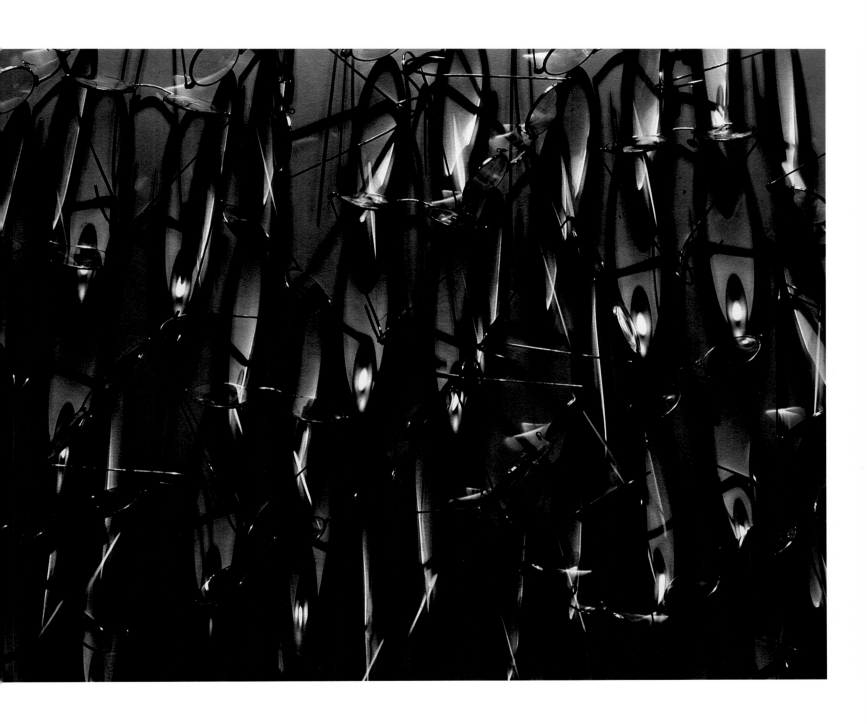

PLATE 109 | *Spectacles,* 1927. Fabric design for Stehli Silks

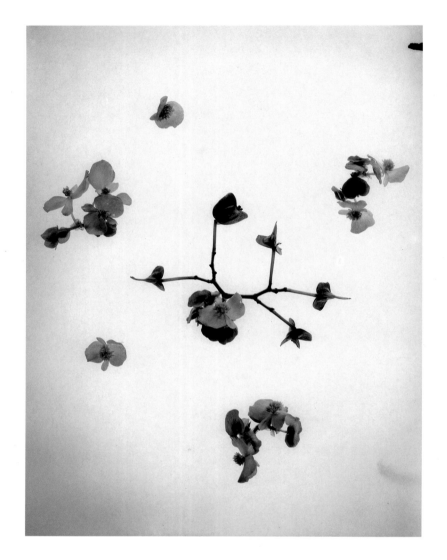
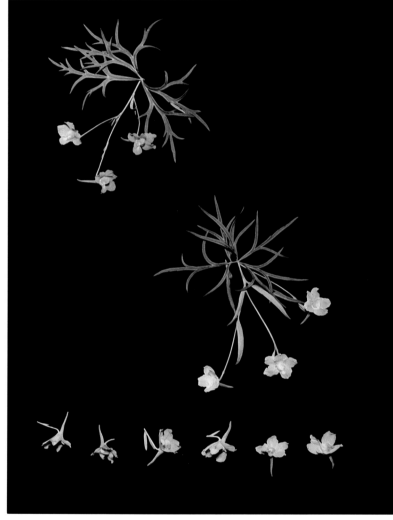

LEFT: *Blossoms, 1926;* RIGHT: *Dancing Flowers, 1926* | PLATES 110—111
Fabric designs for Stehli Silks

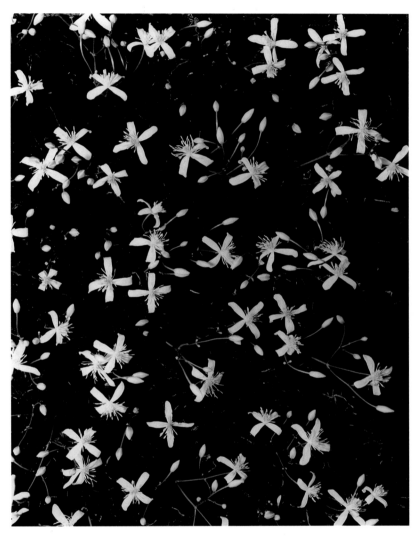

PLATES 112–113 | LEFT: *Grasses,* 1926; RIGHT: *Star Flowers,* 1926
Fabric designs for Stehli Silks

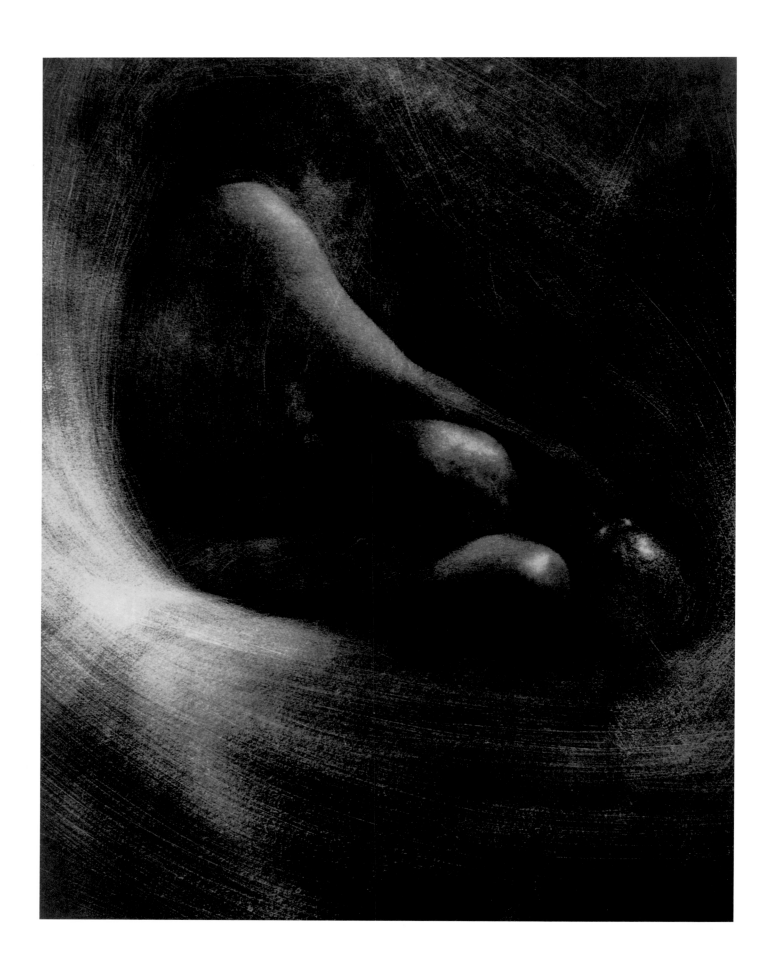

Nude with Vase, c. 1902 | PLATE 114

THE BODY

Mere photo technique [is] not a solution——but like a person of many languages and nothing to say.

—E.S., private notes

Steichen's early nudes followed the conventions of their day. We seldom see nipples, pubic hair or faces. Anonymous, graceful figures of mystery, melancholy and mourning, they are, except for the polished marble quality of *In Memoriam* (plate 121), mere apparitions barely emerging from shadow in symbolist and impressionist poses with a few art nouveau trappings. The photographer has transmuted real women into fabled creatures who exist only in the mind of the beholder.

Initially, the contrast with the later, lustier nudes (plates 122 and 123) seems enormous. These bold, brightly lighted women, definitely three-dimensional, proudly flaunt every sinuous inch of muscle, skin and secondary sexual characteristics. And yet their poses are not so far removed from the earlier, evocative style. They are shot from the front instead of the back. Their gestures expand rather than contract. But their faces are still obscure, and their contorted stretches and bends still belong to the realm of fantasy and legend. Let the viewer supply the identity that fits the story. They remain romantic figures, idealized, the stuff of myth, though perhaps a tougher myth than before.

The hands of Steichen's second wife, Dana, also tell a symbolic story (plate 124). Taken at the same time as *The Blue Sky——Dana* (plate 18), during a lovers' picnic in the grass, those lovely hands, reaching in a style reminiscent of the Delsarte School of movement, express all the joy and hope of a happy new beginning. In retrospect, they represent a dream come true for Steichen, since Dana almost always acquiesced and adapted her needs to his, failing him only by dying early. Those hands, like the other images in this section, represent Steichen's dreams. Unlike the connections he made in the portraits, where he revealed basic truths unique to the subjects, these figures, for all we learn about them, might as well be still lifes. The images never reveal who the women really were or what they wanted.

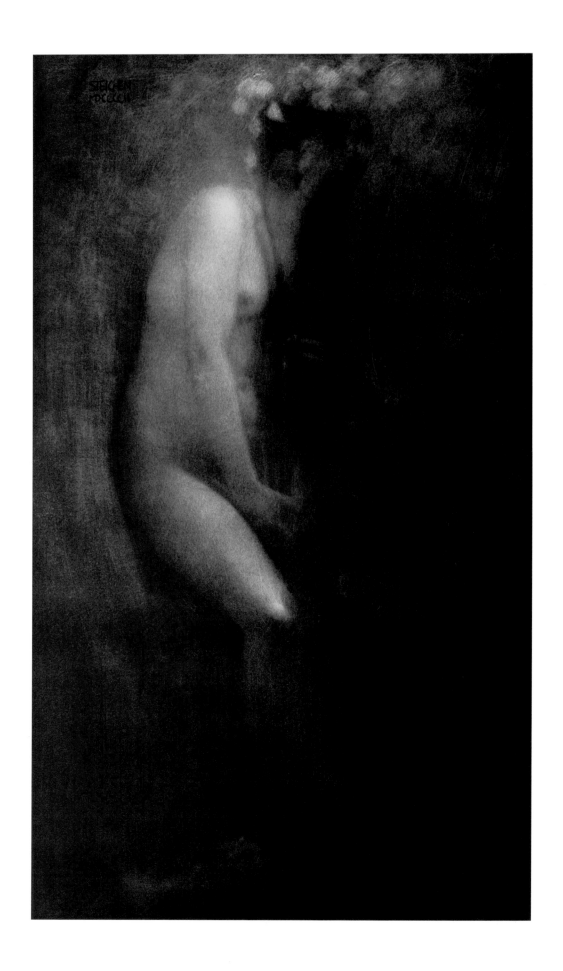

Figure with Iris, Paris, 1902 | PLATE 115

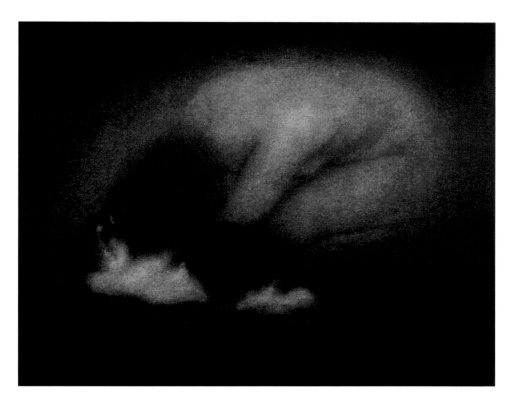

PLATES 116–117 | TOP: *The Cat #1*, 1902; BOTTOM: *The Cat #2*, 1902. Gum platinum print

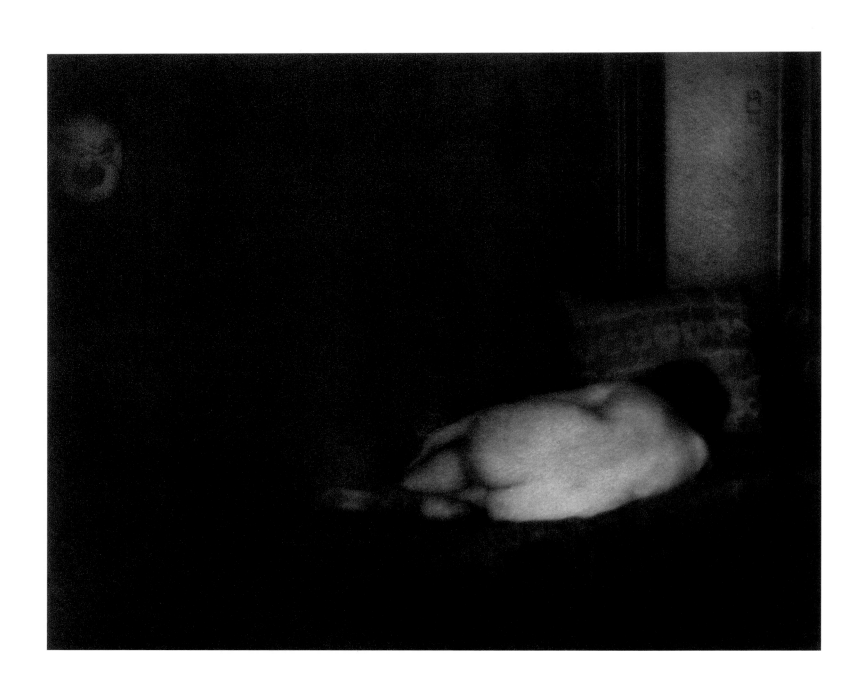

The Model and the Mask, 1906 | PLATE 118

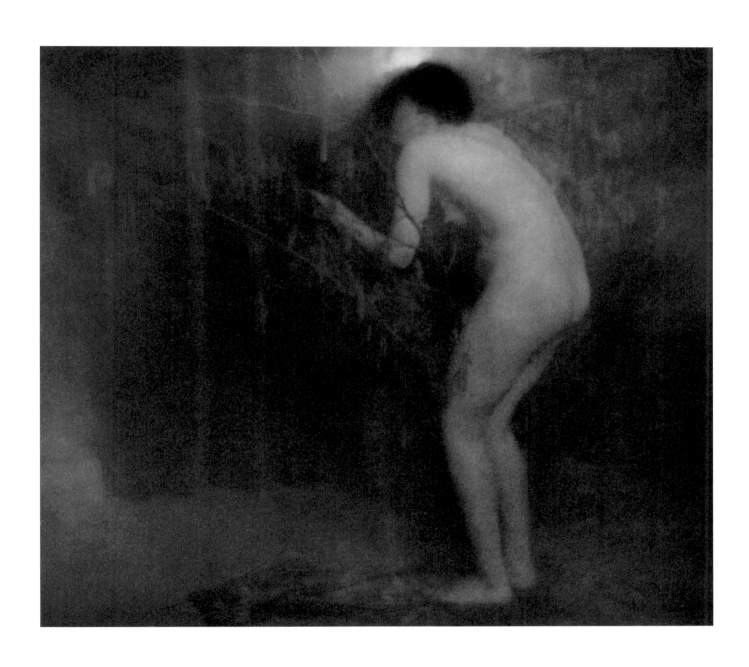

PLATE 119 | *La Cigale,* Paris, 1901

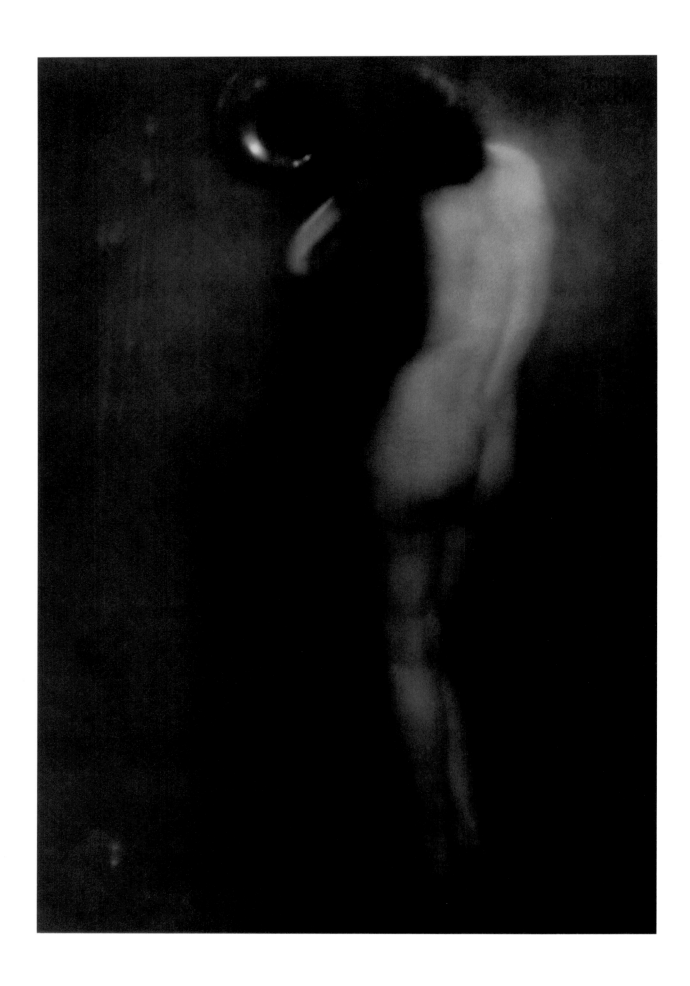

The Little Round Mirror, Paris, 1901 | PLATE 120

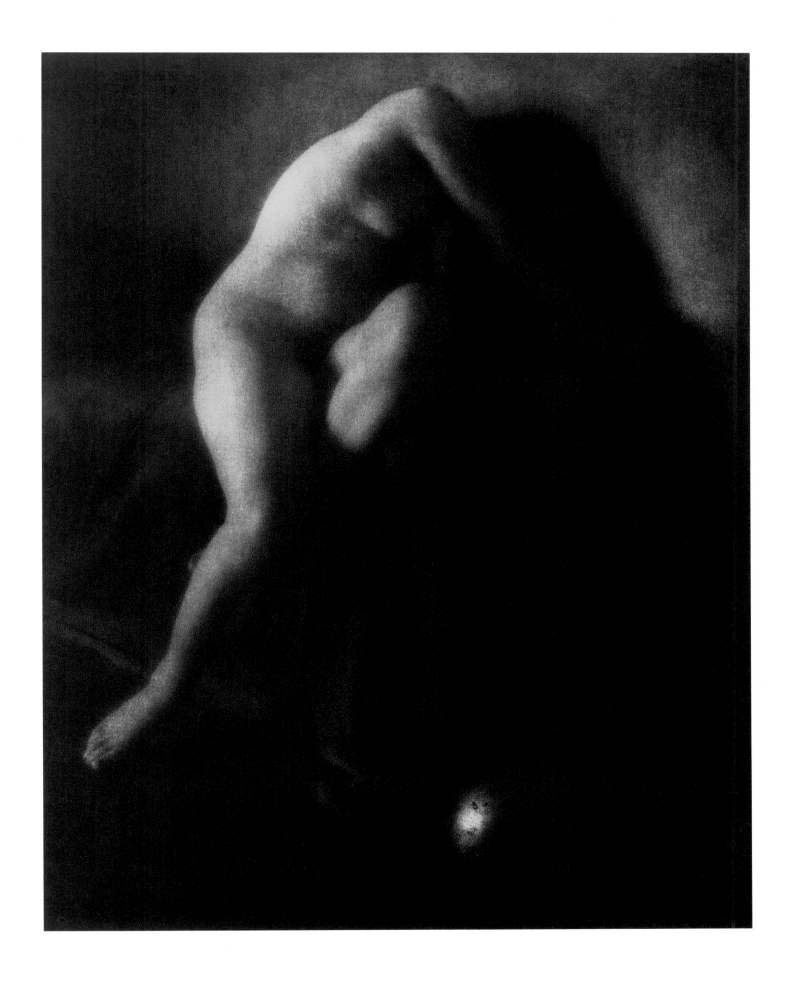

PLATE 121 | *In Memoriam*, New York, 1904. Platinum and gum print

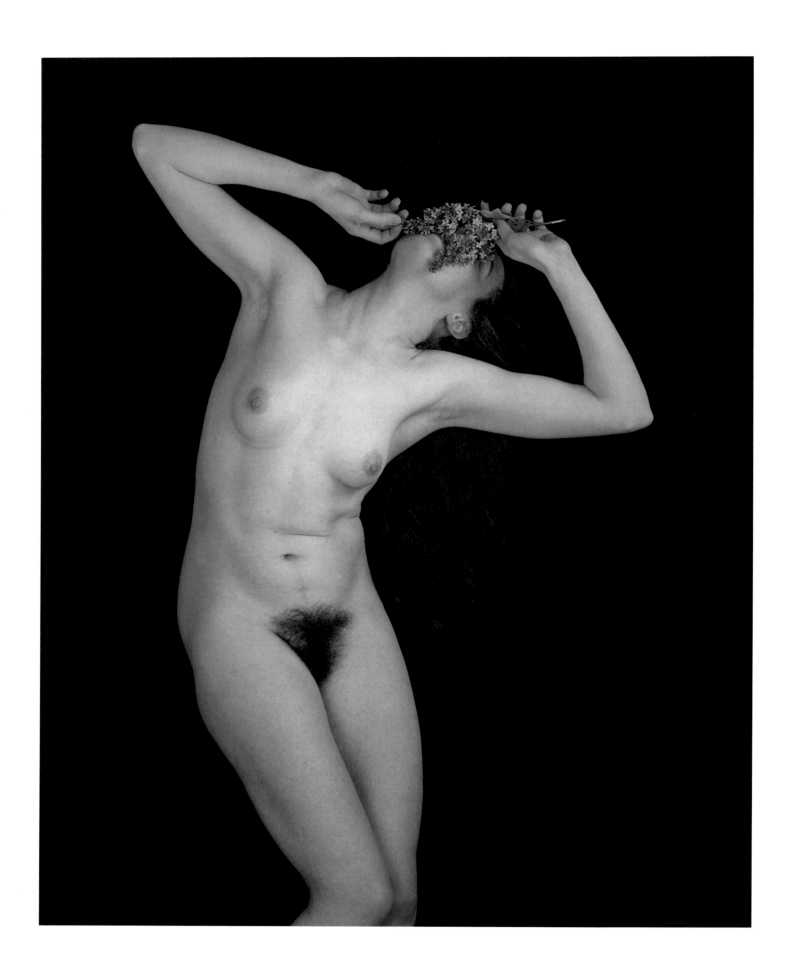

Nude with Lilacs, c. 1936 | PLATE 122

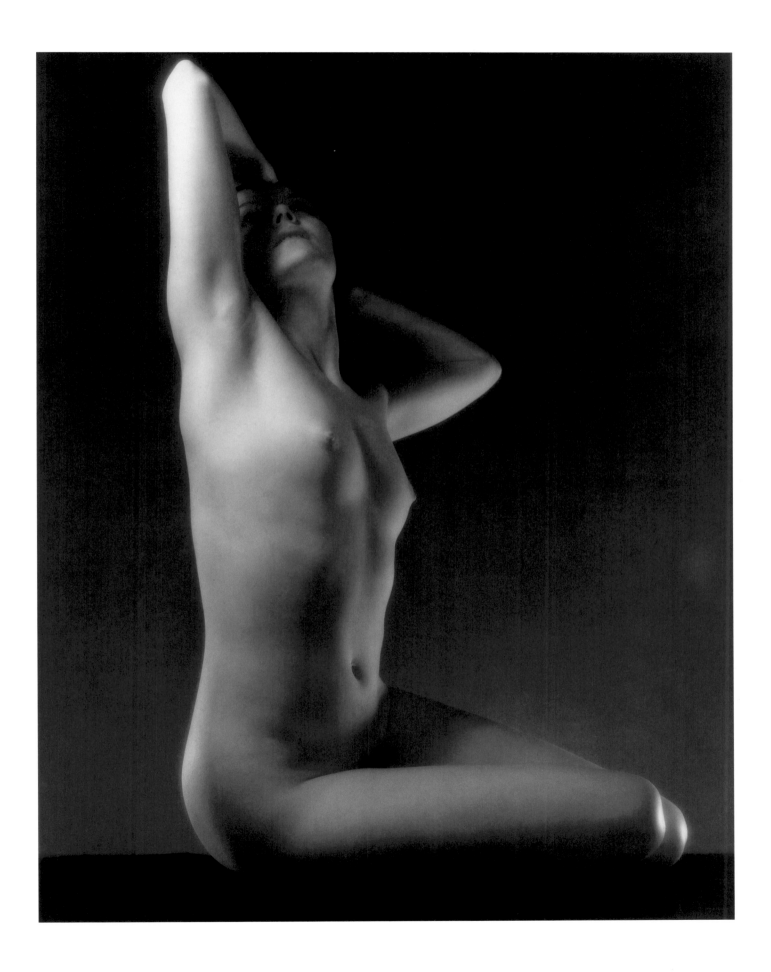

PLATE 123 | *Nude Torso, c. 1934*

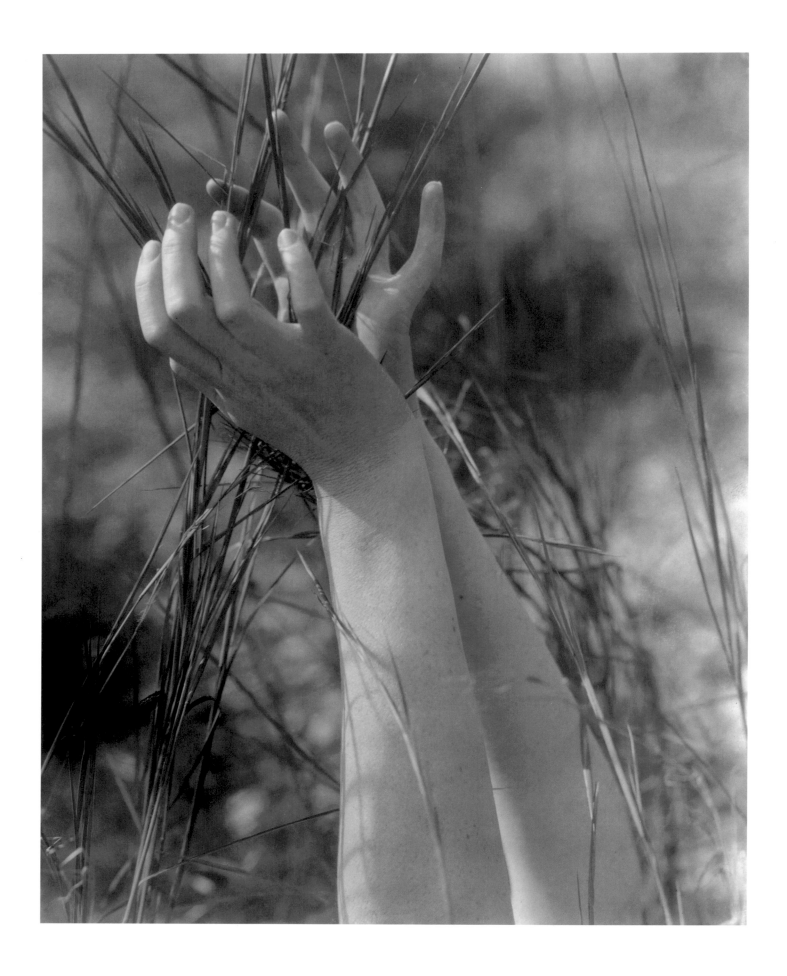

Dana's Hands and Grasses, Long Island, New York, 1923 | PLATE 124

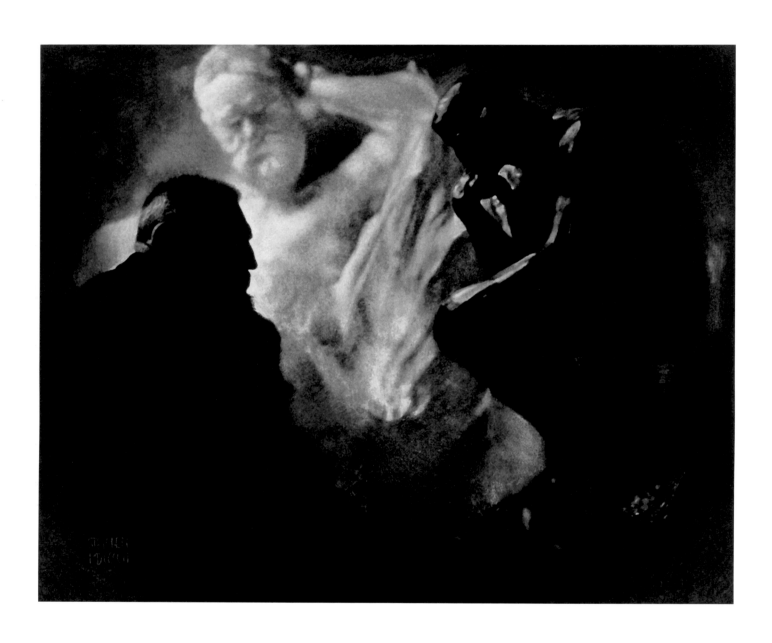

Rodin—"Le Penseur" and "Victor Hugo," Paris, 1902. Negative montage | PLATE 125

ARTISTS

The artist, not the medium, produces a work of art.

—E.S., private notes

The Lascaux Cave drawings probably inspired the revealing story Steichen told about the world's first artist. In the days when people lived in caves, he said, infants born sickly or defective in any way were destroyed. The tribe could not afford to take care of them. But one day, when the men were out hunting, a particularly frail male child was born. The women saw something beautiful in the infant. They decided to keep it and hide it from the men. The little boy grew in secret, hiding in the back of the cave, watching all the activities of the tribe. One day, when he was alone, he picked up a soft stone and a charred stick from the edge of the fire and began drawing on the cave walls the images of the things he had seen: the men returning from the hunt, the wild animals, the food preparation, the celebrations. When the men returned, they were amazed and flattered. They wanted more pictures. The women brought out the boy. Though still of slighter build than the men who hunted and fought, he was acknowledged from then on as a valued member of the tribe.

Whether it was compensation for the fear that society considered an artist a lightweight or a way of distancing himself from the father he considered weak and negative, Steichen was drawn to the huge and the powerful. When he arrived in Paris in 1900, the one artist he wanted to meet was Auguste Rodin, sculptor of massive bronzes that the young American had seen only in newspaper photographs (plate 128). Steichen was intrigued by Rodin's *Balzac*, a powerful head surmounting a tall, bulky torso composed merely of a shroud of drapery. The French public and art critics had denounced this *Balzac* as a scandal.

Steichen lived in Paris from 1900 to 1902 and again from 1906 to 1914, with periodic trips to New York for exhibitions of his own and others' work. He showed both photographs and paintings, often in controversial settings, in both cities, as well as in London, the Hague and at least half a dozen American cities. He won awards and was often involved in organizations that, like the Photo-Secession, promoted new and innovative work destined for rejection by the salons of the academic establishment. In Paris, he formed the New Society of Younger Painters. He took an active part in the intellectual and artistic ferment of his time, and, long before he was under contract to any publications, he knew and photographed some of its major figures.

In Paris, Steichen made it his business to befriend other artists and to photograph the prominent ones. One of these connections led to a spontaneous visit

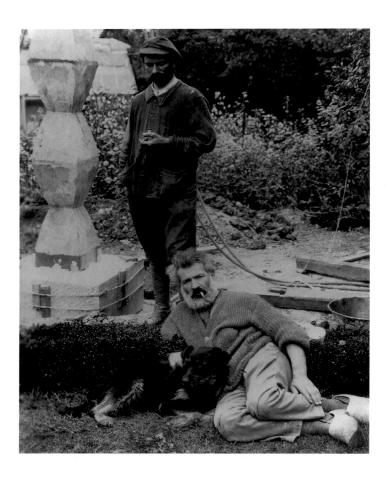

to Rodin's home outside of Paris at Meudon, where Steichen's youthful enthusiasm and admiration impressed the sculptor. The young photographer was given permission to come to Meudon whenever he wished. For a year, he bicycled out often and studied Rodin's work. Then he arranged an all-night session during which he photographed the *Balzac* outdoors by moonlight (plates 126 and 127). Rodin was pleased, quietly paid Steichen a handsome sum for his efforts, later gave him a bronze *L'Homme Qui Marche* (The Walking Man), one of the studies for his large John the Baptist, and began calling Steichen *"mon fils"* (my son).

I have a letter that Rodin wrote to Steichen's mother praising her talented son. I can imagine Steichen's letting Rodin know how much such a tribute would please his mother. What an ideal way to establish a tangible connection between the two people he considered ideal parents. The only one of his own photographs that Steichen could tolerate having on permanent display in his house was the composite of Rodin in profile facing the bronze *Le Penseur* (The Thinker) with the white marble *Victor Hugo* in the background (plate 125).

Of Steichen's many friendships with artists, one that turned out to be most influential in art history was that with the Romanian sculptor Constantin Brancusi (plates 140 and 141). Steichen met Brancusi at Meudon and later, at a gallery, saw the smooth, fat, golden bronze bird that was first called *L'Oiseau d'Or* (The Golden Bird) and later *Maiastra*, after a Romanian legend. He couldn't afford to buy the bird at the gallery price of a thousand francs, so he tracked down the artist at home and arranged, as a *confrère*, to pay Brancusi half that price if the sculpture did not sell at the gallery. Later, Steichen put in his bid for the first

LEFT: Brancusi and workman with *Endless Column* in the garden at Voulangis, c. 1923. Photograph by Edward Steichen

RIGHT: Brancusi's *Maiastra* in the garden at Voulangis. Photograph by Edward Steichen

bronze cast of Brancusi's final, elongated version, *Bird in Space,* when it was still a rough cast fresh from the foundry (plate 142).

Brancusi installed his wood sculpture, *Endless Column,* in Steichen's garden at Voulangis. When Steichen was preparing to give up the Voulangis property and return to the United States for good, he could think of no way to ship the column home other than to cut it in half, and that would have been a sacrilege. So he told the sculptor to take it back. Brancusi arrived with a crew of workmen and promptly set about sawing *Endless Column* in half.

In the 1960s, Steichen gave *Bird in Space* to me and *Maiastra* and *L'Homme Qui Marche* to his daughters. The base of *Bird in Space* was a tall, splayed block of rough wood with a wide crack that Brancusi himself had filled with white plaster. Eventually, I sold the sculpture. When I visited the collectors who bought it, I saw that, unaware of its history, they had had the white plaster in the crack replaced with wood filler and the whole base polished to a smooth, high shine.

When Steichen arrived in New York with *Bird in Space,* the United States Customs Service did not consider it a work of art because it did not look like anything they could recognize. Since it was metal, they calculated its duty under the category of hospital supplies and kitchen utensils. The story reached Gertrude Vanderbilt Whitney, pioneering collector of avant garde art and founder of the Whitney Museum. She offered to finance a lawsuit against the Customs Service. Artists and art experts testified in the *Bird*'s defense. Steichen knew they had won the case and a victory for abstract art when he overheard one of the judges saying that a work of art did not have to look like anything, it simply had to be something that only the artist could have made.

On Steichen's first trip to Paris, he had intended to study painting. He enrolled at the Académie Julian, a well-established art school that still exists, with many of its small, high-ceilinged studios fronting a courtyard in the rue du Dragon exactly as they were in 1900. Steichen often used the story of his experience there as a cautionary tale about "experts" in art and academia. On his first day in Jean-Paul Laurens's live drawing class, a fellow student who had been attending for a while was treated to a round of humiliating criticism from the teacher, while Steichen, the new student's drawing, particularly the hand, was praised in detail. But at the end of the week, Steichen's "perfect" hand was given the same contemptuous tongue-lashing that his classmate's drawing had received, while an even newer student's work was lavishly praised. The long-term students exchanged knowing smiles. That was the end of Steichen's formal art education.

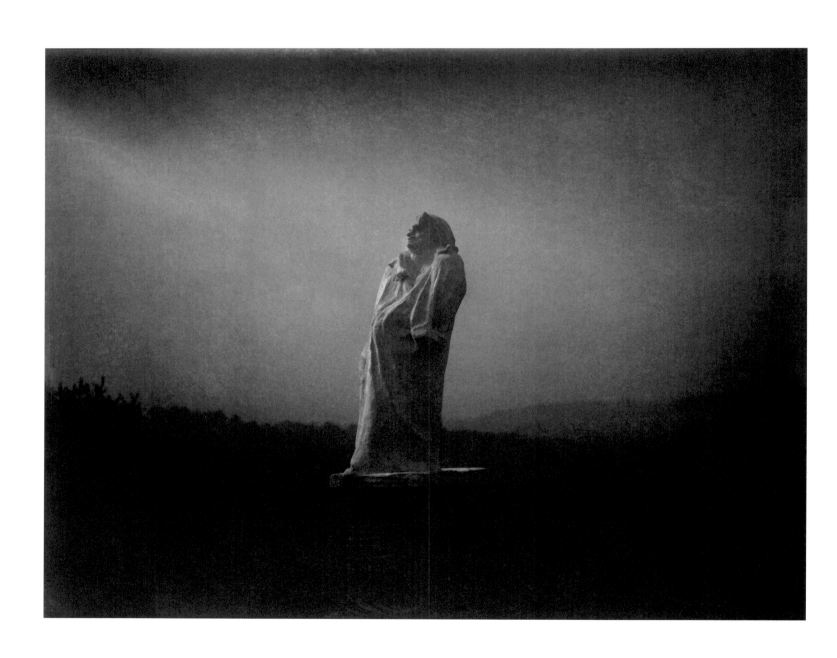

Rodin's "Balzac"— Toward the Light, Midnight, Meudon, France, 1908 | PLATE 126

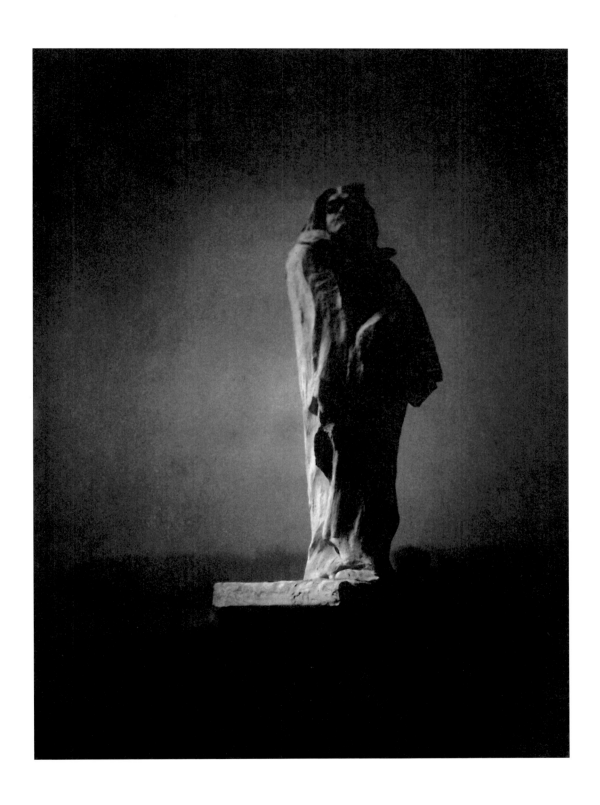

PLATE 127 | *Rodin's "Balzac"—The Open Sky*, Meudon, France, 1908

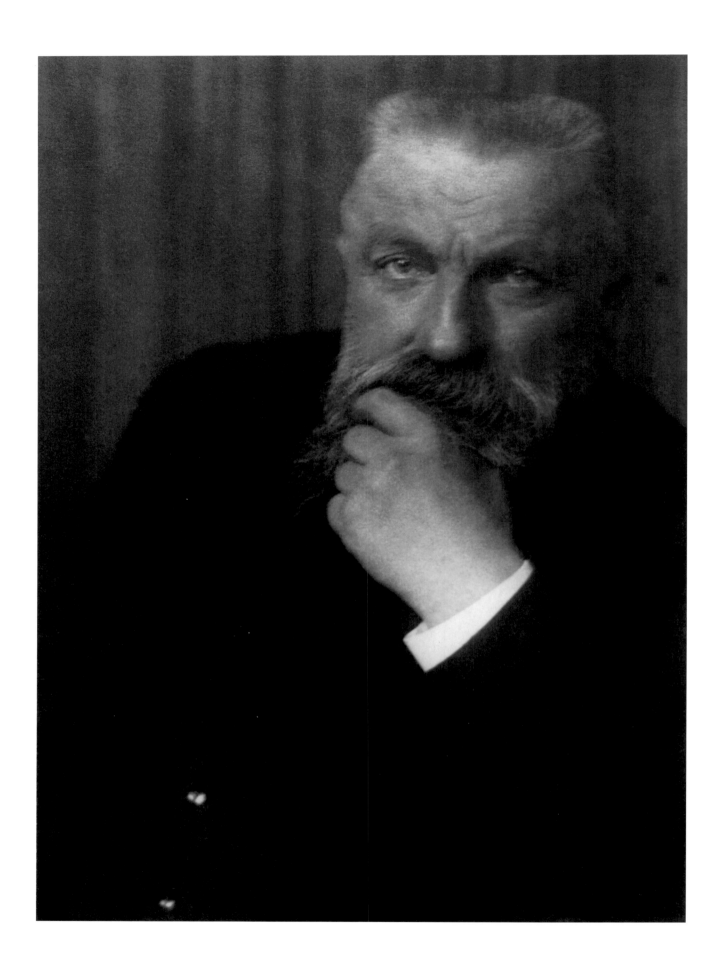

Auguste Rodin, Paris, 1902 | PLATE 128

PLATE 129 | *George Frederick Watts*, London, 1901

Paul-Albert Besnard, 1903 | PLATE 130

PLATE 131 | *Alphons Maria Mucha Standing Before His Poster of Sarah Bernhardt in "La Dame aux Camélias," Paris, 1902*

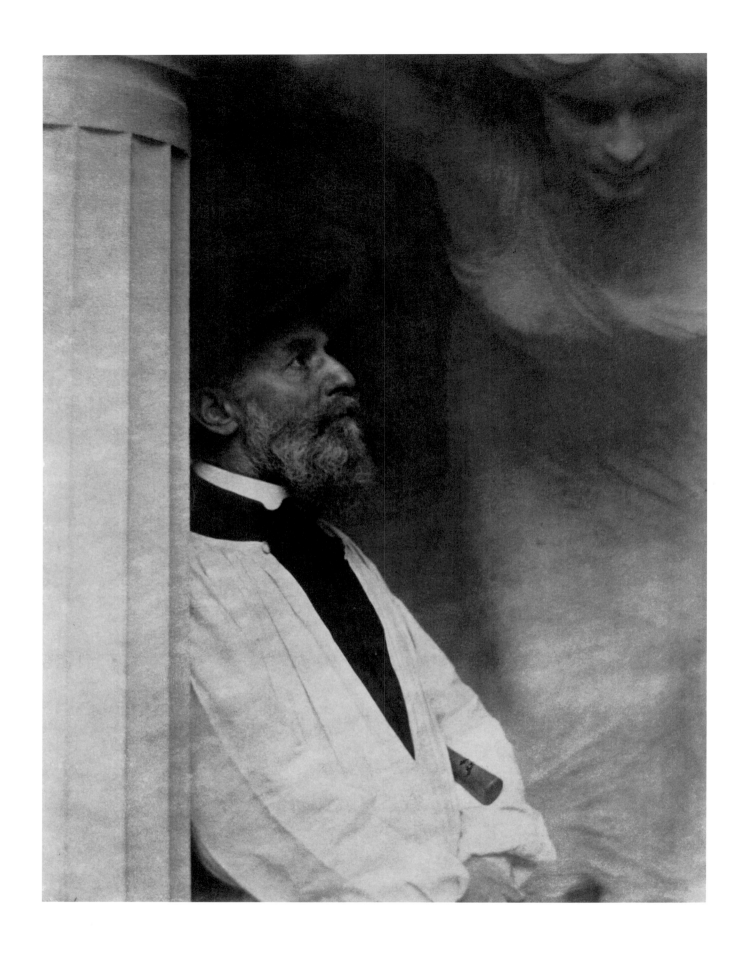

Paul-Albert Bartholomé Standing Before "Les Monuments aux Morts," 1895, | PLATE 132
in Père Lachaise Cemetery, photograph 1901

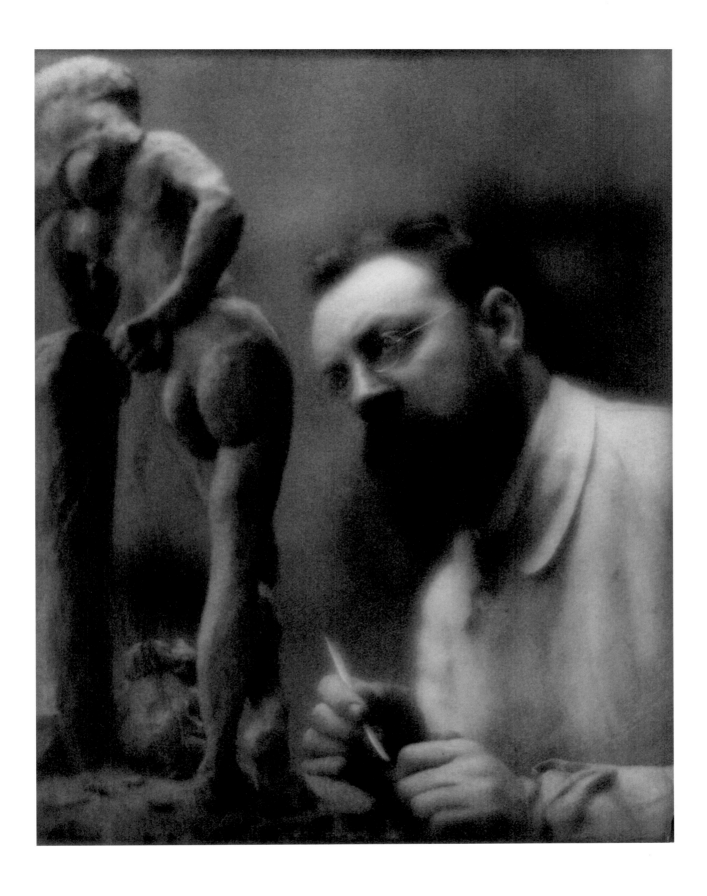

PLATE 133 | *Henri Matisse with "La Serpentine,"* Issy-les-Moulineaux, France, 1909

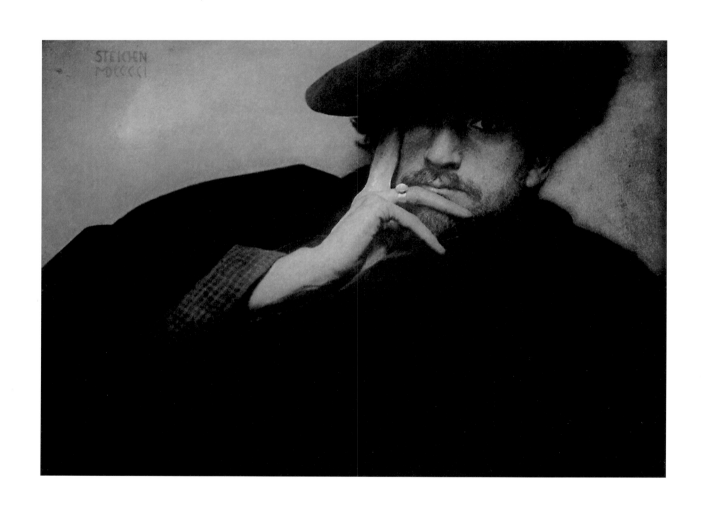

Solitude—F. Holland Day, Paris, 1901 | PLATE 134

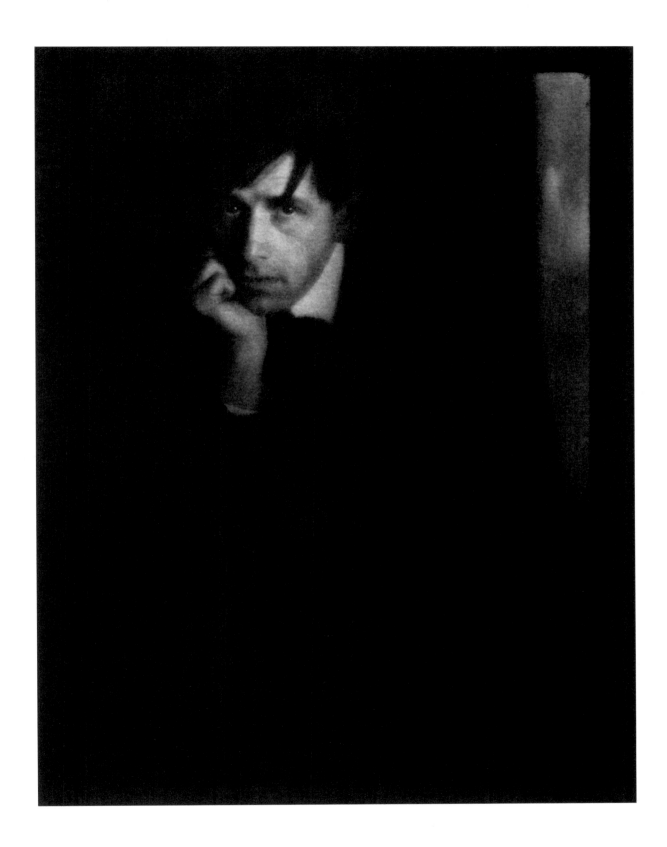

PLATE 135 | *Clarence H. White, 1903*

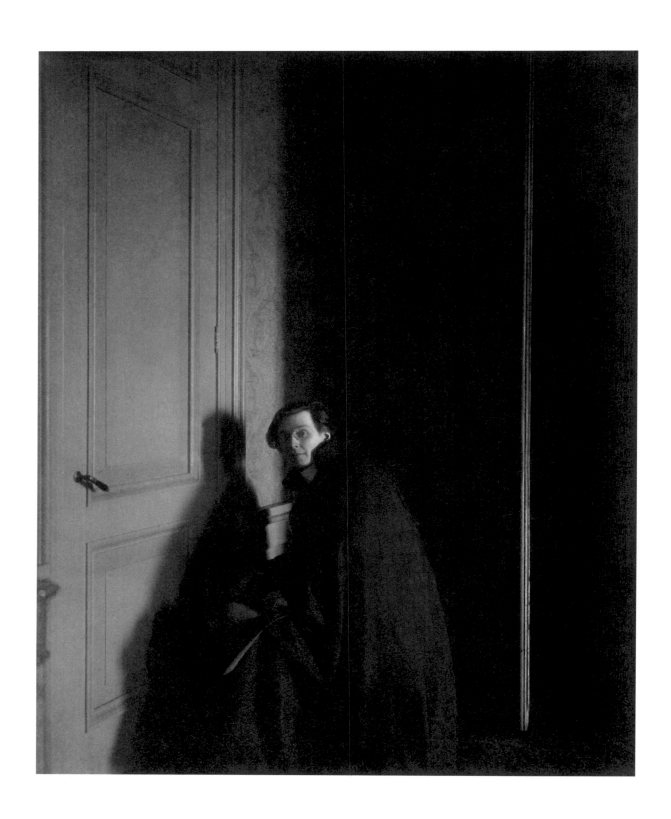

E. Gordon Craig, 1913 | PLATE 136

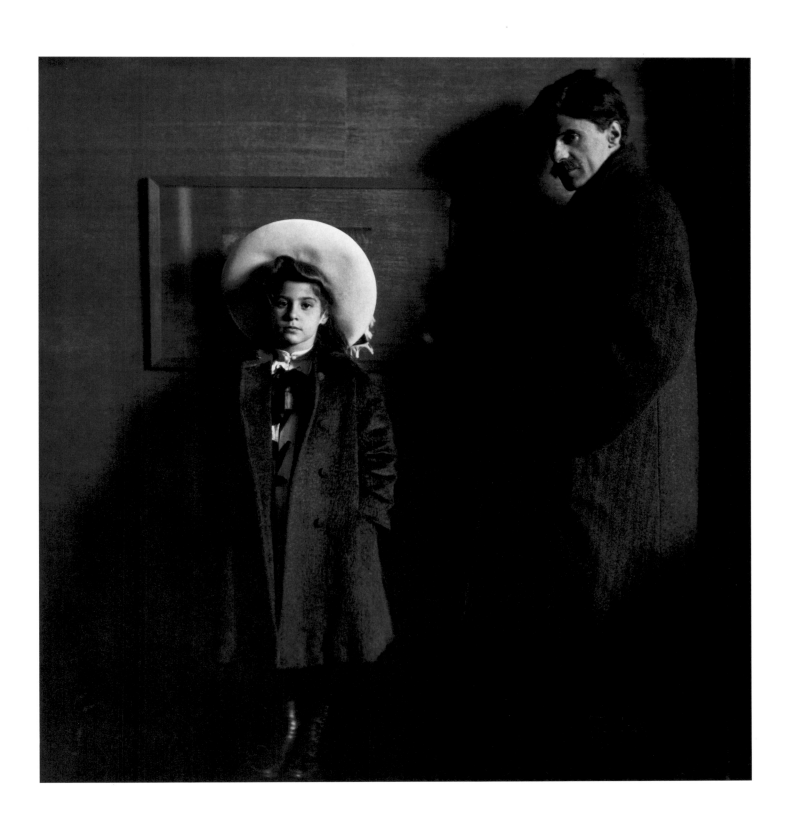

PLATE 137 | *Stieglitz and Kitty,* New York, 1904

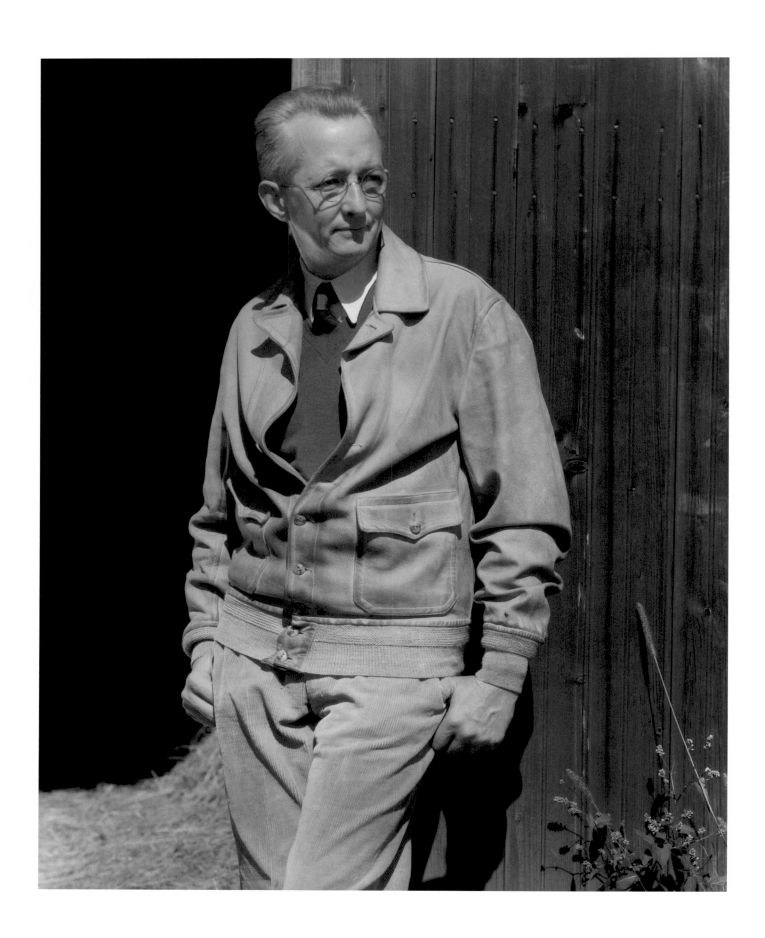

Charles Sheeler, 1932 | PLATE 138

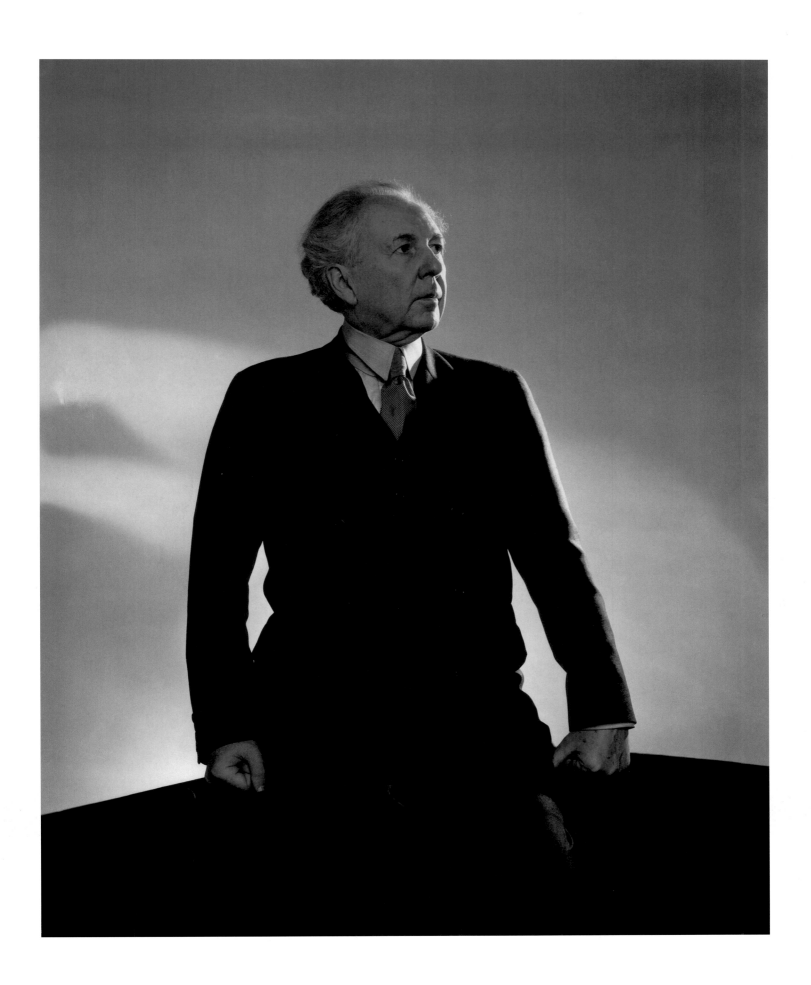

PLATE 139 | *Frank Lloyd Wright*

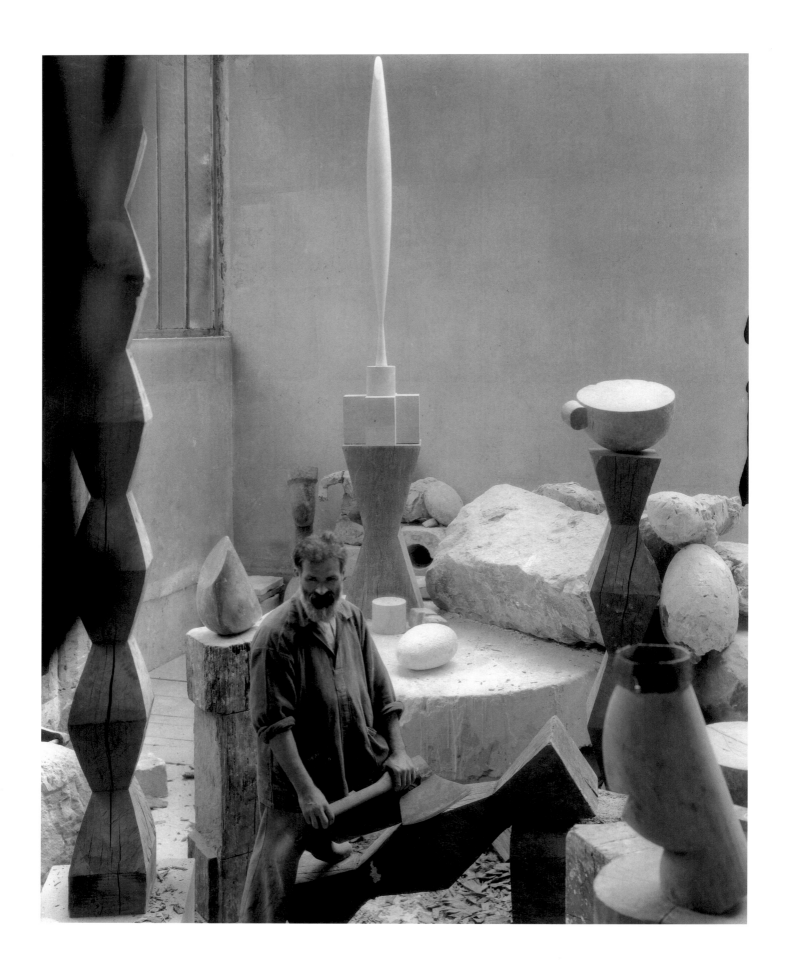

Brancusi in His Studio, Paris, 1927 | PLATE 140

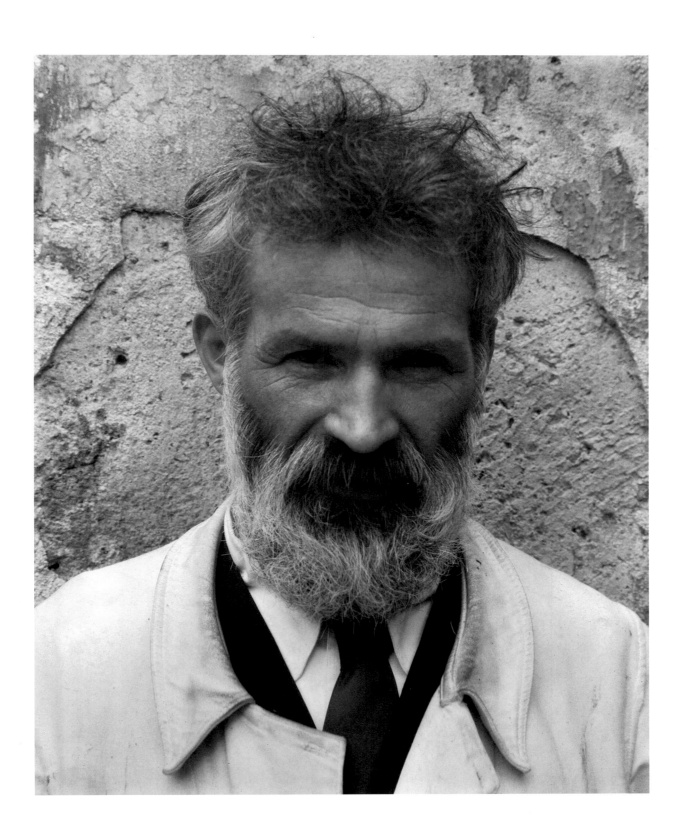

PLATE 141 | *Constantin Brancusi*, Voulangis, France, c. 1922

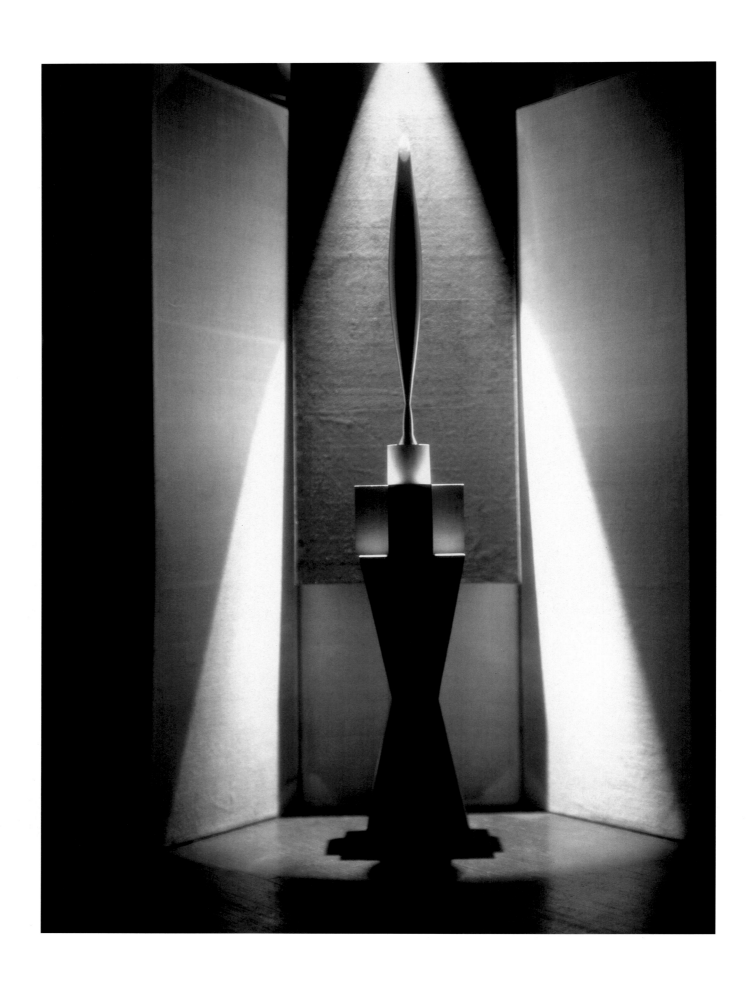

The First Cast of Brancusi's "Bird in Space," c. 1925 | PLATE 142

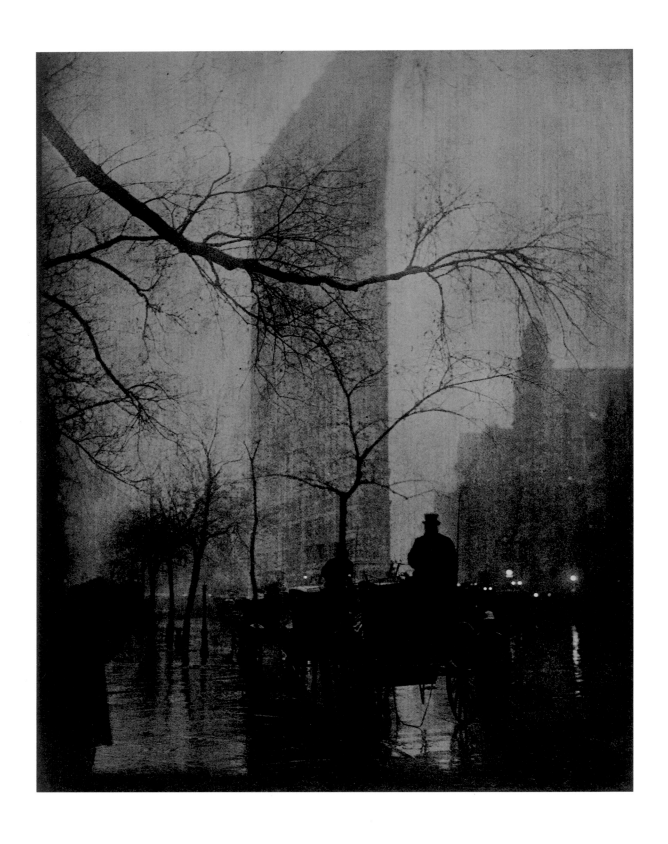

The Flatiron Building, Evening, New York, 1905. | PLATE 143
Gum bichromate over platinum print

EARLY COLOR PROCESSES

To photograph what has never been photographed before does not in itself denote originality. It has no more creative meaning than finding a pearl in an oyster.

—E.S., private notes

While Steichen's favorite scenes were nocturnes with their deep, subtle shadings of blue for seascapes, green for woods, he also used color richly, brilliantly in paintings. He took credit for changing John Marin's palette to the range of colors for which Marin's work is famous. One summer, Steichen invited him out to Voulangis, and they painted together in the sunny, flower-filled garden. At that time, Marin's palette was confined to somber, Whistlerian tones, ochres, grays, black, browns. Steichen's watercolor box was stocked with emerald green, rose madder, vermilion, cadmium yellows, cobalt and cerulean blue, and he kept urging, successfully, that Marin try one after the other.

In 1907, in France, the Lumière brothers perfected their autochrome process, a practical, direct color process that offered both subtlety and accuracy. In the autochrome, a minute layer of starch grains in the primary colors was formed on the glass plate. Steichen bought up a supply of plates as soon as they came on the market and used them to photograph people, flowers and complex scenes in tones ranging from the palest pastels to the flaming hues of autumn (plates 145–148 and 151). In 1908, he arranged for a show of his and other American photographers' autochrome work at 291 in New York. Some of Steichen's autochrome plates were reproduced perfectly in gravure for *Camera Work* in 1908. A little later, a group of German technicians proclaimed that it was impossible to reproduce autochromes successfully on the printed page. After that, the process virtually disappeared.

While most of Steichen's work for magazines and advertising was published in black and white, I have boxes and boxes of three-color plates, red, yellow and blue, made for magazine publication in the 1920s and '30s. The reproductions often were garish, brighter and harsher than life. After Steichen closed his New York studio in 1938, he brought his lab man, Noel Deeks, to Connecticut to set up the lab at Umpawaug and continue experimenting with color printing. He wanted results as rich and subtle as those he had achieved in his earliest private experiments with multiple color processes.

Dana and the Apple (plate 150) was produced in a two-color process. *Moonrise, Mamaroneck, New York* (plate 152) was a platinum and ferroprussiate print. *The Flat-*

iron Building, Evening (plate 143), reproduced here from a three-color halftone in *Camera Work,* was printed in gum bichromate over platinum. *Wheelbarrow with Flower Pots* (plate 144) was made from two separation negatives and, according to Steichen's notes on the back of the print, "printed . . . in sepia and blue, with the red printer used for tint, the blue printer for black."

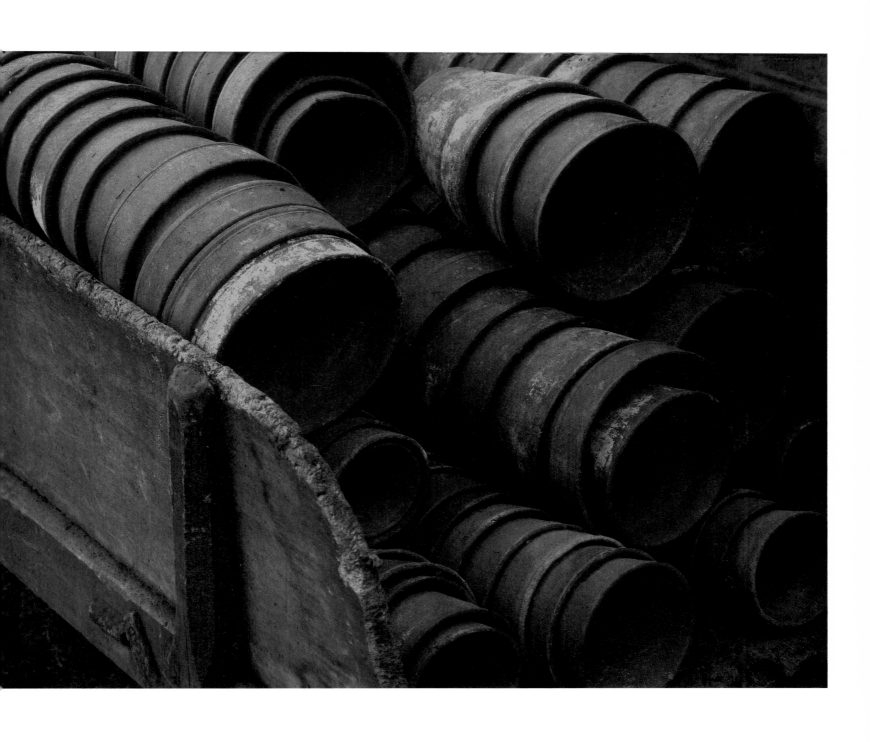

PLATE 144 | *Wheelbarrow with Flower Pots*, France, 1920. "Printed from two separation negatives in
sepia and blue, with the red printer used for tint, the blue printer for black." —E.S.

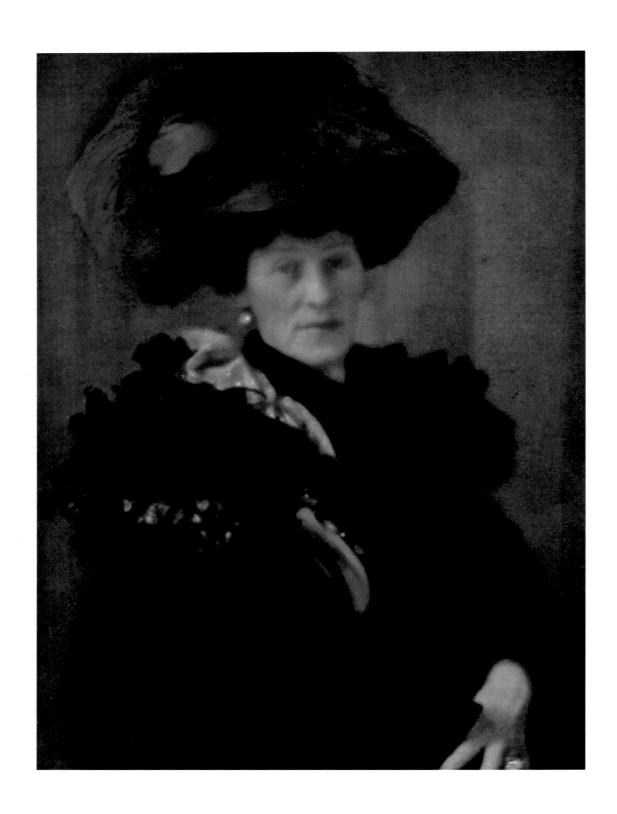

Lady Ian Hamilton, 1907. Lumière autochrome | PLATE 145

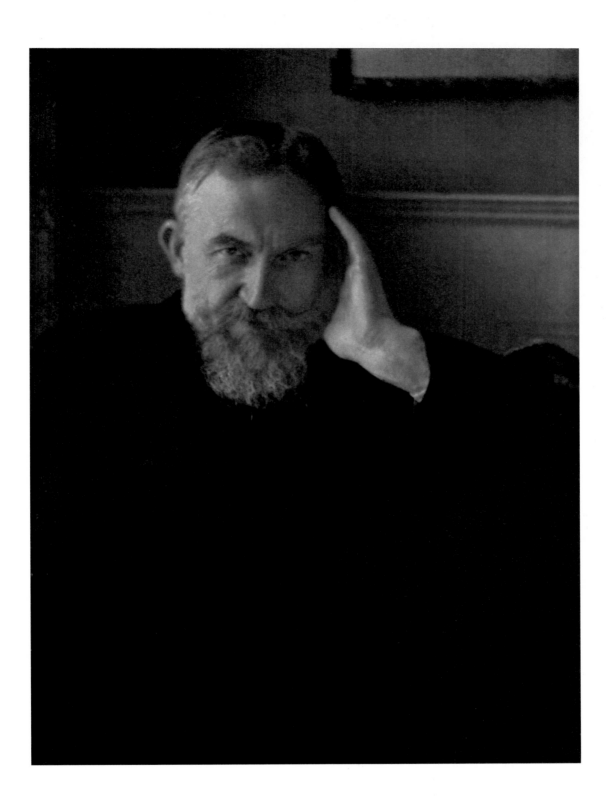

PLATE 146 | *George Bernard Shaw*, 1908. Lumière autochrome

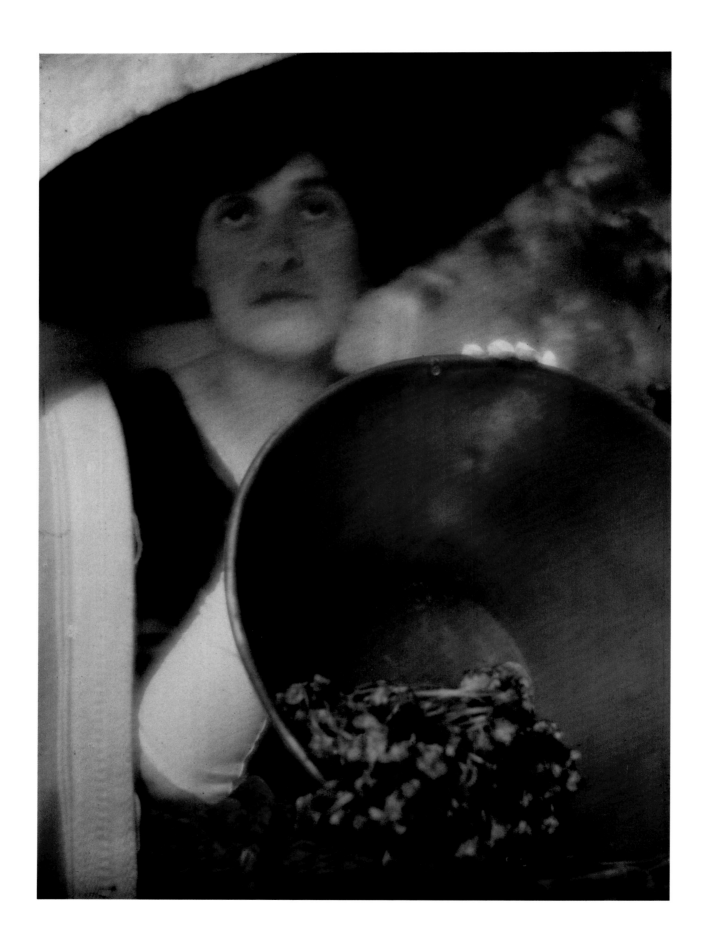

The Copper Bowl, c. 1911. Lumière autochrome | PLATE 147

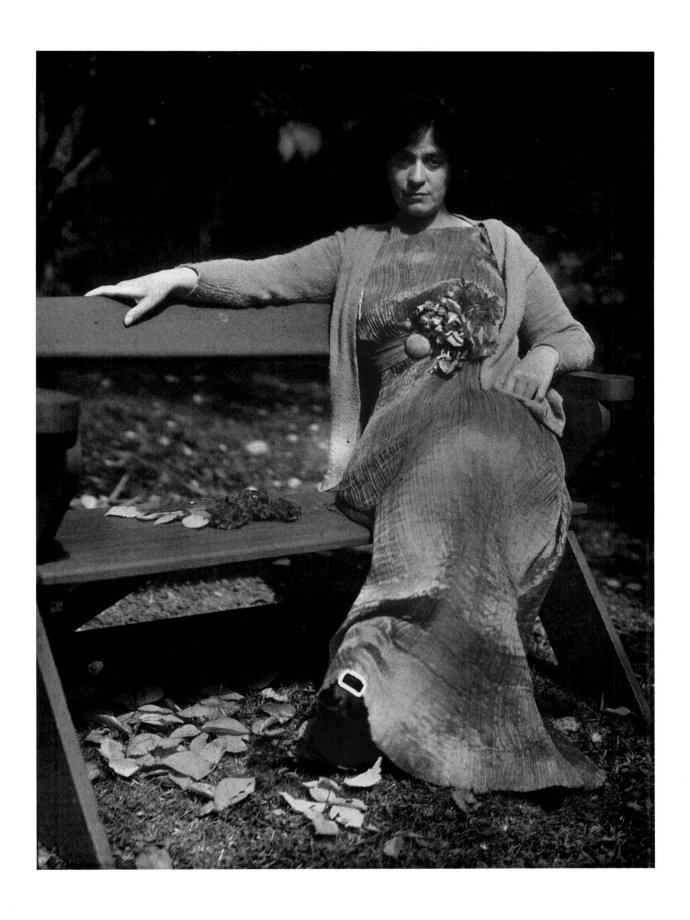

PLATE 148 | *Autumn,* 1908. Lumière autochrome

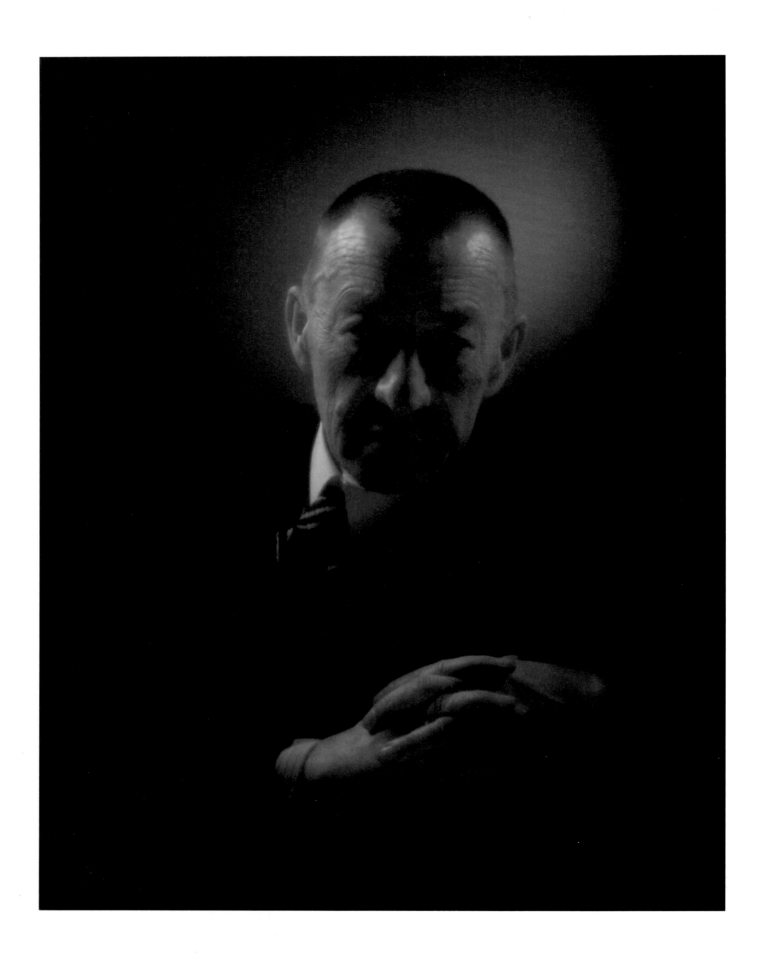

Sergei Rachmaninoff, 1936. Dye transfer print for *Life* magazine | PLATE 149

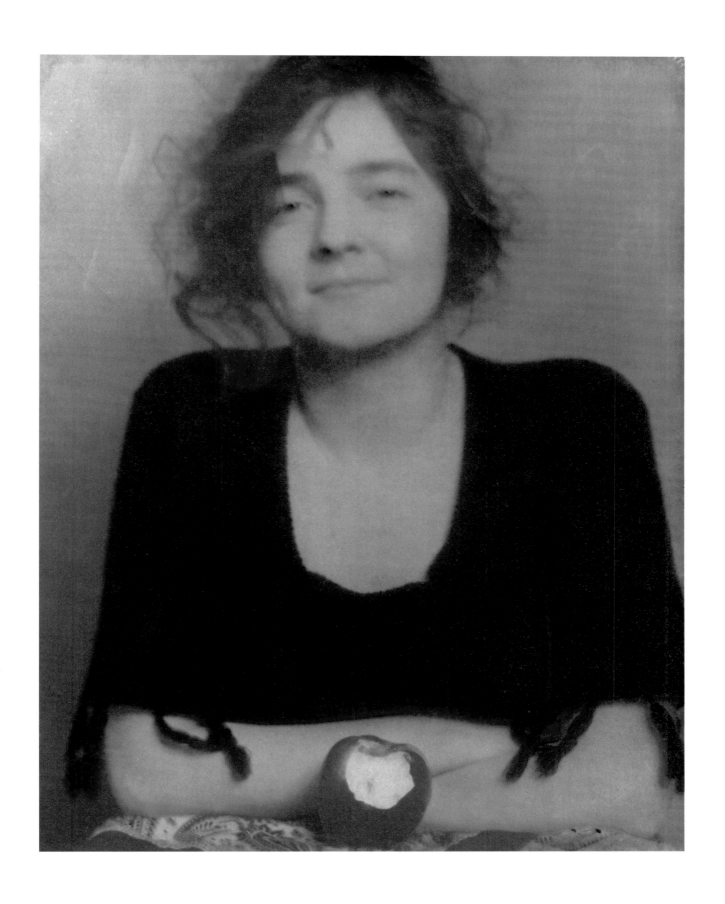

PLATE 150 | *Dana and the Apple*, 1922. Two-color process

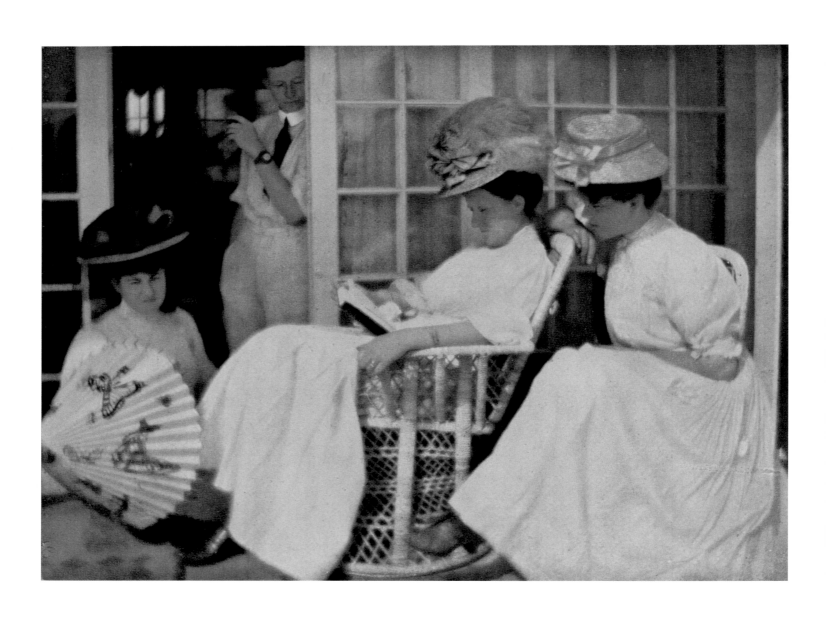

Houseboat on the Thames, 1907. Lumière autochrome | PLATE 151

PLATE 152 | *Moonrise, Mamaroneck, New York, 1904.* Platinum and ferroprussiate print

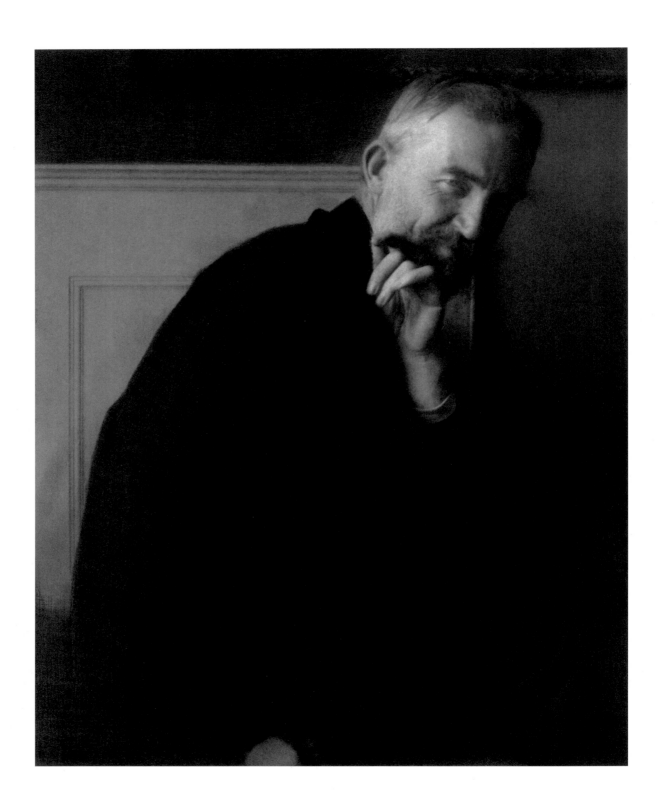

The Photographer's Best Model — George Bernard Shaw, London, 1907 | PLATE 153

WRITERS

Freedom is the most precious asset any artist, in any medium, can have. Freedom may be taken away entirely from without, as by an ideology or by the restrictions imposed by an assignment, an editor or a client. But these are not as destructive as self-imposed restrictions—even when they are associated with an issue, clique, cult, mannerism, or aesthetic. An artist in any medium can become the slave of his inhibitions, habits, fixed ideas, theories, snap judgments and conclusions—all imprisonments of spirit. There are NO good habits.

—E.S., notes for keynote speech at the
Photojournalism Conference in the West,
Asilomar, California, September 1961

I don't know whether Steichen made a conscious decision to photograph painters and sculptors standing and writers sitting. There are exceptions in each category, of course—notably, a wild-haired William Butler Yeats standing as if on a streamlined, studio-rigged suggestion of a windswept tor (plate 157)—but, given the physical requirements of each occupation, the distinction makes sense. The writers have an air of inward-turning concentration, even when they make direct contact with the camera. Many of their poses are similar, but within them, Steichen zeroes in on differences in character and style. Part of his genius was the ability really to look at an individual, find exactly what he needed most to know about that person, and then, in a synthesis of his versatile repertoire of composition, lighting, mechanical know-how and skill in connecting with the human being before him, make the camera communicate that information.

The cynics H. L. Mencken (plate 164) and Alexander Woollcott (plate 166) raise hands to faces in gestures that just might imply thumbing the nose. Willa Cather stands as open and unpretentious as her western plains (plate 159). The serious social thinkers Anatole France and Sinclair Lewis contemplate (plate 155) and scowl (plate 163). The eyes of the playwrights Eugene O'Neill (plate 158) and Luigi Pirandello (plate 162) are like drills penetrating the surface of human behavior. Anita Loos demonstrates all the petulance of one of her blondes seeking the right gentleman (plate 161), while Thomas Mann, stern and imperious, transcends his surroundings (plate 160). Self-consciousness betrays the casual aloof pose of the Bloomsbury aristocrats Vita Sackville-West and Harold Nicolson (plate 167). Colette smolders behind a flamboyant, exotic flower (plate 165). And Dorothy Parker's little dog expresses all of its mistress's bravado (plate 168).

Steichen called George Bernard Shaw (plate 153) the "photographer's best

model." Shaw blossomed in front of the camera with all the versatility of a seasoned movie star. Both Shaw and Maurice Maeterlinck (plate 156), the Symbolist writer whose books influenced Steichen profoundly, believed that the camera offered the greatest potential for the future of art by making the artist's vision and the artist's message readily accessible. Steichen never photographed Gertrude Stein, but an artist of his caliber could not live in Paris without knowing her. He remembered most her big, booming laugh and her assistance in getting Picasso to agree to an American exhibition.

Steichen liked to say that he had gained not a brother-in-law but a brother when Pausl (Lillian Steichen) married Carl Sandburg in 1910. The two men trusted and encouraged each other and influenced each other's view of the world. He photographed Carl often. Before his style went out of fashion sometime after World War II, Sandburg was revered for his six-volume biography of Abraham Lincoln. The day after he corrected the final proof sheet of the last four volumes, *The War Years*, Carl relaxed on the porch at Umpawaug. The project had taken six years of writing after countless years of research. Steichen described Carl at the Umpawaug breakfast table "with a serene and relaxed look, a look that brought to mind [Alexander] Gardner's photographs of Lincoln made the day after the Civil War surrender" (plate 154).

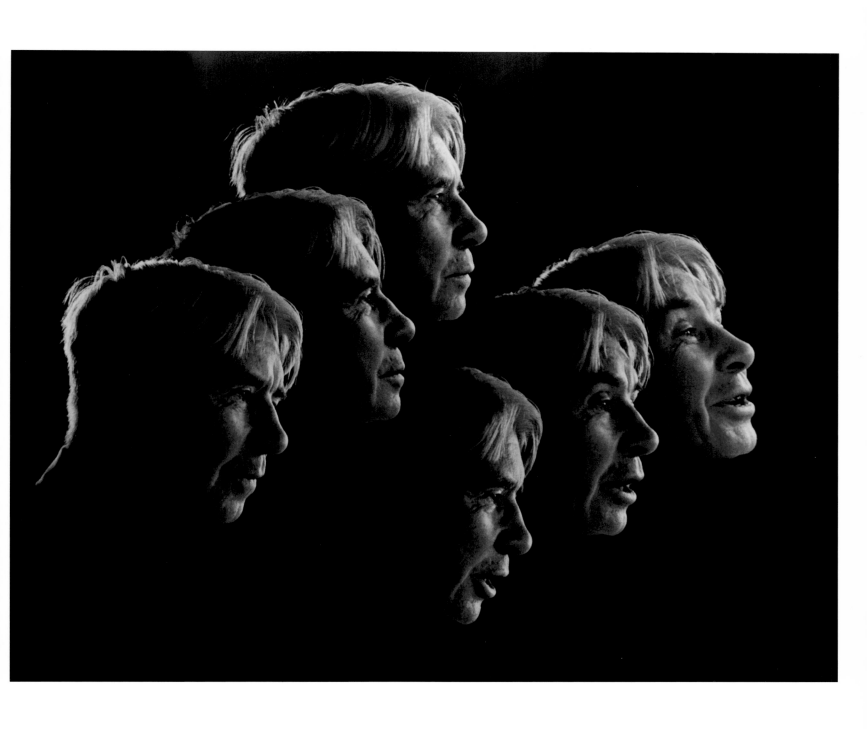

PLATE 154 | *Carl Sandburg*, Umpawaug Farm, 1939. Negative montage

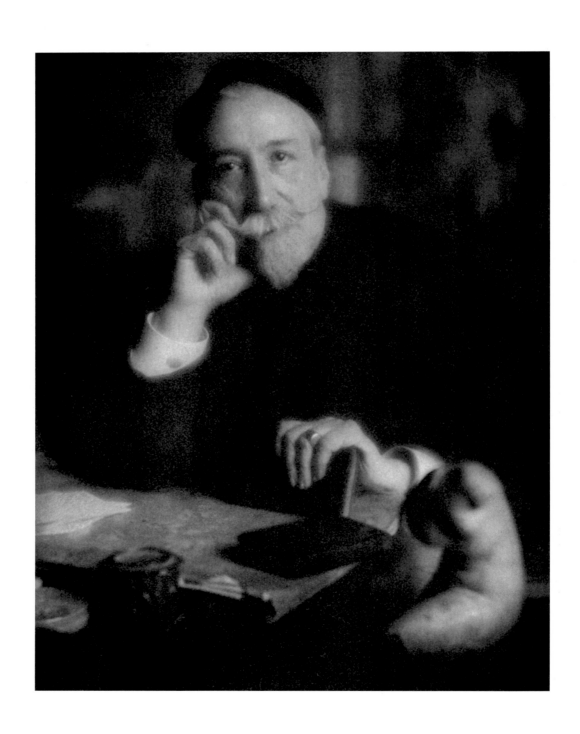

Anatole France, c. 1910 | PLATE 155

PLATE 156 | *Maurice Maeterlinck,* Paris, 1901

William Butler Yeats, New York, 1932 | PLATE 157

PLATE 158 | *Eugene O'Neill*, New York, 1926

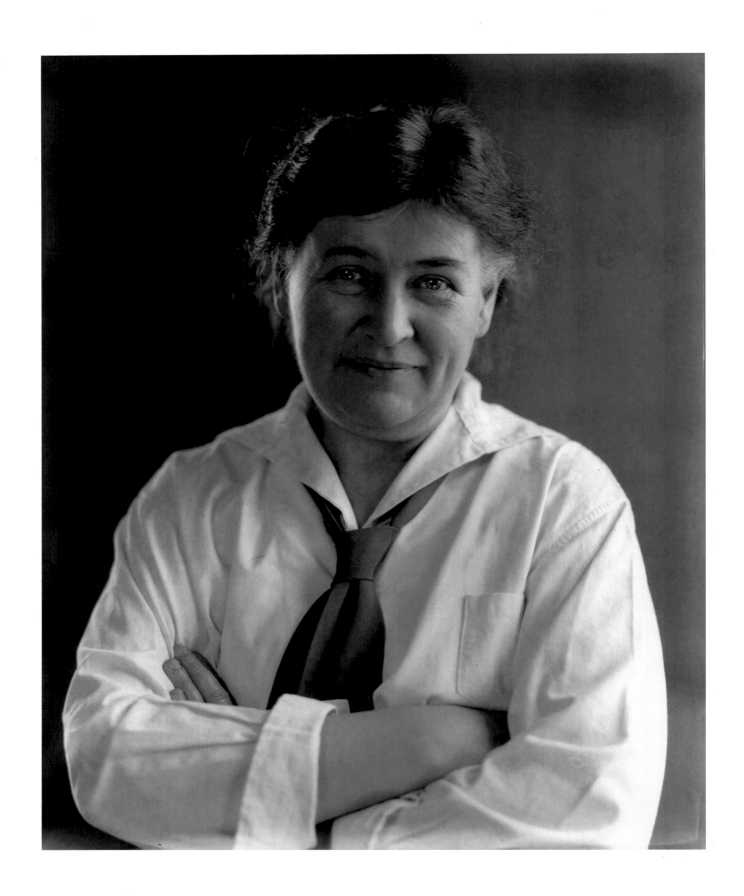

Willa Cather, New York, 1926 | PLATE 159

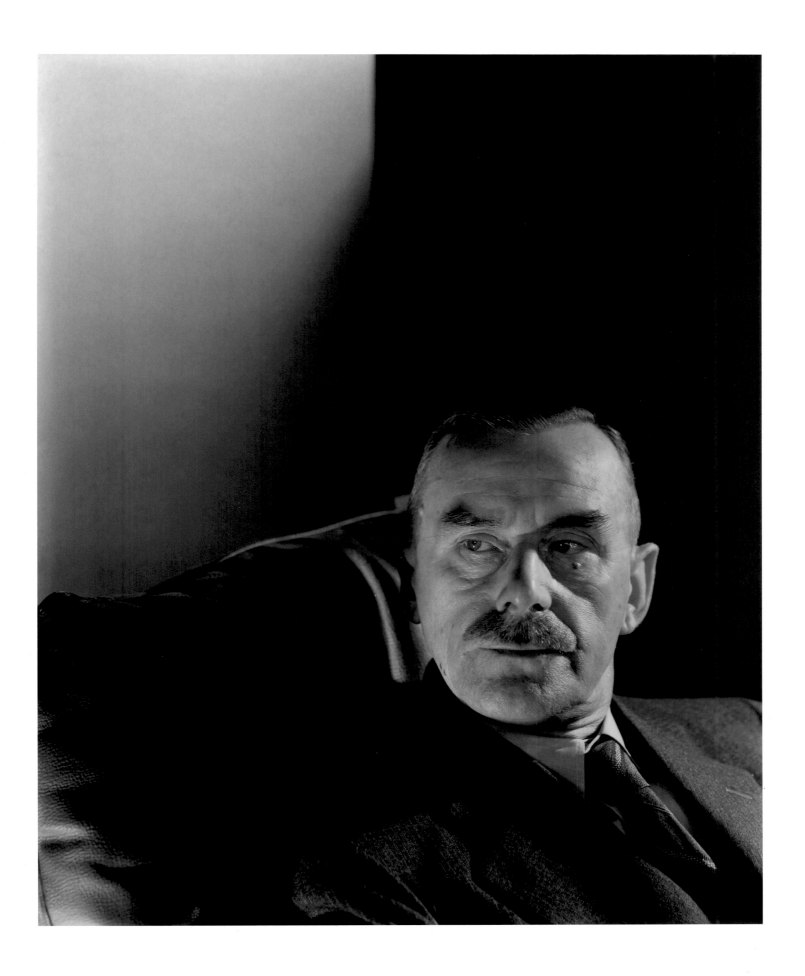

PLATE 160 | *Thomas Mann*, New York, 1934

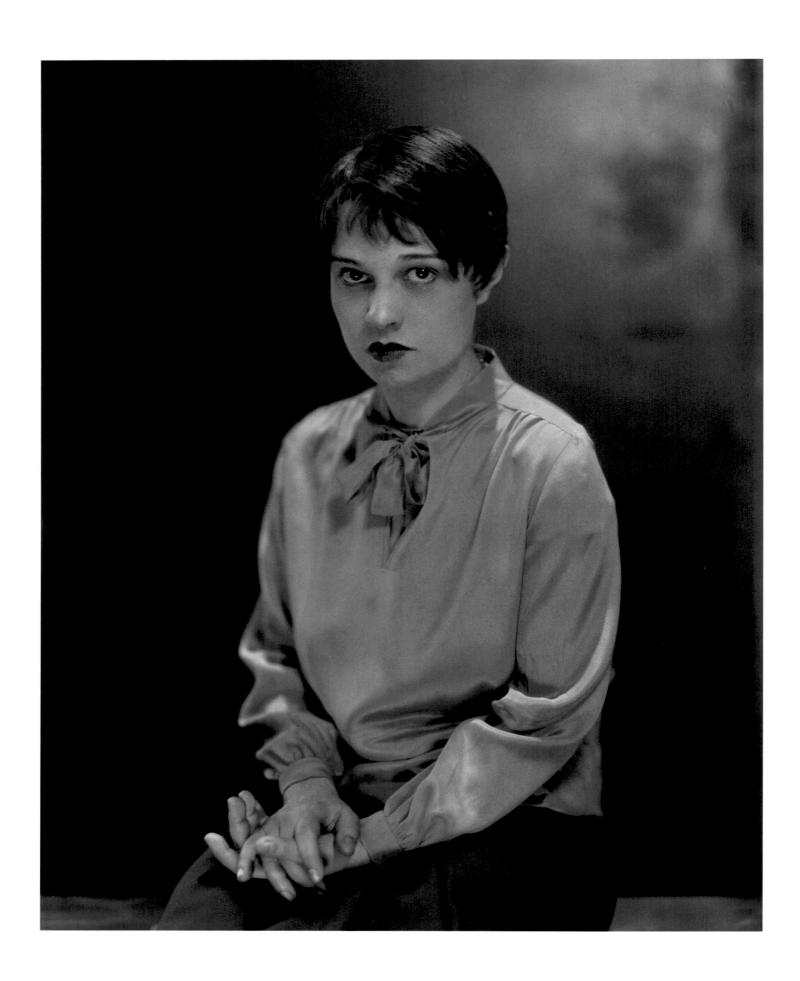

Anita Loos, 1926 | PLATE 161

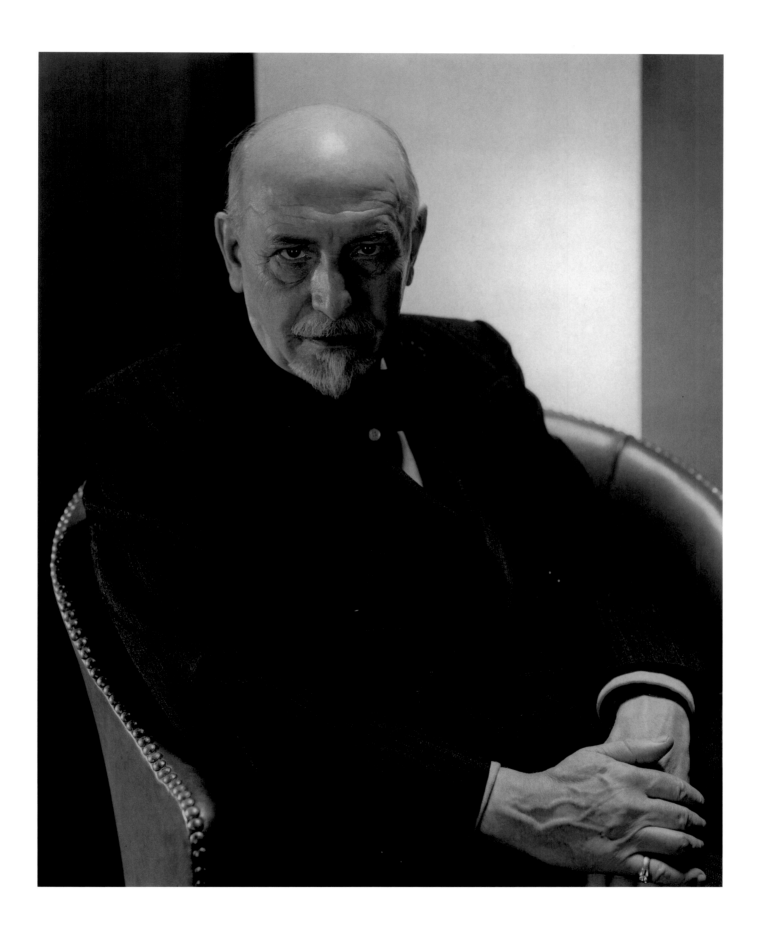

PLATE 162 | *Luigi Pirandello*, New York, 1935

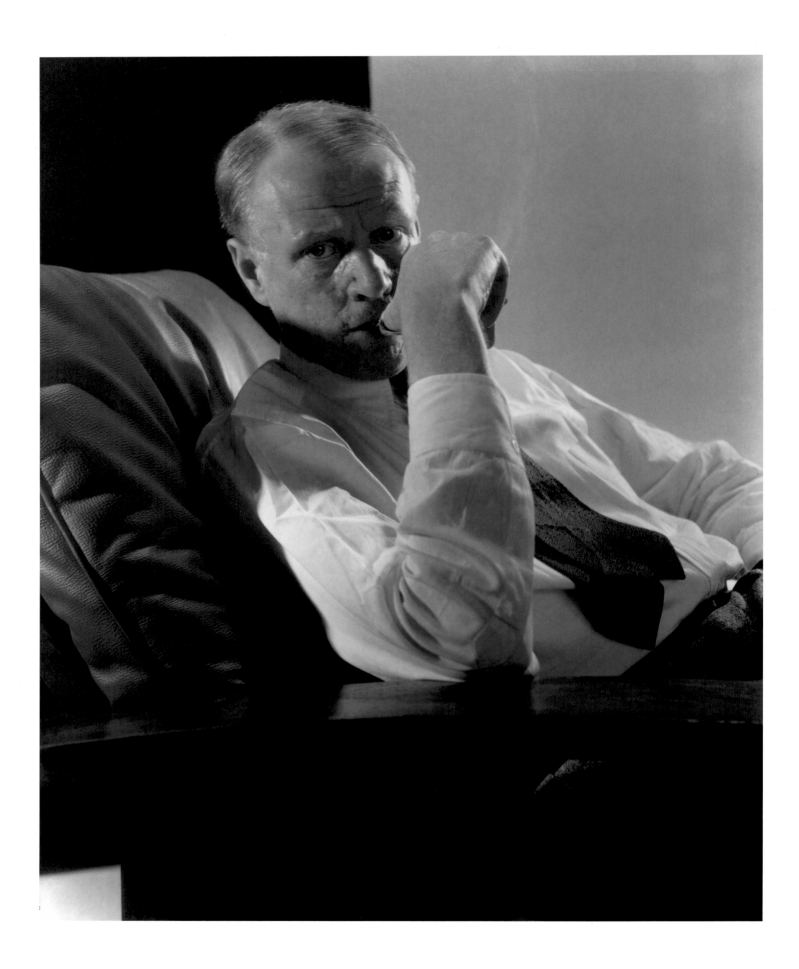

Sinclair Lewis, New York, 1932 | PLATE 163

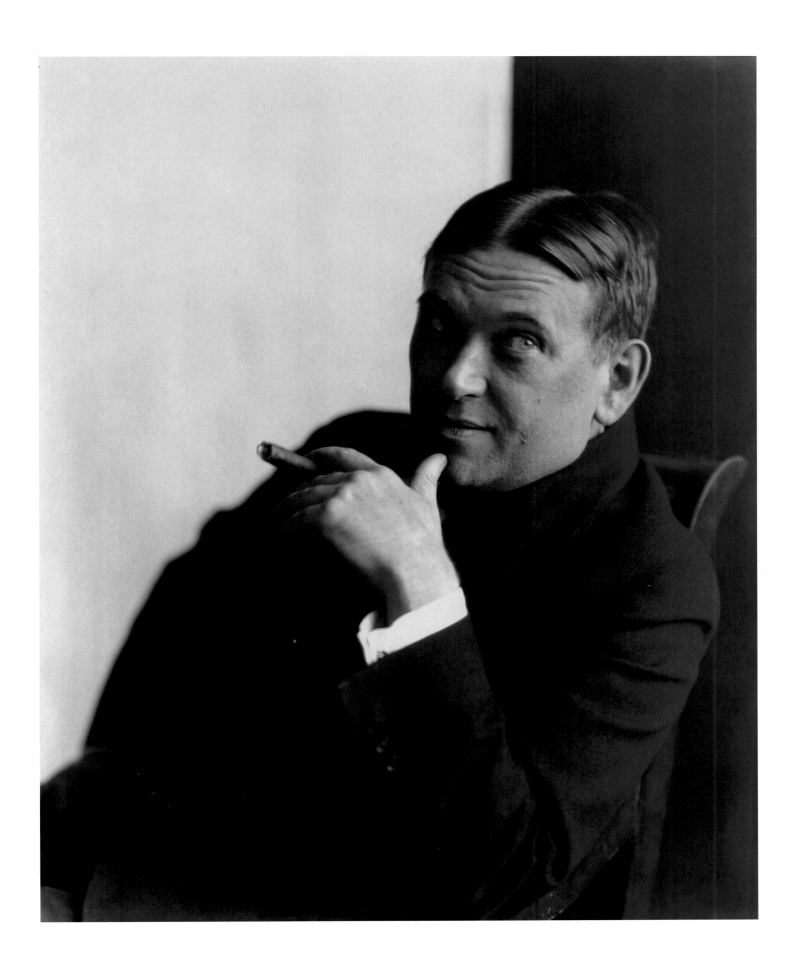

PLATE 164 | *H. L. Mencken*, New York, 1926

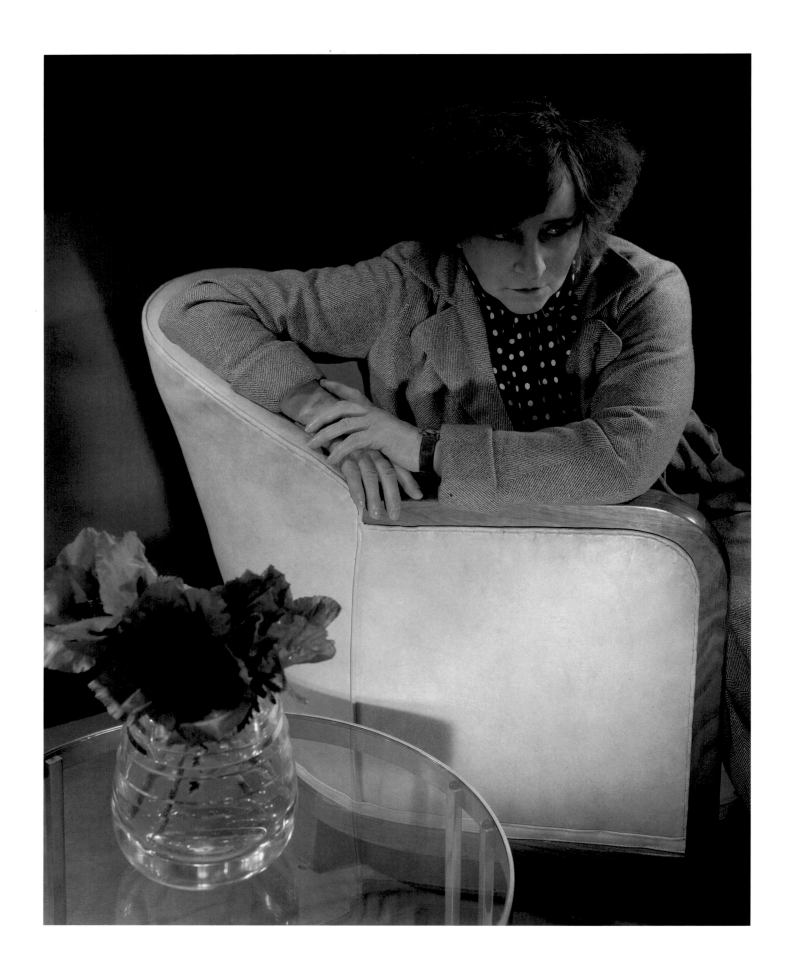

Colette, 1935 | PLATE 165

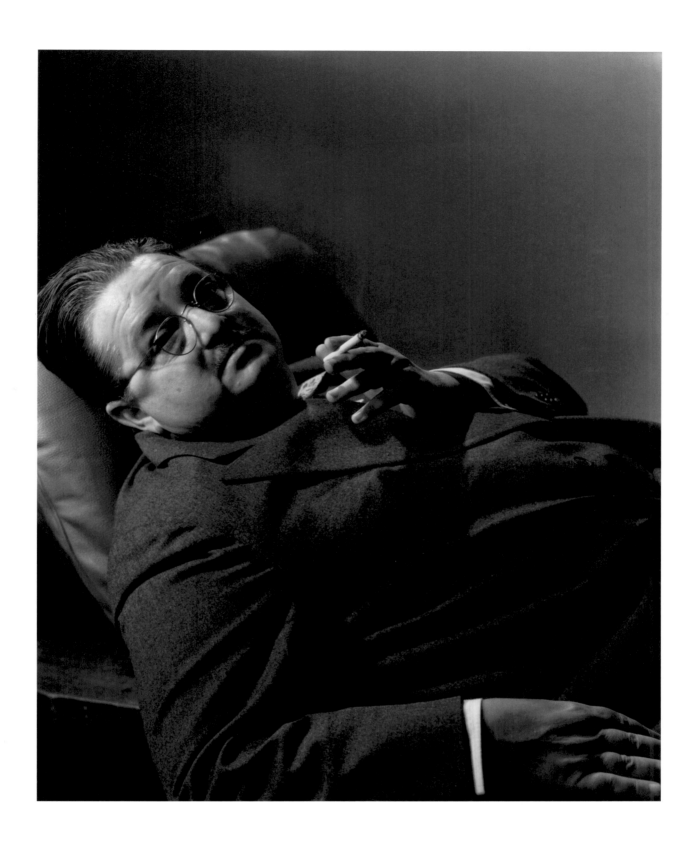

PLATE 166 | *Alexander Woollcott*, New York, 1933

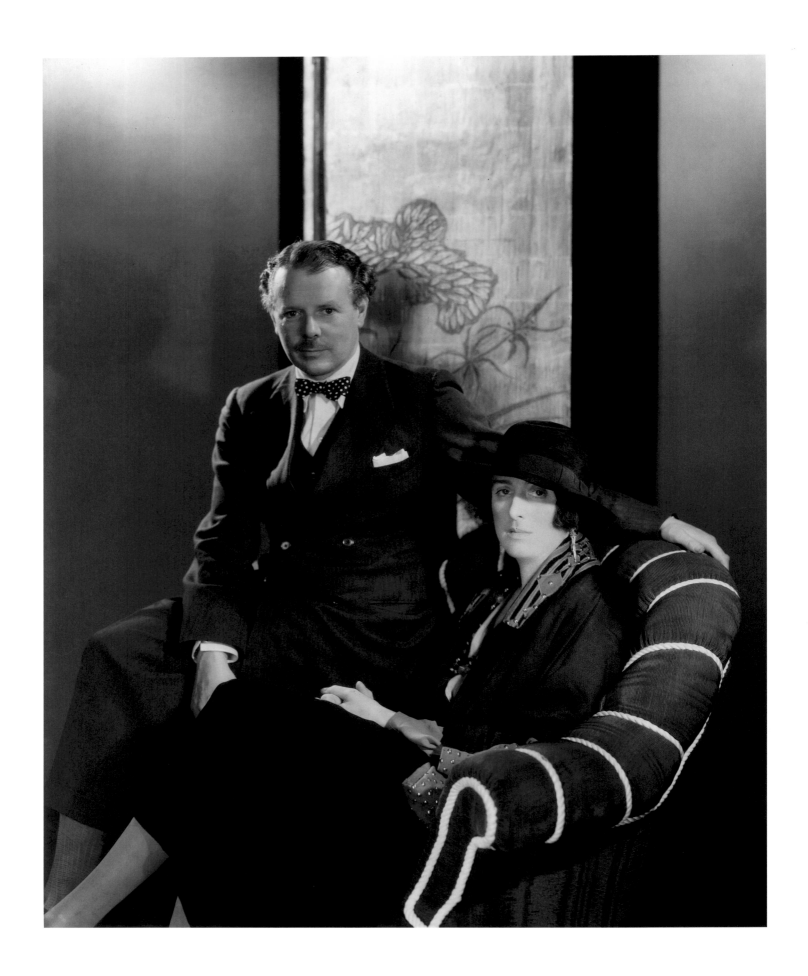

Harold Nicolson and Vita Sackville-West, 1933 | PLATE 167

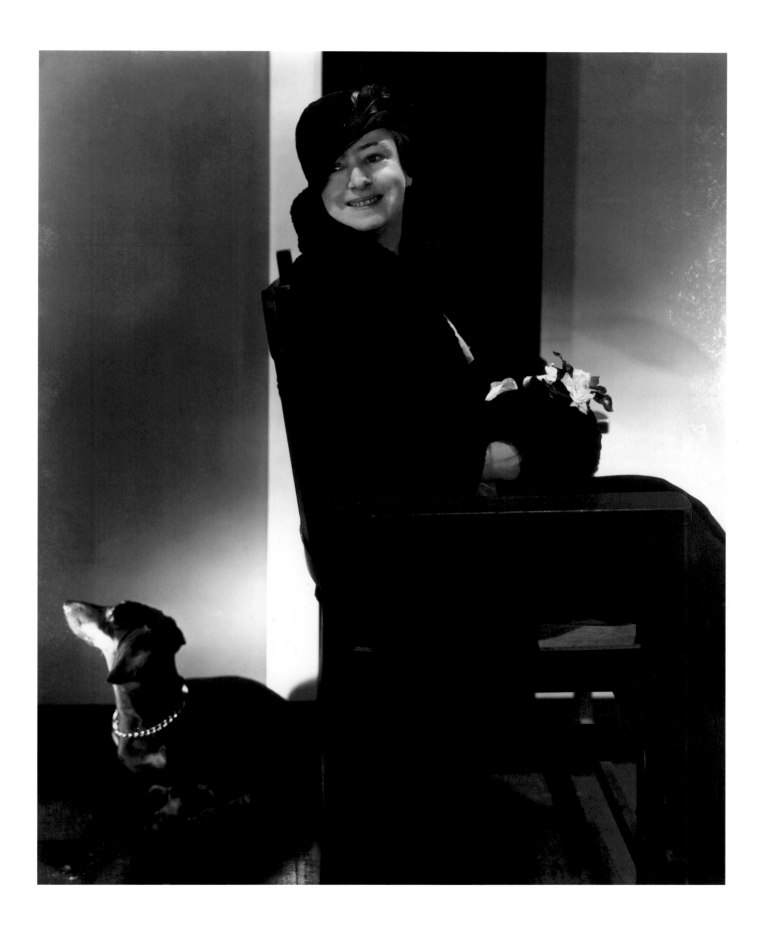

PLATE 168 | *Dorothy Parker*, New York, 1931

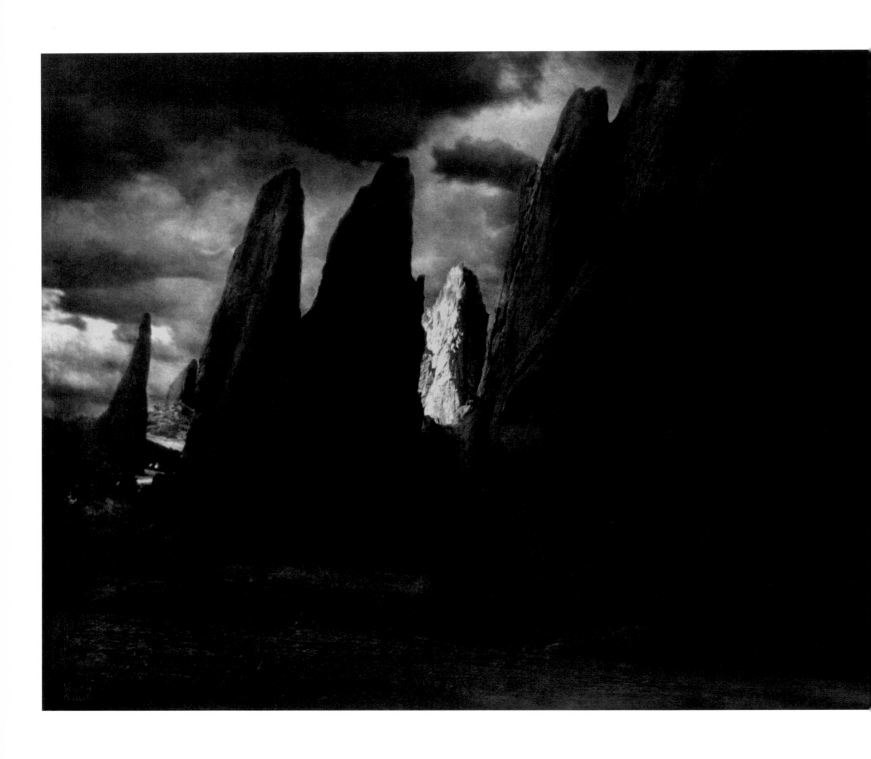

The Garden of the Gods, Colorado, 1906 | PLATE 169

ON THE ROAD

A photo must represent, partake, suggest or reflect the object photographed, but it is not a work of art because it does either or all of these. It must be alive and as a photograph have an existence of its own.

—E.S., private notes

In the 1950s and '60s, the photography that interested Steichen most was photojournalism. During the first half of his career, the sophisticated small cameras and high-speed film that make it possible to document real life under almost any conditions of light and motion didn't exist. Later, a combination of circumstances and temperament gave Steichen little chance to do this kind of work himself on a regular basis, but he was fascinated with its immediacy and its potential for informing a large segment of the public. He believed that his large, thematic exhibitions, in which he assembled the works of many photographers in order to tell a particular story, served a similar purpose.

He did make periodic forays out of the studio to catch life as it happened. His first such experience with a handheld camera was in 1907 with a Goerzanschutz Klapp camera borrowed from a German photographer. He took it to Longchamps racetrack outside of Paris and discovered the attraction was the fashionable audience rather than the horses (plates 170 and 171). In 1938, after closing his New York studio, he took several small cameras on a trip to Mexico (plates 178 and 179). He also managed to use big studio cameras on tripods on location with effects equal to the spontaneity of the best handheld work, as in his 1923 photograph of his second wife, called *The Blue Sky—Dana* (plate 18), and his "snapshot" ads for Eastman Kodak (plates 251–254).

In 1921, Steichen happened to vacation in Venice at the same time as Isadora Duncan. She was on her way to Greece with her pupils, who were also her adopted daughters, known as the Isadorables. She persuaded Steichen to come along by promising that she would let him make motion pictures of her dancing on the Acropolis. Once there, she changed her mind. Her style in movement and costume was based on classic Greek imagery and, faced with the real thing, she was overwhelmed. Steichen settled for borrowing a Kodak camera from the headwaiter at his hotel. Standing among the ancient, sacred stones of the Acropolis, Isadora felt she was too much of an intruder to move, but finally she managed to produce the two appropriate, classic gestures that Steichen recorded (plates 174 and 175).

Steichen also had to travel to document aspects of the twentieth century's two world wars, and he devised and headed units newly established to do so. In

World War I, he had to set up a field unit working round the clock close to the battlefields to produce hundreds of prints of high-altitude aerial-reconnaissance photographs. But first, he had to persuade the pilots of tandem, two-seater, open-cockpit airplanes to sacrifice the protection of a gunner in order to make room for a photographer with a 90-centimeter camera. Lieutenant Colonel Billy Mitchell, an early and fierce proponent of aviation's military uses, took up a camera himself to make the point.

In World War II, with the help of influential friends, Steichen bulldozed his way into the Navy by inventing a unit to document naval aviation. Though past retirement age, he insisted on doing sea duty and was aboard the aircraft carrier *Lexington* when it was assigned to cover the taking of Kwajalein Island by the Marines and was subsequently torpedoed. To illustrate the tension of the strike preparations, Steichen used infrared film that darkened the carrier's superstructure and the sky and highlighted the positions of the ship's crew (plate 180). To capture the rushing motion of a plane taking off from the deck, he arranged deliberately for the plane to be blurred and the background sharp by making an exposure of about a tenth of a second (plate 177). When the men in his unit asked what he wanted them to photograph, he told them, "Photograph everything that happens, and you may have made some historic photographs. But above all, concentrate on the men. The ships and planes will become obsolete, but the men will always be there."

In the 1940s, Steichen began creating the large, thematic exhibitions in which he assembled the works of many photographers in order to tell a particular story. Saddened by his own participation in two immensely destructive world wars, he wanted these exhibitions to play a part in preventing future wars. With *The Road to Victory, Power in the Pacific* and *Korea* all offering images of combat and its destructive residue, Steichen found that viewers were moved at the moment but then quickly erased the ugly information from memory. He realized that he had to emphasize positive alternatives to hideous destruction: images of creation, connection, beauty, love and joy, the things that made life worth living. That was the guiding vision of *The Family of Man.*

The Family of Man was a tremendous success at the Museum of Modern Art and in traveling editions sent around the world by the United States Information Agency. In 1994, the last traveling edition was permanently installed in a castle transformed into a museum of photography at Clervaux in Luxembourg, and the book version is still in print. (It never occurred to Steichen to ask MOMA for a share of the royalties from the book.) In the late 1960s, I found it displayed not under "Art" but in the "Religion" section of a major bookstore. While many critics and intellectuals praised it, *The Family of Man* was also the butt of criticism by some purists in the art and academic worlds. In *The House of Intellect* in 1959, Jacques Barzun cited *The Family of Man* as a contemptible example of pornographic sentimentality. Other critics and curators objected to what they considered the devaluation of individual photographers' work when their pictures were used to serve Steichen's themes.

When he went to Moscow with *The Family of Man* in 1959, Steichen took along several cameras, including a Minolta miniature camera scarcely bigger than a cig-

arette lighter. In the USSR, there were strict rules about what could be photographed, but Steichen learned to shoot secretly from the hip. He was particularly fond of the picture of Russians looking at a photograph of a rural American audience (plate 181). At a time of uneasy thaw in the Cold War, the possibility for peace seemed heightened when it was hard to tell the difference between Americans and Russians.

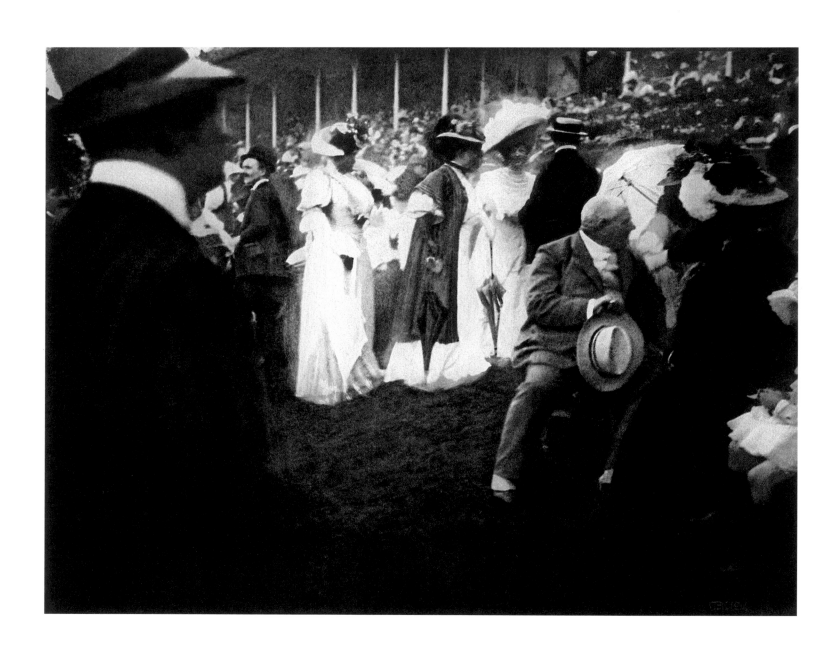

Steeplechase Day — The Grandstand, Longchamps racetrack, Paris, 1906 | PLATE 170

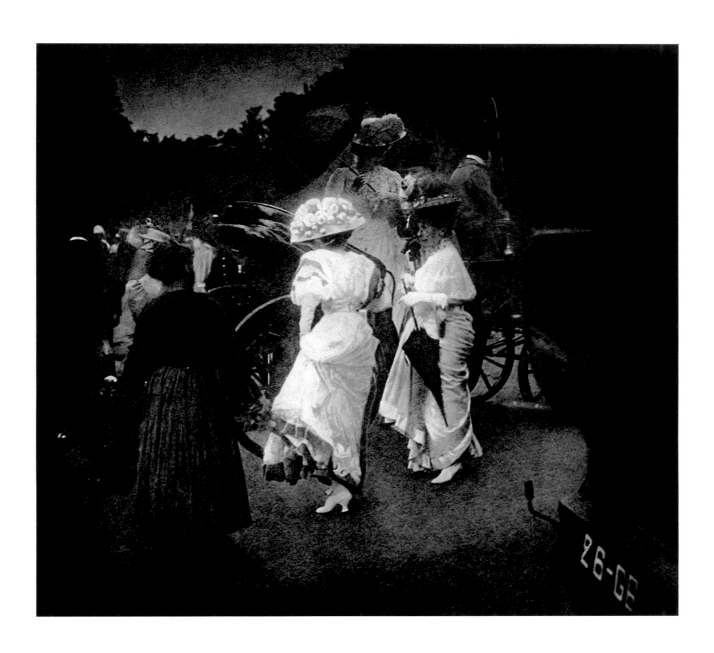

PLATE 171 | *Steeplechase Day—After the Races,* Longchamps racetrack, Paris, 1906

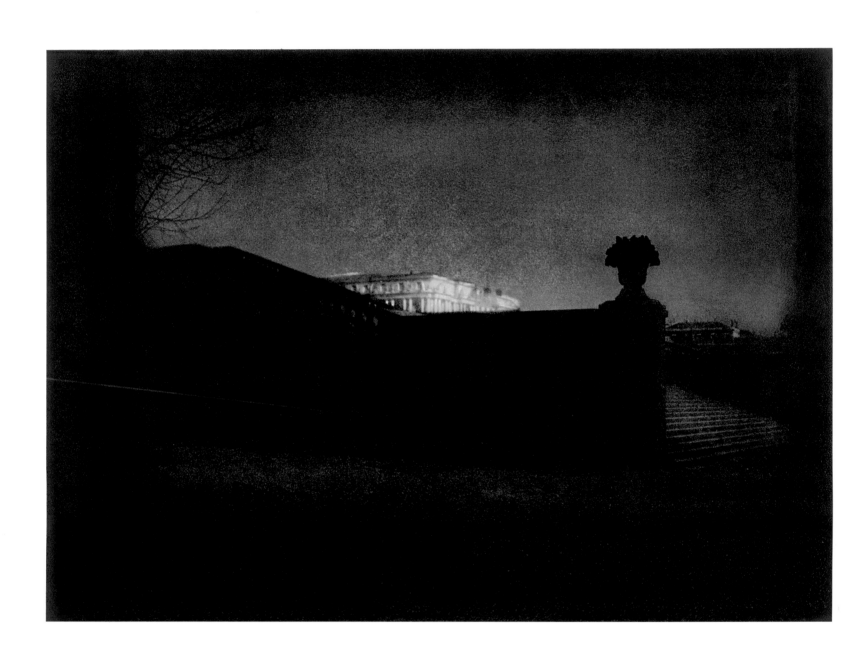

Nocturne—Orangerie Staircase, Versailles, c. 1910 | PLATE 172

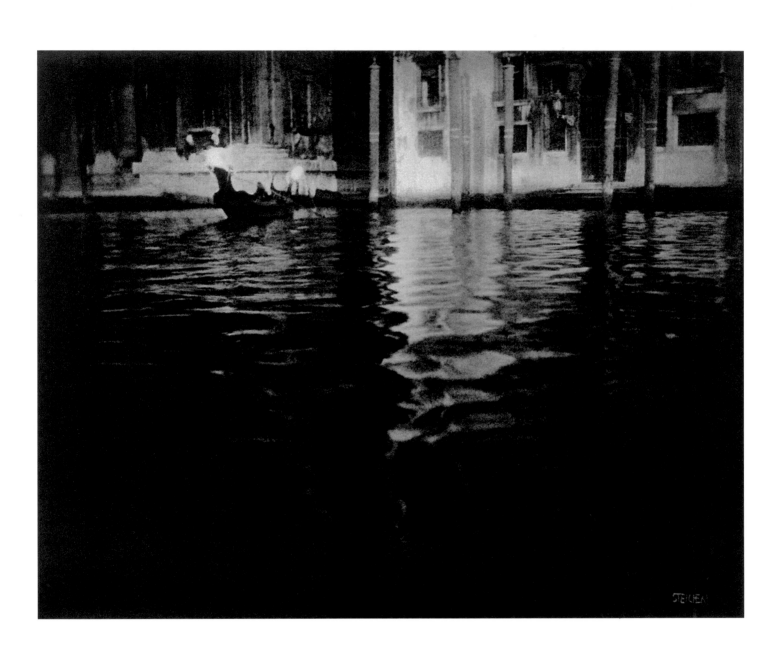

PLATE 173 | *The Grand Canal,* Venice, 1921

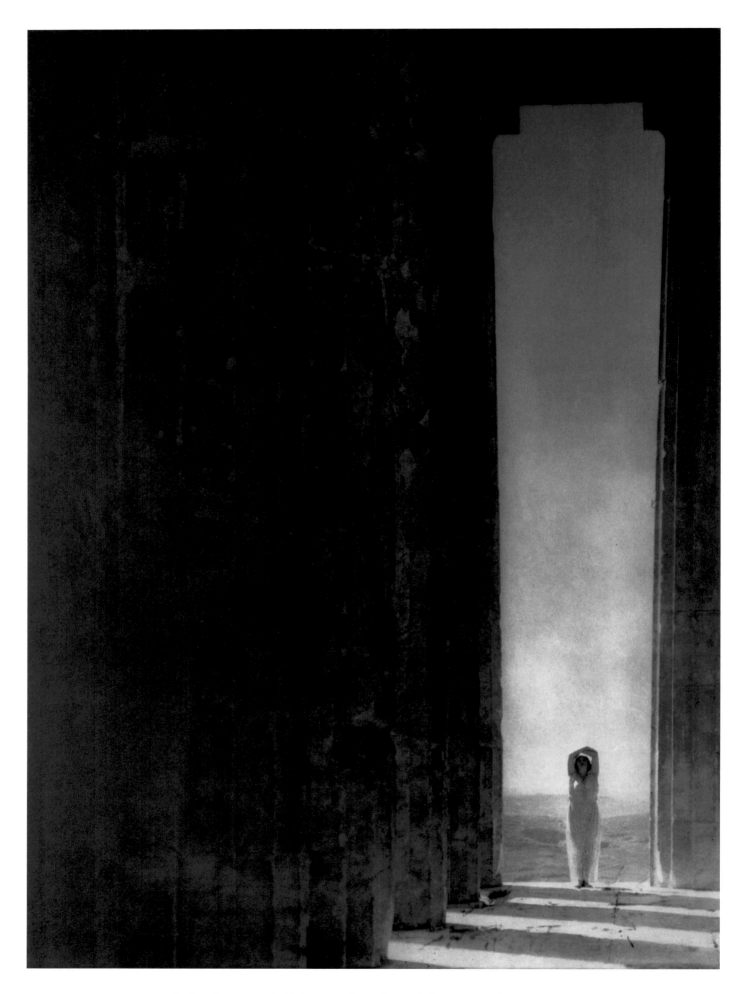

Isadora Duncan at the Columns of the Parthenon, Athens, 1921 | PLATE 174

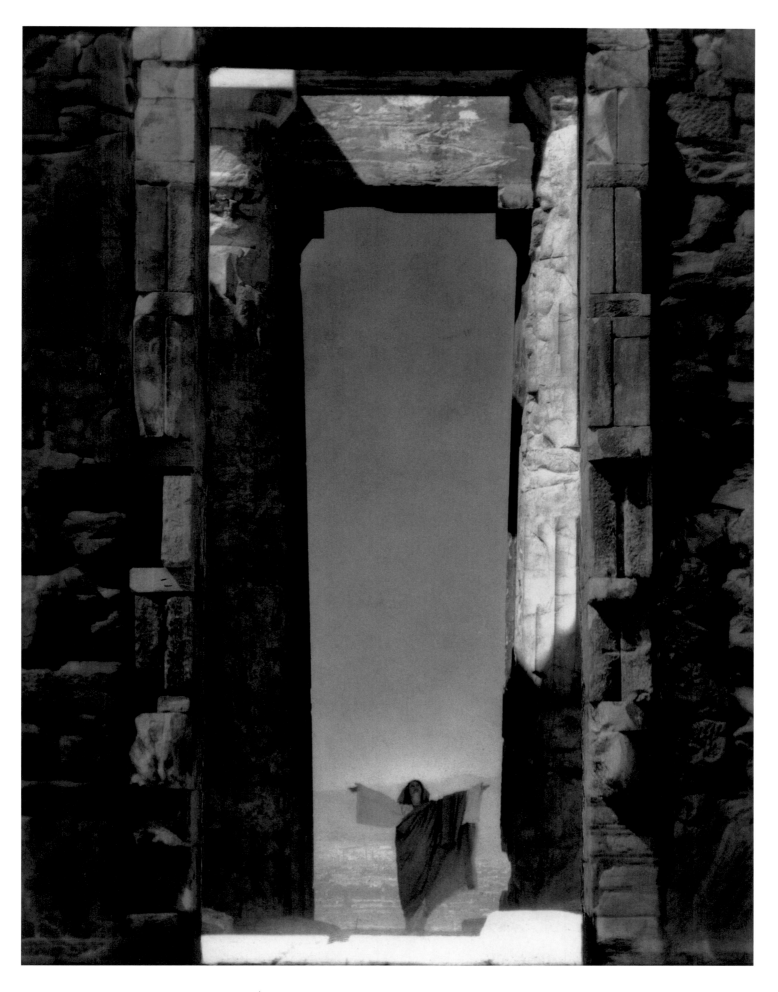

PLATE 175 | *Isadora Duncan at the Portal of the Parthenon,* Athens, 1921

E. Gordon Craig at Notre-Dame, Paris, 1920 | PLATE 176

PLATE 177 | *U.S.S. Carrier "Lexington"—Hellcat Goes Thundering Off the Deck,* 1943.
U.S. Navy photograph

Market Women, Mexico, 1938 | PLATE 178

PLATE 179 | *The Man Child*, Yucatán, 1938

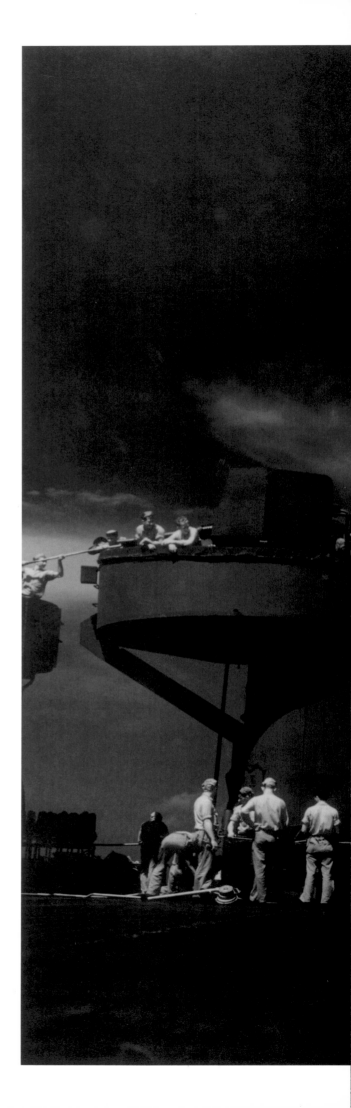

U.S.S. Carrier "Lexington"—Getting Set for the Big Strike on Kwajalein, 1943. U.S. Navy photograph, infrared | PLATE 180

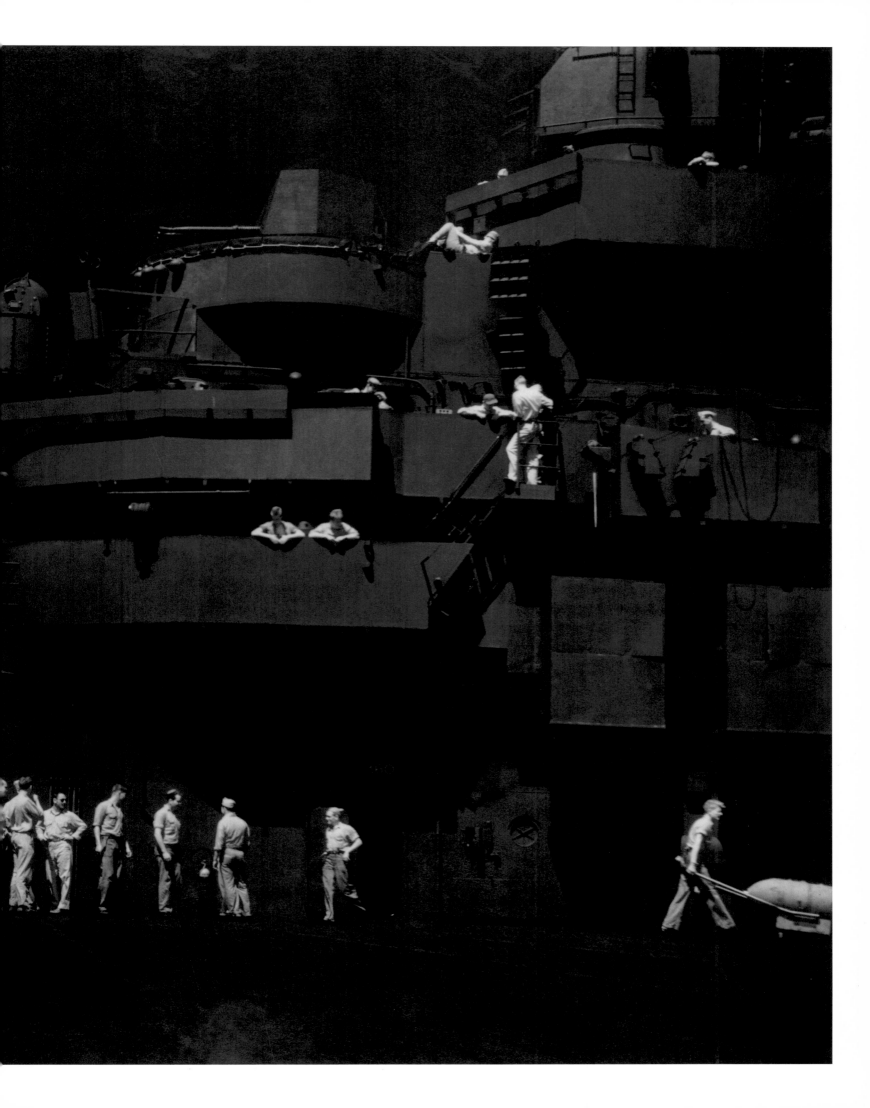

Russians Viewing the Moscow Exhibition of "The Family of Man," 1959 | PLATE 181

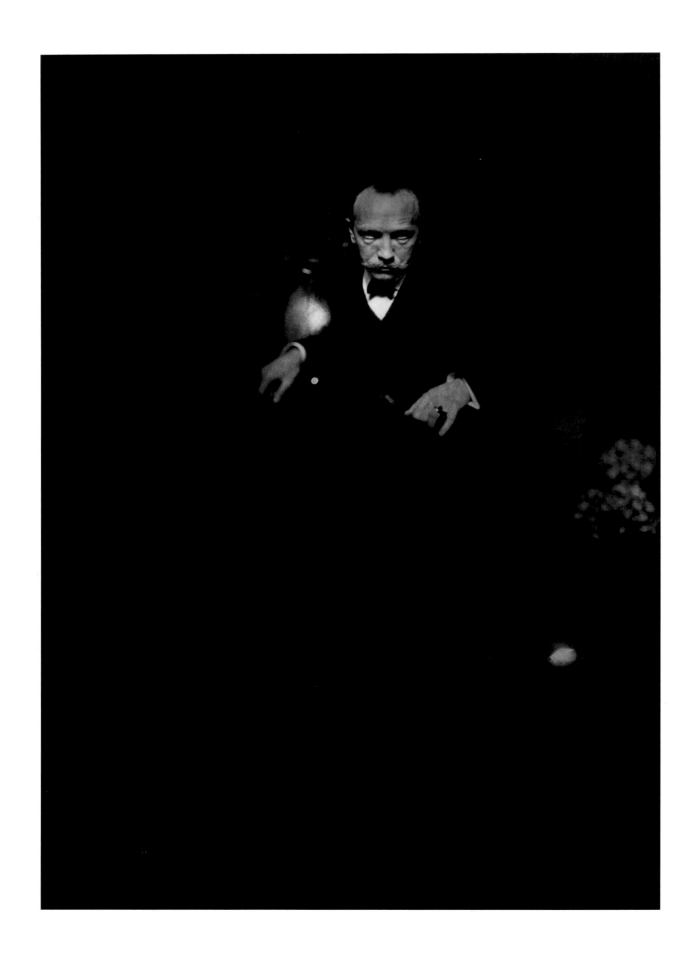

Richard Strauss, New York, 1904 | PLATE 182

MASTERS OF MUSIC

A good photograph only comes to life with [an] existence of its own if [the] photographer brings to the dominating array of facts of nature his own spontaneous combustion.

—E.S., private notes

The vigorous upper body movement of the conductor, the bowing of the violin, the flexing and extending of the pianist are a kind of dance. Music is motion. So I have grouped dancers together with composers, conductors and instrumentalists. In the portrait of Richard Strauss (plate 182), it is the position of the hands in relation to the forward-thrusting head that makes the composer appear about to leap out of the shadow and into dramatic action.

The photographs of violin virtuoso Jascha Heifetz (plate 183), conductor Leopold Stokowski (plate 184), song and dance man Maurice Chevalier (plate 187), and the Ziegfeld Follies girl Ann Pennington (plate 188) demonstrate some of the many ways in which Steichen made use of shadows and panels. Here they serve to amplify the sense of motion even when the subject, like Stokowski, was at rest. George Gershwin and Irving Berlin appear, correctly in terms of their music, earthier, more like regular guys, than the other musicians, a little closer to the man in the street (plates 186 and 185).

Steichen photographed several sequences of Martha Graham, one in a striped gown, one in a white dress with fluttery sleeves, one in classical drapery. Graham understood that Steichen's film was not fast enough to capture her in action, so in the sequence in plates 189–192, she held the end point of each thrusting gesture and, in charged stillness, produced a striking, exalted expression of the dancer as pure motion. On that same trip to Greece with Isadora, Steichen posed Maria-Theresa Duncan, one of the Isadorables, in an open place on the Acropolis. He made several exposures in nearly the same pose, but only in one did Steichen capture the precise moment when the wind and the light turned the dancer's gown into a shimmer of flame (plate 193).

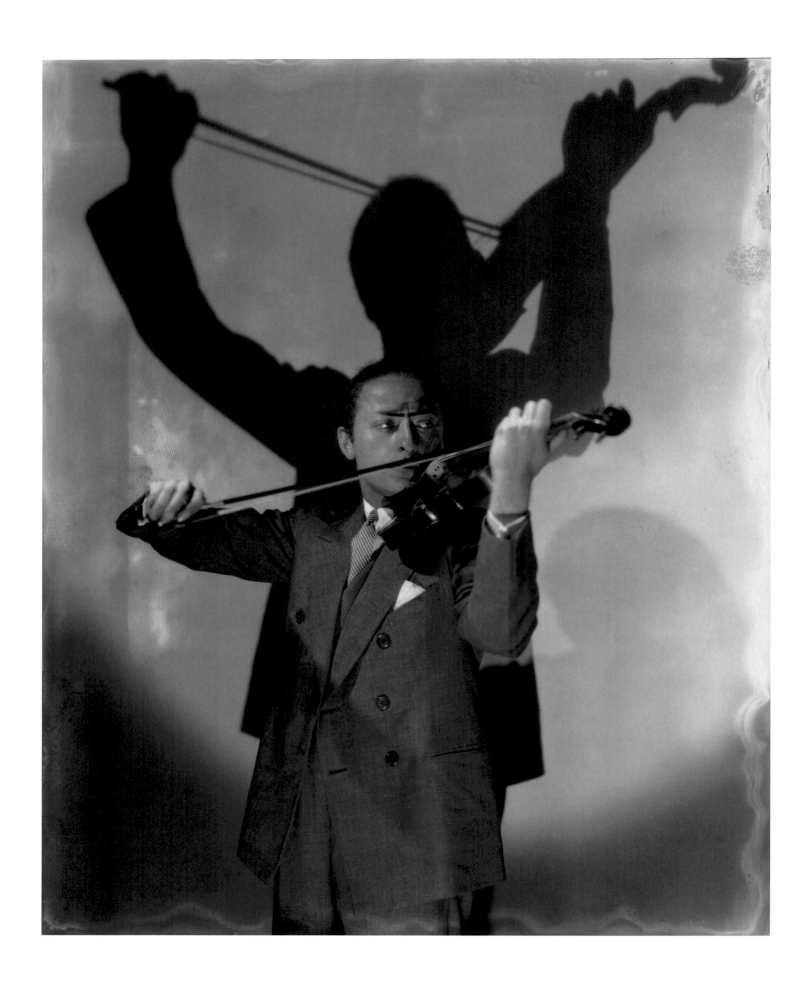

Jascha Heifetz, New York, 1928 | PLATE 183

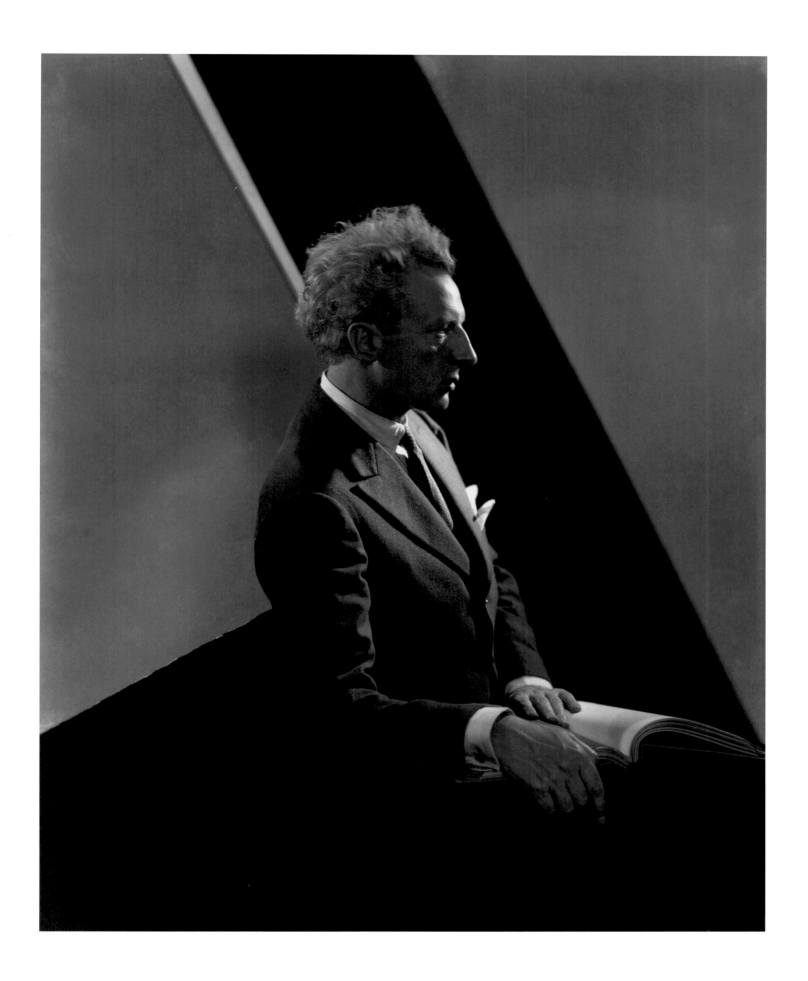

PLATE 184 | *Leopold Stokowski, 1928*

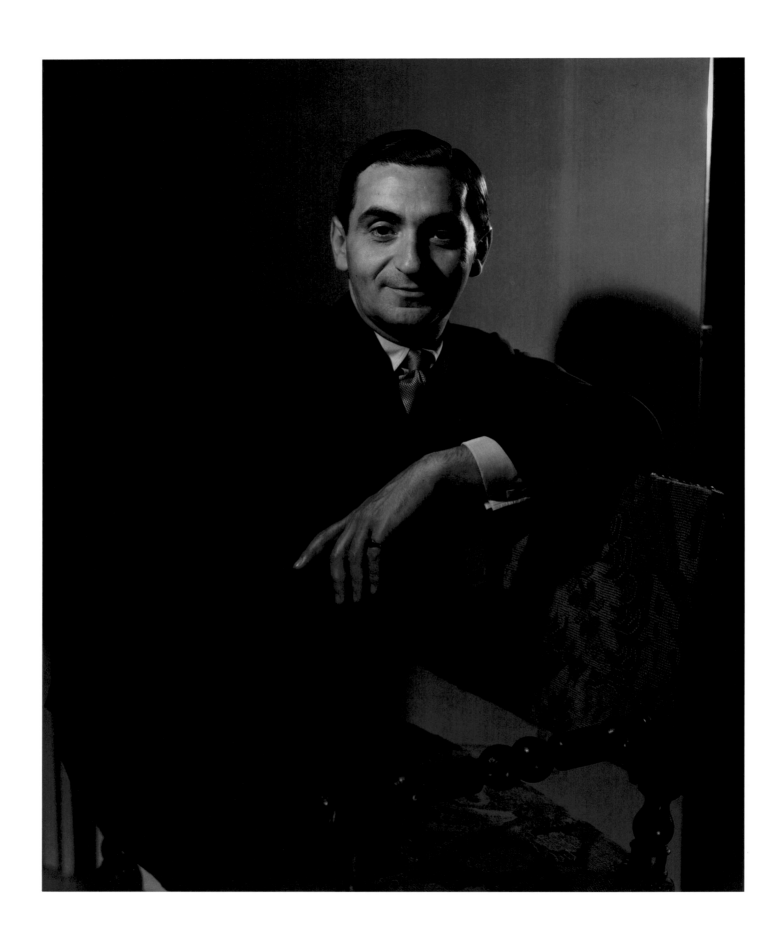

Irving Berlin, 1932 | PLATE 185

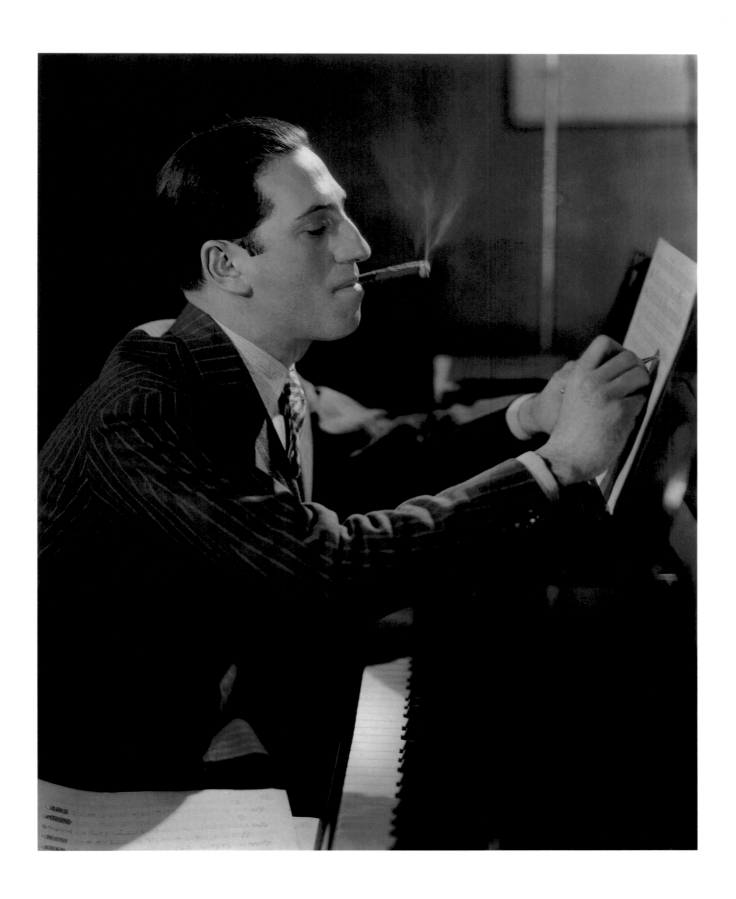

PLATE 186 | *George Gershwin, 1927*

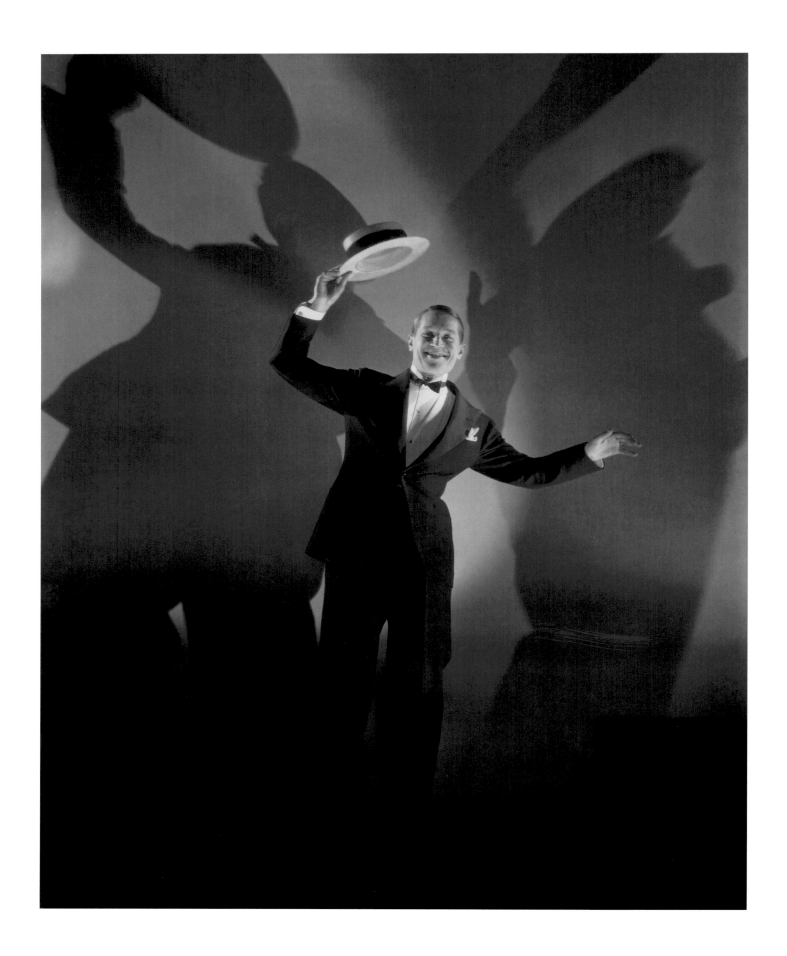

Maurice Chevalier, New York, 1929 | PLATE 187

PLATE 188 | *Ann Pennington, Ziegfeld Follies Girl*, New York, 1925

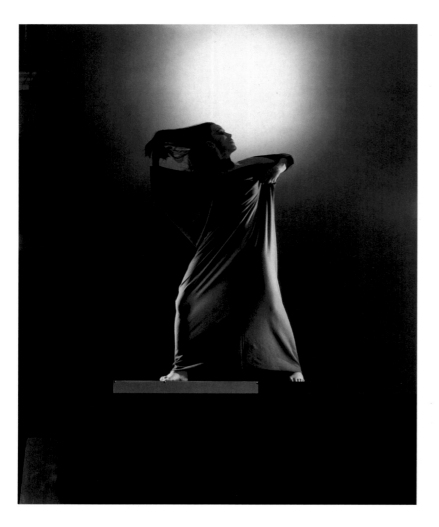
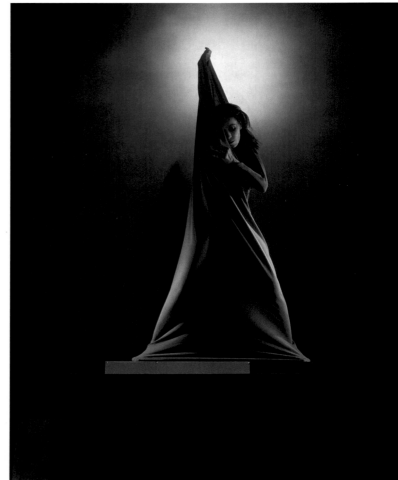

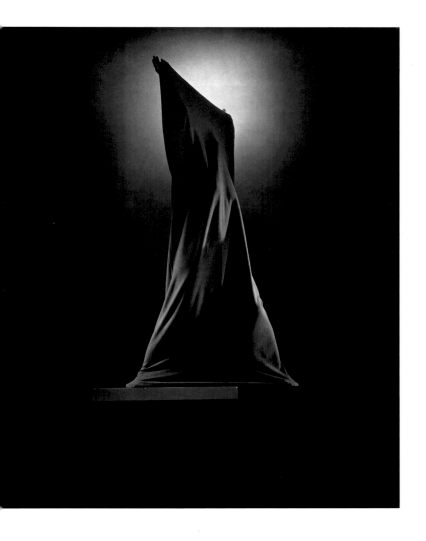

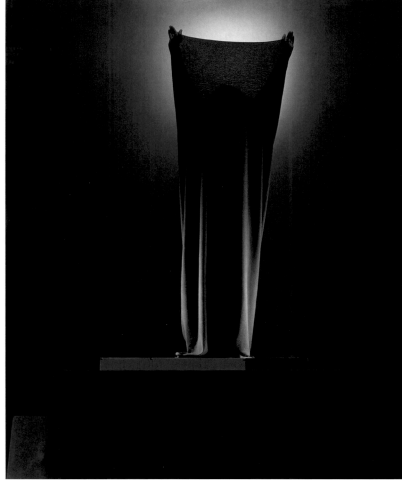

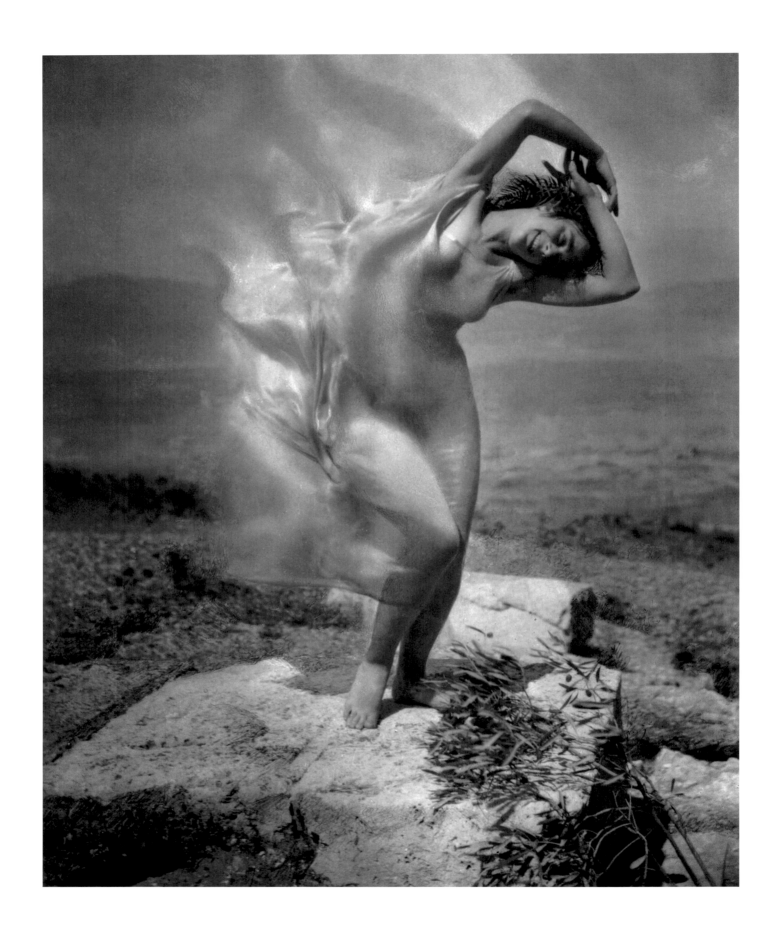

Wind Fire—Maria-Theresa Duncan on the Acropolis, 1921 | PLATE 193

The Brooklyn Bridge, 1903 | PLATE 194

NEW YORK CITY

Ever since I have been able to make my voice heard, I have raised it, sometimes vociferously, in furthering development toward new horizons . . . and applauding every individual, every movement and direction furthering the expanding horizons. I'm not so happy about any kind of restriction.

—E.S., notes for keynote speech at the
Photojournalism Conference in the West,
Asilomar, California, September 1961

I once asked Steichen which he would choose, city or country, if he had to live in just one place. He said he supposed it would have to be the city, but it would be a reluctant choice. His heart was rooted in landscape and in country settings where he could garden on a grand scale. In the country, he put years of careful planning into the space in which he lived. In the city, Steichen's quarters were always merely functional and temporary. However, some of the rooms he inhabited inspired the backyard photographs in plates 204–206.

After he and Clara separated during World War I, Steichen slept on a cot in his studio, and Mary, who had refused to go back to France with her mother, was installed at age ten as a long-term house guest at the home of Dr. William Stieglitz, Alfred's brother. In the 1920s, Steichen took a room as a lodger in Dana's mother's apartment on the Upper West Side. When I met him in 1959, he kept a bare, grimy, two-room apartment, a dismal third-floor walk-up, in the West Forties, handy to the Museum of Modern Art. Despite his preference for country life, Steichen grew up artistically in Paris and, for more than sixty years, New York City served as the nucleus of his professional life.

It happens that I am writing this chapter from a loft within walking distance of the sites of two of Steichen's studios and the subjects of some of his best photographs of the city. Less than a dozen blocks up Sixth Avenue, at the corner of Fortieth Street, is the Beaux Arts Building with its big studio windows and carved stone trim. It still houses working photographers. Steichen had a studio there from 1923, when he became photographer in chief for Condé Nast Publications, until 1934, when he moved uptown to a small building with a garage on the ground floor at 139 East Sixty-ninth Street. By then, he lived full-time in Connecticut, scheduled only one sitting a day and drove in directly from Umpawaug to his studio's private garage.

In the 1920s, Steichen was restless for new things and was very much in demand. He designed glass vases and decorative objects for Steuben and a piano case for Steinway. He had a plaster bust made through a new mechanical process

called photo-sculpture. At the suggestion of his daughter Mary, he photographed everyday objects for *Baby's First Picture Book,* and then *Baby's Second Picture Book,* precursors of today's children's board books. He worked long hours under pressure, fitting in private portrait sittings between other assignments. Then he would stay up most of the night working on a private project, which might be anything from photographing to putting together a crystal radio set. In those days, he was famous for a quick temper exacerbated by frazzled nerves. At one point, he was sent away to North Carolina for a "rest."

As relief from the routine of his magazine assignments, Steichen photographed what he saw from the Beaux Arts studio window. The El is long gone, as are the breadlines (plate 203), and Bryant Park, across the street, has been restored to an improved version of its original state, but many of the surrounding buildings still stand, looking the same as they did when, in *Stars on Sixth Avenue* and *Drizzle on Fortieth Street* (plates 202 and 199), Steichen recorded the tricks that electric lights and rain could play on their surfaces seen through a camera lens.

Steichen rented his first New York studio in the summer of 1902. It was on the top floor of a converted brownstone at 291 Fifth Avenue and around the corner from the headquarters of the New York Camera Club. Three years later, he moved across the hall to a slightly larger space in Number 293 and turned over his original quarters to the Photo-Secession for their "Little Galleries." Alfred Stieglitz had coined the word "photo-secession," but Steichen was dissatisfied with its vagueness. He and other photographers who took their work as artists seriously finally persuaded Stieglitz to form an organization that would elect fellows. They formed a governing council, and Stieglitz accepted the title of director. In 1905, Steichen persuaded Stieglitz that a gallery for a field as small as photography could be a viable operation. Steichen's idea was to show innovative work in painting and sculpture, as well as photographs. In Steichen's words, "As we had not succeeded in getting photographs hung with paintings in any art gallery, we should try the opposite tack and bring the artists into our sphere."* Steichen designed the galleries, installed the first exhibitions and, back in Europe, kept Stieglitz informed about interesting American and European artists and arranged for their exhibitions at 291.

Steichen's pencil sketches of his designs for Steuben Glass

For a long time, Steichen's role in initiating the pioneering exhibitions in other media at 291 was not properly credited by art historians. Steichen attributed this lapse to a small economy in a telegram. Stieglitz had agreed that the first nonphotographic exhibition at 291 would be an exhibition of Rodin drawings to be arranged by Steichen. Then, without warning, Stieglitz announced an exhibition of watercolor drawings by Pamela Coleman Smith. To save twenty-five cents, Steichen changed the message "Do you still want Rodin drawings?," which established his prior claim, to "Do you want Rodin drawings?," which could be interpreted as merely following Stieglitz's lead. I suspect that Stieglitz broke his agreement and subsequently permitted the distortion of credit in order to protect his own leadership role, with which Steichen became increasingly restive. During World War I, Steichen, the naturalized American patriot,

A Life in Photography (New York: Doubleday, 1963).

and Stieglitz, proud of his German origins, fell out over national loyalties, and after the war, they disagreed deeply over the definition and function of the art of photography.

Decades ago, 291 gave way to the block-long, fifteen-story Textile Building, but the neighborhood streets still contain enough nineteenth-century churches, five-story brownstones with bracketed cornices and garlanded stone palazzi with little domed towers for me to imagine the handsome young photographer from Milwaukee via Paris dashing along, hair and coattails flying, setting up shop on Fifth Avenue as the nineteenth century gave way to the twentieth and the neighborhood flourished as a center of grand hotels, shopping and entertainment. I imagine young Steichen late in the day, laden with tripod and big box camera, a supply of photographic plates stuffed into his coat pockets, boarding an omnibus, or a horse-drawn cab if he was flush, and heading downtown to photograph the Brooklyn Bridge (plate 194) or Trinity Church (plate 208) at his favorite hour, twilight.

I can stand in the spot in Madison Square Park where Steichen must have set up his camera late on a rainy winter afternoon in 1905 to photograph a handsome skyscraper completed in 1902, the Fuller Building (plate 143), its twenty stories made possible by the hydraulic elevator. It was quickly nicknamed the Flatiron Building because of its wedge shape, determined by the angle at which Broadway and Fifth Avenue meet. From that same spot in Madison Square Park, I can turn around and look up Fifth Avenue to the 102-story Empire State Building, photographed by Steichen only twenty-seven years later on assignment for *Vanity Fair.* To capture the dizzying height of what was, in 1932, the tallest building in the world, completed from excavation up in less than a year, he made a multiple exposure and called it *The Maypole* (plate 198).

The two photographs and the short time span between the construction of the Flatiron and the Empire State Buildings represent for me the scope of the changes to which Steichen adapted, the awe that he and his contemporaries felt at mankind's capacity for technical progress and their faith in its benefits. He communicated this optimistic wonder in his studies of the George Washington Bridge (plates 195 and 196) and Rockefeller Center (plate 197). Both were still under construction at the time. Steichen was no Diego Rivera, whose mural commissioned for Rockefeller Center was removed because of its anticapitalist sentiments. Nevertheless, in the foreground of his photograph, Steichen paid tribute to the laborers who constructed the building.

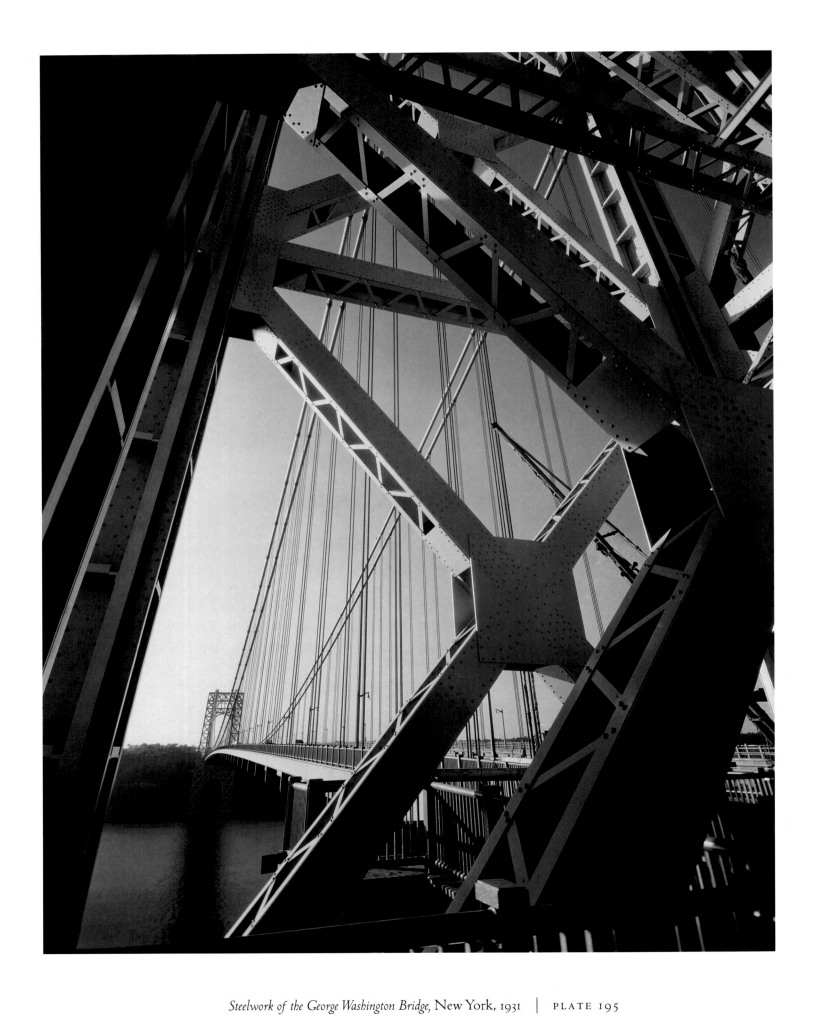

Steelwork of the George Washington Bridge, New York, 1931 | PLATE 195

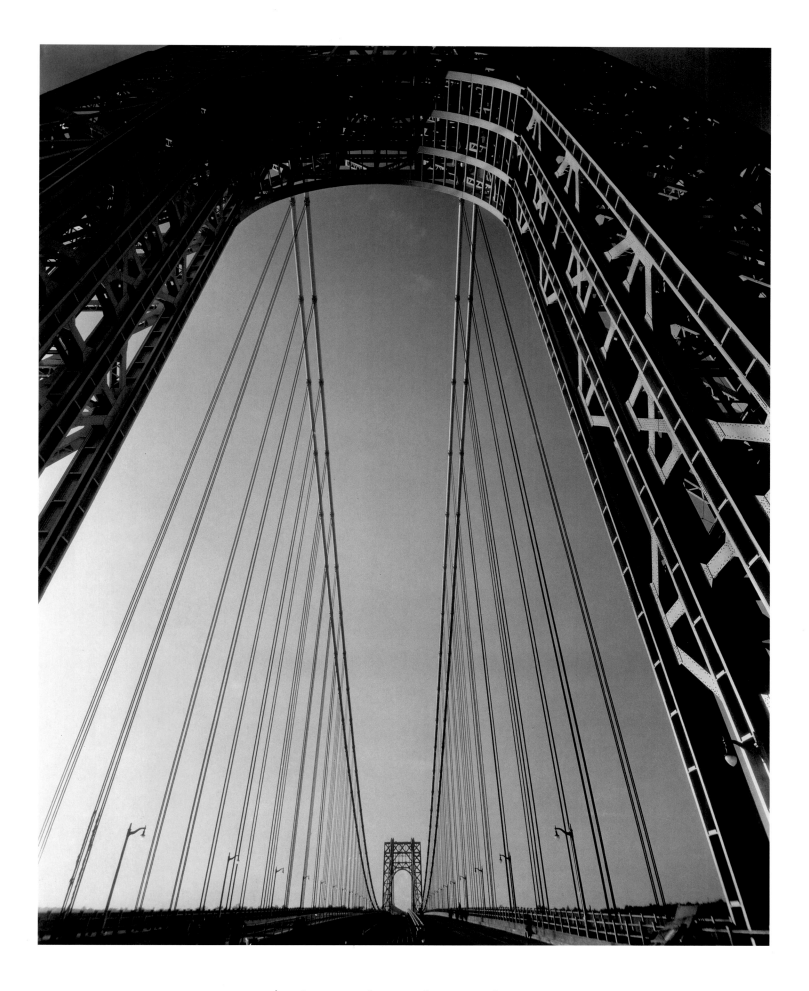

PLATE 196 | *The George Washington Bridge*, New York, 1931

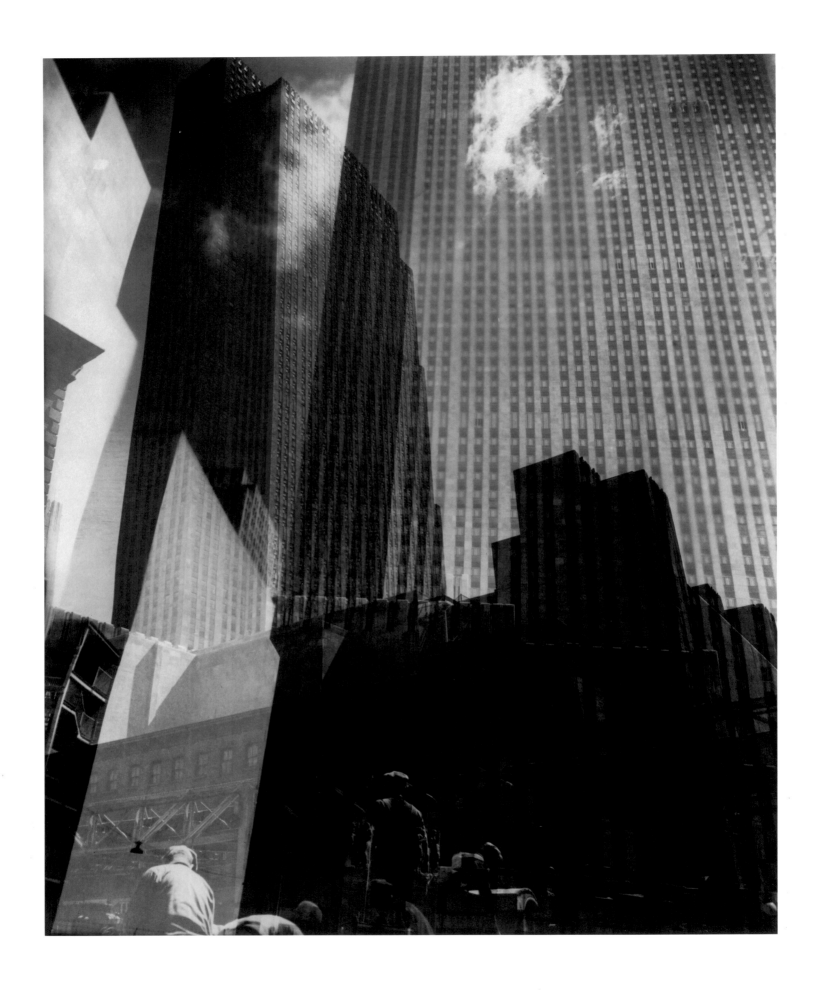

Rockefeller Center, New York, 1932. Multiple exposure | PLATE 197

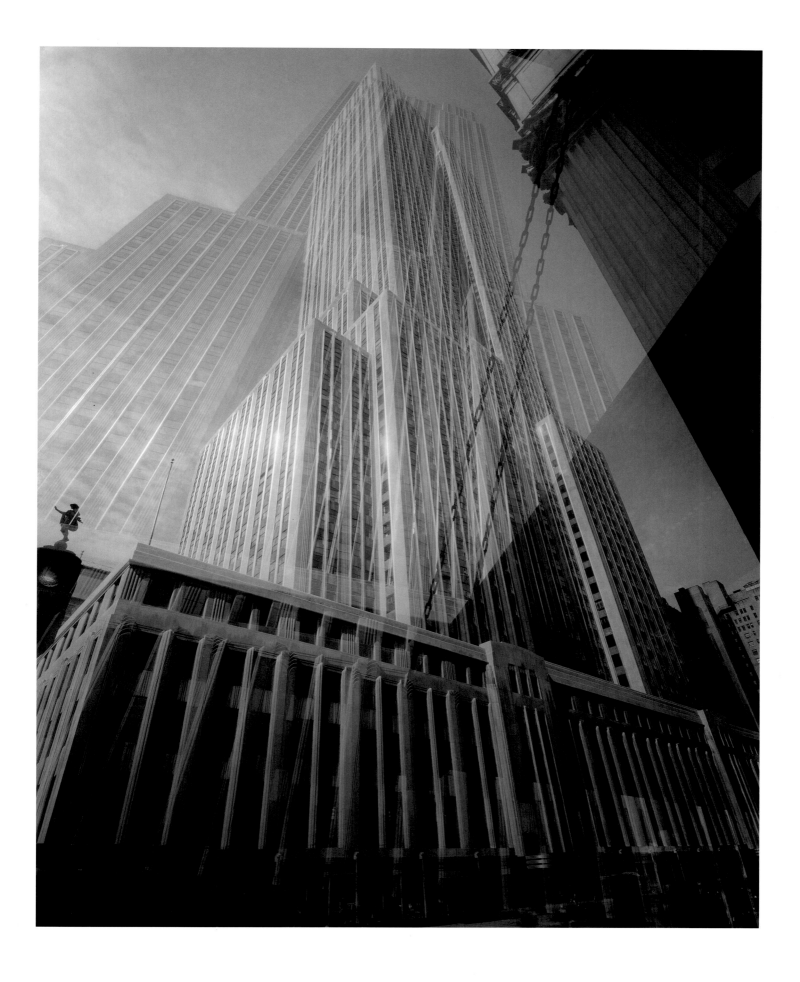

PLATE 198 | *The Maypole—The Empire State Building*, New York, 1932. Negative montage

Drizzle on Fortieth Street, New York, 1925 | PLATE 199

PLATE 200 | *Sunday Night on Fortieth Street*, New York, 1925

Times Square Montage, New York, 1935 | PLATE 201

PLATE 202 | *Stars on Sixth Avenue*, New York, 1925

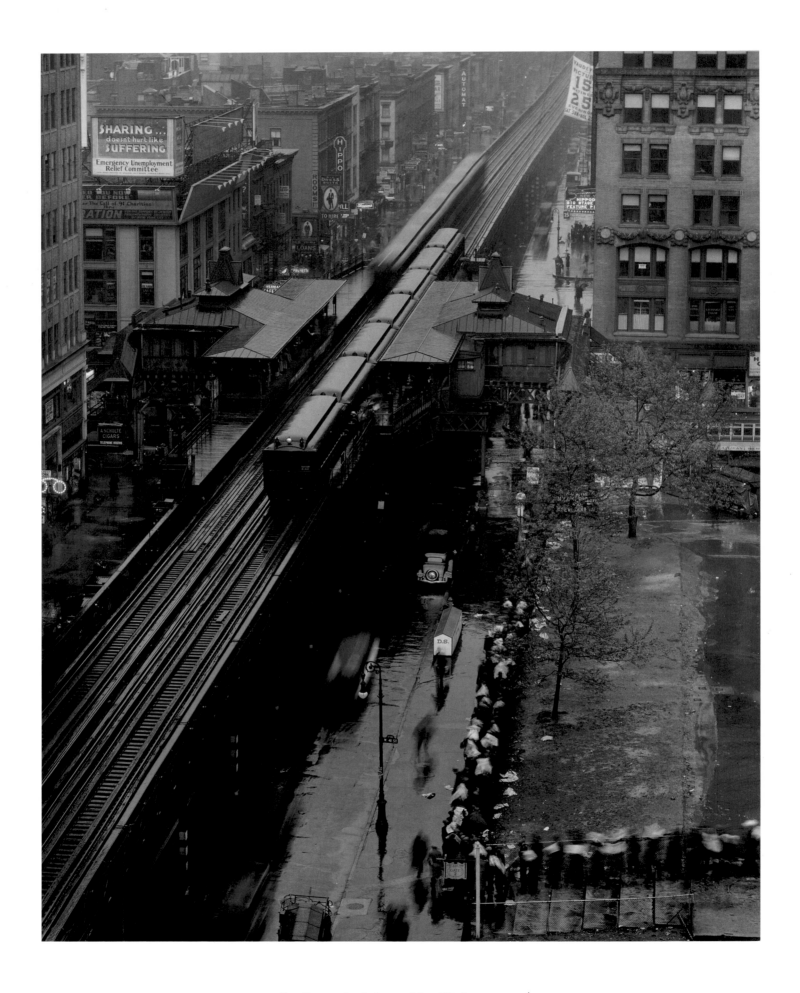

Breadline on Sixth Avenue, New York, c. 1930 | PLATE 203

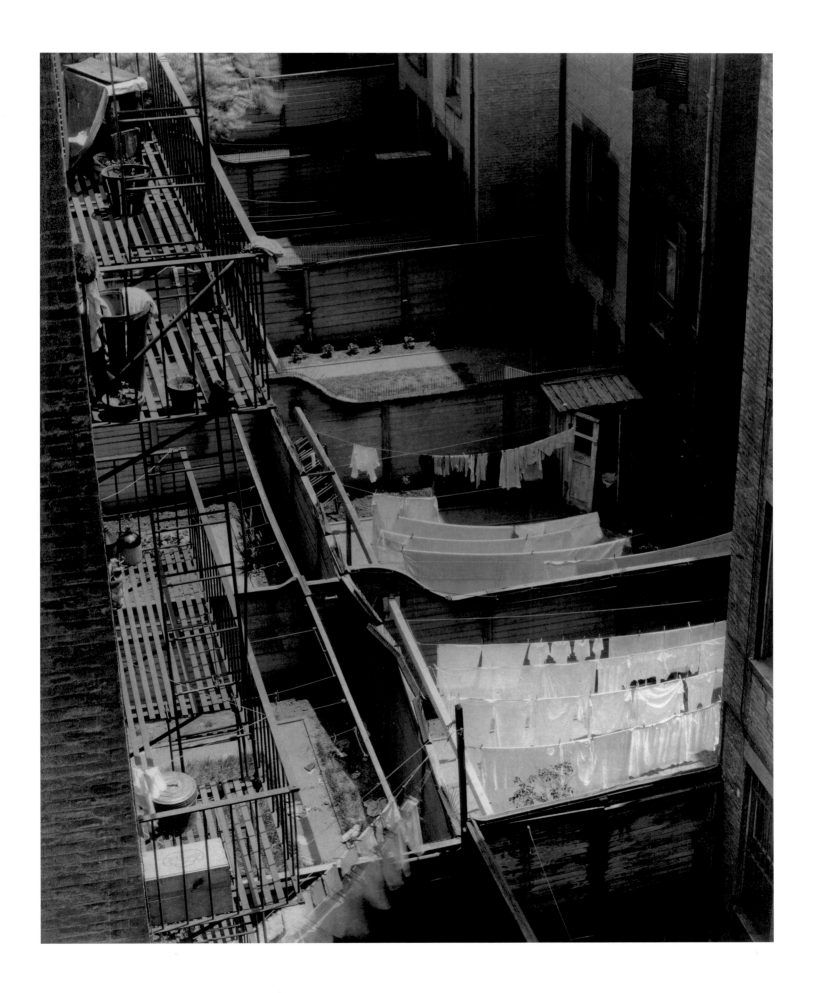

PLATE 204 | *Backyards,* New York, c. 1922

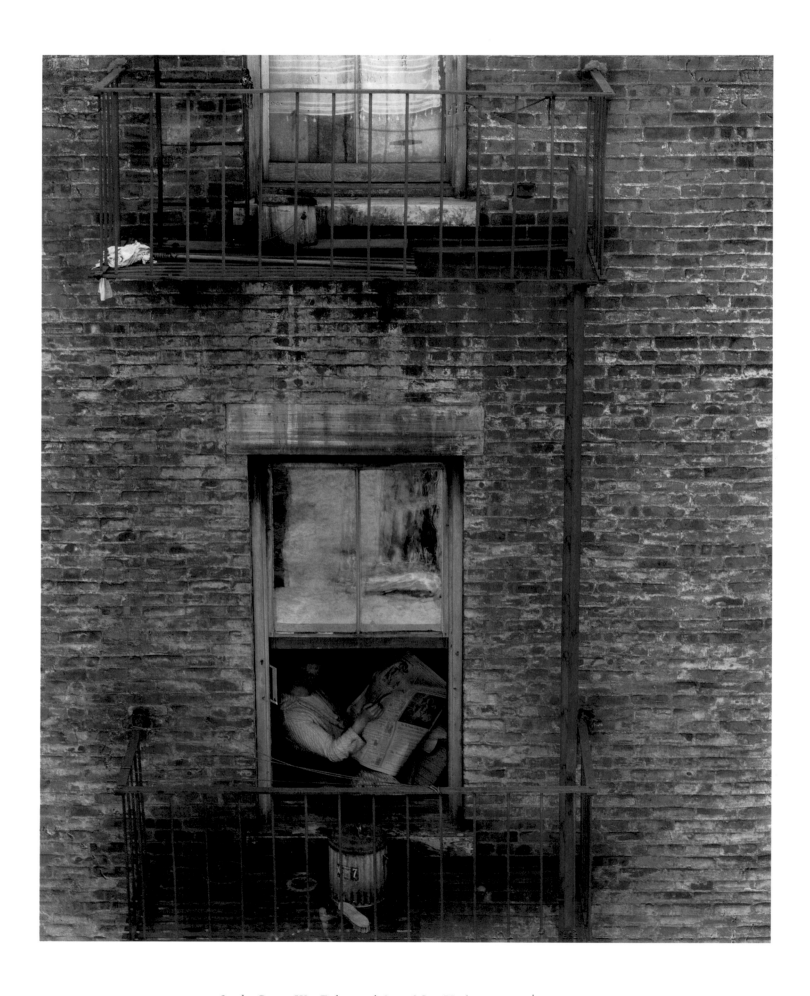

Sunday Papers, West Eighty-sixth Street, New York, c. 1922 | PLATE 205

PLATE 206 | *Laughing Boxes,* New York, c. 1922

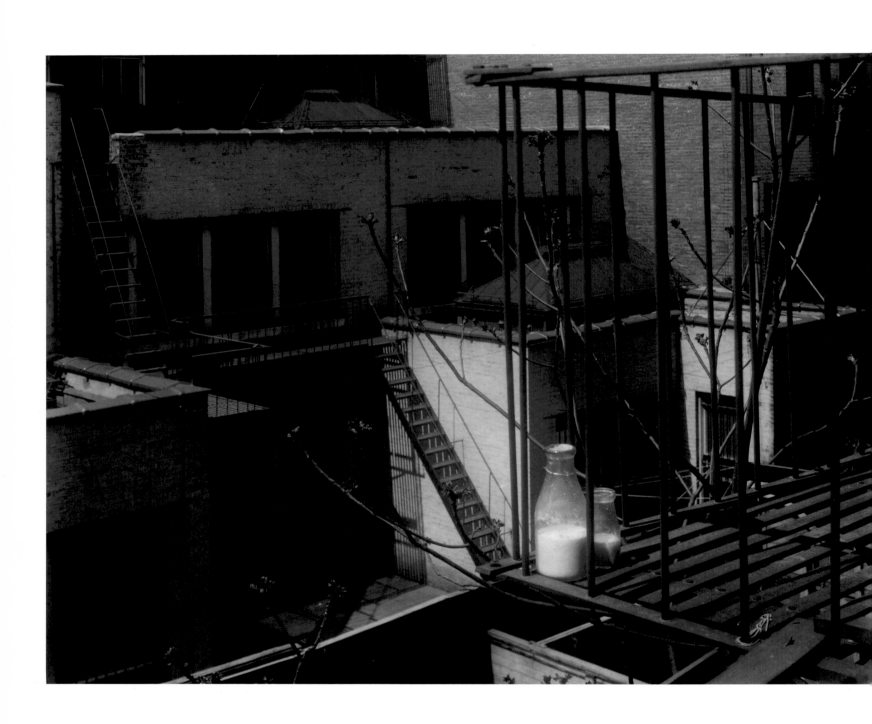

Milk Bottles—*Spring*, New York, 1915 | PLATE 207

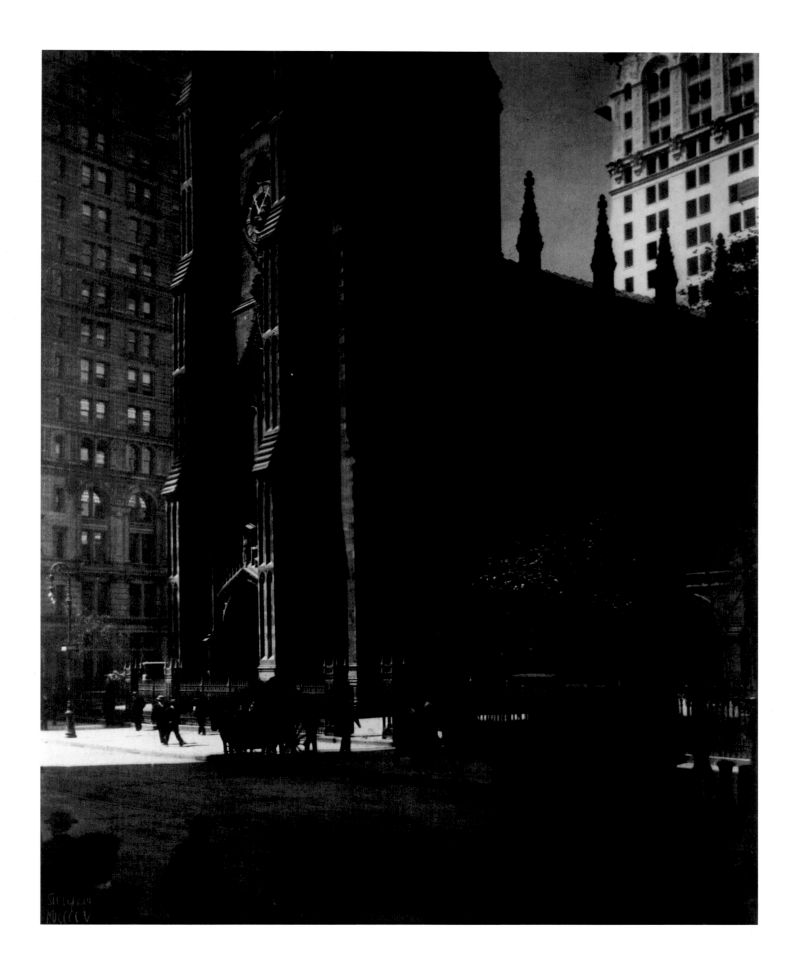

PLATE 208 | *Trinity Church,* New York, 1904

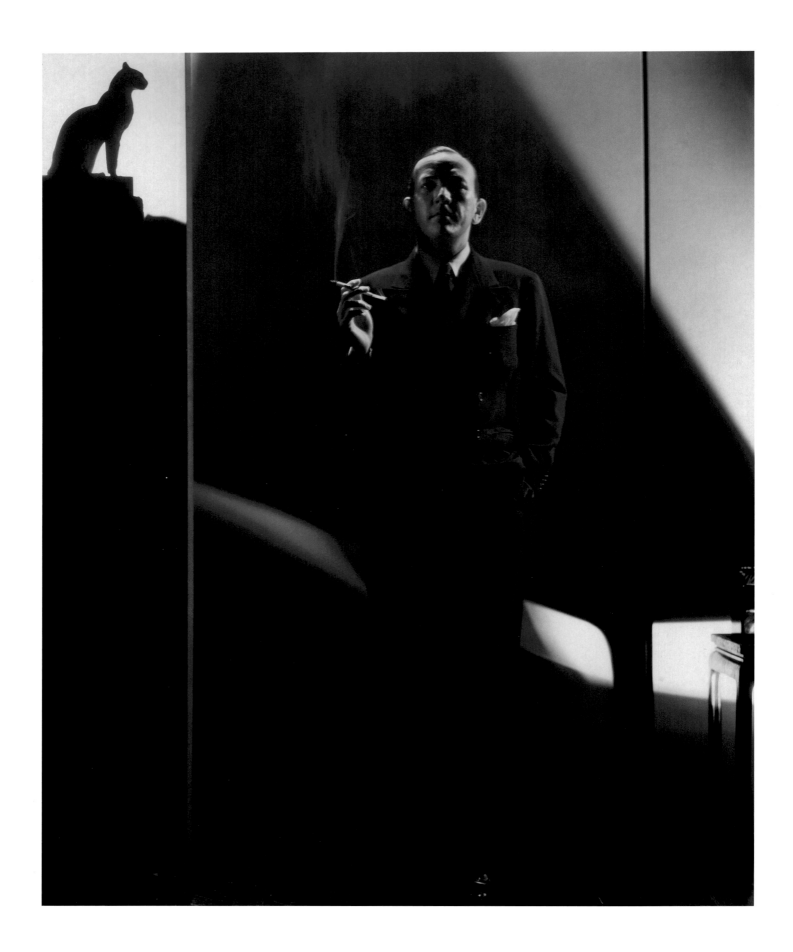

Noël Coward, New York, 1932 | PLATE 209

GLAMOUR

Painters of billboards or painters of academic pictorial bilge are painters in the same sense that snapshotters, pictorialists, and cheesecakers are photographers, but none of these painters or photographers are artists. It is only the artist that creates the work of art, not the medium.

—E.S., private notes

A magazine photograph of a celebrity is as much a merchandising tool as an advertisement or a fashion spread. In the *Vogue* and *Vanity Fair* years, particularly before *Vanity Fair* ceased publication in 1936, one thing that kept Steichen enthusiastic was the variety of personalities and occupations he encountered. It didn't matter whether he was well acquainted with the work of the celebrities who entered his studio or whether he knew little or nothing about them. His versatility and instinct for seizing the salient points of a character colluded enthusiastically with his subjects in the sports and entertainment fields to put across vividly whatever each was selling.

Often, with these celebrities, as with fashion and advertising, the product was that mesmerizing, titillating fantasy known as glamour. Sensuality, sophistication, mystery, virility, mythic ritual, glamour in all its varieties of seductive power sold goods and attracted audiences. The images here are icons of glamour. Louise Brooks stands for all time as the epitome of the reckless, coldhearted temptress (plate 215). Garbo's titanic fury (plate 213) was, in fact, merely her response to her film director, who called her back to the set after a ten-minute session with Steichen in which she felt so understood that she told Steichen, "You! You should direct movies."

While I can imagine Steichen chuckling privately about many of these images, one of the icons in this section is meant to be understood by everyone as a send-up. In Steichen's first sittings with Marlene Dietrich, her mentor, Josef von Sternberg, never left her side. She would pose stiffly, frozen in whatever pose he commanded. Once, finally, von Sternberg was not present. Dietrich, surrounded by props representing frivolous luxury, came spontaneously alive in front of Steichen's camera and happily spoofed the worldly siren she played so well (plate 222).

Steichen often used props as symbols to add variety and emphasize the message: Anna May Wong's apparently disembodied head equated with the royal Chinese flower, the chrysanthemum, representing all the mystery of the Orient (plate 216); Merle Oberon's exotic goddess beauty colder than the marble bust in the foreground (plate 211); Joan Crawford wrapped in what could be a shroud,

stretched stiffly over the chair back, a sleek death's-head delivered to the executioner's block (plate 218); Crawford again, standing (plate 223), a stony goddess, her stark determination reinforced by the hard-edged ottoman and background panel; the serene, captive beauty of Sylvia Sidney's face beneath an allusion to a gilded cage (plate 219); the swirl of a grand staircase setting the stage for Ronald Colman as a skeptical aristocrat (plate 217); the ancient Egyptian cat presiding over an ephemeral Noël Coward, sardonic playwright and actor, here a mere apparition of head, hands and perfect pocket handkerchief emerging from the shadows with a devilish wisp of smoke (plate 209).

Applying lipstick becomes glamorous in a white-tie setting (plate 221), while the cigarette in the man's hand authenticates his sophistication. Another cigarette just slightly hardens the gentle, debonair charm of the knowing heartbreaker Leslie Howard (plate 212), but for the boxer Jack Sharkey smoking says, "I'm the toughest of the tough guys—don't mess with me" (plate 220). Bending to receive flowers from the little girl, Primo Carnera, wrestler and boxer, becomes a benign Hans Christian Andersen giant (plate 210), while no props, only lighting, is needed to spell out the straight-arrow hero in young Gary Cooper (plate 224) and the animal intensity in the famously uninjured face of the gentleman boxer Gene Tunney (plate 214).

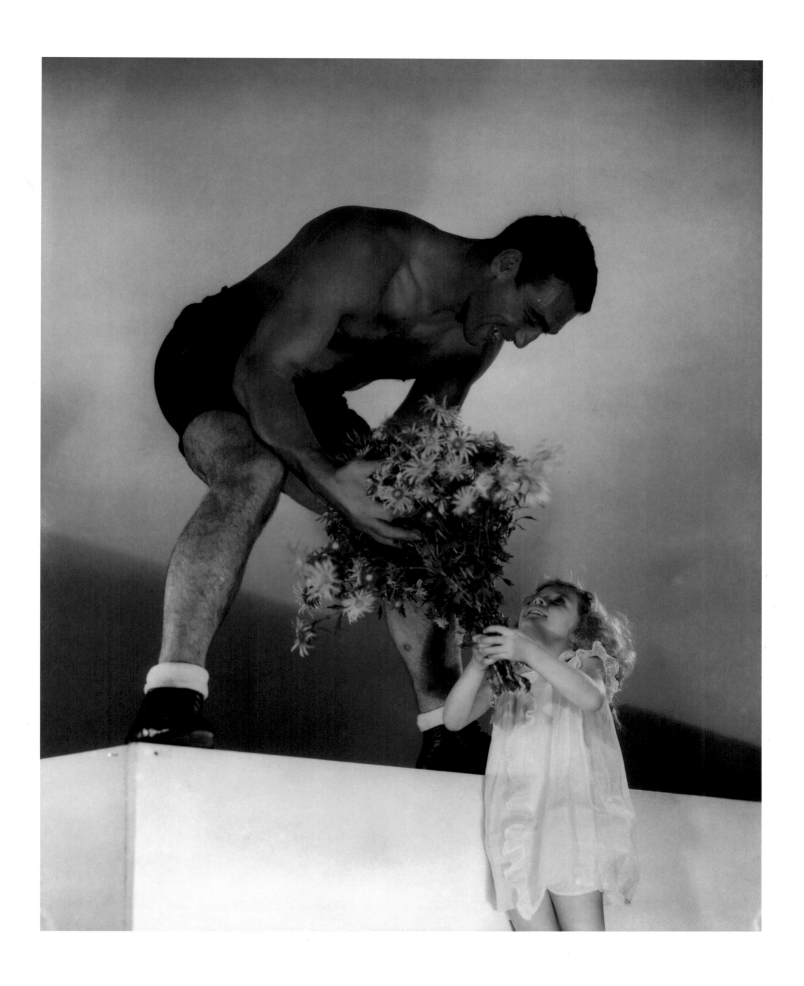

PLATE 210 | *Primo Carnera, Boxer and Wrestler, 1933*

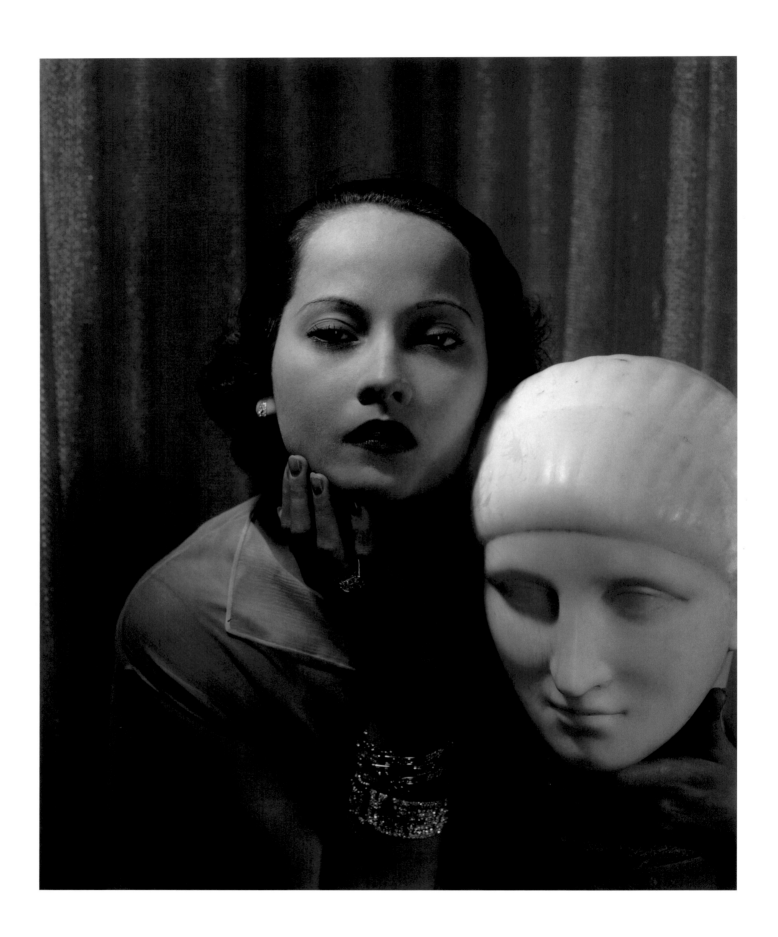

Merle Oberon, 1935 | PLATE 211

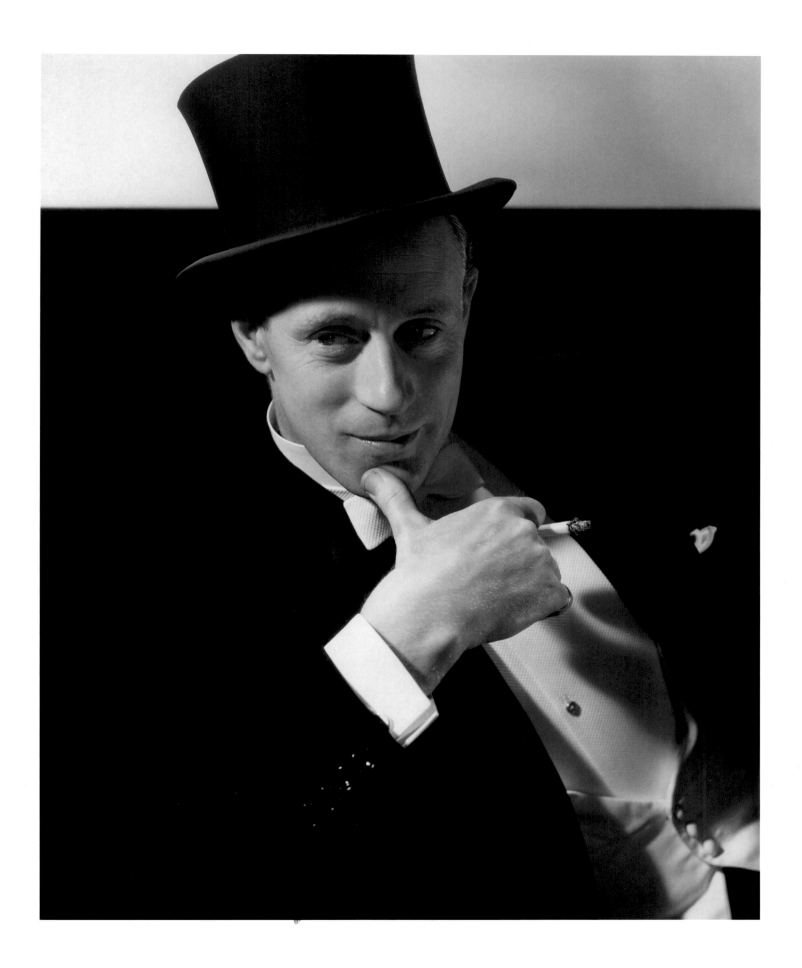

PLATE 212 | *Leslie Howard, 1933*

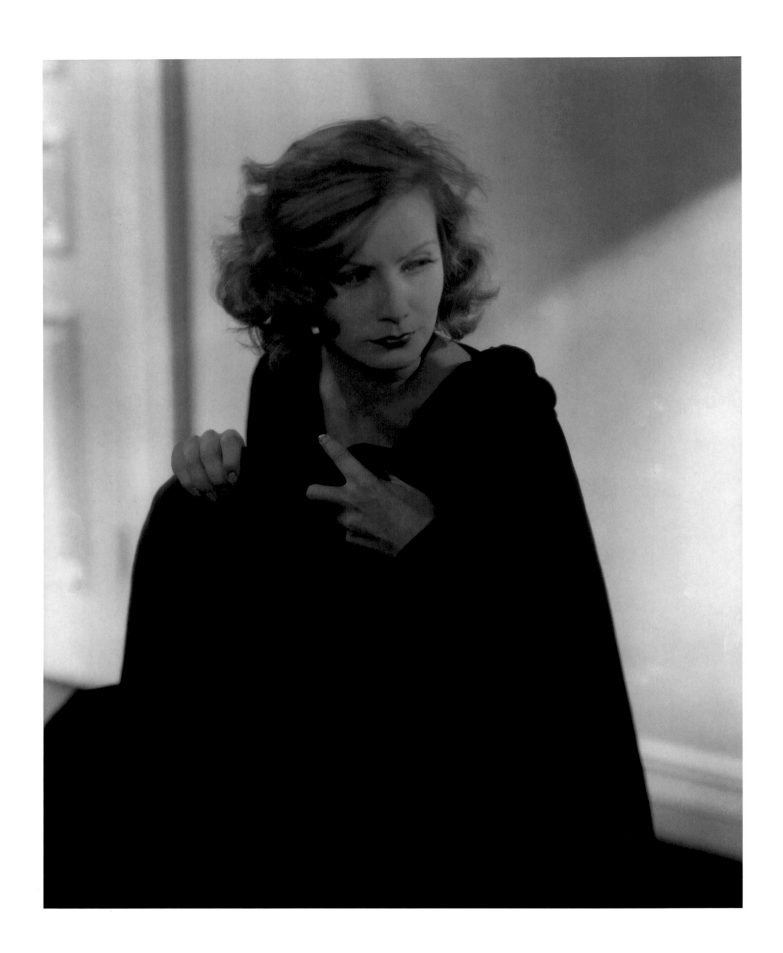

Greta Garbo, Hollywood, 1928 | PLATE 213

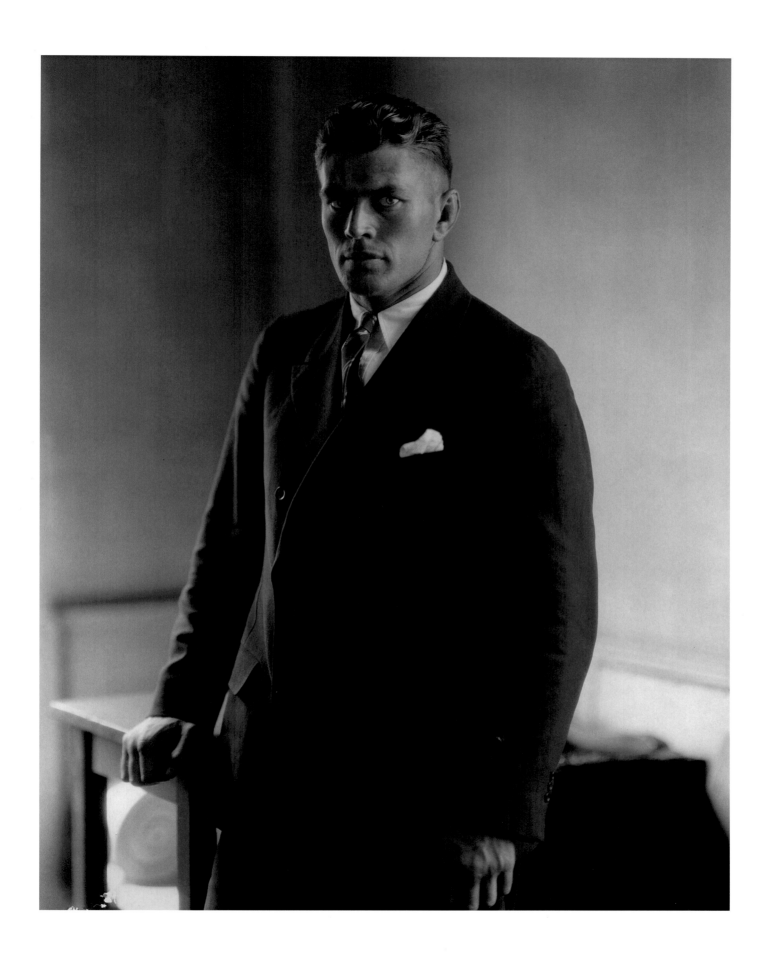

PLATE 214 | *Gene Tunney, Gentleman Boxer, 1926*

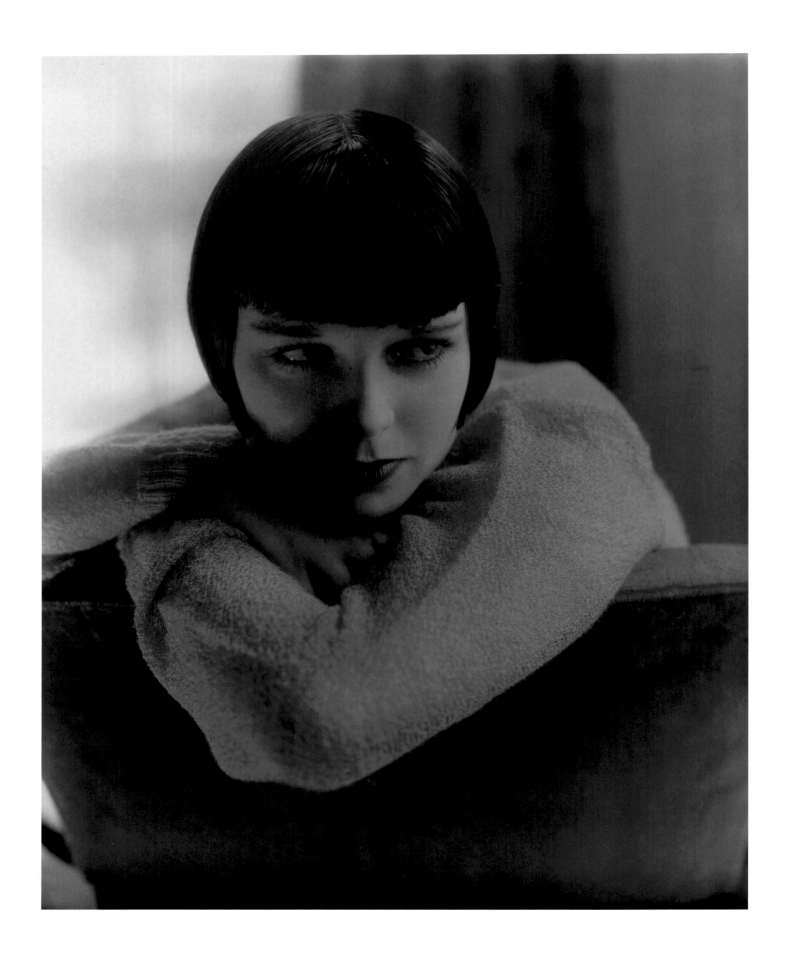

Louise Brooks, 1928 | PLATE 215

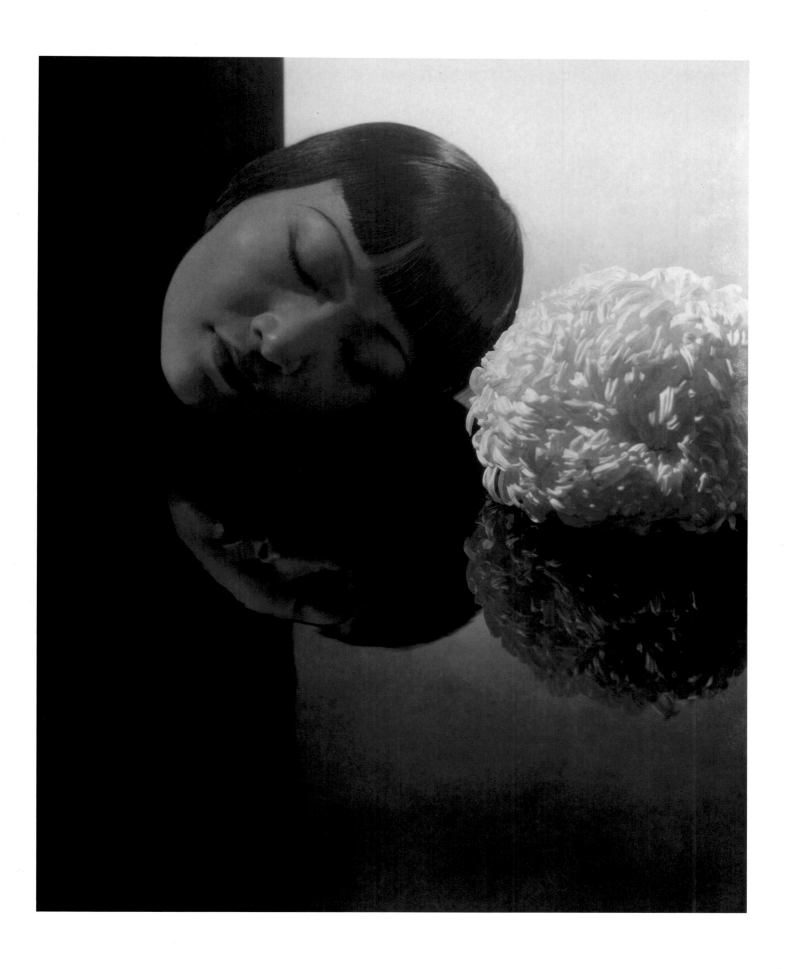

PLATE 216 | *Anna May Wong*, New York, 1930

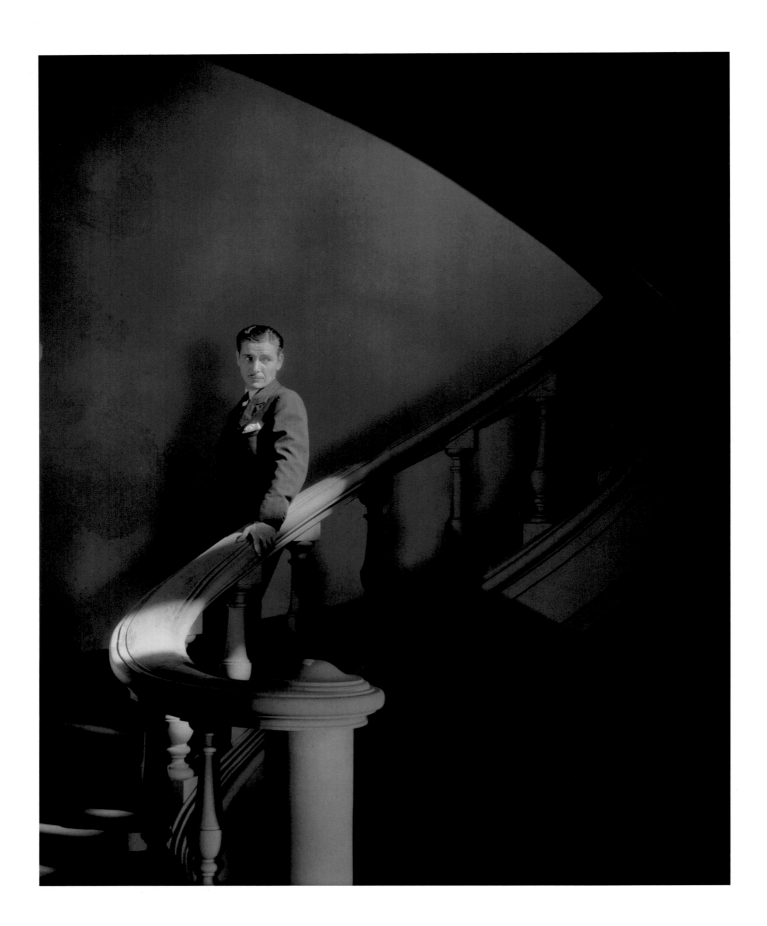

Ronald Colman, 1931 | PLATE 217

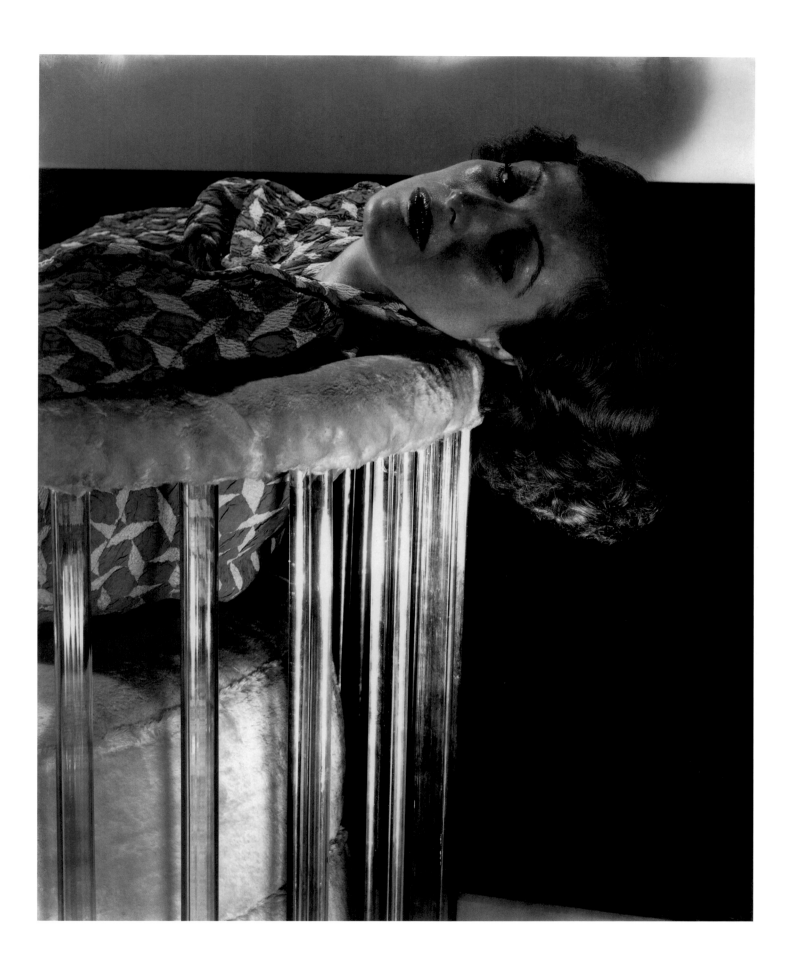

PLATE 218 | *Joan Crawford*, New York, 1932

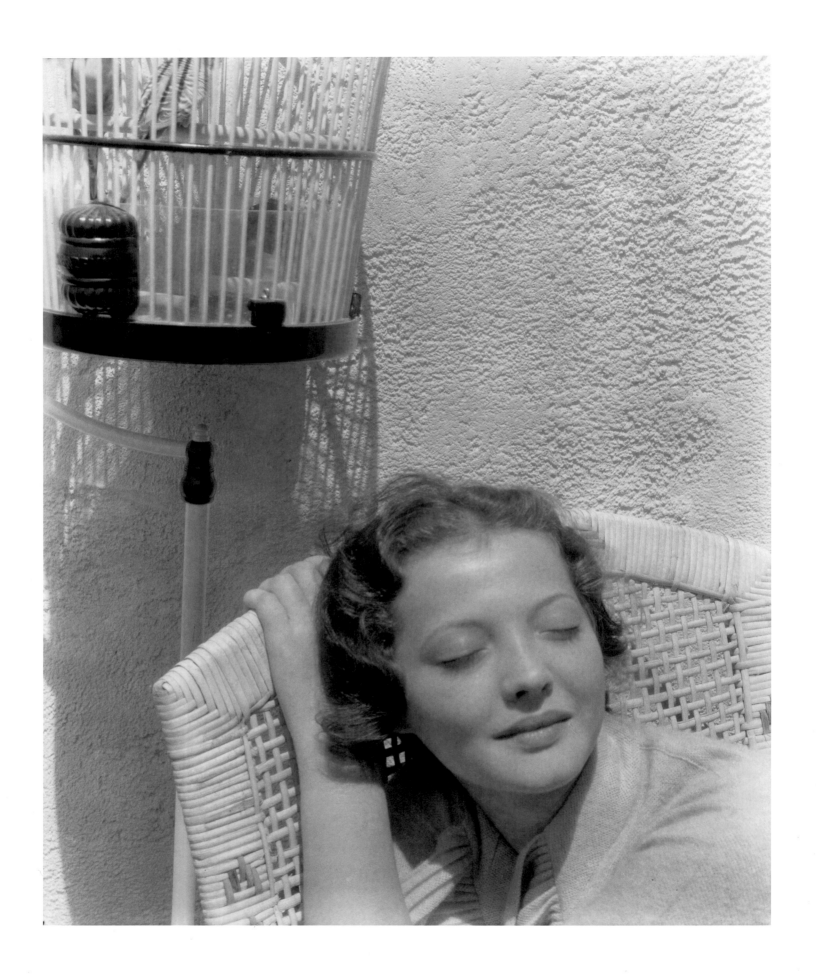

Sylvia Sidney, Hollywood, 1931 | PLATE 219

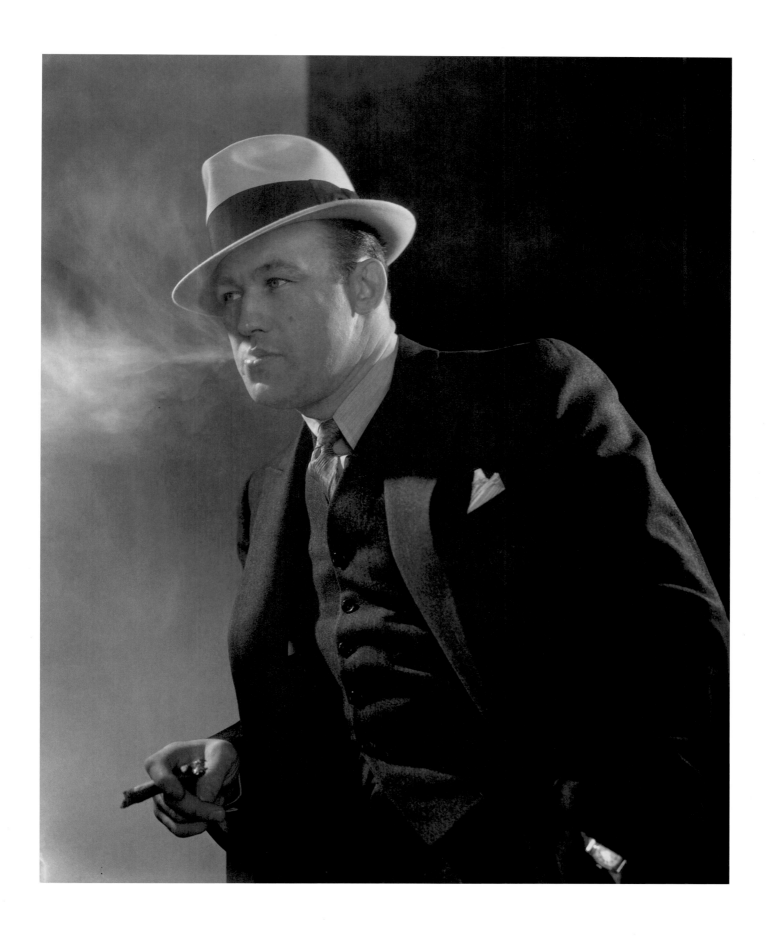

PLATE 220 | *Jack Sharkey, Prizefighter*, New York, 1932

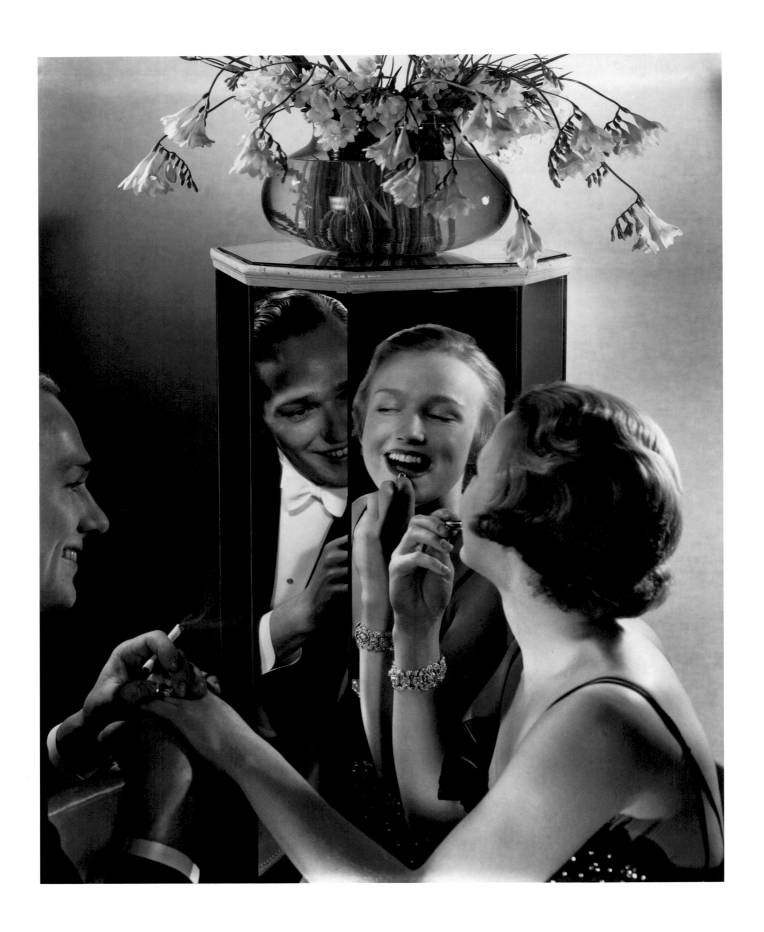

Advertisement for Coty Lipstick, 1935. The J. Walter Thompson Agency | PLATE 221

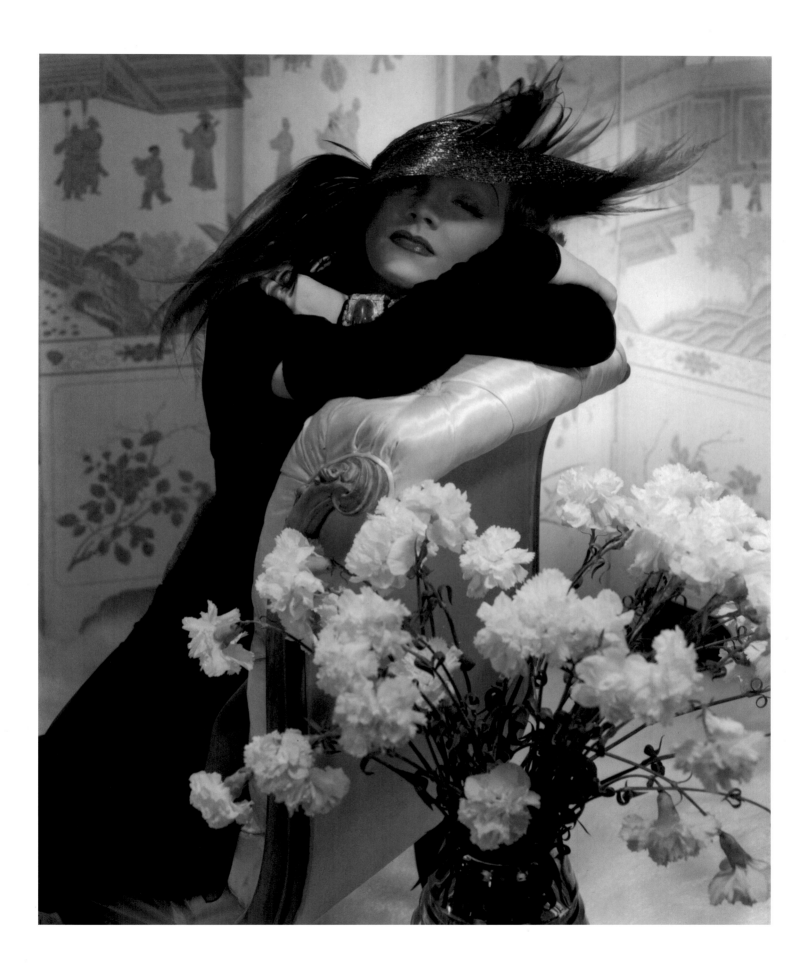

PLATE 222 | *Marlene Dietrich*, New York, 1932

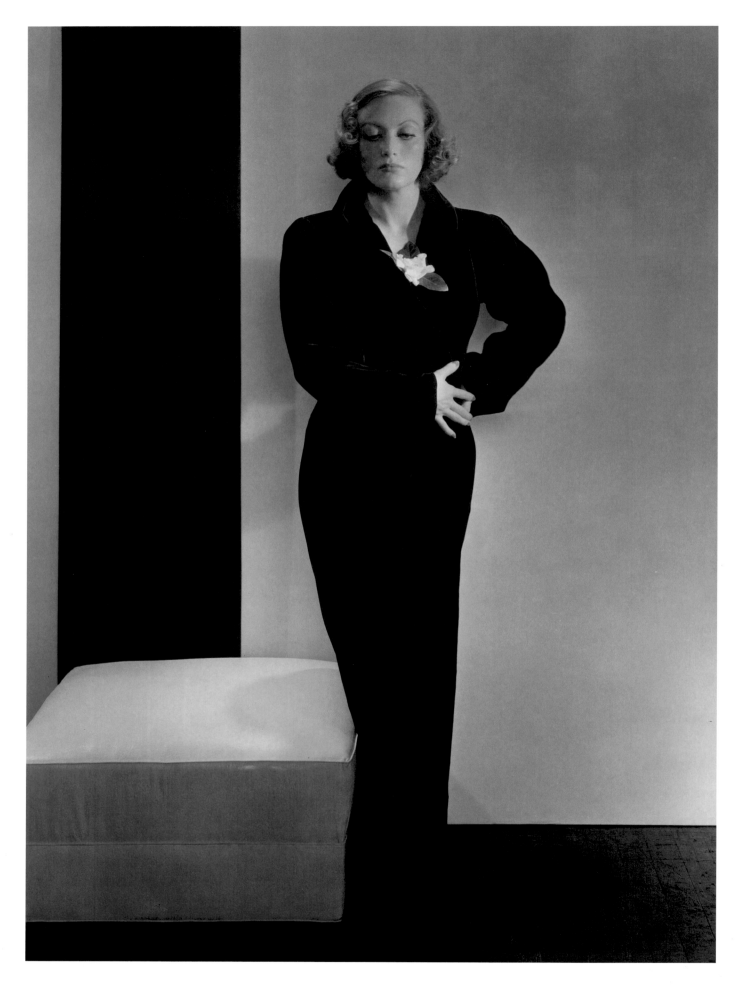

Joan Crawford, New York, 1932 | PLATE 223

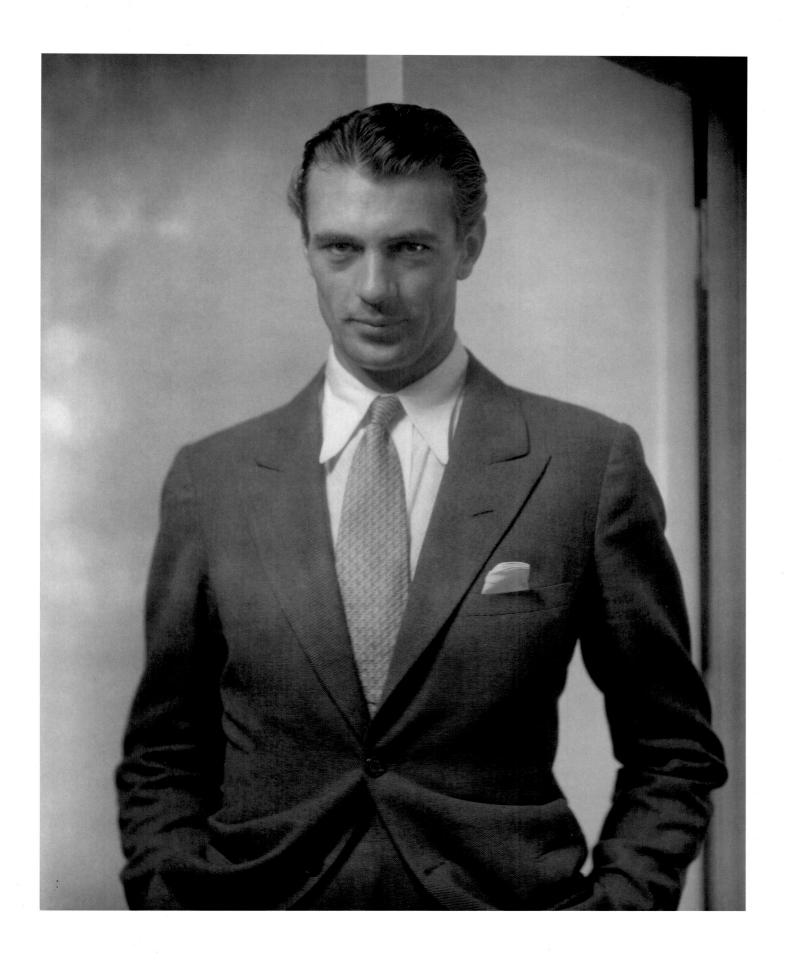

PLATE 224 | *Gary Cooper*, Hollywood, 1928

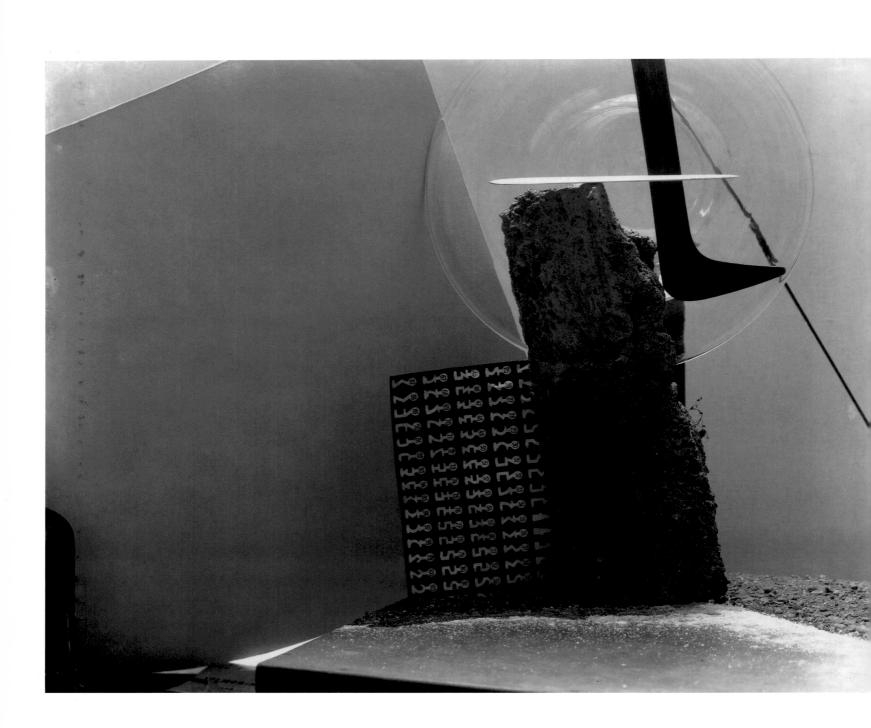

Time-Space Continuum, c. 1920 | PLATE 225

SCALE
AND SYMBOL

Control may give a man the privileges of making a fool of himself as well as creating a work of art.

—E.S., private notes

Steichen called the period from 1920 to 1923 three of the most productive years of his life, and I consider the work he produced then among the best, and the least publicly acknowledged, of his contributions to photography. World War I had ended, and he was depressed. He had experienced the danger of close artillery fire, observed the blood and bullet wounds of the dead at first hand, and, while he had never shot anyone, his work in charge of photo reconnaissance had located targets for killing. The idea that restored his interest in living and working again was to use art to make an affirmative contribution to life. To do that, he decided to reorient his entire approach to photography. He was through with painting and the pictorial style. In thinking about ways to communicate with a large audience, he became interested in photographs designed for the printed page. He returned to his house and garden at Voulangis and assigned himself a second apprenticeship.

That apprenticeship made it clearer than ever that photography was the ideal medium for Steichen with his combination of aptitudes for both the literal and the romantic, the scientific and the artistic. To refine his technique precisely, he experimented over one summer with a white cup and saucer. He photographed them against a graduated scale of tones from white through a continuum of grays to black velvet. Since he considered this exercise purely technical, he kept none of the prints or negatives. But other experiments produced results that were artistically as well as technically important. Every time Steichen set out to make the most realistic photograph of a subject, he ended up choosing or stumbling upon an artifice that made the final image appear more intensely real than any purely literal representation could do.

He wanted to find out how to represent volume, scale and weight in a photograph. His subjects were apples and pears picked from his own garden. He tried using sharp focus in direct sunlight, as in *Pear on a Plate* (plate 228), and, dissatisfied with its failure to represent volume sufficiently, devised some extraordinary experiments with diffused light. He constructed a tent of blankets in the greenhouse and placed both fruit and camera under it. In his own words, "From a tiny opening not larger than a nickel, I directed light against one side of the covering blanket, and this light, reflected from the blanket, was all. Then, to get as much

depth as possible, I made a small diaphragm that must have been roughly *f*28. I removed some of the blankets to compose and focus the picture, replaced them, and made a series of exposures that ran from six hours to thirty-six. The most successful ones took thirty-six hours."*

Steichen had not taken into account the contraction that occurred with the cool night air and the expansion in the warmth of daylight. Everything, including camera, fruit and covering, moved infinitesimally, and the camera produced not one but a series of overlapping sharp images. To the eye, they read as one, but one that gave the impression of being more than two-dimensional. Such images as *Three Pears and an Apple* (plate 229) and *An Apple, a Boulder, a Mountain* (plate 227), which retain their depth even when enlarged to four-by-five-foot mural size, became abstract images, experiments in scale.

Steichen first stumbled on the possibilities of what he called abstraction in photography with *Wheelbarrow with Flower Pots* (plate 144), when his friends came up with associations such as heavy artillery and logjams. He began to think that other literal photographs might offer metaphoric possibilities. Einstein's theory of relativity was being discussed everywhere at that time, so in *Time-Space Continuum* (plate 225) Steichen put together several objects that he considered symbols, including a locksmith's pattern sheet representing, I suppose, the key to the universe. No one understood it. He tried other symbolic arrangements. While a few viewers find it instantly clear that *From the Outer Rim* (plate 232) is phallic, *Triumph of the Egg* (plate 233) vaginal, and *Harmonica Riddle* (plate 234) suggests a pregnant belly and its impregnator, most observers from 1921 to the present have claimed to be baffled by these highlighted arrangements of glass bell, harmonica, orange and egg. Steichen concluded that symbols work only when they are universal.

Steichen's other quest in the 1920–1923 period was for a basic artistic discipline. He could not accept for himself the anything-goes autonomy of the postimpressionist painter. He turned to the memory of his one acknowledged mentor, Rodin, who had said, *"Quand on commence à comprendre la nature, les progrès ne cessent plus"* (When one begins to understand nature, progress never ends). So Steichen began to look for nature's discipline in the spiral shell (plate 231) and the ratios of plant growth, such as the pattern found in the arrangement of seeds on a sunflower (plate 240). He found Theodore Andrea Cooke's *The Curves of Life, Being an Account of Spiral Formations and Their Applications to Growth in Nature*, a book that discussed the spiral in everything from shells and plants to the spiral nebulae, as well as its use in architecture and Leonardo's findings relating the spiral to the proportions of the human body. Later, Jay Hambidge's *Dynamic Symmetry* claimed that the proportions found in the growth of the spiral were the basis of the Parthenon and ancient Greek vases.

Several realistic painters had used Hambidge's diagrammatic guidelines for proportion, but Steichen felt that, since these proportions were based in a two-dimensional system, they were better suited to abstraction. Using Hambidge's formulas, he cut out three triangles and began shaping them into a variety of figures, called Oochens, characters in an imaginary republic, intended for a chil-

A Life in Photography (New York: Doubleday, 1963).

dren's book. In making the tempera paintings of the Oochens according to the discipline of a grid laid out in the proportions of extreme and mean ratio, Steichen claimed he experienced an exhilarating sense of freedom that he had never known before in painting. He once boasted to me that the lines of his geometric paintings followed a strict discipline derived from nature, while Mondrian's were random, with the lines "just put wherever he pleased."

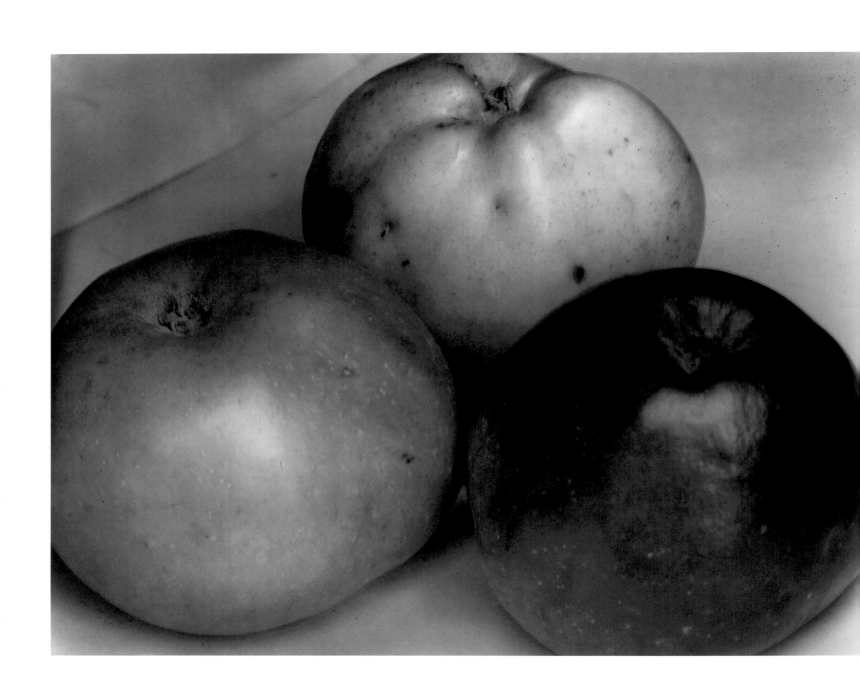

Three Apples, France, c. 1920 | PLATE 226

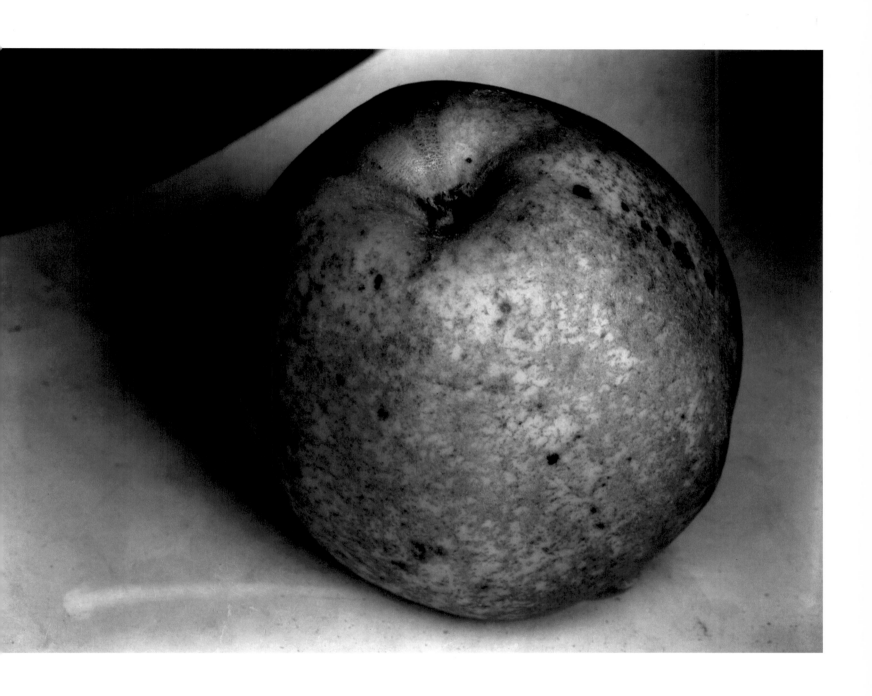

PLATE 227 | *An Apple, a Boulder, a Mountain*, France, c. 1921

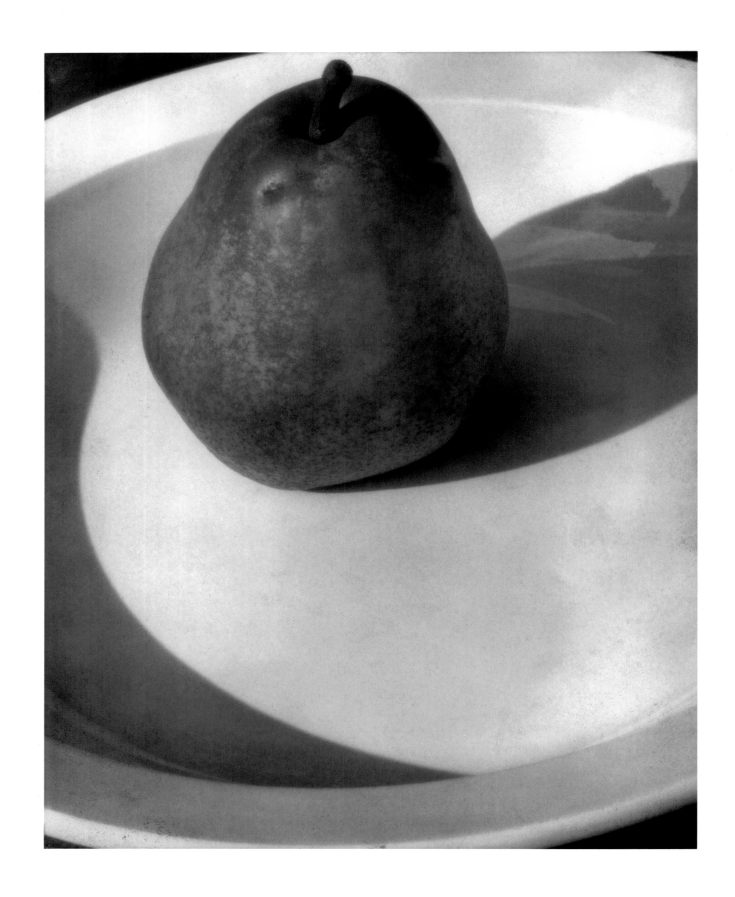

Pear on a Plate, France, c. 1920 | PLATE 228

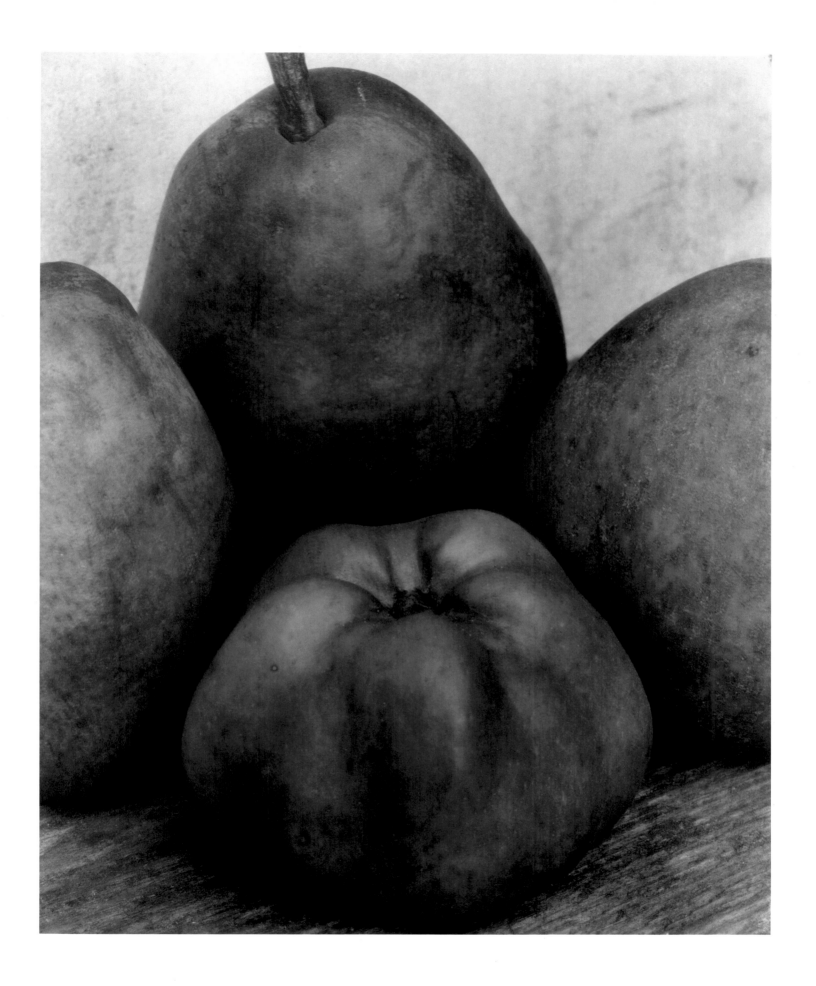

PLATE 229 | *Three Pears and an Apple*, France, c. 1921

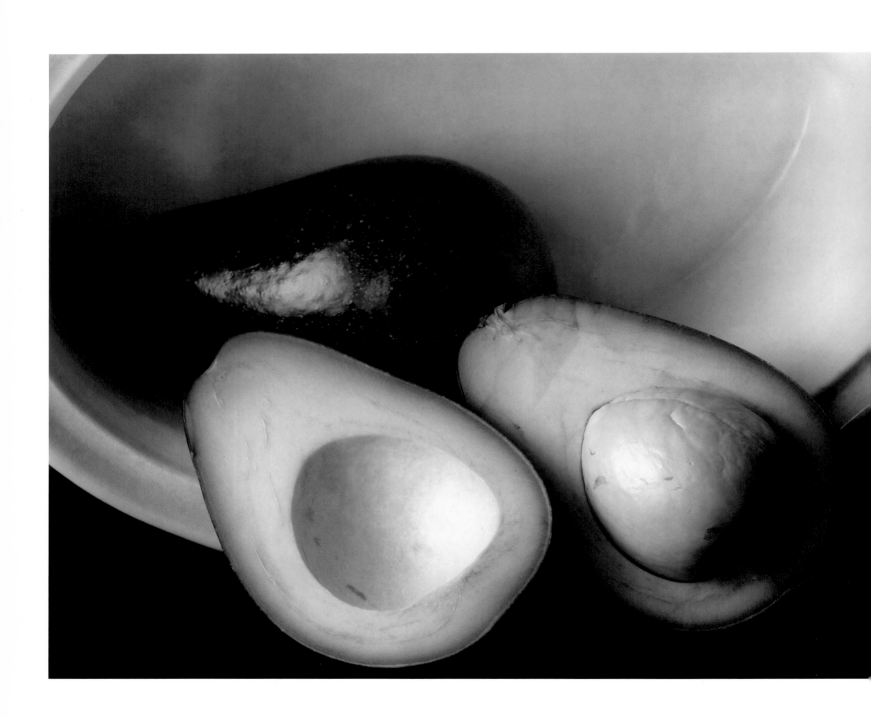

Avocado, France, c. 1920 | PLATE 230

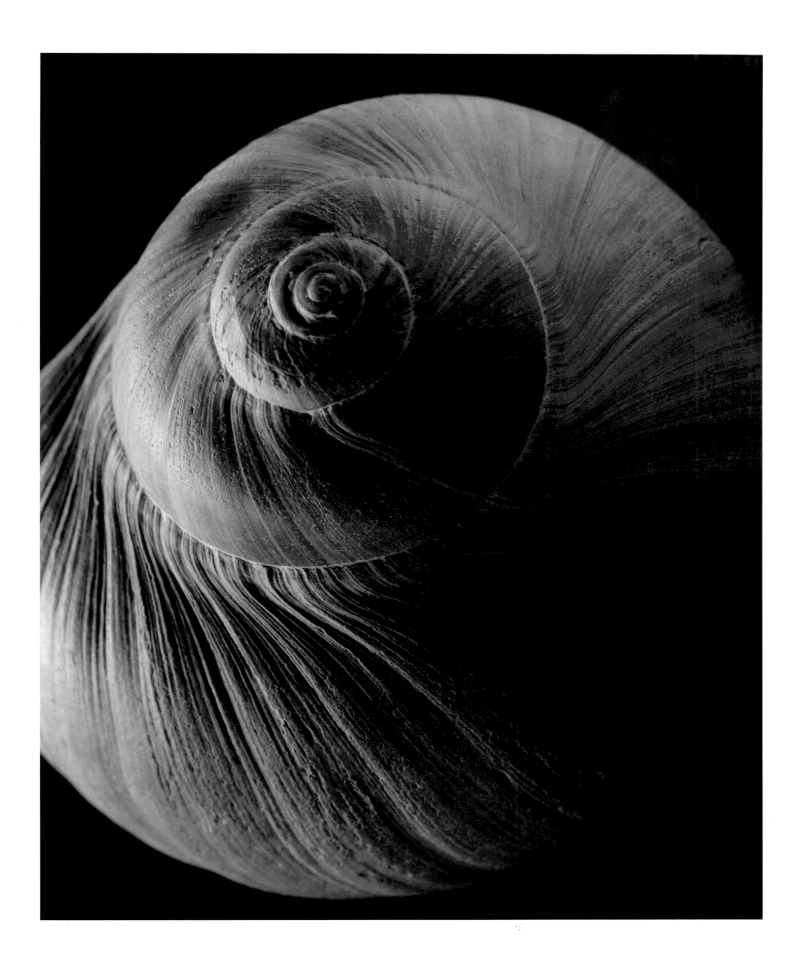

PLATE 231 | *Spiral Shell*, France, c. 1921

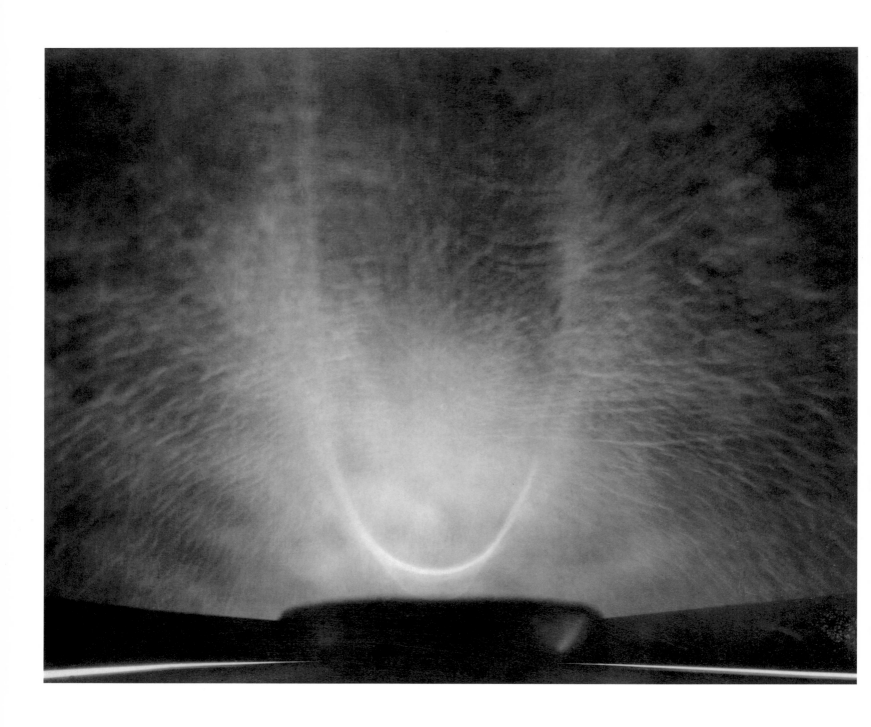

From the Outer Rim, France, c. 1921 | PLATE 232

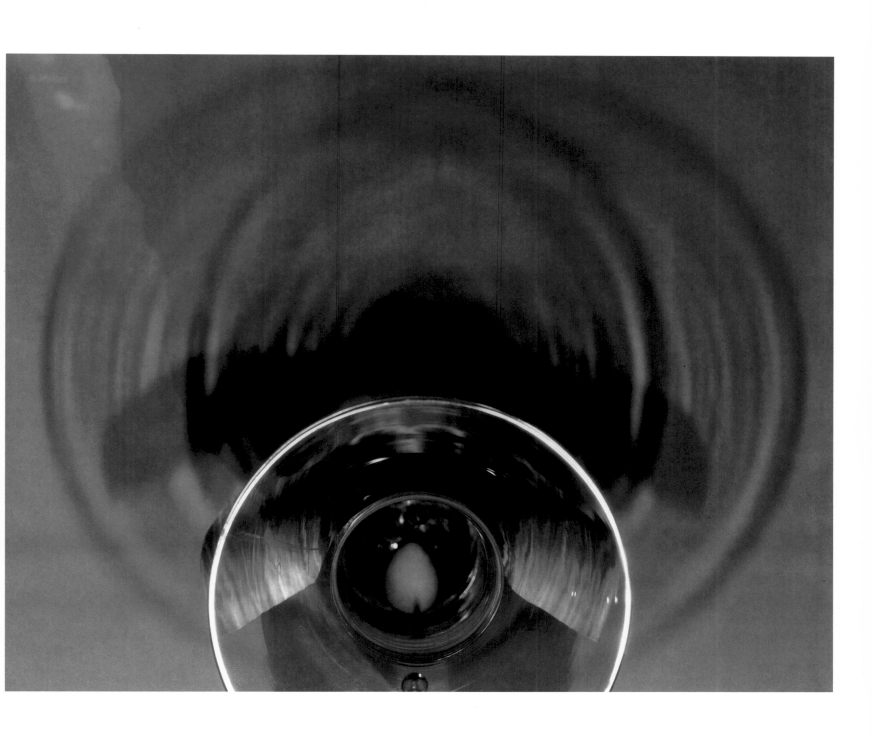

PLATE 233 | *Triumph of the Egg*, France, c. 1921

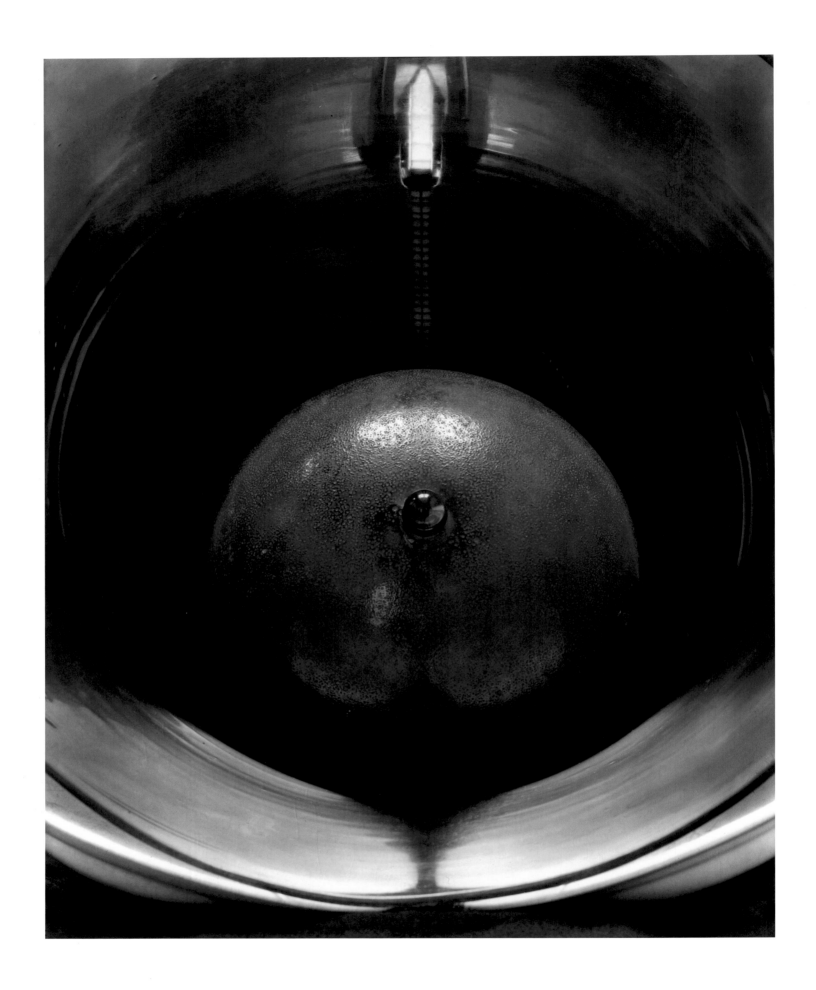

Harmonica Riddle, France, c. 1921 | PLATE 234

PLATE 235 | *Diagram of Doom #1*, France, c. 1921

Diagram of Doom #2, France, c. 1922 | PLATE 236

PLATE 237 | *Diagram of Doom #3*, New York, 1925

Spider and Web | PLATE 238

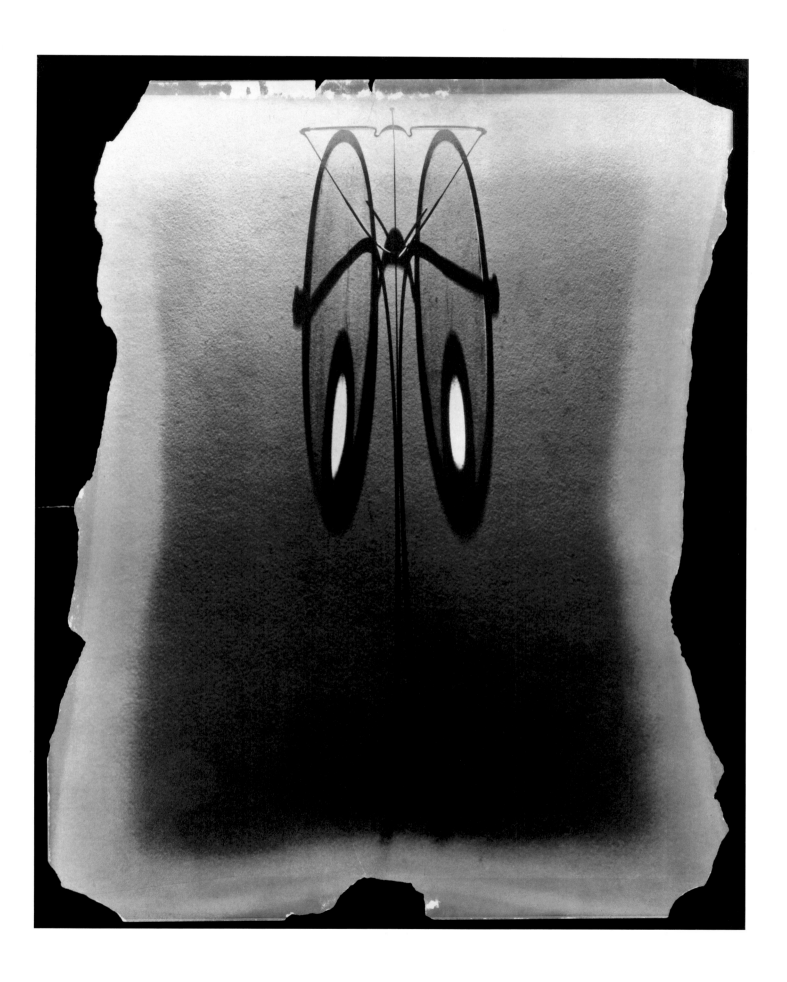

PLATE 239 | *Spectacle Butterfly*, New York, 1926

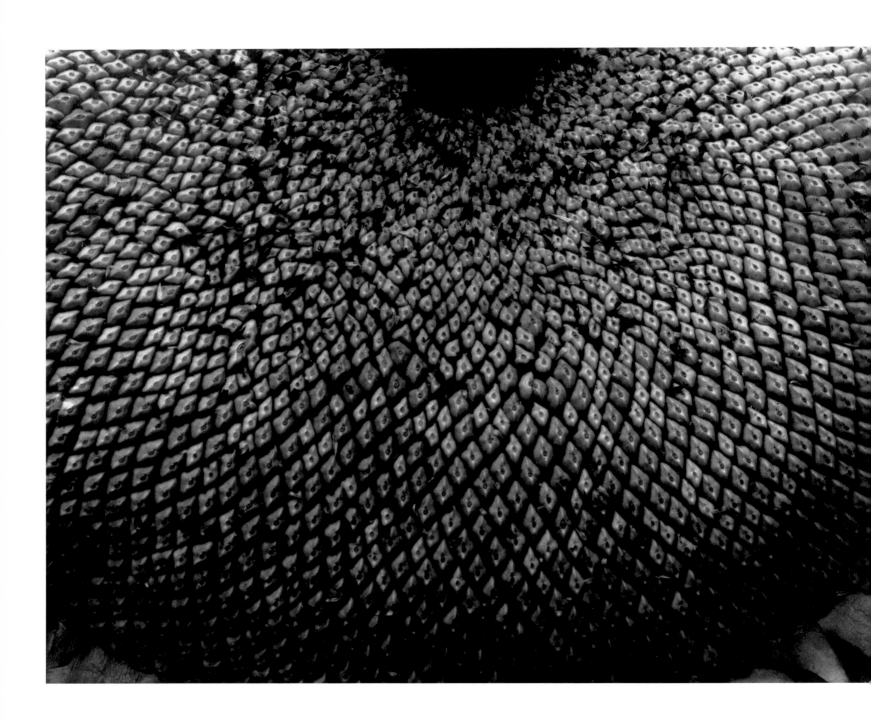

Sunflower Seeds, Part of series "Sunflowers from Seed to Seed," 1920–1961 | PLATE 240

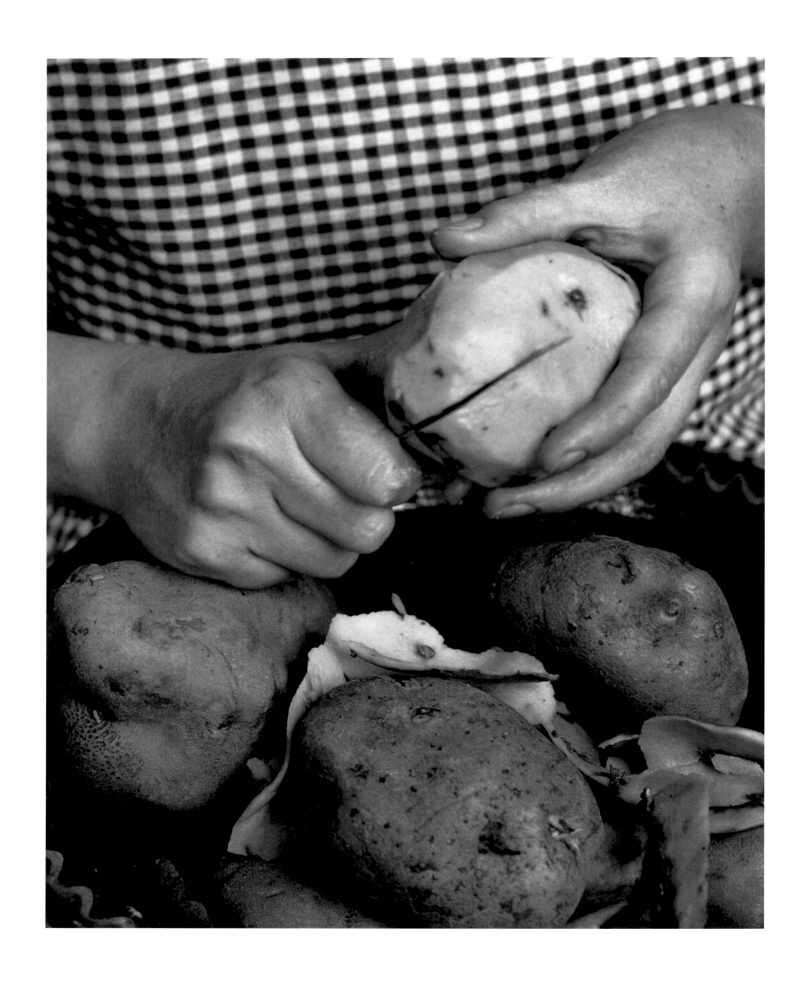

Peeling Potatoes, 1923. Advertisement for Jergens Lotion. | PLATE 241
The J. Walter Thompson Agency

IMPROVISATION

It must be as plain to you as it is to me that [creativity] cannot be regularly and artificially turned into producing masterpieces on a job assignment scheduled, say, for a Wednesday or Thursday at 2:30 p.m. On a job, we may be willing to settle for whatever we can connive, but I am convinced that to be a good job, it must partake of some of the basic essences of an inspired sense of reality. No trick effects or fancy angles can bluff their way and pass as creativity.

—E.S., notes for keynote speech at the
Photojournalism Conference in the West,
Asilomar, California, September 1961

In his quest after World War I for a way to reach large audiences with photography, Steichen considered becoming a movie director. Possibilities for motion always fascinated him. Late in life, he said that film was the real future of photography. With his commanding temperament, his mastery at manipulating composition and lighting and his ability to evoke and connect with moments of real emotion in his subjects, he probably would have done well. As a magazine photographer, he drew repeatedly on those same abilities, particularly in the improvisations he devised for advertising and theater scenes.

Shortly after he began photographing for *Vogue* and *Vanity Fair,* Steichen was asked to make photographs for some of the J. Walter Thompson advertising agency's clients. At the time, when photographs were used at all in ads, they tended to be stilted. Steichen brought them to naturalistic life. Later, he repudiated the tricks and seductions used by advertisers to sell goods, but at the beginning, he threw himself into these assignments with all the verve he always brought to a new challenge. For Jergens Lotion, to support the claim that a woman who did her own housework could keep her hands in beautiful condition by using the client's product, he wanted to show real women engaged in real work. A model with perfect hands peeling potatoes would not do. Mrs. Stanley Resor, the wife of the president of the agency, volunteered to pose for the ad herself, and Steichen was delighted with her proficiency at this lowly household task (plate 241).

Steichen was certainly not above tricks of his own. Product endorsement by a socialite has always been considered a draw, as has a pretty girl, but, in the 1920s and '30s, prominent society women did not feel obliged to remain young, slim and glamorous forever. So, to find models for Ponds Cold Cream, Steichen had the agency staff scour the suburbs until they located attractive young women who happened to bear the same names as well-known, older socialites.

To sell cameras and film for Eastman Kodak, Steichen refused again to use professional models. He had the agency look for "real people." He was delighted with the casting, but he went further to guarantee the results he wanted. He posed his people looking at stock snapshots unrelated to their own experience. At the last minute, he substituted lively snapshots of subjects that would be of interest to them and then, quickly, photographed their spontaneous expressions of genuine pleasure (plates 251–254).

Steichen remained proud of the advertising photographs he made for public service organizations like the Manhattan Eye, Ear and Throat Hospital (plate 257), the New York Post-Graduate Hospital, the Federation of Jewish Philanthropies and the Travelers' Aid Society. During the Depression, widespread homelessness was a relatively new phenomenon in New York, and the homeless women who came to the city to look for work or to relieve their families of a burden were often rounded up and given lodging for the night by the Travelers' Aid Society. To find models for a brochure, Steichen suggested that the agency staff bring him, without selection, the first twenty women who emerged from a shelter in the morning. For composition's sake, he told the women to face different directions and had some stand on tables, chairs and stepladders. At first they primped but, as they waited, they became absorbed in their own concerns, and their natural expressions returned (plate 258). He concentrated on doing his job, and he made sure the women were paid a fee, but he reported that he found the experience heartbreaking.

The point in the photographs of actors in this section is not individual portraiture but the story being told. Among Steichen's favorites were Beatrice Lillie as "Rule, Britannia" (plate 246) and Charlie Chaplin. Steichen claimed that Beatrice Lillie did all the work, and all he had to do was push the button. Chaplin, however, was shy when he didn't have an action to perform. So Steichen set up a scene consisting of a vertical panel and a horizontal one along which he moved a bowler hat a little closer to the actor with each shot. Armed with a cane as protection against the encroaching hat, Chaplin sprang to life (plate 242).

For *Vanity Fair*, Steichen often produced photographs designed to telegraph the spirit of a whole play. He would engage the cast in improvisations that might not represent an actual scene but would certainly tell a significant part of the story. Not all of these have worn well over time. One that has is the photograph of the three soldiers in Maxwell Anderson's *What Price Glory?* Steichen reminisced with the actors about his own Army days and came up with an improvisation based on looking for cooties in the trenches (plate 244).

The Green Pastures by Marc Connelly was a retelling of the Old Testament through Negro spirituals. Plate 259, shot with actors standing on different levels in the studio, represents the march to the Promised Land. Some of the actors appear twice in the two-page spread, because Steichen made it by joining two separate pictures together. In the play, the Angel Gabriel, God's right-hand man, carries the horn that, with one blast, can end the world. Periodically, as human sinning escalates, he turns to God and asks, "Now, Lawd? Now?" (plate 260).

Sometime after 1965, I did research for a chapter called "The Big Time Studio Photographer," part of a *Time-Life* book series. After spending a month or so interviewing fashion and advertising photographers and watching them at work in their studios, I came away with a clear idea of the differences between the photojournalist who catches things, in Cartier-Bresson's term, "on the run," and the impresario who arranges for everything to happen. Steichen—who, with hundreds of acres at his disposal, chose to build his house in the bottom of a bowl so that he could control his entire view—was definitely in the impresario category. Like the very best directors in stage or film, he had a practical magician's repertoire of ways to blend his intentions with his subjects' potential and create realities more convincing than life.

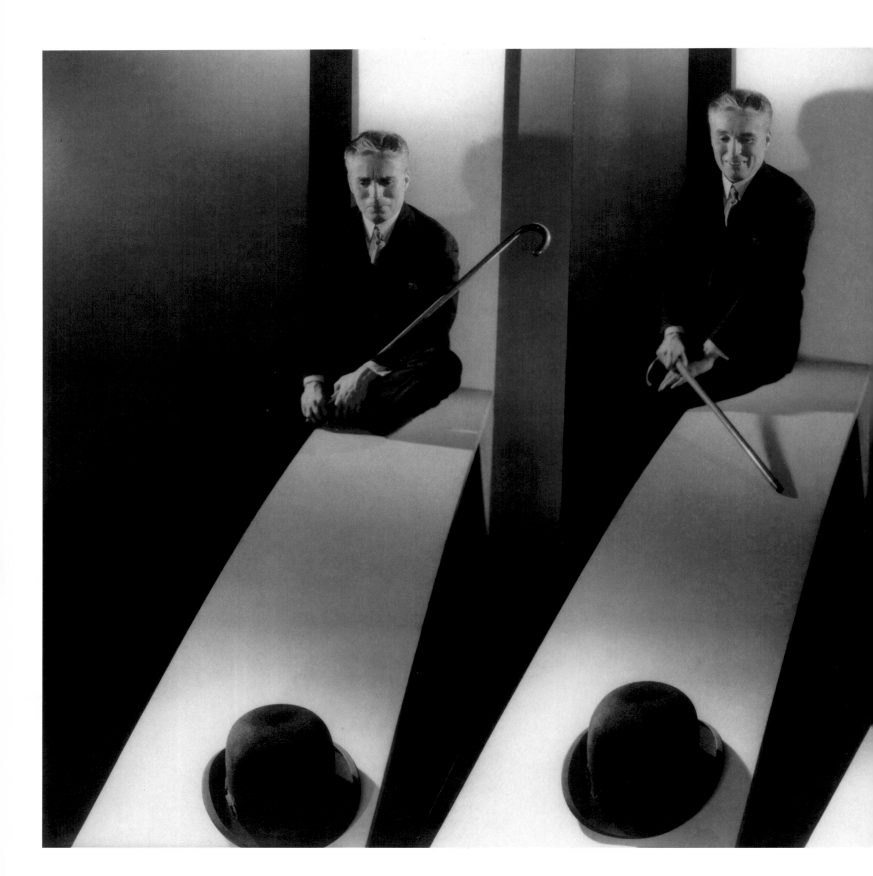

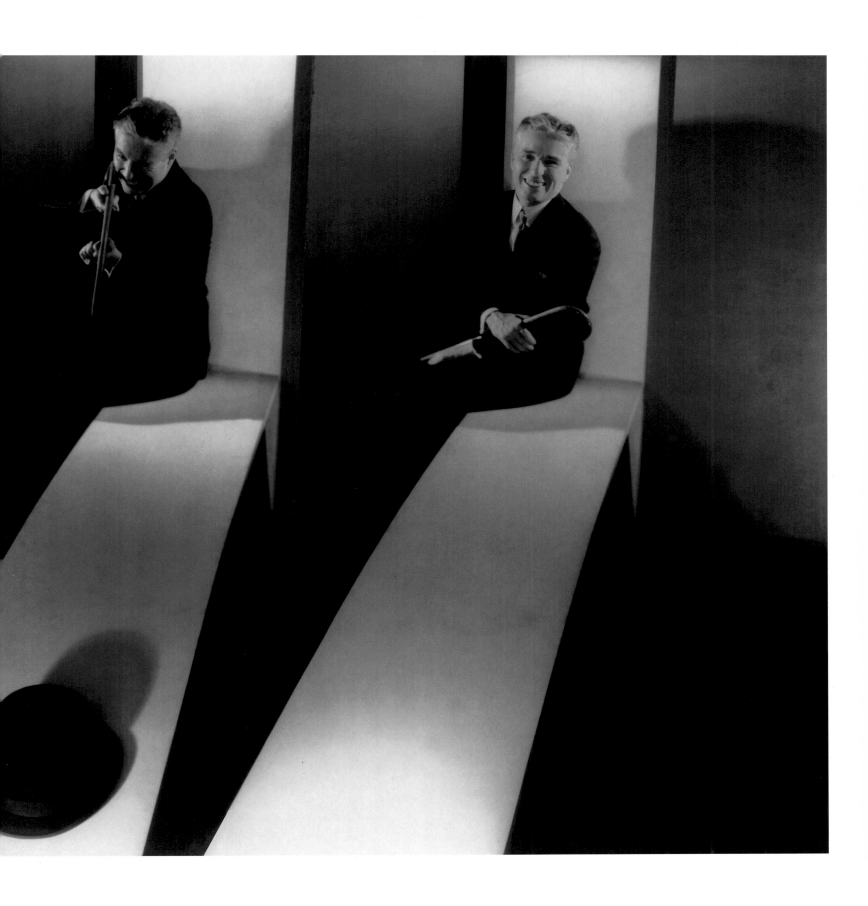

PLATE 242 | *Hat Trick — Charlie Chaplin*, New York, 1931

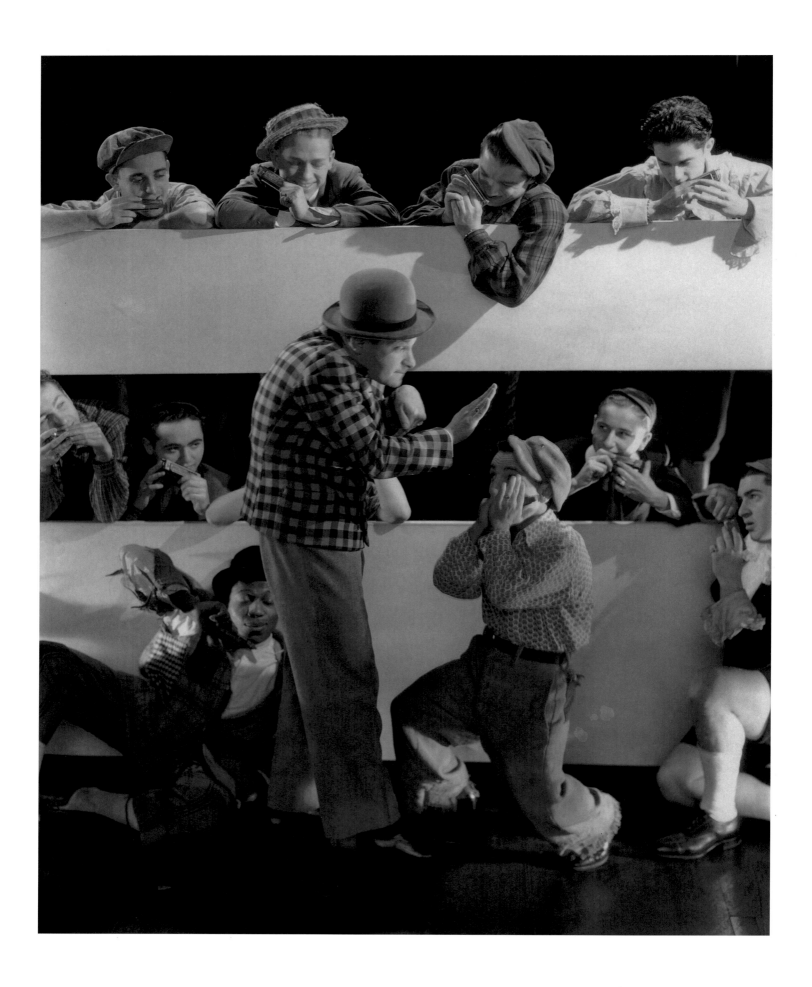

Borrah Minevitch and the Harmonica Rascals, 1931 | PLATE 243

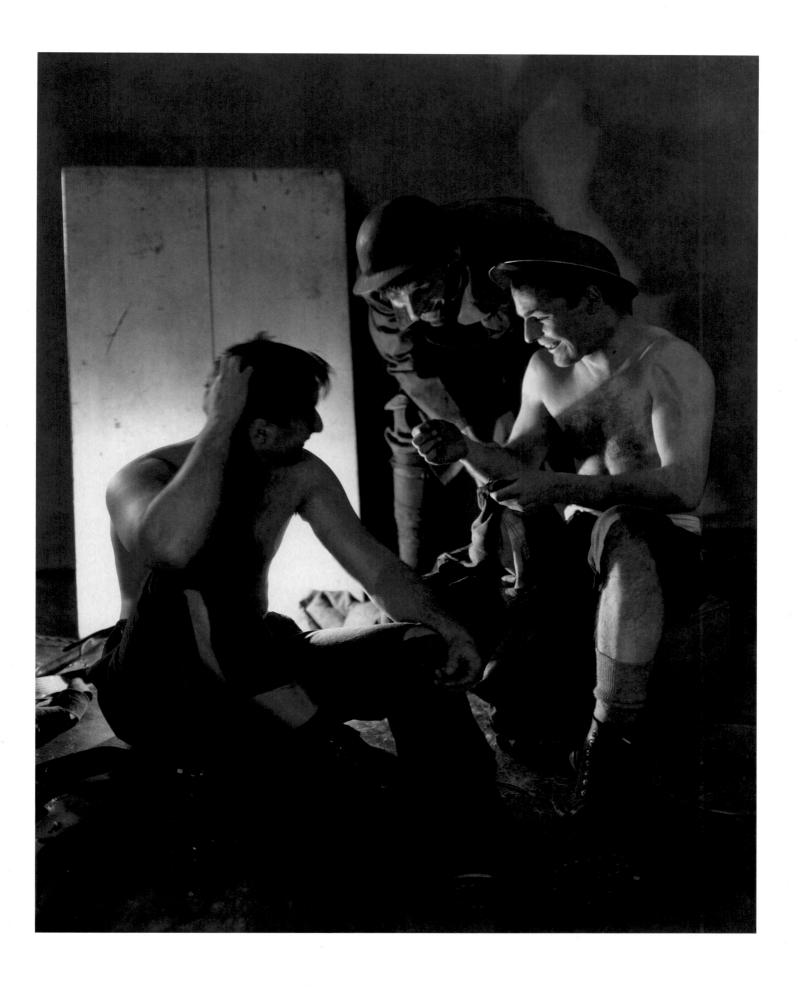

PLATE 244 | *"What Price Glory?"— Looking for Cooties*, New York, 1924

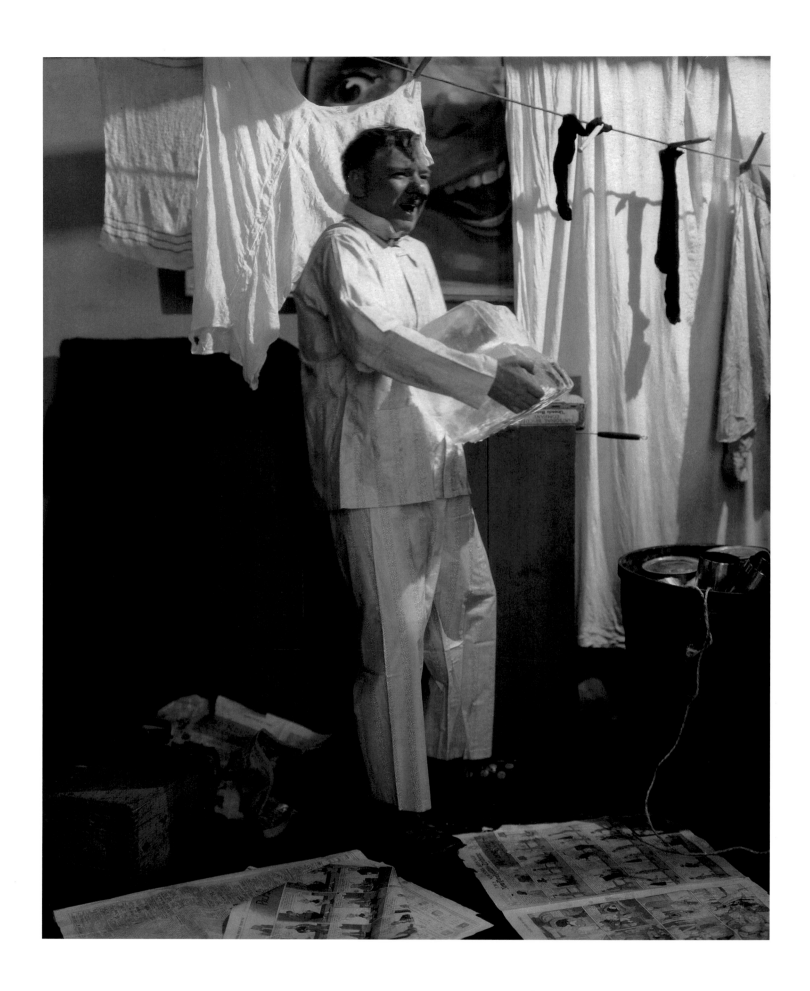

W. C. Fields, New York, 1925 | PLATE 245

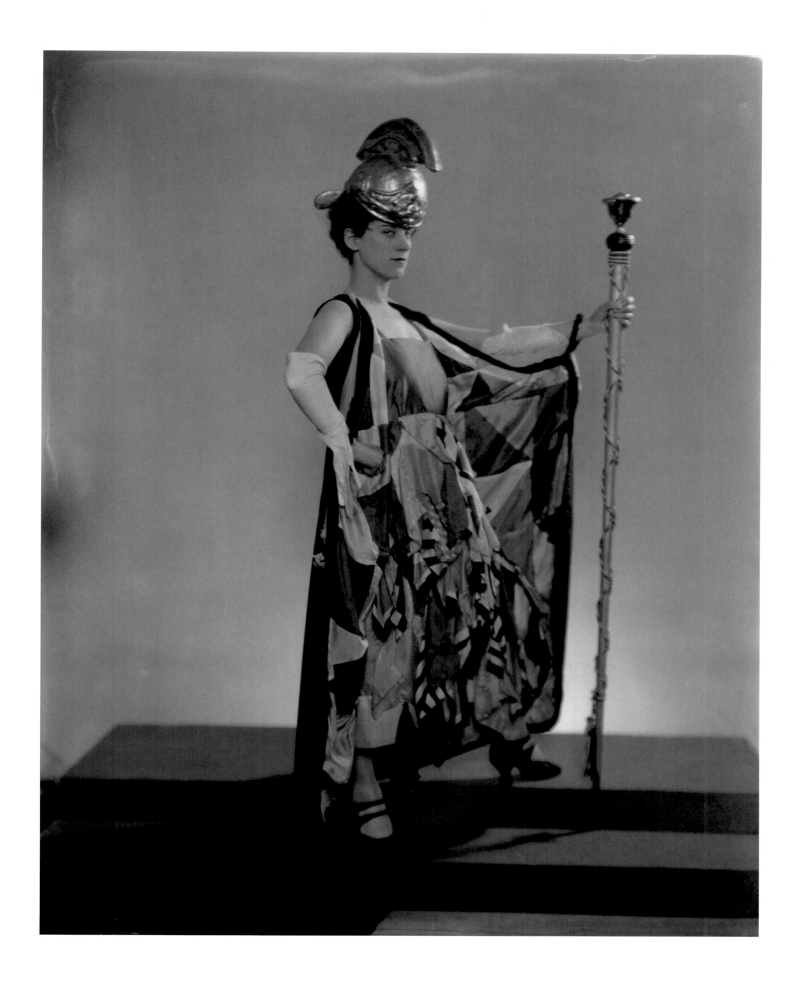

PLATE 246 | *Beatrice Lillie—"Rule, Britannia,"* New York, 1924

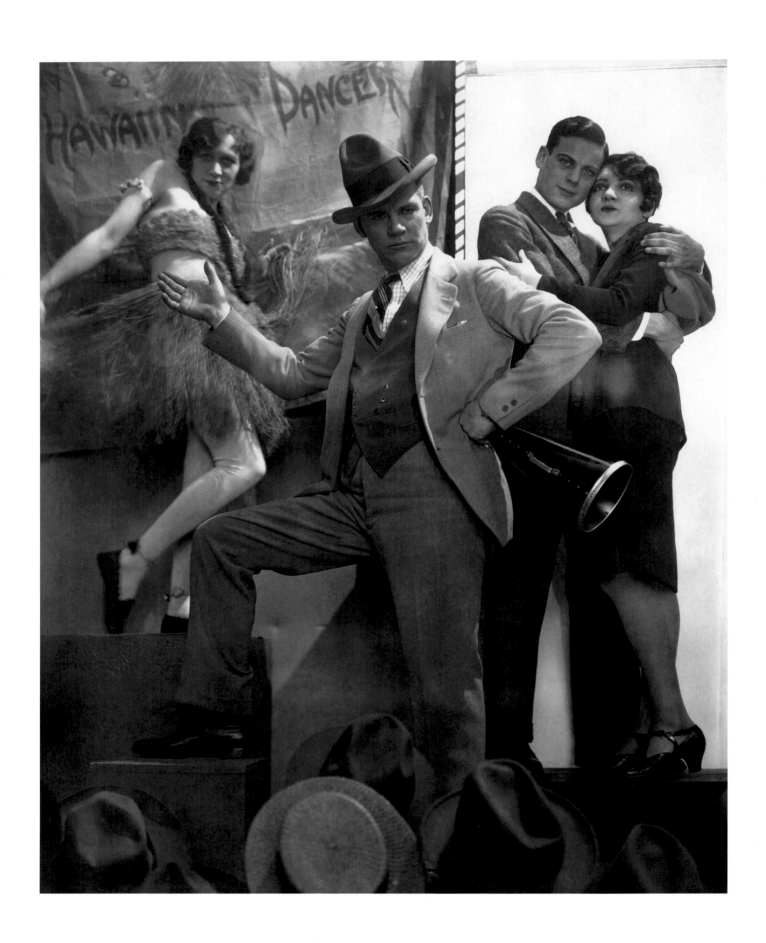

Walter Huston in "The Barker," New York, 1927 | PLATE 247

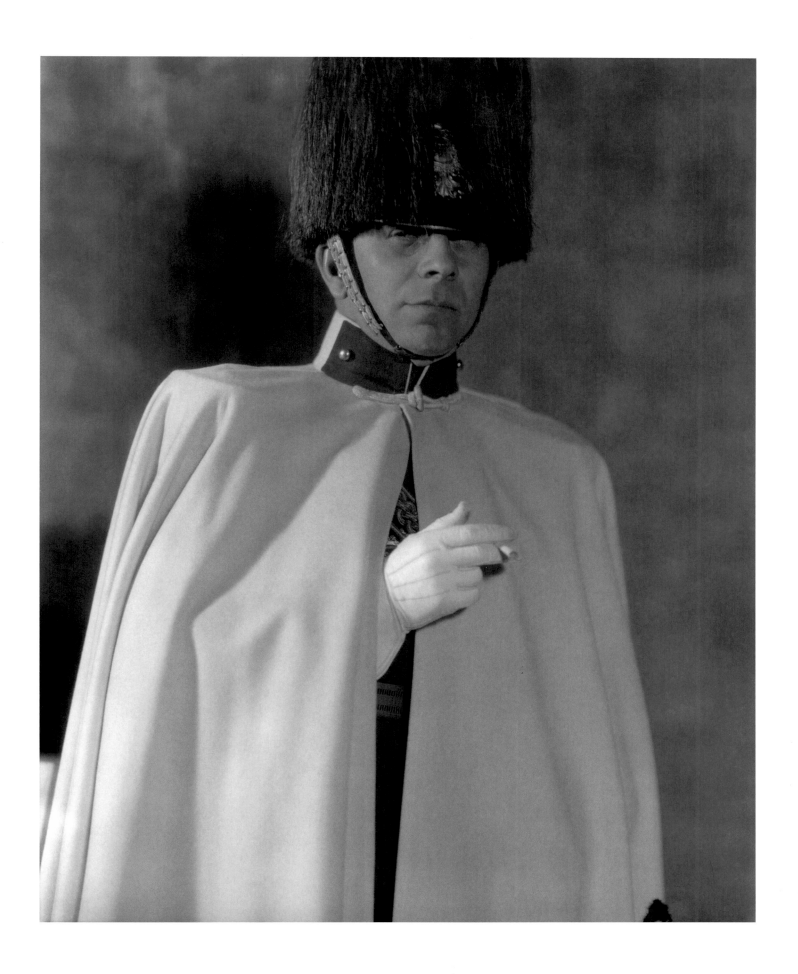

PLATE 248 | *Erich von Stroheim,* Hollywood, 1927

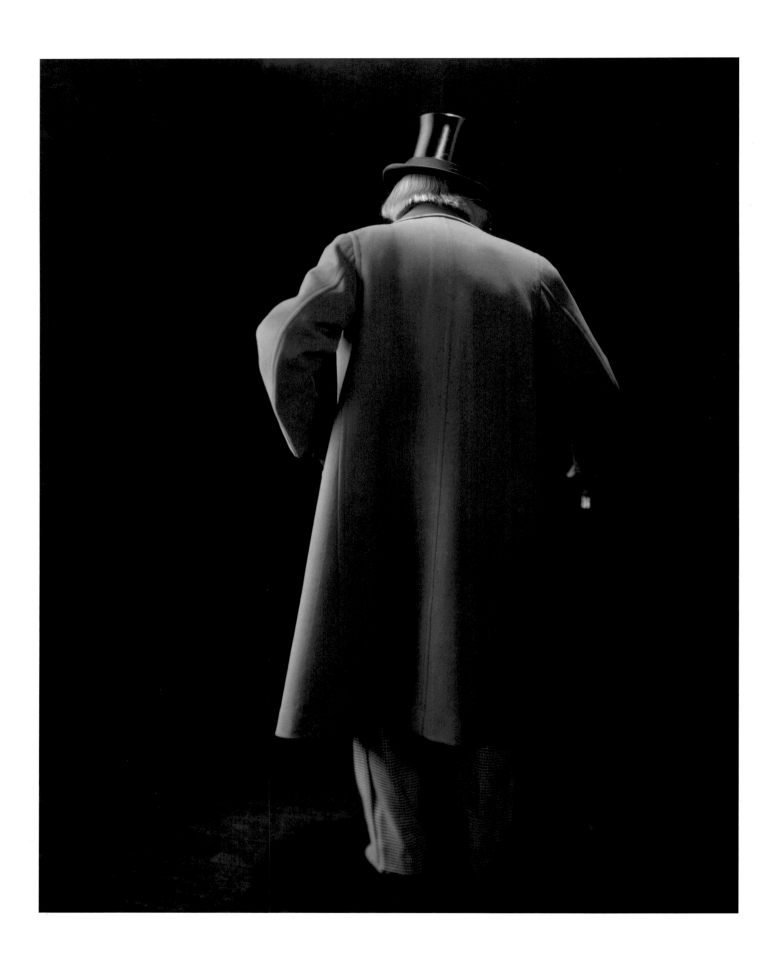

George Arliss in "Old English," New York, 1924 | PLATE 249

PLATE 250 | *Ed Wynn*, New York, 1930

PLATES 251–254 | Advertisements for Eastman Kodak, 1933. The J. Walter Thompson Agency

Loretta Young, 1932 | PLATE 255

PLATE 256 | *Morgan Farley in "An American Tragedy," 1926*

The Clinic Stairs, 1932. Publicity photograph for New York Eye, | PLATE 257
Ear and Throat Hospital. The J. Walter Thompson Agency

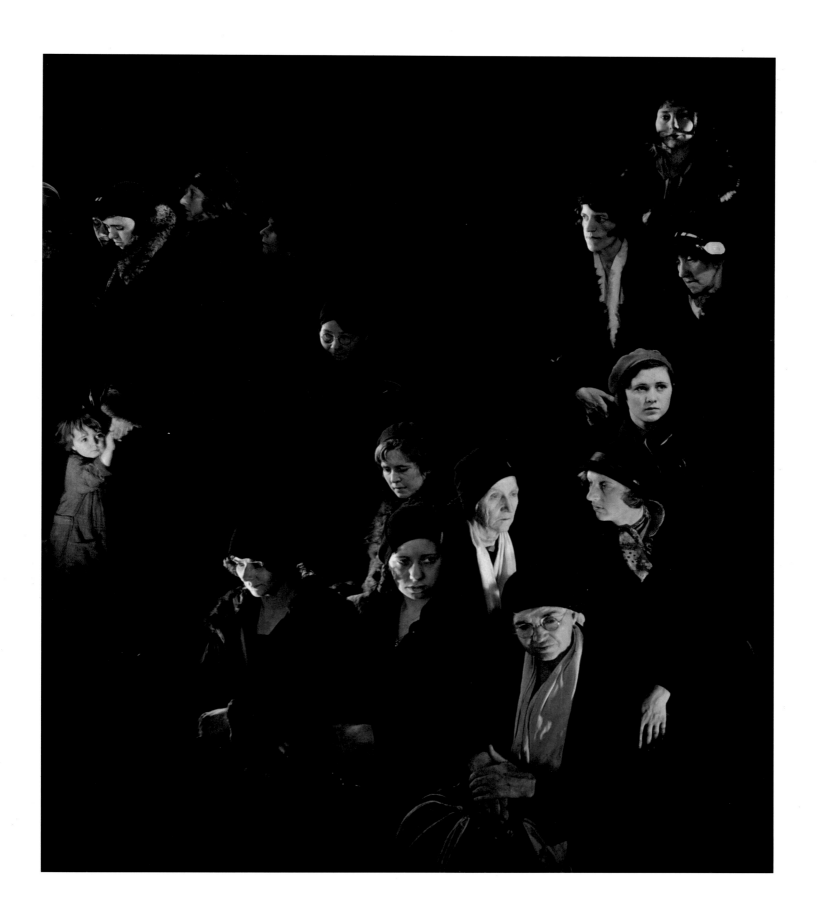

PLATE 258 | *Homeless Women — The Depression*, 1932. Publicity photograph for
Travelers' Aid Society. The J. Walter Thompson Agency

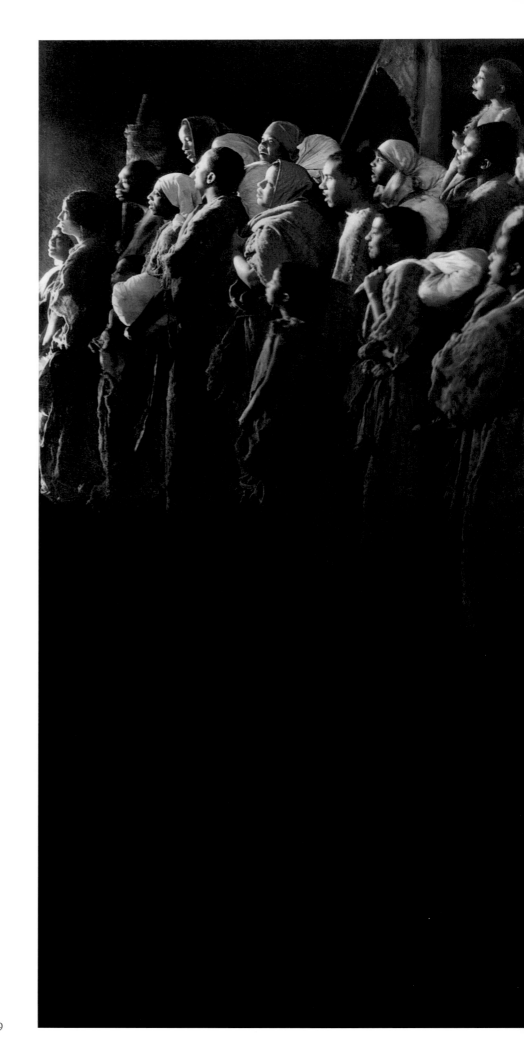

"The Green Pastures"—Exodus to the | PLATE 259
Promised Land, New York, 1930

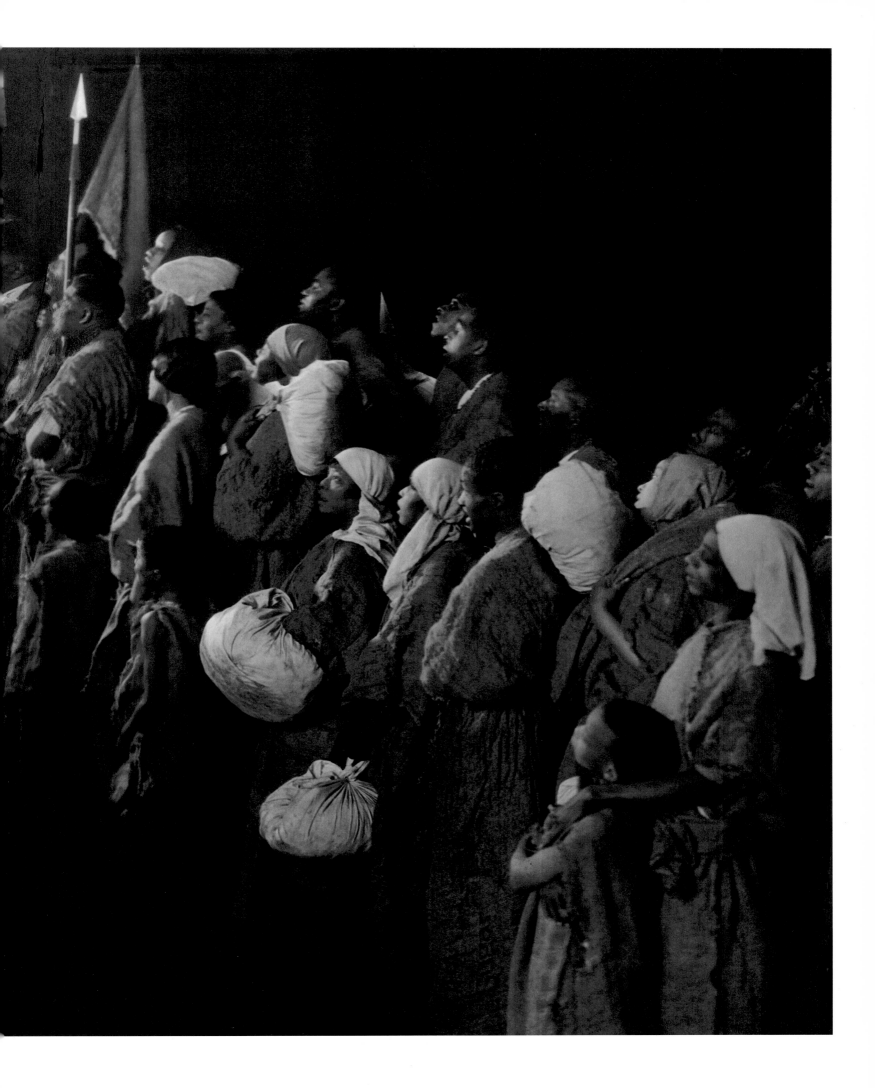

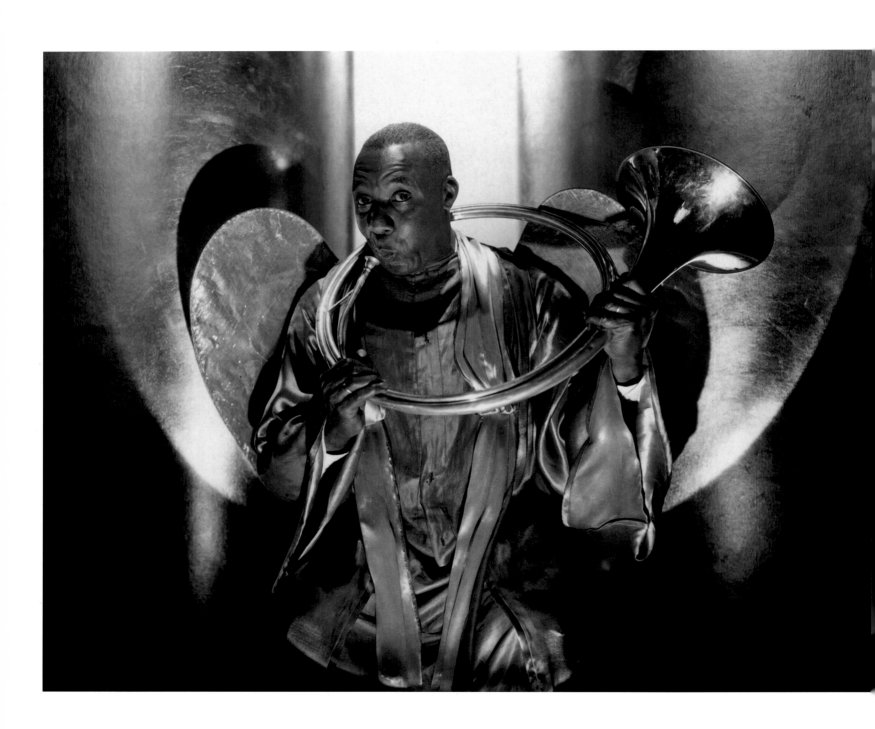

Wesley Hill as the Angel Gabriel in "The Green Pastures," New York, 1930 | PLATE 260

Venerable Tree Trunk, Umpawaug Farm, 1932 | PLATE 261

FORCES OF NATURE

Explore the universal through the particular.

—E.S., private notes

In this section, most of the images are of natural objects or creatures in detailed close-up. They were made over a forty-year span. Branches, bark, frost, rocks, a frog, a racehorse, children playing, these are among the most straightforward black-and-white photographs in the Steichen canon, and yet, even more than the images in the section called "Glamour," they are icons. Most are Steichen's personal icons, made for his own private satisfaction. He called these "'extracurricular' photographs . . . the stimulus that really kept me going."*

In 1906, when he discovered that a Steichen photographic portrait had become a status symbol, he fled back to France with his young family to avoid becoming a "stale stereotype." In 1947, when he became director of photography at MOMA, he stopped photographing in order to devote his entire attention to the work of others, but he allowed himself one exception: he could photograph the surroundings on his own farm. From 1923 to 1938, when, month after month, he turned out photographs of fashions and celebrities, stretching every mental muscle, and often physical ones, to keep the work fresh and challenging, he remembered Rodin's advice to go to nature for inspiration. Nature, courtesy of those woodlots outside of Milwaukee, was where he had started. A true nineteenth-century romantic, even in his optimistic embrace of every new mechanical device and art form, he revered nature, challenged it, relied on its regenerative powers. It was the contact with nature through the private photographs and his own hands-on, grand-scale gardening that kept him alive and interested in the magazine work for fifteen years. When at last, inevitably, the sittings became routine, he closed his studio.

At fifty-nine, he was eager for freedom to explore new photographic projects and devote more time to plant breeding. Along with his romantic devotion to nature, Steichen retained the capacity for wonder, particularly wonder at the ever evolving processes and uses of photography. He called photography both the easiest and the most difficult medium. It was easy in the sense that anyone could pick up a loaded camera, press the button and get some kind of result. It was difficult because it presented the artist with a prearranged set of visual information that could frustrate even an inspired and relentless tinkerer like himself. On the

A Life in Photography (New York: Doubleday, 1963).

other hand, Steichen, the artist who found the rigorous geometric discipline of the golden mean freeing, could and did respond with the same kind of inventive joy to the physical limitations of the camera.

In *A Life in Photography*, pleading the importance of an artist's freedom, Steichen wrote that it can be "curtailed by commercial conditions or by the theories of aesthetics ordained by various groups, cults, cliques or isms. But it seems to me that the most damaging restrictions on an artist's liberty are self-imposed. So often, what may have begun as fresh thinking and discovery is turned into a routine and reduced to mere habit. Habits in thinking or technique are always stultifying in the long run. They are also contagious, and when a certain set of habits becomes general, a whole art period can condemn itself to the loss of freedom. It is probably this stultifying process, more than anything else, that transforms the avant-garde of one generation into academicians in the eyes of the next."

Periodically, Steichen agonized over questions of the artist's value to society and his own yearning to use the photographer's art to enhance human experience. His broadest public achievement in this vein was *The Family of Man*, but in photographing fragments of natural objects, he shared with others the private things that most enhanced his own life. A silvery curl of bark (plate 263) or its deep and ancient grain (plate 261), a held breath of raindrops (plate 270), wriggling ribbons of watery light (plate 264), a windswept mane (plate 262), a joyful splash (plate 272), they all make the point. How exhilarating, how wondrous, the smallest details of life in its natural forms can be.

PLATE 262 | *Gallant Fox*, Long Island, New York, 1930

Birch Bark, 1934. For the Limited Editions | PLATE 263
Club 1936 edition of Thoreau's *Walden*

PLATE 264 | *"The Water Laves the Shore As It Did a Thousand Years Ago"* (Thoreau), 1934.
For the Limited Editions Club 1936 edition of Thoreau's *Walden*

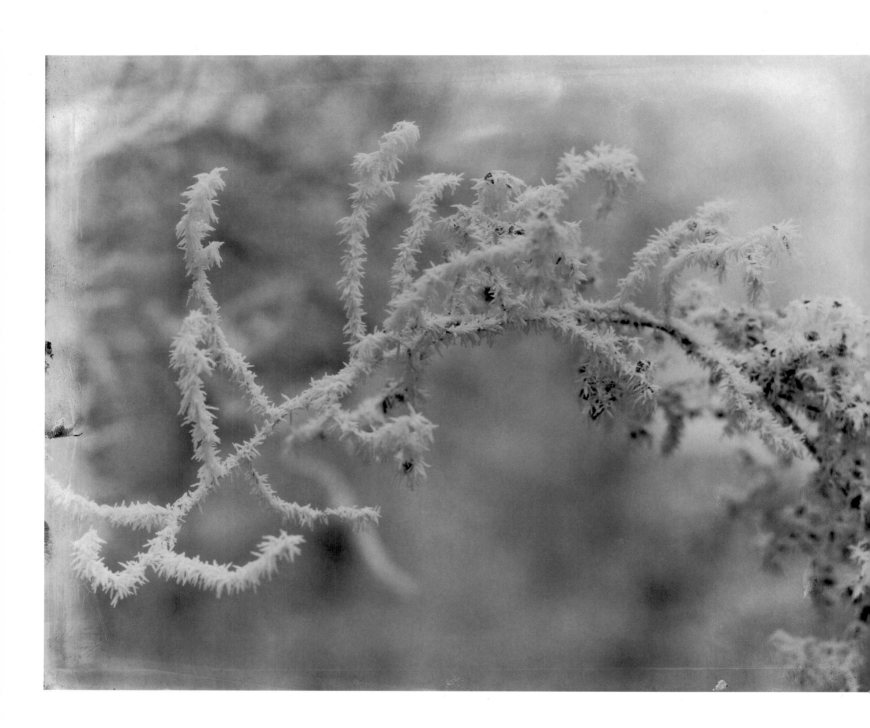

Snow Frost, 1920 | PLATE 265

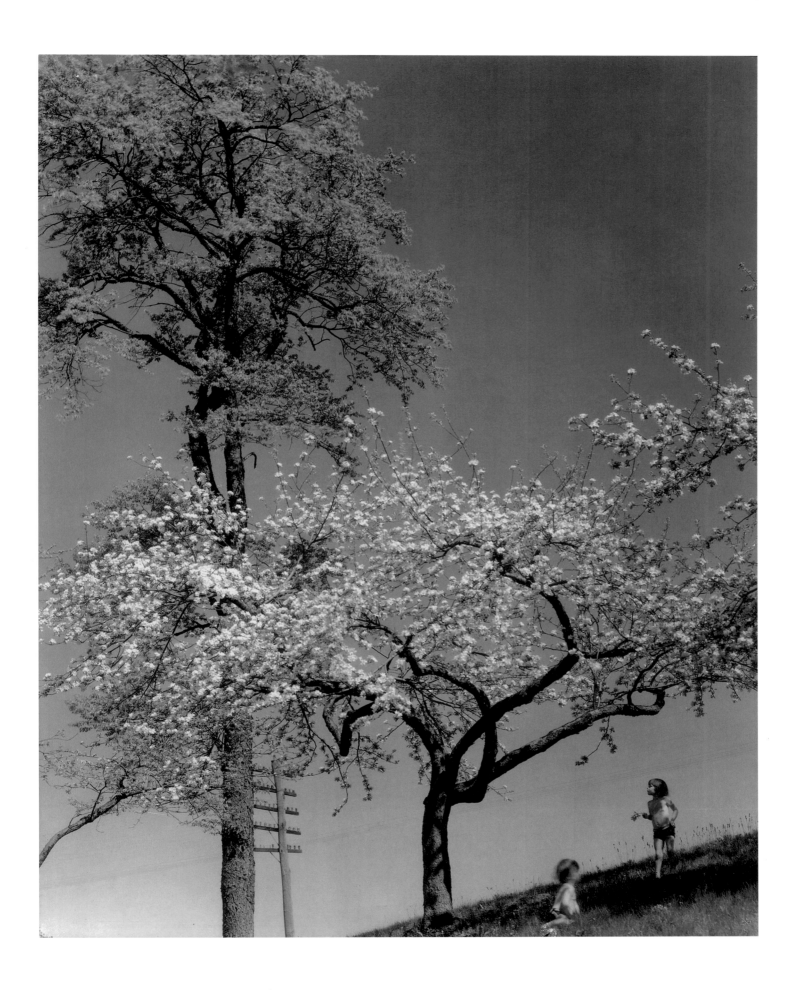

PLATE 266 | *Singing Wires and Buzzing Bees* (Nell and Joan Martin), Umpawaug Farm, 1932

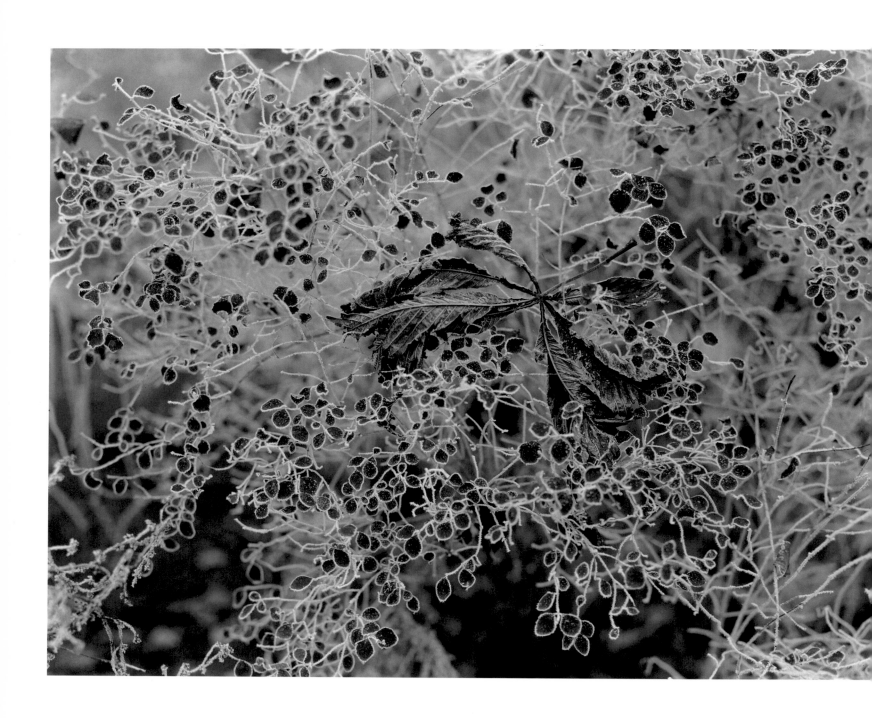

Interloper, Voulangis, France, 1920 | PLATE 267

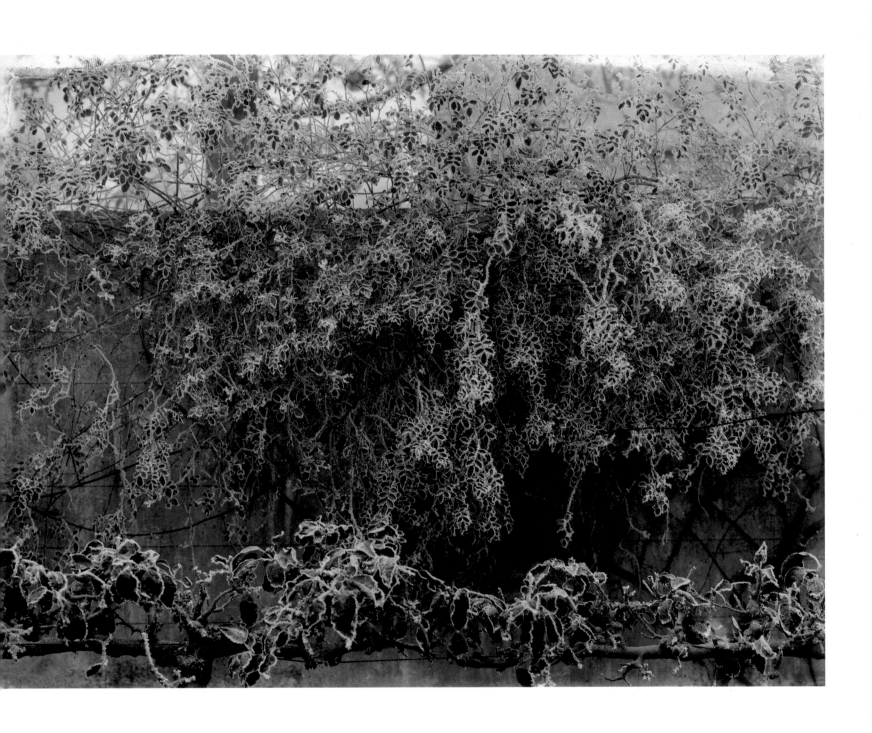

PLATE 268 | *Frost on Rambler Roses,* Voulangis, France, 1920

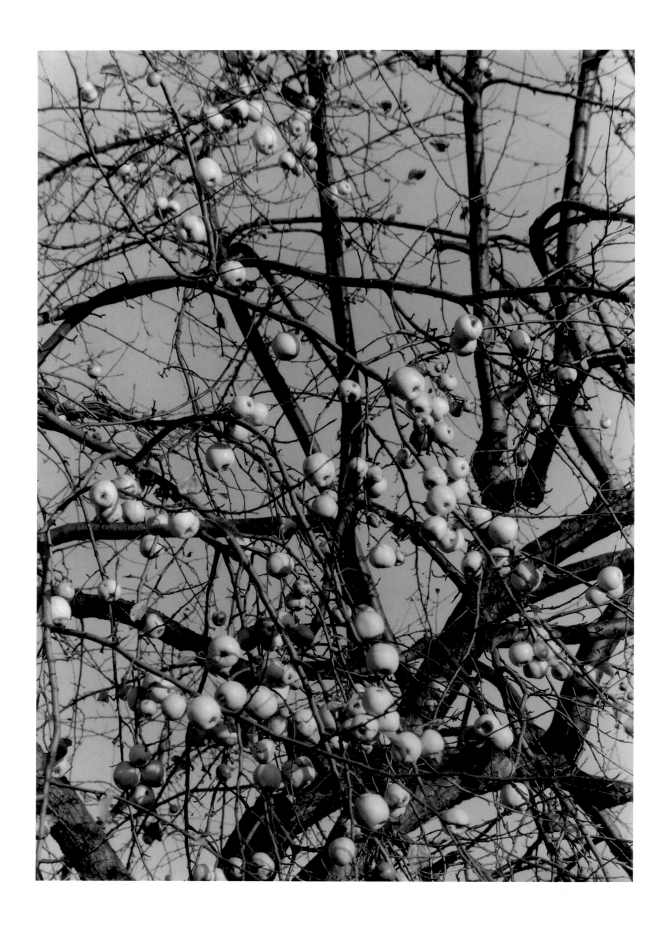

Crabapples, Umpawaug Farm, 1930s | PLATE 269

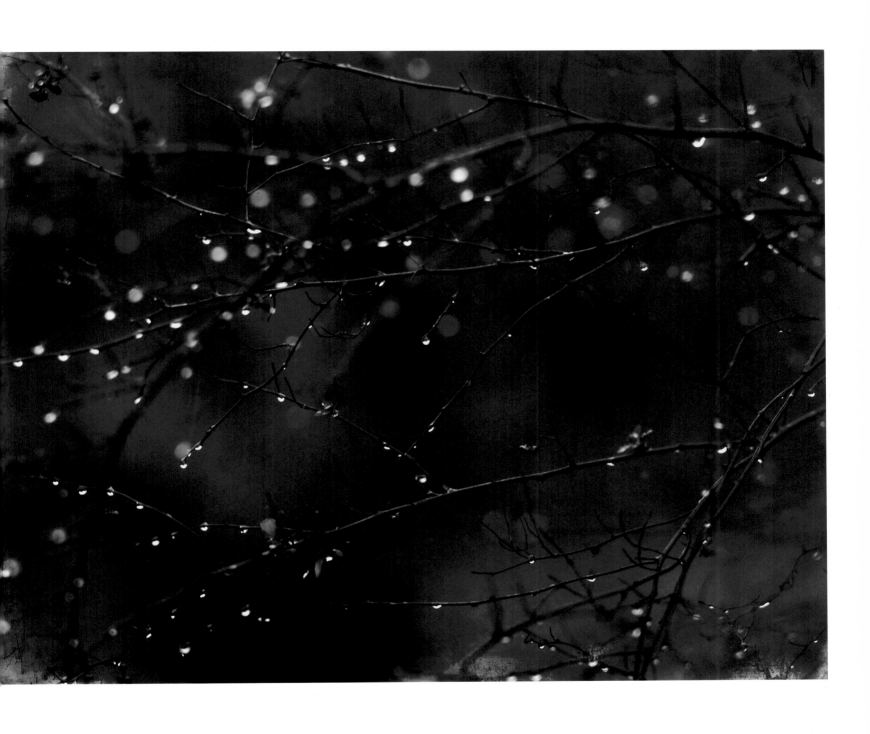

PLATE 270 | *Raindrops on Branches,* France, 1920

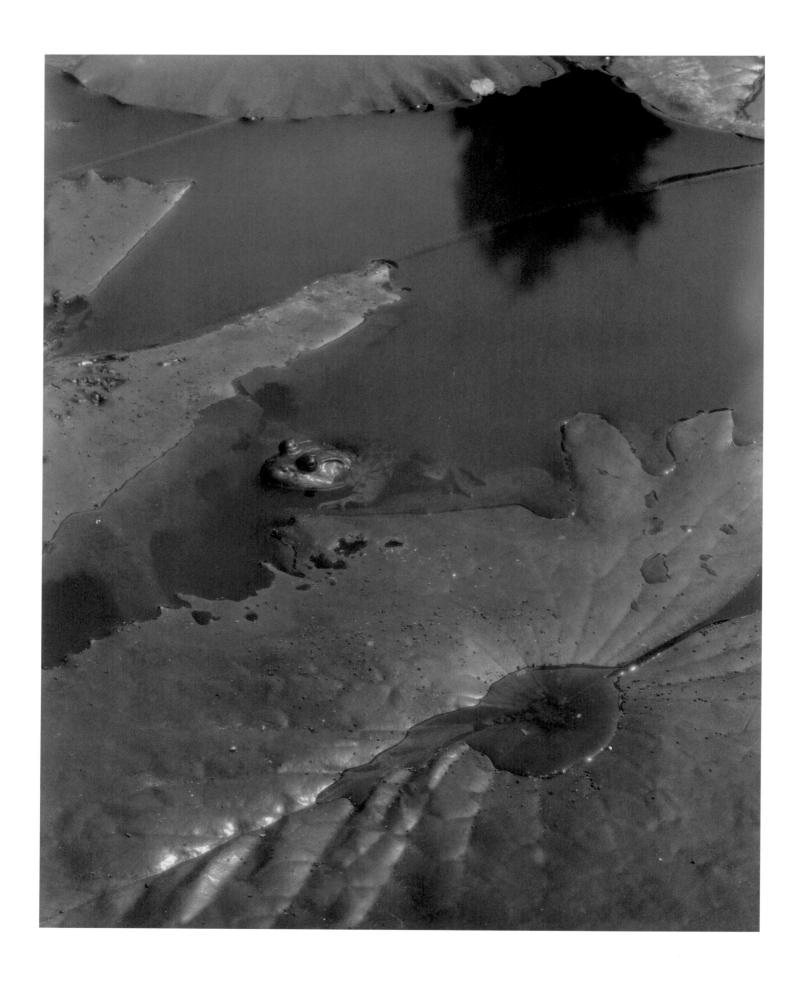

Frog on Lily Pad, Seven Springs Farm, Mount Kisco, New York, 1915 | PLATE 271

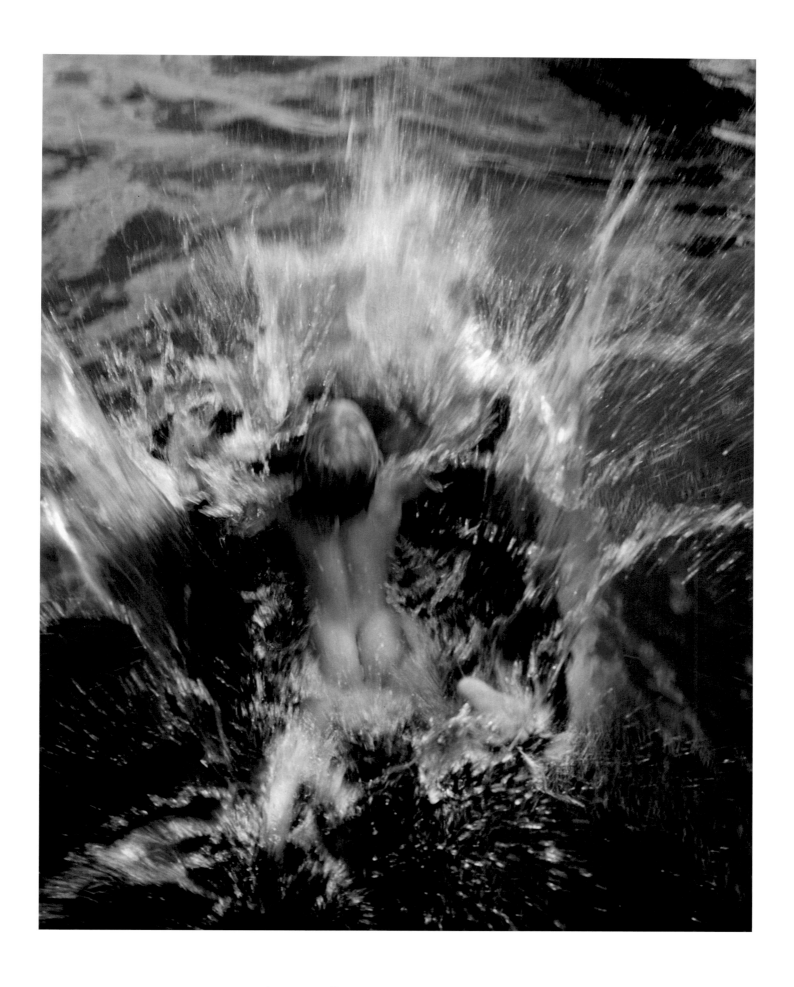

PLATE 272 | *Dana Miller at Umpawaug Pond,* 1954

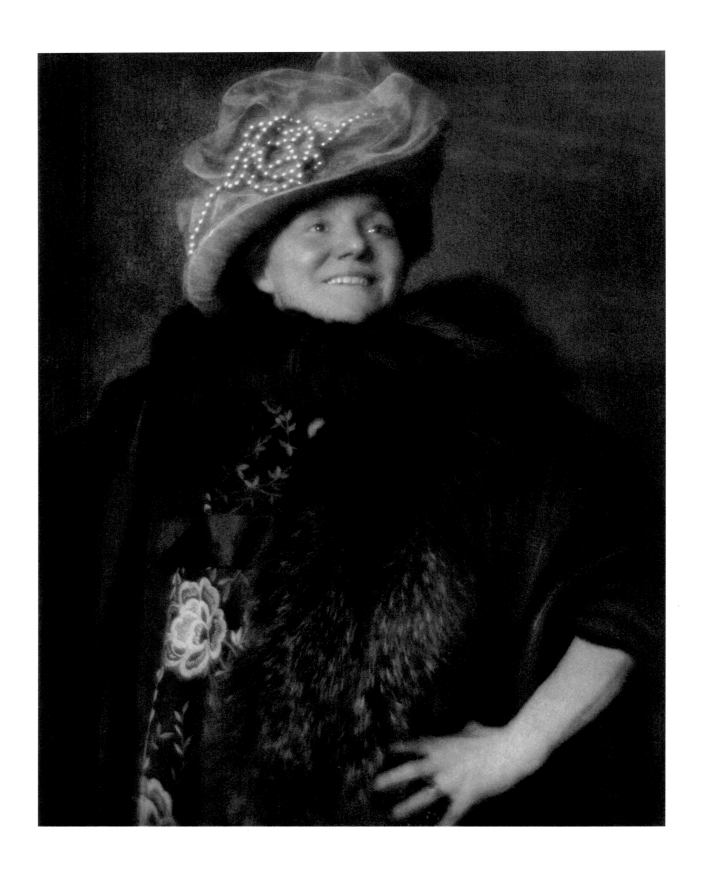

Vitality — Yvette Guilbert, Paris, 1901 | PLATE 273

ON STAGE

We are all too prone to drift along relying on the impetus of past achievements to carry us into the unknown future. We are sometimes even so carried away by the importance of what we think we are doing that we forget the role personal humility plays before the vast things that remain unaccomplished or not even begun. Let us not be led into the trap of self-satisfaction, the futility of trying to find deep and esoteric meanings in photographs we have made, because this usually results in obfuscation. The meaning of a good photograph and its significance will not escape an intelligent observer, just as no amount of slick phrases will in the long run successfully mask a vacuum that may be there.

—E.S., notes for keynote speech at the
Photojournalism Conference in the West,
Asilomar, California, September 1961

In his commercial years, Steichen had much in common with the successful actors he photographed. Whether they were enthusiastic or weary, inspired or distracted, the scheduled performance had to go on, the sitting had to be shot. There were times when both actor and photographer had to rely on technique to get them through and hope that technique would, in the words of the renowned acting teacher Michael Chekhov, "awaken his emotions and stir his imagination to such an extent that the barely smoldering spark of inspiration will suddenly flare up and burn brightly."*

Steichen told very few stories about his celebrity sitters. There was a heavy volume of work to be turned out by his studio, and his attention was on the elements that would make an engaging picture, not tidbits of gossip for dining out. When he did have a story, it was usually more about his own role in solving difficulties under pressure.

For an actor, sitting for a portrait was not unlike a regular day's work. He or she showed up, donned a costume (either one out of the wardrobe of the current play or street clothes appropriate to his public image) and assumed his role. A few actors were uneasy simply posing and needed the photographer/director to assign a task, a scene to play. Some, as we have seen in "Improvisation," cooperated brilliantly with Steichen by inventing new characters in the studio. With other performers, like the radio comedian Eddie Cantor (plate 285) and the chanteuse Yvette Guilbert (plate 273), the role was the performer's vivid personality itself. In the portrait of Paul Robeson as Eugene O'Neill's beleaguered

*Michael Chekhov, *To the Actor on the Technique of Acting* (New York: Harper & Brothers Publishers, 1953).

Emperor Jones (plate 276), it is tempting to assign prescience to Steichen and read into the photograph Robeson's future as a valiant, battered crusader for civil rights and equal opportunity.

Steichen had great respect for the actors who, like Katharine Cornell, fully inhabited their roles and seemed simply to become the characters they played (plates 277 and 279). His own ability to become empathically absorbed with the subject in front of his camera was very similar. Usually, he could do so without surrendering his technical command. His only acknowledged examples of failure to do so were those sittings with the superb and enchanting actresses Eleanora Duse and Lillian Gish. With performers who always remained actors acting, Steichen made sure to capture the most exaggerated moments of their histrionic approach. Alla Nazimova (plate 280) offers a prime example. So does John Barrymore (plate 284), whose perfect profile matters so much more than his interpretation of Hamlet.

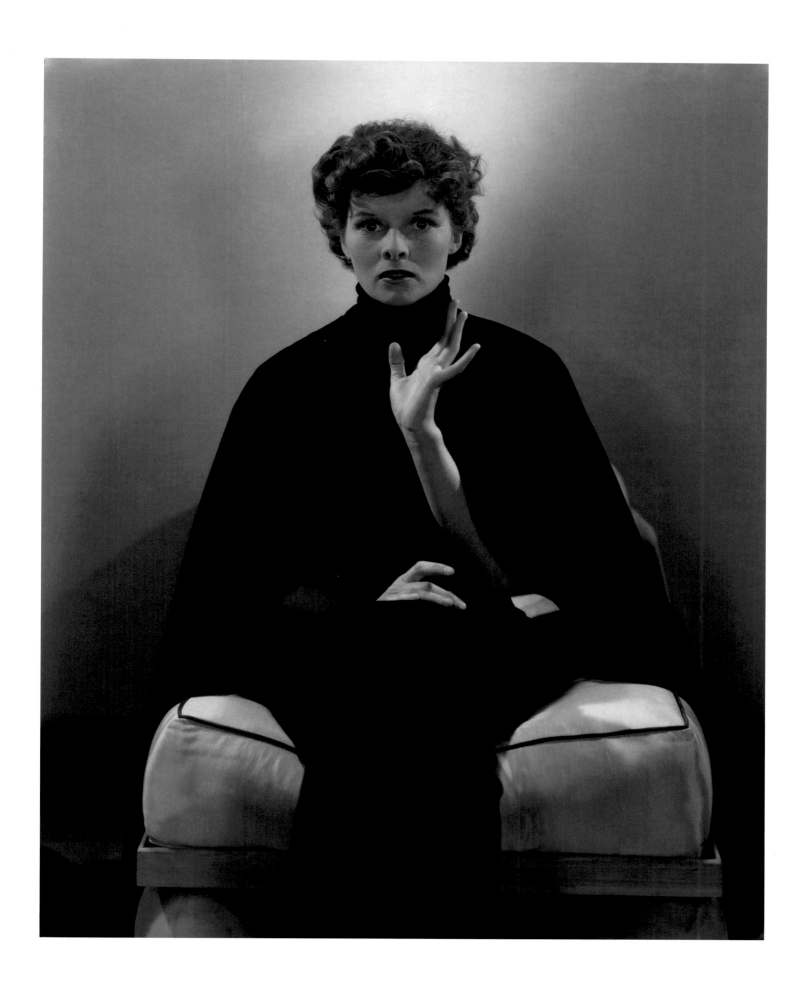

PLATE 274 | *Katharine Hepburn, 1933*

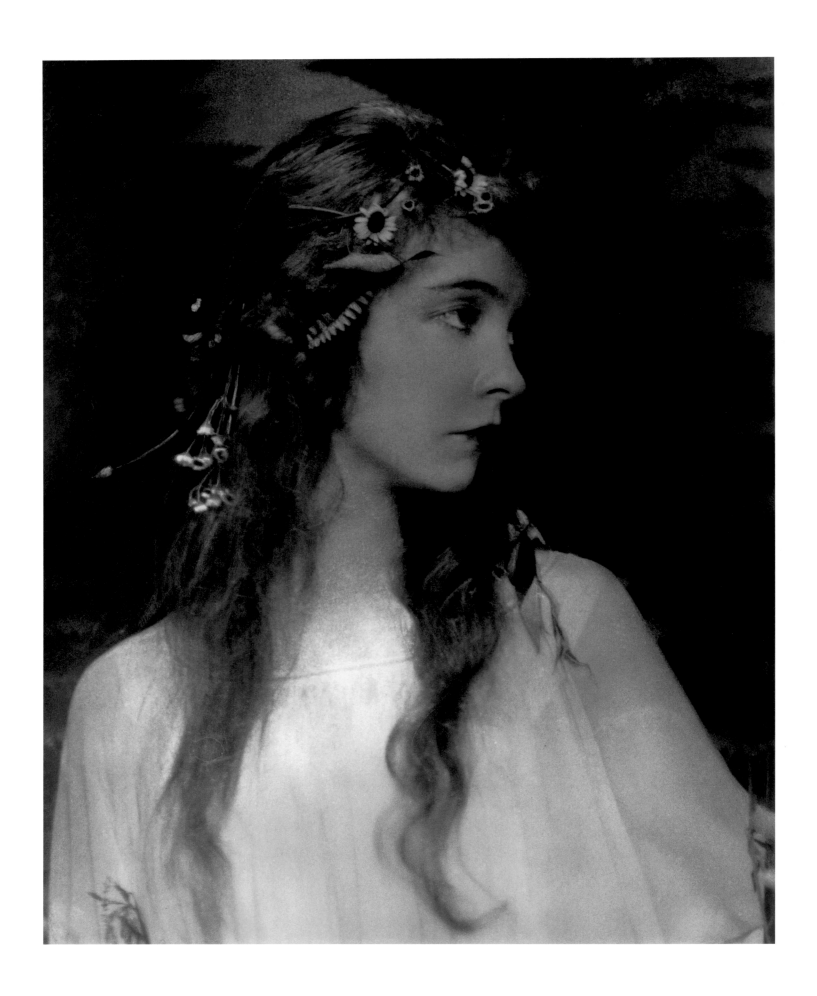

Lillian Gish as Romola, New York, 1923 | PLATE 275

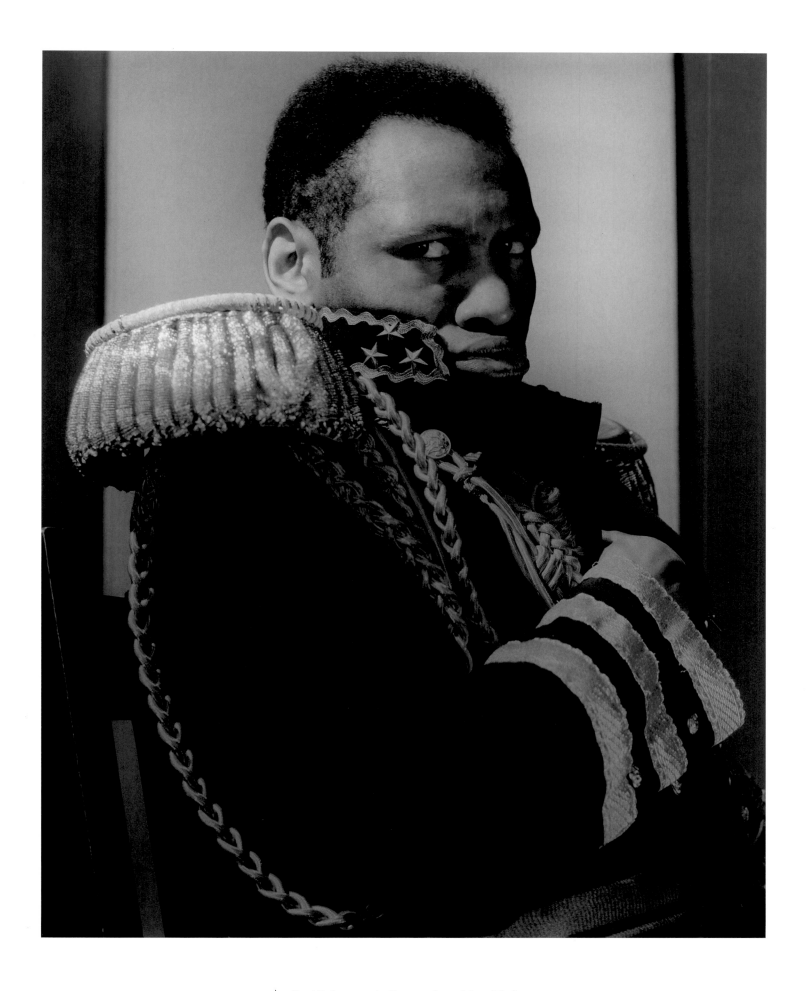

PLATE 276 | *Paul Robeson as the Emperor Jones,* New York, 1933

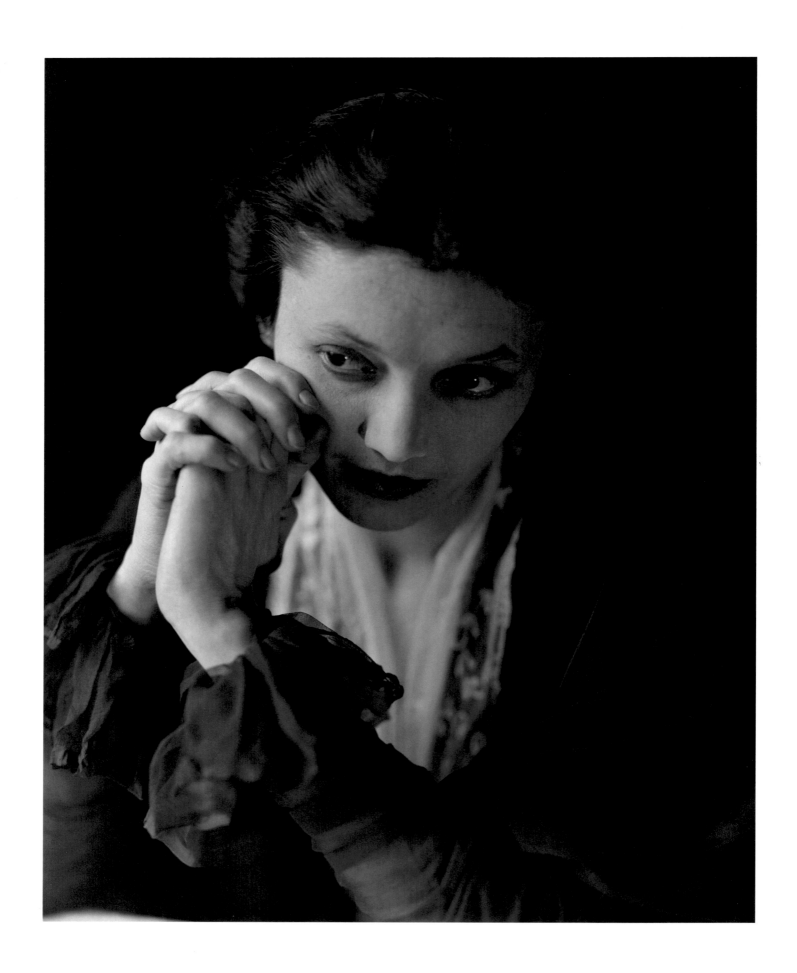

Katharine Cornell—Improvisation, New York, 1925 | PLATE 277

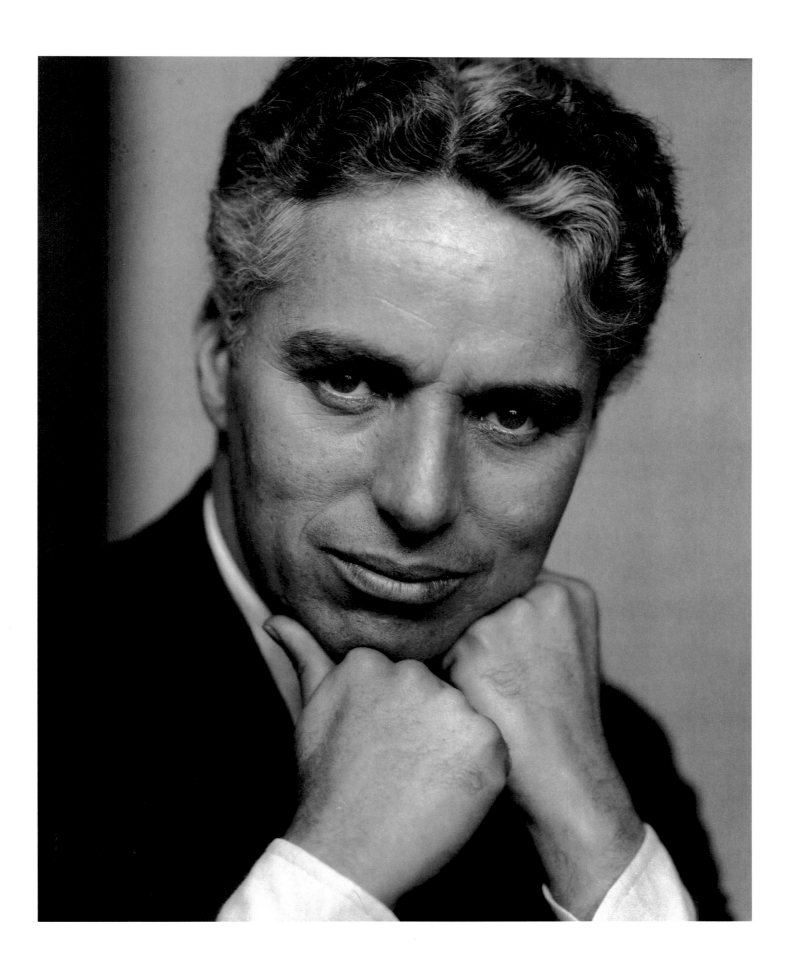

PLATE 278 | *Charles Spencer Chaplin, 1931*

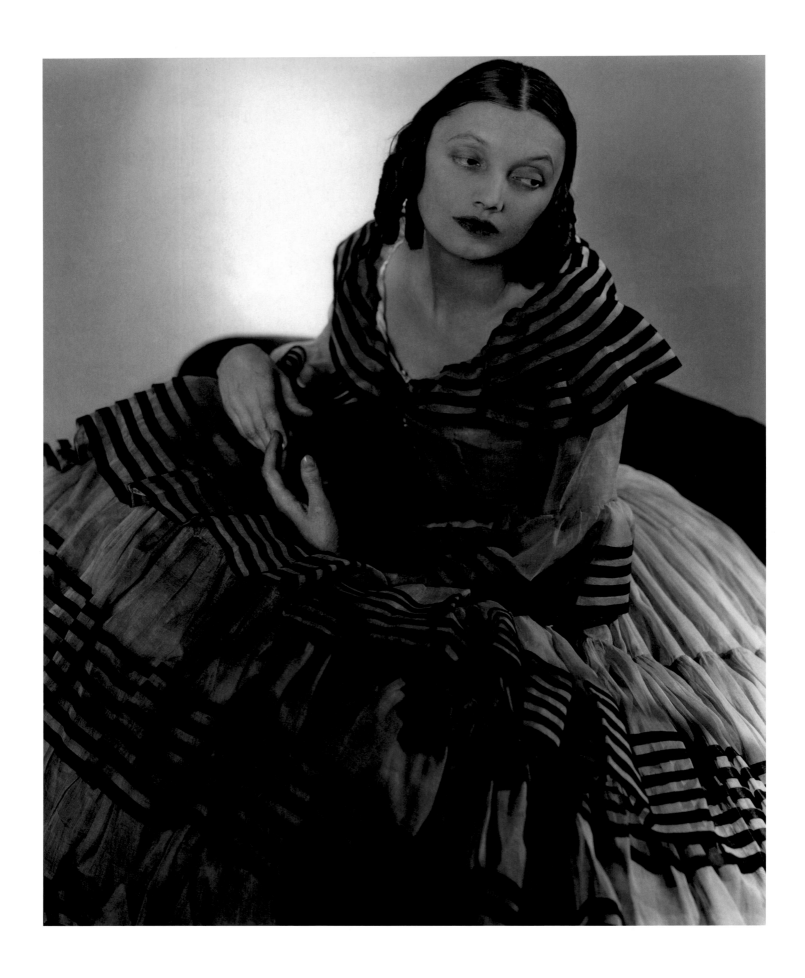

Katharine Cornell in "The Barretts of Wimpole Street," New York, 1931 | PLATE 279

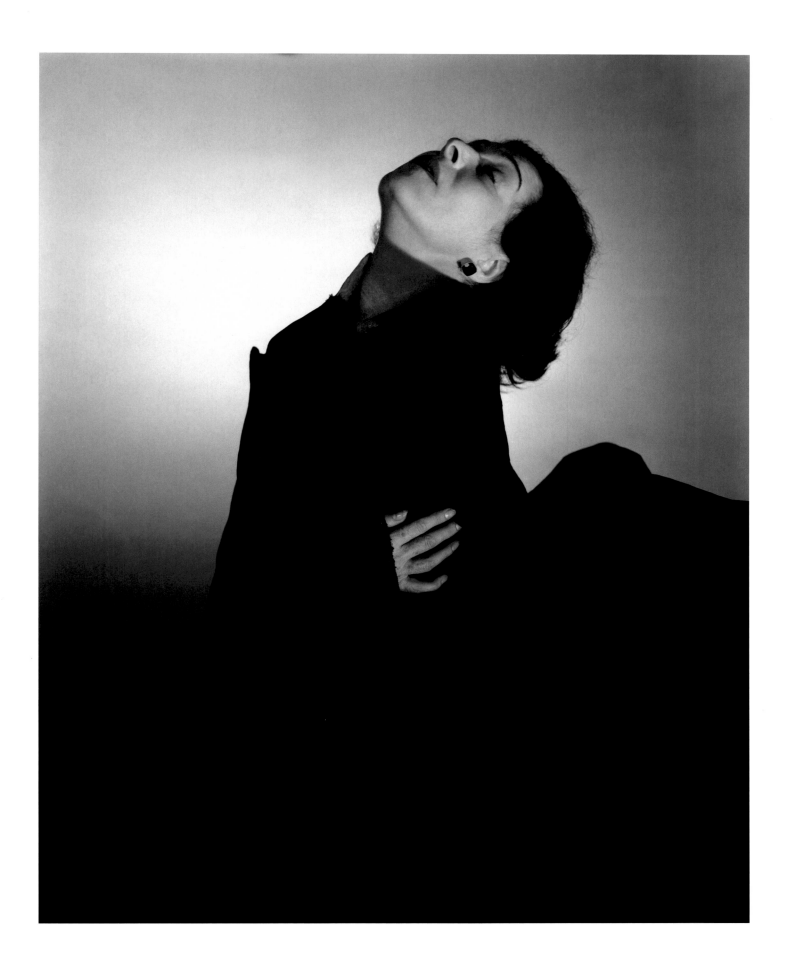

PLATE 280 | *Alla Nazimova*, New York, 1931

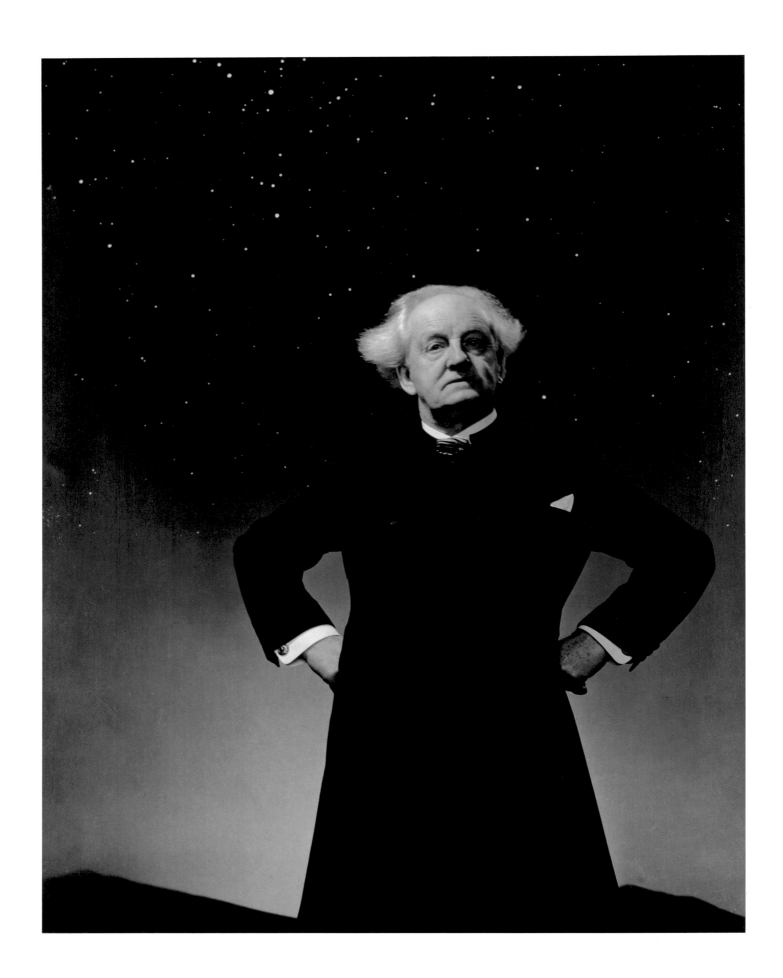

Gerhardt Hauptmann, New York, 1932 | PLATE 281

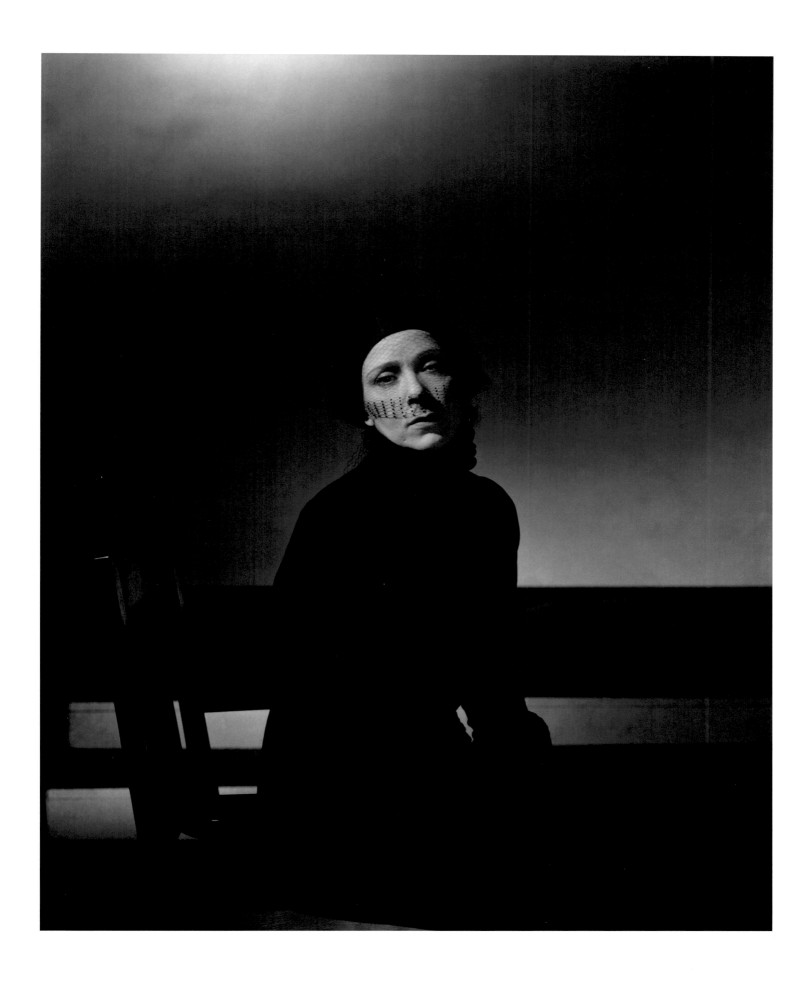

PLATE 282 | *Eugénie Leontovitch,* New York, 1930

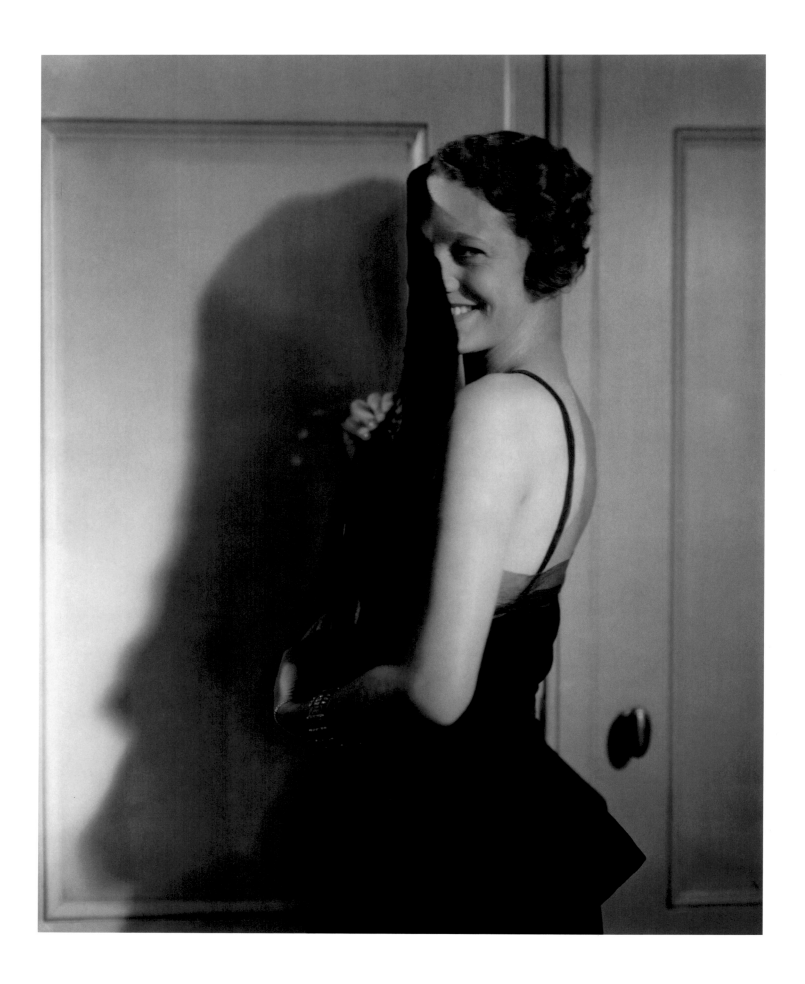

Gertrude Lawrence, 1928 | PLATE 283

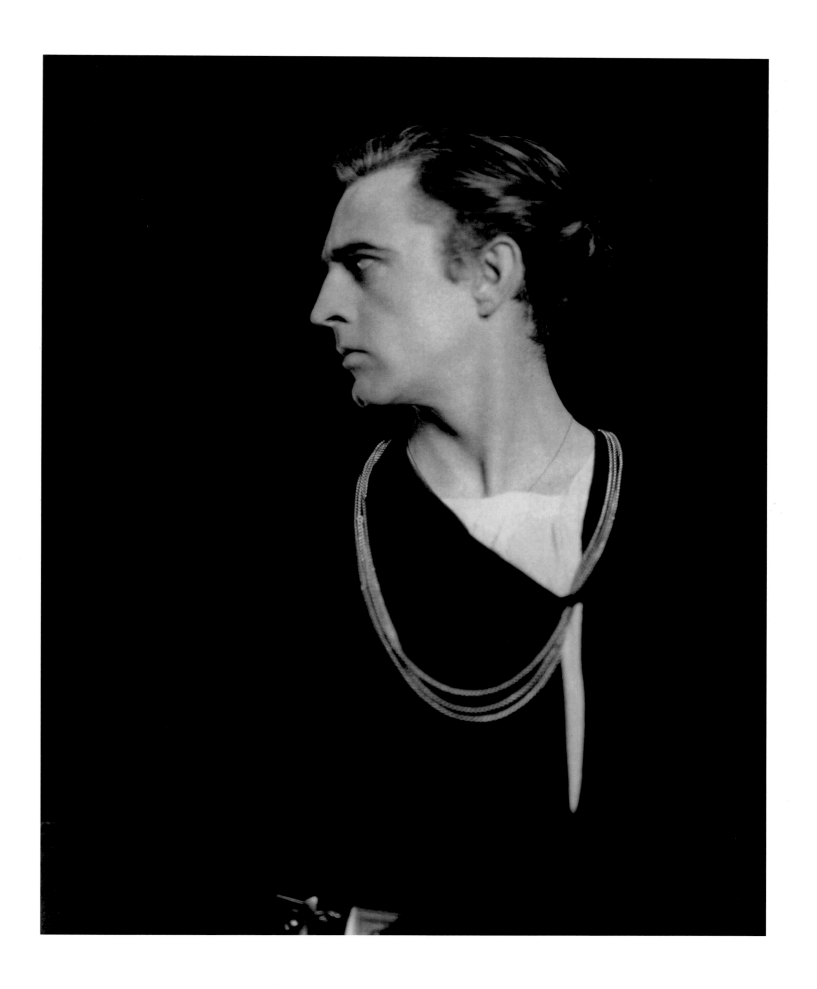

PLATE 284 | *John Barrymore as Hamlet*, New York, 1922

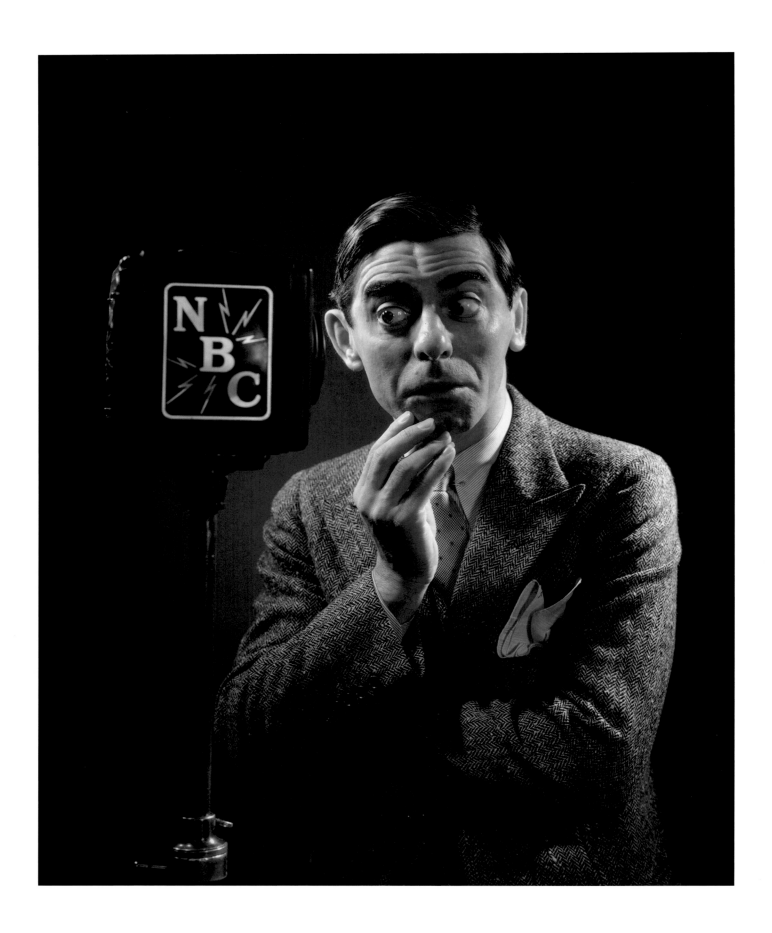

Eddie Cantor. Advertisement for NBC. The J. Walter Thompson Agency | PLATE 285

PLATE 286 | *Charles Laughton*, New York, 1935

Ann Harding, 1923 | PLATE 287

PLATE 288 | *Alfred Lunt and Lynne Fontanne, c. 1930*

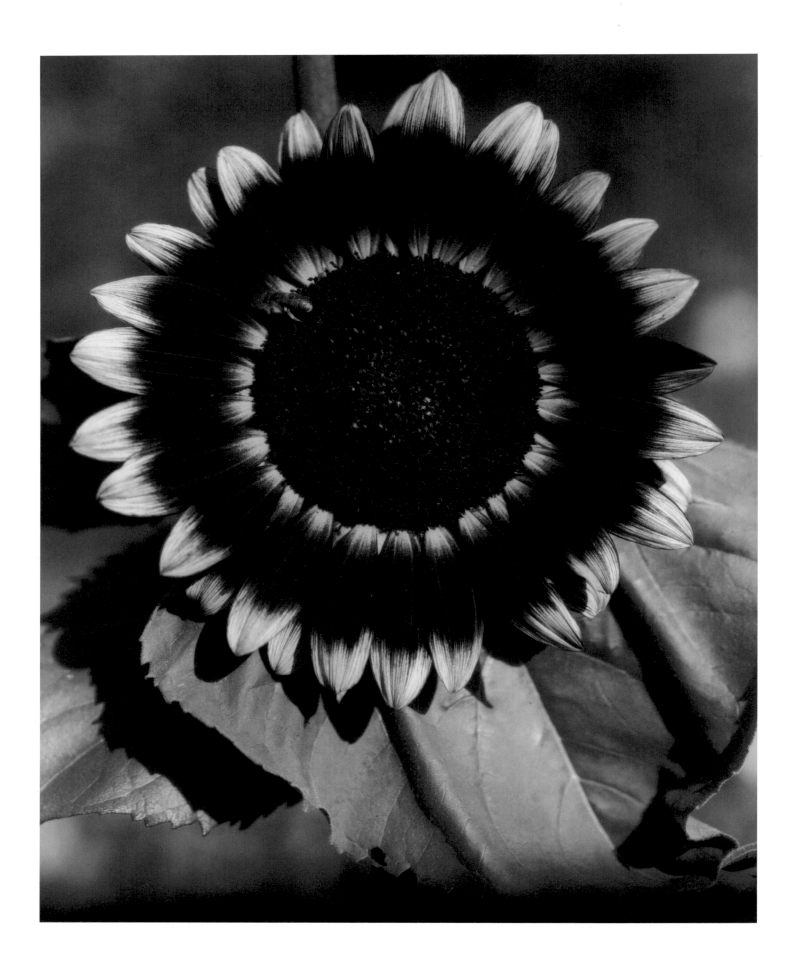

Bee on a Sunflower, Part of series "Sunflowers from Seed to Seed," 1920–1961 | PLATE 289

FLOWERS

By using the term nature, we mean reality, and once we become consciously aware of reality and see with all our knowledge, experience and senses, not just our eyes, and feel with all our being, the ground begins to open toward creativity. We can theorize and intellectualize to our heart's content in our analyzing and soul-searching time, but if a photograph is to become alive, our instinct and intuition must be allowed to fire up our vision, our imagination and sensitize our awareness to the rushing, living compulsion that produces a fine photograph — perhaps a great one. Then again, this may be considered only a definition of the growing pains in the beginning of creativity. In itself, it may just be a moment, an experience that does not produce an immediate tangible result, but is salted away within oneself. It may also begin nine months or even nine years of gestation before bearing fruit. It will never be lost.

—E.S., notes for keynote speech at the
Photojournalism Conference in the West,
Asilomar, California, September 1961

In Steichen's telling of his family history, Jean-Pierre, his father, was reduced to an insignificant irritant, replaced symbolically by the powerful and encouraging Rodin, a more fitting complement to the heroic determination and support of Marie, his mother. One of Steichen's prized possessions was a short letter from Rodin to Marie, congratulating her on her talented son. But the love of gardening came from Jean-Pierre, who tended the land around their house and provided the family table with vegetables and the house with flowers. There were more vegetables than they needed, and as a boy, Steichen was assigned to peddle them to the neighbors door to door. In later life, he wasted little time or space on food plants. He would grow only the edibles that could not be bought easily in the grocery store: bibb lettuce, kohlrabi and the tiny, sweet wood strawberry, *fraise des bois.* He loved flowers. And of course he loved the challenge of growing them bigger and better than anyone else.

Steichen was never content to live without a garden—or without a gardener to tend it. In 1908, he moved his young family to a leased house at the edge of Voulangis, a tiny village thirty kilometers east of Paris, a long uphill trudge from the nearest railroad station at Crécy-en-Brie (now called Crécy-la-Chapelle). The narrow two-story house was set in a large walled garden. He photographed his 1920–1923 experiments in scale and symbol there and, in 1914, *Heavy Roses* (plate 308), which he later called an omen of the war to come that fall. Always a voracious reader when on the trail of something new, Steichen assigned himself books on botany and genetic theory and set out to prove that, contrary to Mendel's claims, acquired characteristics could be inherited.

The garden at Voulangis, 1920.
Photograph by Edward Steichen

Steichen planted some poppy seeds in a corner used as a shortcut and tram-
pled by many feet. The flowers grew up bent and twisted. Steichen planted seeds
from those flowers in a more protected location, and the next generation came
up bent and twisted. Believing that he had triumphed over accepted wisdom, he
moved on to sunflowers and delphinium and commenced his lifelong avocation
of plant breeding. For Steichen, devotion to the repetitive cycles of a garden
banked order and continuity against the roller coaster of the artist's intense but
temporary absorption in one new project after another. And while flowers might
disappoint, they did not argue.

His goal for sunflowers and poppies was simply optimum growth. Sunflowers
interested him particularly because the curves of the logarithmic spiral, the basis
of the golden mean, turned up in the growth pattern of their seeds. He pho-
tographed the sunflowers over many years, starting in 1920 and ending in the
1960s with a bright bouquet shot in the house at Umpawaug in 35-millimeter
Kodacolor (plates 289, 291–292, 298–304). He called the series "Sunflowers
from Seed to Seed." His plans for his favorites, the delphinium, were more ambi-
tious. In his gardens, as in his other work, Steichen needed to push the limits of
possibility. So he set out to create delphinium that had not existed before. His
experiments in Voulangis were cut short in 1914 by the First World War, but he
started again in Connecticut in 1929.

The best-known varieties of delphinium produce clusters of predominantly
blue flowers along vertical stalks. Steichen concentrated first on fixing large flow-

ers with stalks sturdy enough to hold them, then on fixing the colors, which might vary from lavender to pale pastel or deep royal blue that shaded into white or pink. Every time he fixed a color, he named that delphinium for a poet. When it was the turn of Paul Claudel, the French poet and diplomat, Agnes Meyer arranged to bring Claudel to lunch. At Umpawaug, Steichen experimented with many things, including the making of wine. At lunch, he served a proper French wine, but toward the end of the meal, he asked his guest if he would care to taste a wine made on this farm. Claudel consented. The wine was tasted and found acceptable. Then Steichen asked if he would care to taste a wine made on this farm from grapes grown on this farm. Claudel again consented. The wine was poured. The poet-diplomat sniffed, sipped, and then, with an expression of intense regret and a twinkle in his eye, proclaimed, *"Ah, pauvre France!"* (Poor France!)

In my time, there were two acres of irrigated fields at Umpawaug devoted to delphinium breeding, but in the 1930s, there were more than six acres of delphinium under cultivation. Fields of blue flowers spread across the road and down into a broad swamp, where they flourished. Decades later, peat dug from that swamp still fertilized the Umpawaug gardens. (In 1971, the swamp was bought by a consortium of Redding residents and, in 1973, turned over to the Audubon Society. It was named the Edward J. Steichen Memorial Wildlife Preserve.) Realtors used to list Steichen's delphinium fields as one of the major attractions for the neighboring properties. In 1936, when the Museum of Modern Art exhibited Steichen's live delphinium, horticulturists were astonished at Steichen's pure blues, rich, consistent solid blues without the usual invading white or pink.

In 1941, war interfered once more with delphinium breeding, and the poet project was aborted. After World War II, Steichen concentrated his horticultural energies on one new delphinium, the Connecticut Yankee. Every day, all summer long, he patrolled his farm rows of delphinium, inspecting crosses, fitting bags over plants to protect their seeds, delicately transferring pollen from the stamen of one chosen flower to the pistil of another, making notes in his little book. The notes were in a hieroglyphic that no one but Steichen understood. After years of cross-breeding, he managed to produce a strain of large delphinium flowers that were not clustered vertically up a straight, tall stalk but were scattered at random over a big, loose bush, rather like a busy colony of variegated blue butterflies. These were the Connecticut Yankees.

After a hybrid strain is perfected, many generations must be grown in order to make sure that the seeds will run true. Finally, in 1965, the Connecticut Yankee was ready to be turned over to a commercial seedsman. Steichen's friend Frank Reinelt, a breeder of primroses and begonia in Santa Cruz, found an appropriate seed grower farther down the California coast, in a valley turned into a brilliant patchwork of flower fields, between Guadalupe and Santa Maria, a few sand dunes and one small range of hills away from the Pacific Ocean. Steichen had a patent on his creation for three years before it passed into the public domain. Unfortunately, many of the Connecticut Yankees available from seed catalogues today have been allowed to revert to an earlier type. What Steichen

developed was a tall, loose bush aflutter with big flowers, but it has been allowed by some commercial producers to shrink to a sad, tapering dwarf spike.

While Steichen referred to the landscaping at Umpawaug as having been done with an axe, the area near the house was cultivated with finer tools. In warm weather, pots of trailing fuchsia hung from the beams that formed a trellis at the front door. Poppies bloomed in analogous reds in the field north of the house. Blue-and-white morning glory laced the hedge bordering the driveway. Flower beds changed shape from time to time. I had brought my guitar to Umpawaug before we were married. Steichen particularly liked a French Canadian wedding song in which the young man tells the young woman he is courting that, if they marry, they will sleep in a big square bed covered with white linen and, at each corner, *des bouquets de pervenches,* bouquets of periwinkle. The next spring, Steichen had periwinkle, *Vinca minor,* a shiny-leafed ground cover with floppy blue flowers, planted at each corner of the house. On the front lawn, he made new beds devoted entirely to white flowers: cleome, fragrant nicotiana, petunia, spider chrysanthemum.

In the greenhouse, an untidy riot commanded the benches. No good English gardener would put up with it, Steichen liked to say. Begonia, coleus, mallow, gardenia, fragrant lemon and rose geranium all tumbled together with a fig tree and two seedlings doomed in our climate—*Araucaria excelsa,* or Norfolk Island pine, and *Sequoia sempervirens,* coastal redwood. Then there was the *Aralia elegantissima.* Steichen had fed this delicate plant a hormone, giberellin, and turned it into *Aralia elephantissima,* a beautiful monster whose once lacy leaves were more like human hands and whose thin stems had become solid, woody trunks. A perpetual beauty contest operated in the greenhouse. Plants that had reached their peak were chosen to fill the gravel trays around the perimeter of the living room.

In that room, on a stand next to the fireplace, a big fuchsia often dangled a trail of blossoms. The stand was a World War I artillery shell, about three feet tall and eighteen inches across. Steichen had the U.S. Army ship it back from Europe packed with camera gear. In the house, the plants in the gravel trays bordering the floor-to-ceiling windows blended with the swamp maples just outside, as well as with the willows, the shad and the sweep of pink dogwood across the pond. A shallow skylit alcove at one end of the living room served sometimes as a studio for photographing flowers. Its counter held a massive bunch of whatever happened to be the star of the garden or greenhouse at the moment: delphinium or sunflowers in a big glass globe; pots of blazing red amaryllis in bloom; the loose-jointed, trailing jungle cactus, *Epiphyllum,* with its huge, fiery flowers that lived for just one day.

Part of the lure of gardening is its elusive potential for mastery. The gardener becomes, though never so much as he would like, the god of his own piece of earth. Steichen was ruthless, an Old Testament god whose law was optimal growth. He might photograph dead begonia leaves (plate 307) and wilted sunflowers with loving attention, but in his garden anything that did poorly was consigned to the rubbish heap. (From there, Serge, the gardener, would rescue the discards and tend his own plant hospital in a corner near the greenhouse. This annoyed Steichen, but he never interfered.)

Steichen was an attentive deity. Every day, in all seasons and weather, he walked many times between house and greenhouse, a distance of about three city blocks, across the lawn, through a small pine grove, along a wide grass path between the two farm fields with their bare trellises of overhead irrigation pipes. And back again. He clung stubbornly to this trip at least twice daily. As his strength failed, we placed benches for resting along his route. Toward the end, after much protest, he was persuaded to make the trip in a golf cart.

In his last two years, Steichen spent most of his time sitting in the big club chair in his floor-to-ceiling bay window surrounded by greenery inside and out (plate 294). He dressed haphazardly in the soft fabrics his tender skin required. His all-season corduroy trousers and silk-lined cashmere bathrobes were pocked with holes from the ashes of a continual chain of cigarettes and cigars. His feet shared the ottoman with Tripod, an aging three-legged beagle who had adopted us and then outlived the last of the Irish wolfhounds. Steichen's orientation to time and people became precarious, but he never had a moment of confusion about the physical surroundings he had made for himself.

Some of Steichen's most satisfactory relationships over the years were with the gardeners he employed. In France, it was the uneducated gardener's free-spirited copy of one of Steichen's own paintings that inspired him to make the bonfire marking the end of his own painting career. In Connecticut, he found at least two men who shared his vigorous love of growing things and with whom respect deepened into reciprocal affection. The first was Valentine, a solid local man with many homespun skills. The other was Sergei Milaschewitsch, whom we called Serge.

Serge and Helen, refugees from Communist regimes in Russia and Yugoslavia, lived for close to twenty years in the apartment between the photography lab and the greenhouse. More than gardener and housekeeper, they were part of the essential fabric of life at Umpawaug. In those last years, with death very much on his mind, Steichen had vivid, terrifying dreams in which Serge figured as rescuer. In a typical one, he was trapped in the greenhouse when it burst into flames. There was no way out until suddenly Serge appeared and led him to safety.

In March of 1973, Steichen began to fail rapidly. The pacemaker installed two years before to arrest his congestive heart failure had not helped. He spent his final days in a hospital bed set up in the bedroom whose windows looked out across the pond to the shadblow tree. Dying at home was not an entirely peaceful process, but eventually, late on the morning of March 25, everything went quiet.

Steichen was cremated, as he had wished. Since art and nature had absorbed his capacity for worship, the appropriate final ceremony was an open house where friends and family could gather one last time in the retreat Steichen had fashioned out of both. Later, the Museum of Modern Art organized a memorial service, and I arranged for the Tokyo String Quartet, then a young group starting out, to play the last Beethoven quartet, Opus 135 in F major, the one Steichen used to listen to shaking his fist, calling it Beethoven's last angry dialogue with God.

Steichen had given specific instructions for a very private, virtually secret

grave site. For years, two canisters of ashes sat on the shelf of his bedroom closet. One contained half of his mother's ashes. (The remainder were buried with his father's.) The other held the ashes of Fintan, his last Irish wolfhound. He wanted both of these canisters to be emptied and mingled with his own in a place he had chosen. Halfway up a wooded hill on the way to the house stood a huge mound of boulders unlikely ever to be moved no matter who owned the property. All the ashes were to be buried quietly at the base of this outcropping. Then a small brass plaque giving his name and dates was to be attached to one of the biggest boulders. He had instructed Kathleen Haven to design the plaque and Grace Mayer to pay for it. I wasn't sure about the legality of his instructions for the ashes, but I was determined to carry them out. Toward sunset on the last day of the Labor Day weekend in 1973, two trusted friends and I carried the three canisters and a shovel to the boulders on the hill. In silence, we dug a hole and, as a burning ball of sun streaked the sky beyond Topstone cliff with tatters of flame, poured the ashes from the three canisters together into their resting place.

About two years after Steichen's death, I visited Helen and Serge in the new house that had been built for them on the estate where they were working. The house was much nicer than their apartment at Umpawaug, and the pay was higher, but they were not happy. Serge missed the soaring spirit and the empathic bond that had given meaning to his work. He told me he had dreamed about "Mr. Steichen" every night for a year. Then, one night, the old man came to him in his dream and said, "It's all right, Serge. Everything will be all right now." And Serge never dreamed about Steichen again.

At his ninetieth birthday dinner, Steichen said, "When I first became interested in photography, I thought it was the whole cheese. My idea was to have it recognized as one of the fine arts. Today, I don't give a hoot in hell about that. The mission of photography is to explain man to man and each man to himself. And that is the most complicated thing on earth and also as naïve as a tender plant."*

*Quoted in an article by Thomas F. Brady, *New York Times*, March 28, 1969.

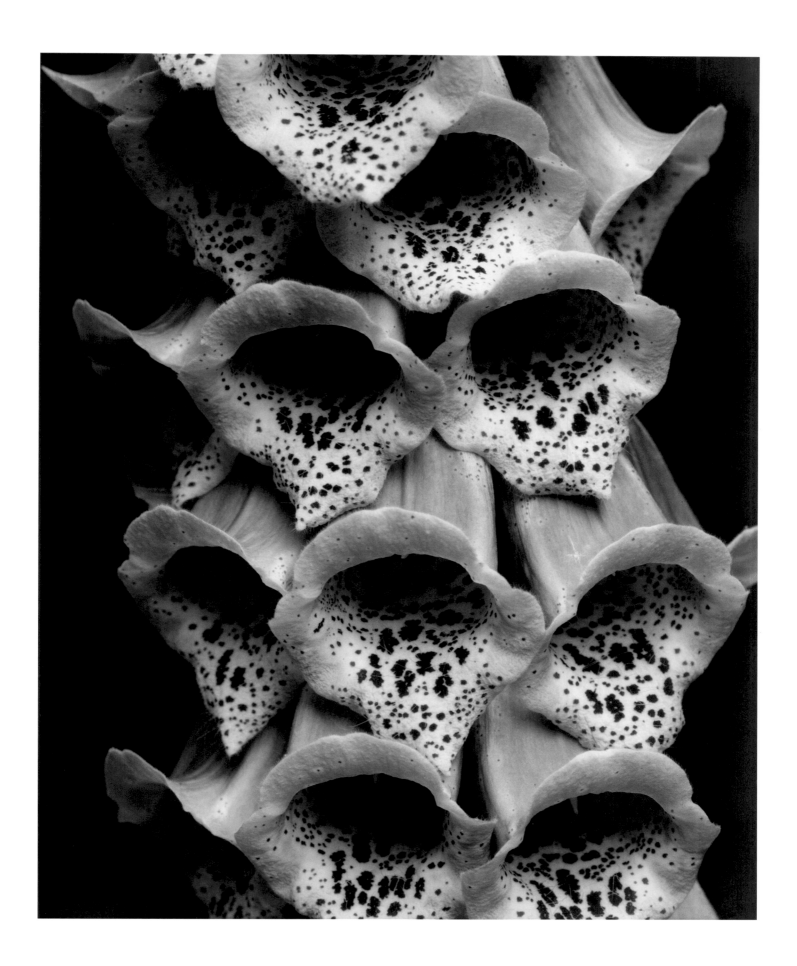

PLATE 290 | *Foxgloves*, France, 1926

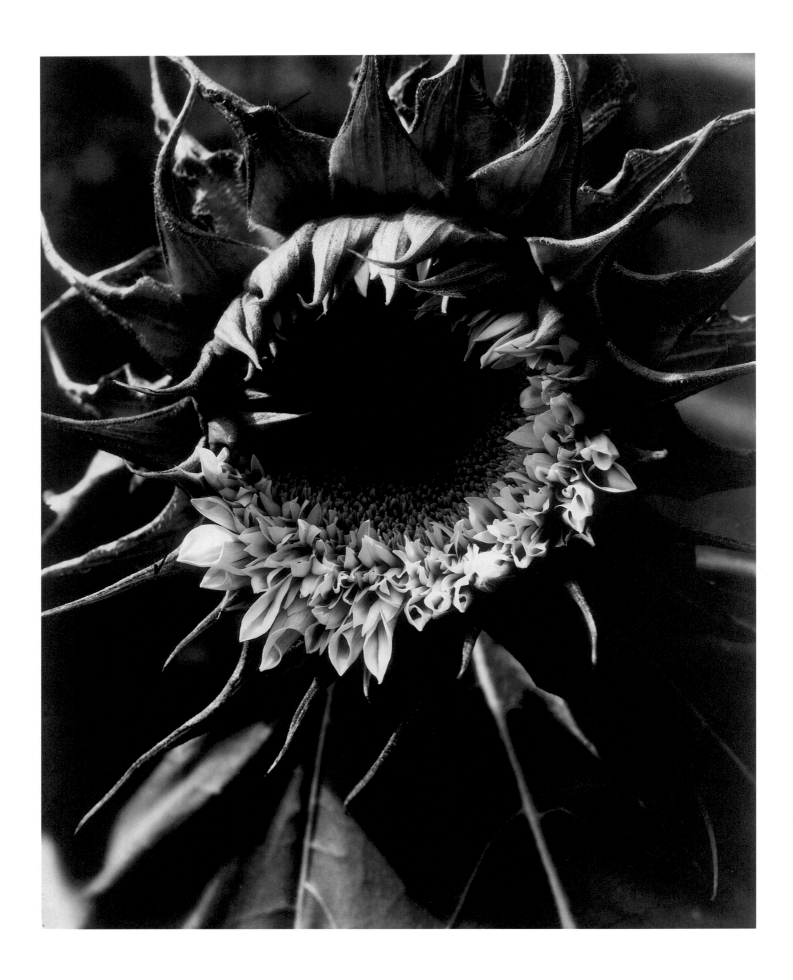

Sunflower, Part of series "Sunflowers from Seed to Seed," 1920–1961 | PLATE 291

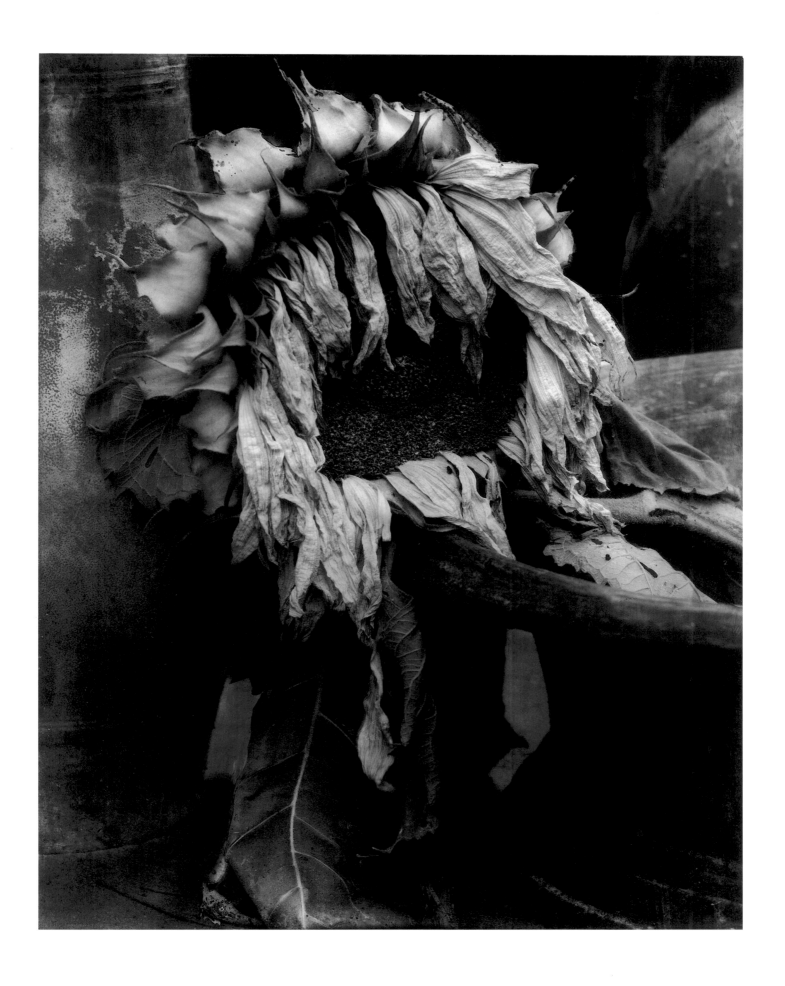

PLATE 292 | *Dead Sunflower,* Part of series "Sunflowers from Seed to Seed," 1920–1961

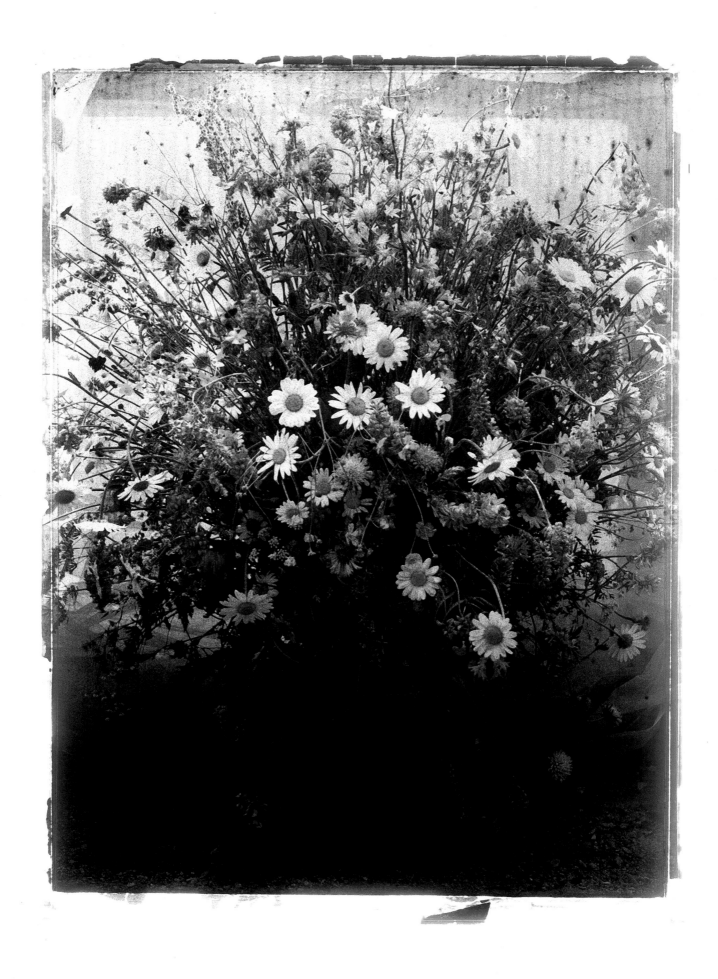

Daisies, c. 1912. Lumière autochrome | PLATE 293

PLATE 294 | *Indoor-Outdoor Garden*, Umpawaug Farm, 1950s

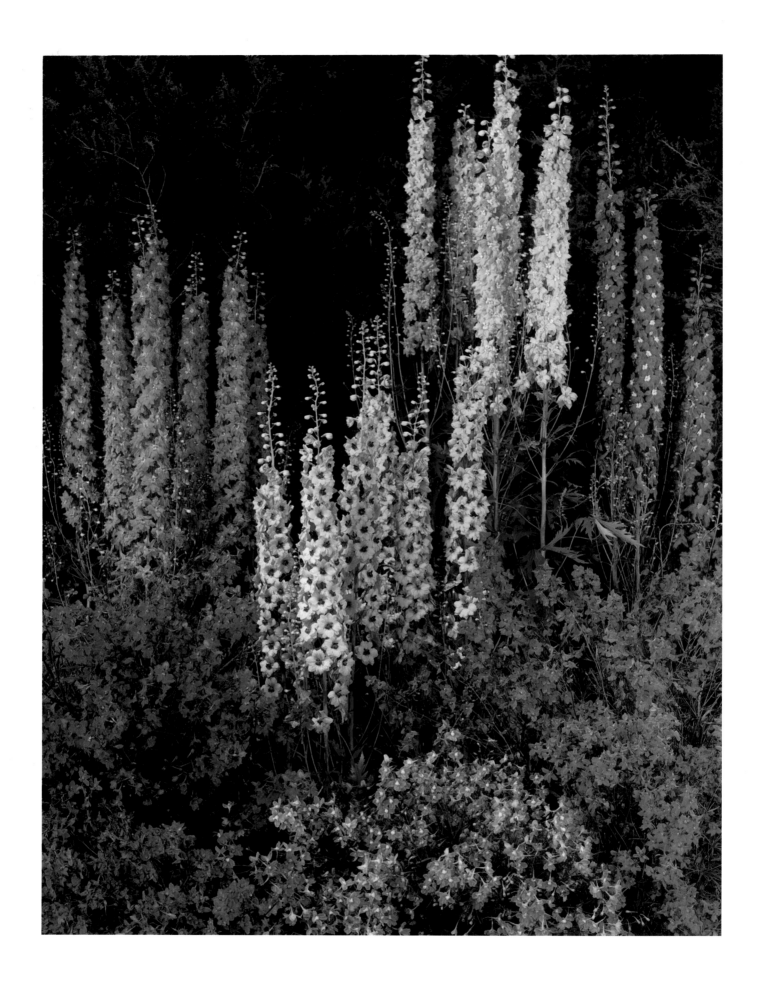

Delphinium, Umpawaug Farm, 1940 | PLATE 295

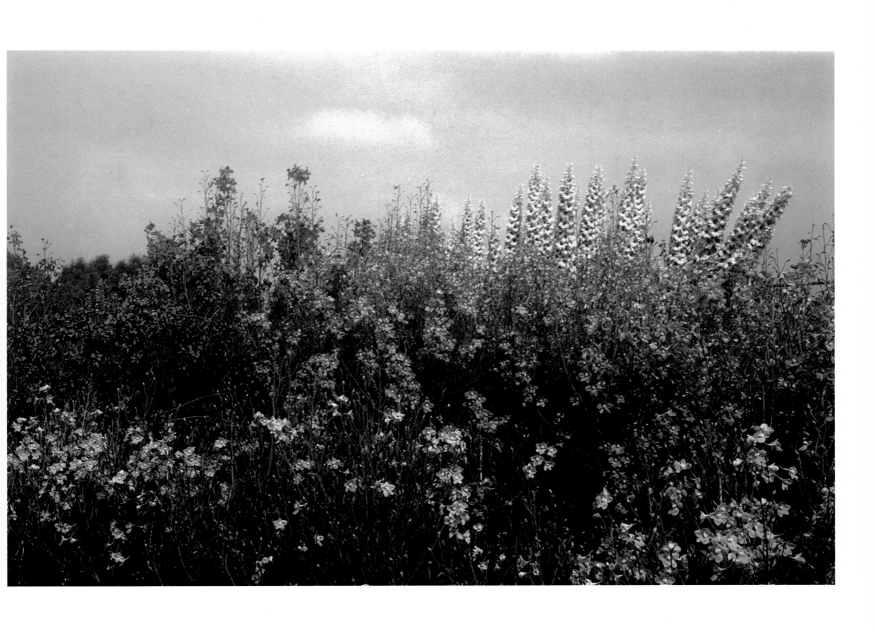

PLATE 296 | *Blue Wave Delphinium—Precursor of the Connecticut Yankee*, Umpawaug Farm, 1950s

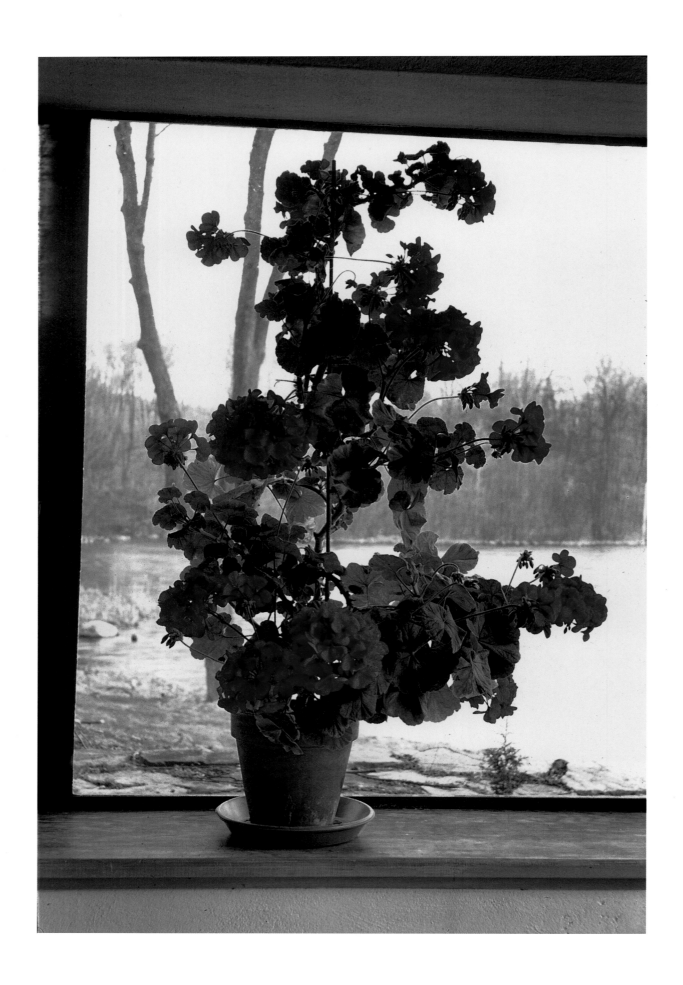

Geraniums on Bathroom Windowsill, Umpawaug Farm, 1950s | PLATE 297

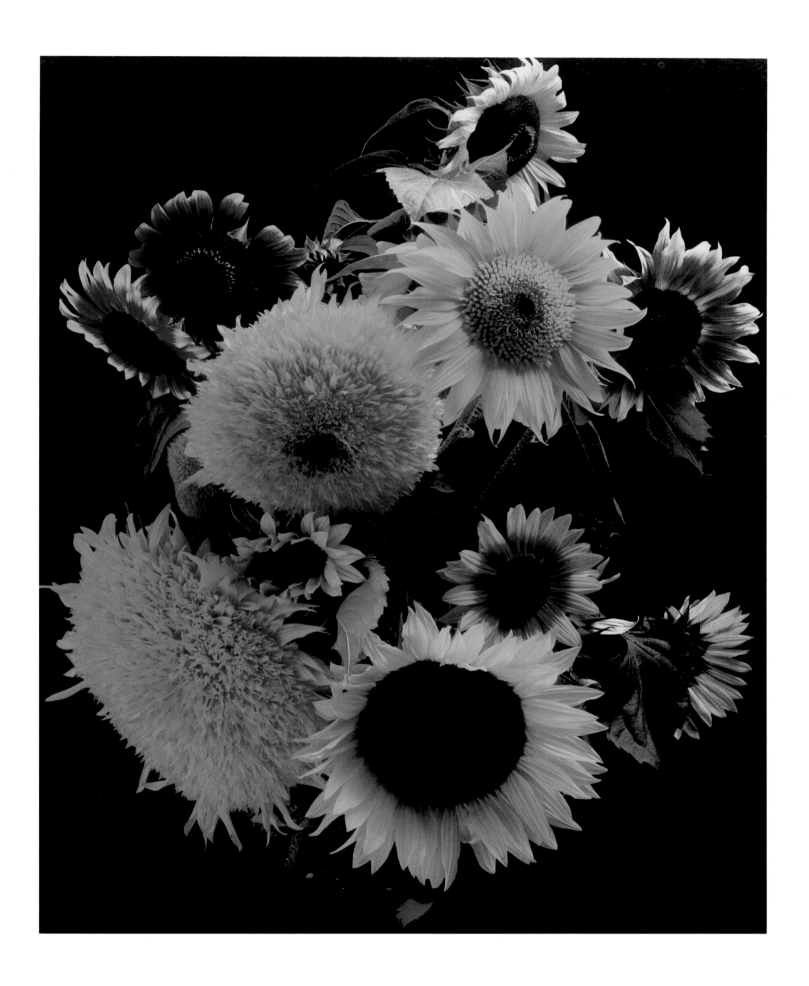

PLATE 298 | *Bouquet of Sunflowers,* Umpawaug Farm, 1965. Postscript to series
"Sunflowers from Seed to Seed," 1920–1961

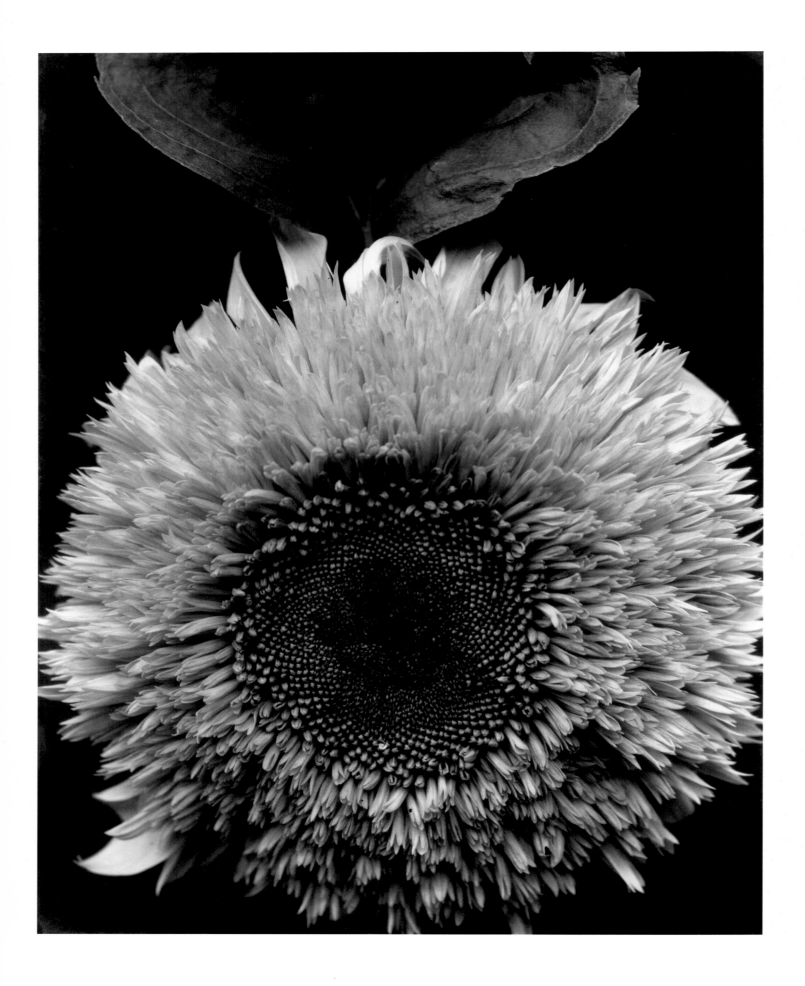

Chrysanthemum Sunflower, Part of series "Sunflowers from Seed to Seed," 1920—1961 | PLATE 299

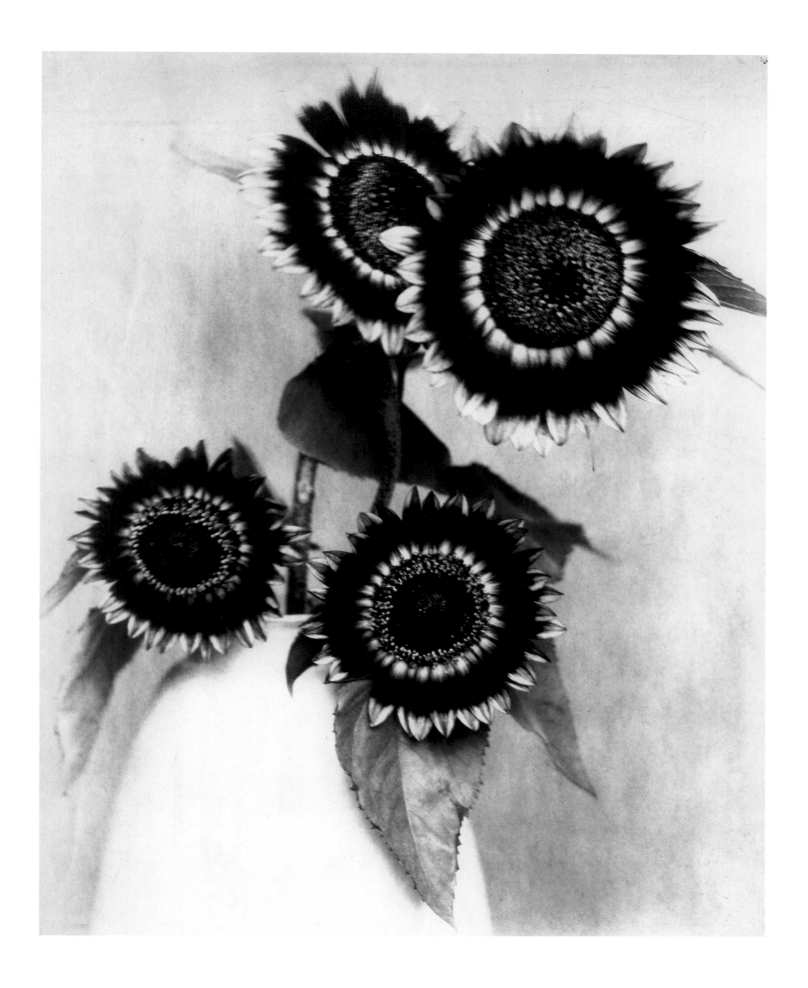

PLATE 300 | *Four Sunflowers,* Part of series "Sunflowers from Seed to Seed," 1920–1961

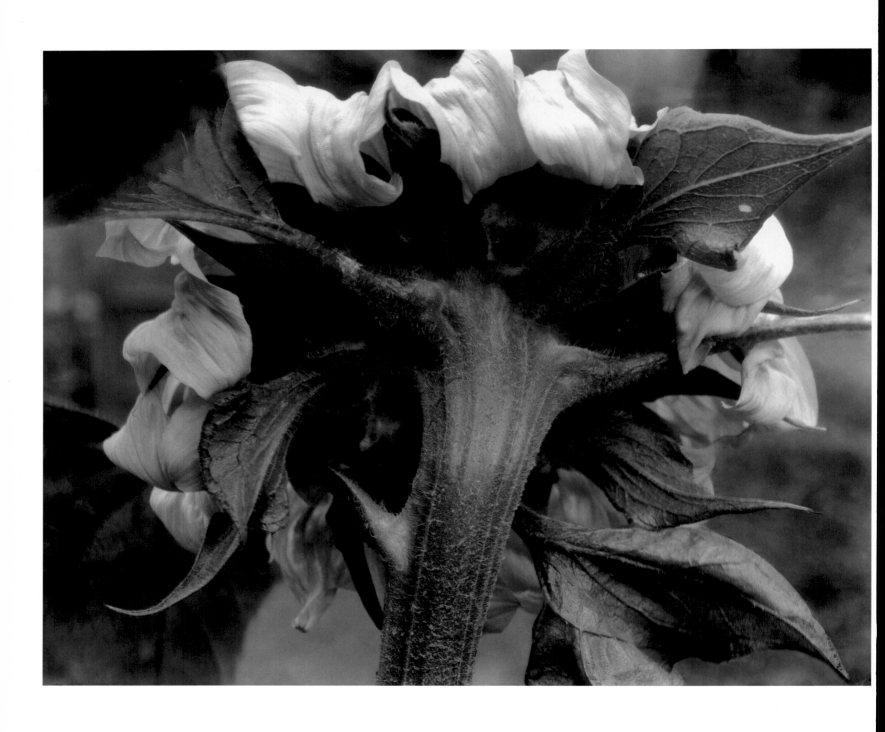

Mature Sunflower, Part of series "Sunflowers from Seed to Seed," 1920–1961 | PLATE 301

PLATE 302 | *Aging Sunflower,* Part of series "Sunflowers from Seed to Seed," 1920–1961

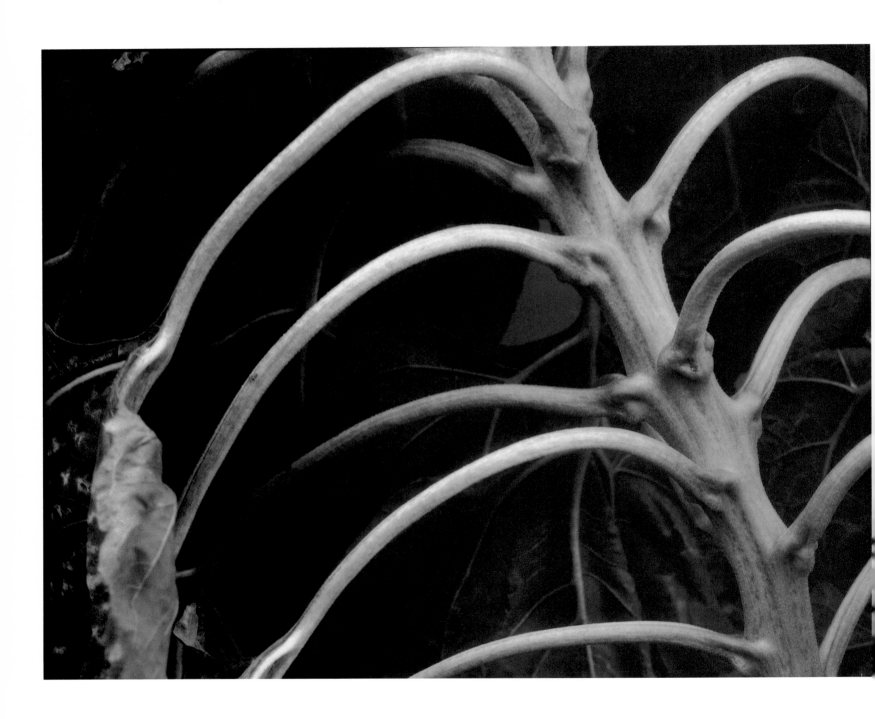

Backbone and Ribs of a Sunflower, Part of series | PLATE 303
"Sunflowers from Seed to Seed," 1920–1961

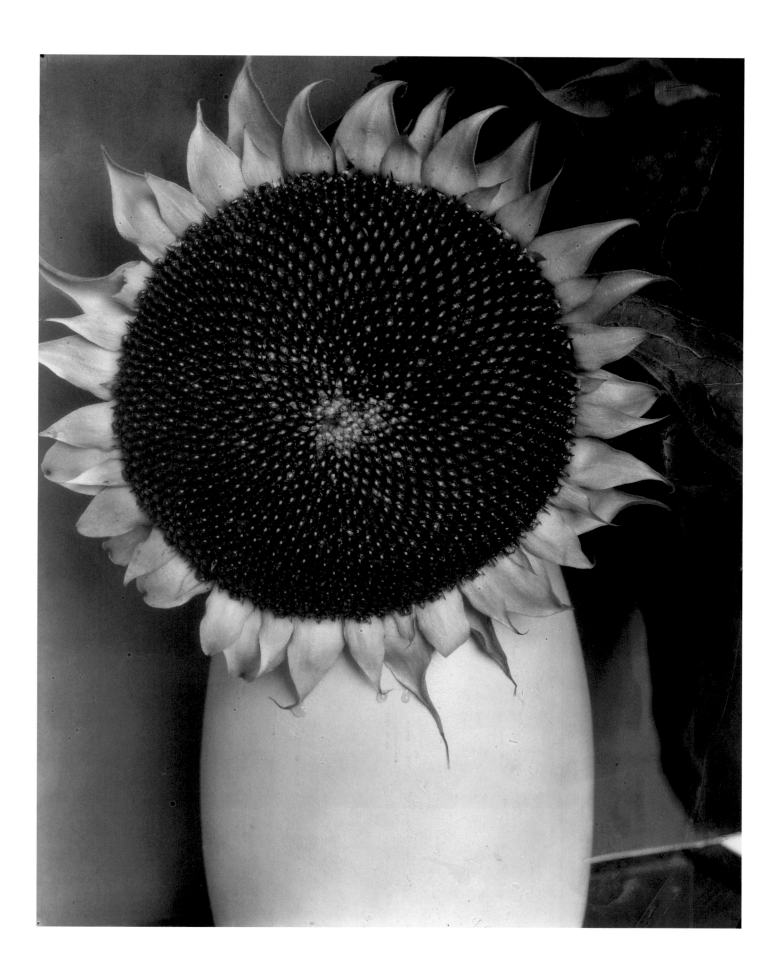

PLATE 304 | *Sunflower in a White Vase,* Part of series
"Sunflowers from Seed to Seed," 1920–1961

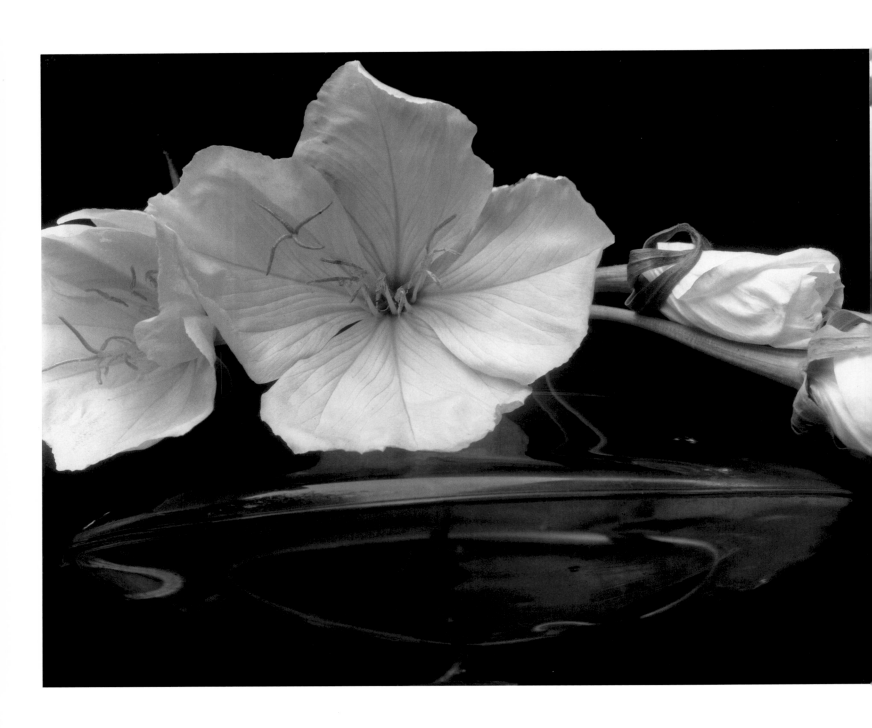

Evening Primroses, before 1928 | PLATE 305

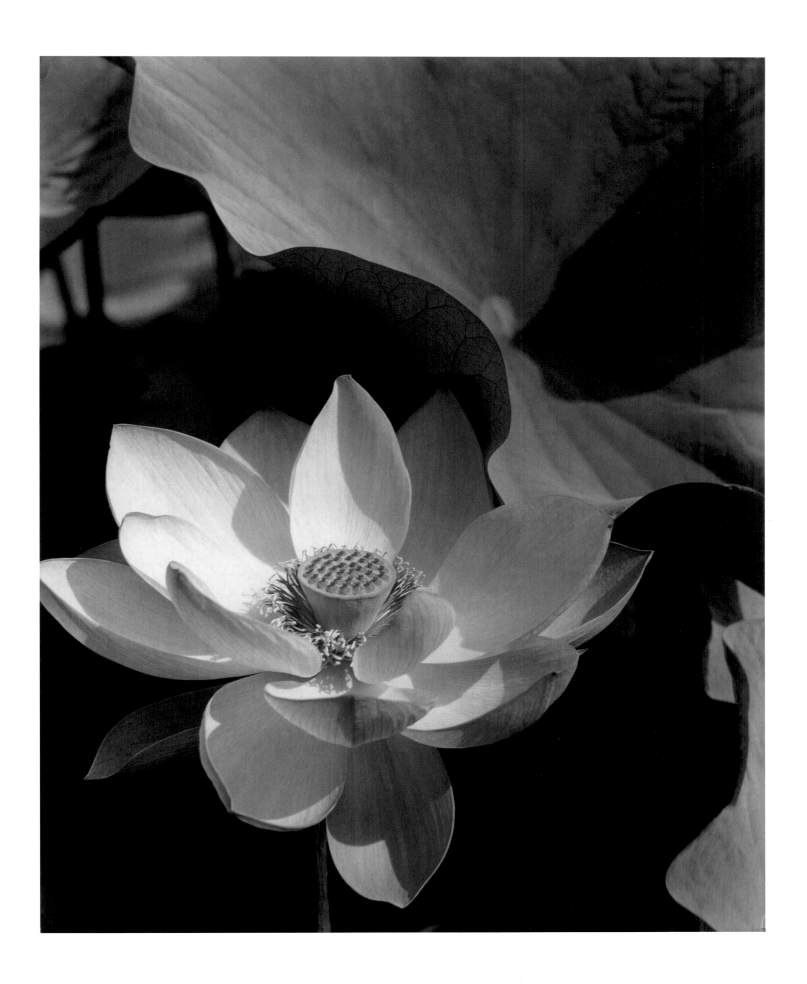

PLATE 306 | *Lotus,* Mount Kisco, New York, 1915

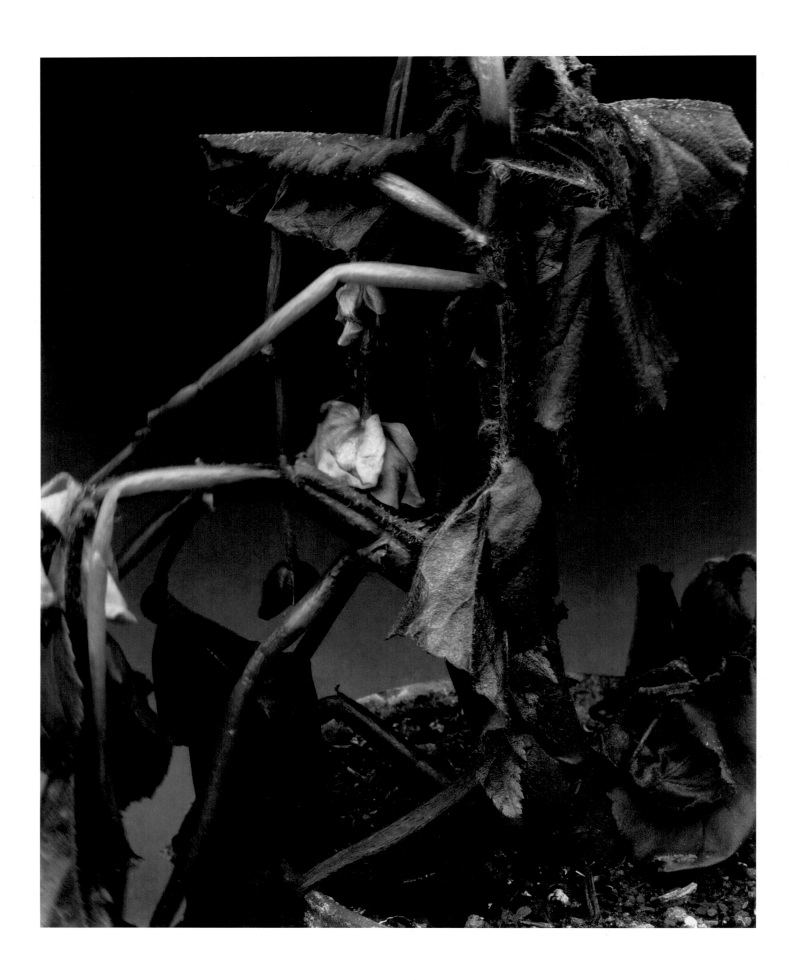

Frozen Begonia Plant, France, 1922 | PLATE 307

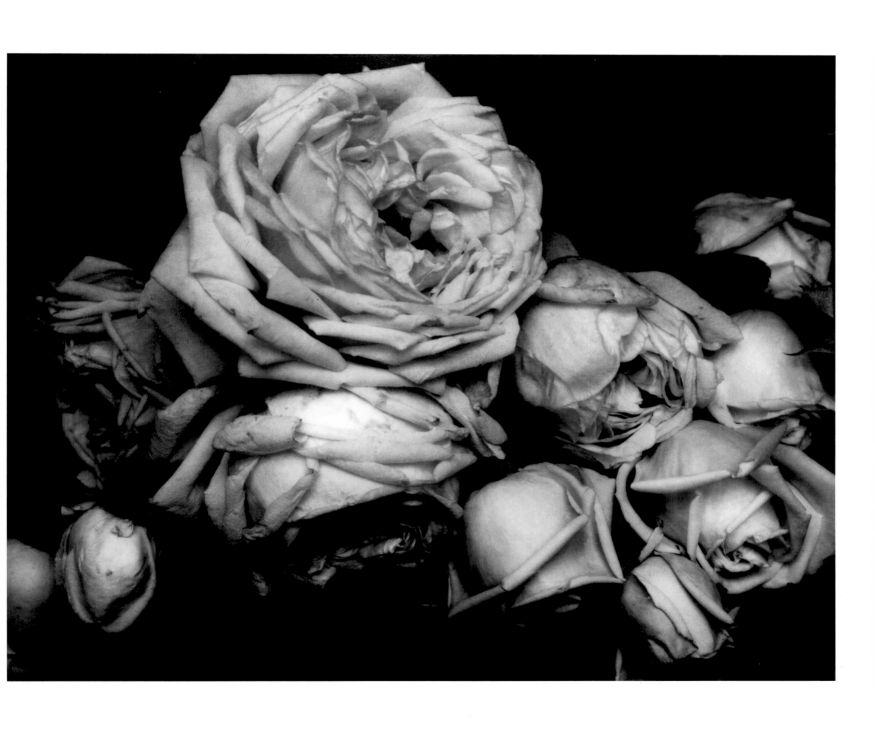

PLATE 308 | *Heavy Roses*, France, 1914

CHRONOLOGY

1879. March 27: Eduard [*sic*] Jean Steichen, first child of Marie Kemp and Jean-Pierre Steichen, born in Luxembourg.

1881. Immigration to America. Family settles in Hancock, Michigan.

1883. Sister, Lillian (Pausl), is born.

1888. Boards at Pio Nono College near Milwaukee.

1889. Family moves to Milwaukee.

1894–1898. Apprenticeship at American Fine Art Company, lithographers, in Milwaukee.

1897. Receives prize for envelope design for National Education Association Convention, Milwaukee. Organizes Milwaukee Art Students' League.

1899. First public showing of E.S. photographs, in the second Philadelphia Salon (October 21 to November 19).

1900. Enters Chicago Salon. Receives encouragement from Clarence H. White. En route to Paris, meets Stieglitz in New York City, who buys three prints. Represented in London Photographic Salon and has twenty-one prints in *The New School of American Photography* exhibition organized by F. Holland Day at the Royal Photographic Society. Represented in third Philadelphia Salon.

1901. Meets Rodin. E.S. painting exhibited in the Paris Salon of 1901. Elected member of the Linked Ring photographers' society, London.

1902. Exhibits fourteen prints in *American Pictorial Photography,* arranged by the Photo-Secession at the National Arts Club, New York City. Becomes a founder of *Camera Work* (Photo-Secession quarterly from 1903 to 1917). First one-man show of E.S. paintings and photographs, at La Maison des Artistes, Paris. Returns to New York and rents studio at 291 Fifth Avenue. Photograph, *The Black Vase,* purchased by the Belgian government.

1903. On January 31, the President's Cup of the Camera Club of New York is presented to "Newcomer" (Eduard J. Steichen) for his photograph of Bartholomé. The Steichen Number of *Camera Work* appears in April. Wins top prize in Eastman Kodak Competition, Special Commendation in the Wiesbaden (Germany) Awards and First Prize in Portrait Class in the Bausch & Lomb Quartercentury Competition. Marries Clara E. Smith on October 3.

1904. Exhibits at the Corcoran Gallery of Art, Washington, D.C., and at the Carnegie Institute, Pittsburgh. Receives Best Picture prize for *Rodin—"Le Penseur" and "Victor Hugo"* in the International Exhibition at The Hague. Daughter Mary born July 1.

1905. Shows twenty-nine paintings at the Galleries of Eugene Glaenzer and Co., New York. Collaborates with Stieglitz in establishing the Little Galleries of the Photo-Secession at 291 Fifth Avenue. Awarded two first prizes in Eastman Kodak competition, and first prize in Goerz competition.

1906. Exhibition of Photographs by Eduard Steichen, including experiments in three-color photography, at 291. *Camera Work* issues *The Steichen Number* and *Special Steichen Supplement,* April 30 to May 27. Shows in *An Exhibition of Photographs Arranged by the Photo-Secession* at the Pennsylvania Academy of Fine Arts, Philadelphia. Returns to France in May.

1907. Works with Lumière autochrome plates.

1908. Show of Rodin drawings, initiated by E.S., opens at 291 on January 2. Initiates show of Matisse drawings at 291. E.S. paintings and drawings shown in exhibitions at the National Arts Club, New York, and at Pratt Institute, New York; an exhibition of color and monochrome photographs shown at 291. Daughter Kate Rodina born May 27. Lillian marries Carl Sandburg on June 15.

1909. Initiates shows of paintings by Alfred Maurer and John Marin at 291. Shows own photographs at the National Arts Club, at 291 and in the international group at the Dresden exhibition.

1910. Shows color photographs and paintings at 291 and at the Montross Gallery, New York; paintings at the Worcester Art Museum in Massachusetts; and twenty-one photographs at the Albright Art Gallery, Buffalo. Begins hybridizing delphinium at Voulangis, France. Initiates shows of work by Cézanne and E. Gordon Craig at 291.

1911. Begins painting large mural decorations for home of Mr. and Mrs. Eugene Meyer. Initiates shows of work by Picasso and Max Weber at 291.

1912. Initiates show of work by Arthur B. Carles at 291.

1913. Double issue of *Camera Work* (#42–43, April–July 1913) devoted to Steichen.

1914. Returns to New York with wife and children at outbreak of World War I. Initiates show of work by Constantin Brancusi at 291.

1915. Exhibitions of E.S. paintings at M. Knoedler and Co., New York.

1917–1918. Commissioned First Lieutenant in U.S. Army.

1918–1919. Made Chevalier of the Legion of Honor. Receives Medaille d'Honneur des Affaires Etrangères and Distinguished Service Citation. Retires from Army with rank of Lieutenant Colonel on October 31, 1919.

1920–1923. Begins "second apprenticeship" in photography. Makes paintings of yin and yang symbols. Studies extreme and mean ratio in plant growth and design. Renounces painting with symbolic bonfire at Voulangis.

1923. Divorces Clara in France. Begins work as chief photographer for Condé Nast Publications on March 28. Begins advertising photography for the J. Walter Thompson Agency. Takes studio in the Beaux Arts Building, 80 West Fortieth Street, New York.

1926–1928. Gertrude Vanderbilt Whitney finances successful suit against U.S. government to prove that Brancusi's abstract *Bird in Space,* imported by E.S., is a work of art.

1928. Buys property he calls Umpawaug Farm in West Redding, Connecticut.

1929. Publication of *Steichen the Photographer* by Carl Sandburg (Harcourt, Brace and Company, New York). Announces marriage to Dana Desboro Glover.

1930. Makes photographs for *The First Picture Book: Everyday Things for Babies* (Har-

court, Brace and Company) in collaboration with daughter Mary Steichen Martin.

1931. Publication of *The Second Picture Book.* E.S. becomes Honorary Fellow of the Royal Photographic Society of Great Britain.

1932. Exhibits photomurals of the George Washington Bridge in *Murals by American Painters and Photographers,* directed by Julien Levy, at the Museum of Modern Art, New York. Designs photomurals on aviation theme for Center Theatre, Radio City, New York.

1933. Designs photomurals for the New York State Building at the Chicago World's Fair. Marie Kemp Steichen dies.

1934. Moves studio to 139 East Sixty-ninth Street.

1935. Begins selecting photographs for *U.S. Camera Annuals.* Designs four pieces of glass for Steuben.

1936. Displays hybrid delphinium at the Museum of Modern Art.

1937. Receives Annual Advertising Awards' Silver Medal.

1938. Closes studio at 139 East Sixty-ninth Street. One-man retrospective exhibition of 150 prints at the Baltimore Museum of Art.

1940. Receives the Art Directors Club medal.

1942. Commissioned Lieutenant Commander USNR. Creates *Road to Victory,* new form of thematic photo exhibition using mural-size prints and text by Carl Sandburg. Receives honorary master of arts degree from Wesleyan University.

1944. Supervises U.S. Navy film, *The Fighting Lady.*

1945. Placed in command of all Navy combat photography and named director of U.S. Navy Photographic Institute. Awarded Distinguished Service Medal. Receives Honorary Fellowship, P.S.A. Creates exhibition *Power in the Pacific* for the Museum of Modern Art (book published by U.S. Camera Publishing Corp.). Receives the Art Directors Club medal for work on *The Fighting Lady.*

1946. Released from active duty in the Navy with rank of Captain. Publishes *U.S. Navy War Photographs: Pearl Harbor to Tokyo Harbor* (U.S. Camera Publishing Corp.).

1947. Becomes director of department of photography at the Museum of Modern Art in July. Publishes *The Blue Ghost,* an account of the U.S.S. *Lexington* (Harcourt, Brace and Company). MOMA exhibitions: *Three Young Photographers: Leonard McCombe, Wayne Miller, Homer Page; Music and Musicians.*

1948. MOMA exhibitions: *In and Out of Focus; Fifty Photographs by Fifty Photographers; Four Photographers: Lisette Modell, Bill Brandt, Ted Croner, Harry Callahan.*

1949. Receives U.S. Camera Achievement Award for the "most outstanding contribution to photography by an individual." MOMA exhibitions: *The Exact Instant; Roots of Photography: Hill-Adamson, Cameron; Realism in Photography: Ralph Steiner, Wayne Miller, Tosh Matsumoto, Frederick Sommer; Six Women Photographers: Margaret Bourke-White, Helen Levitt, Dorothea Lange, Tana Hoban, Hazel and Frieda Larsen; Roots of French Photography.*

1950. Retrospective exhibition and award of Fine Arts Medal at American Institute of Architects headquarters, Washington, D.C. Briefly resumes Navy service to evaluate photography and make recommendations during Korean War.

MOMA exhibitions: *Photographs of Picasso by Mili and Capa; Newly Acquired Photography by Stieglitz and Atget; All-Color Photography; Fifty-one American Photographers; Lewis Carroll Photographs.*

1951. MOMA exhibitions: *Korea; Abstraction in Photography; Twelve Photographers' "Forgotten Photographers"; Memorable Life Photographs; Photographs as Christmas Gifts; Five French Photographers: Brassaï, Cartier-Bresson, Doisneau, Rosnis, Izis.*

1952. Receives *Popular Photography* magazine award. Begins preparations for *The Family of Man.* Starts exhibition series called *Diogenes with a Camera*; work shown in parts I and II of series includes Edward Weston, Frederick Sommer, Harry Callahan, Esther Bubbley, Eliot Porter, W. Eugene Smith, Ansel Adams, Dorothea Lange, Tosh Matsumoto, Aaron Siskind, Todd Webb.

1953. MOMA exhibitions: *Always the Young Strangers; Post-War European Photography.* Selects American section for *The Exhibition of Contemporary Photography—Japan and America* in Tokyo.

1954. Museum of Modern Art gives seventy-fifth birthday dinner in E.S.'s honor and announces establishment of the Edward Steichen Purchase Fund.

1955. Exhibition *The Family of Man* opens January 24. Receives awards from the Newspaper Guild, the American Society of Magazine Photographers, the Philadelphia Museum School of Art, the National Urban League, Kappa Alpha Mu. E.S. travels to Japan, Berlin, Paris, Amsterdam, Munich and London to open or prepare for showings of *The Family of Man.* Begins photographing shadblow tree at Umpawaug.

1956. MOMA exhibitions: *Diogenes with a Camera III* and *IV:* Manuel Alvarez Bravo, Walker Evans, August Sander, Paul Strand, Schenk, William Garnett, Marie-Jean Beraud-Villars, Shirley Burden; *Language of the Wall: Parisian Graffiti Photographed by Brassaï.* Creates exhibition *Contemporary American Photography* at the Musée d'Art Moderne in Paris.

1957. Dana Steichen dies on February 19. E.S. gives illustrated lecture, "Experimental Photography in Color," at Museum of Modern Art. Receives honorary doctorate of fine arts from the University of Wisconsin, as well as first annual award "for outstanding achievement in fostering international understanding through photography" from Nippon Kogaku K.K. MOMA exhibition: *Seventy Photographers Look at New York.* Suffers stroke.

1958. MOMA exhibition: *Photographs from the Museum Collection.*

1959. Begins making motion-picture film of the shadblow tree. Receives distinguished service award of the New York Botanical Society. Becomes chairman of the National Urban League project "America's Many Faces." MOMA exhibition: *Toward the New Museum of Modern Art: Photography Section.* Travels to Moscow with Carl Sandburg for opening of *The Family of Man.* Suffers second stroke.

1960. MOMA exhibitions: *The Sense of Abstraction; Toward the New Museum of Modern Art: Photography Section II.* Marries Joanna Taub on March 19. Receives honorary doctorate of fine arts from the University of Hartford and German Prize for Cultural Achievement in Photography from the Photographic Society of Germany. Undergoes prostate surgery (nonmalignant).

1961. Retrospective exhibition *Steichen the Photographer* opens on March 27, his

eighty-second birthday, at the Museum of Modern Art. Museum announces plans for the Edward Steichen Photography Center in new building. Receives Premier Award of the Royal Photographic Society of Great Britain, an award from the Photographic Society of Japan, and the 1961 Art in America Award. Delivers keynote speech on "The Photographer and His Times" at the ASMP Asilomar Conference in California. MOMA exhibition: *Diogenes with a Camera V:* Bill Brandt, Lucien Clergue, Yasuhiro Ishimoto.

1962. Gives illustrated lecture, "Toward Abstraction," at Museum of Modern Art. Placed on honor roll of ASMP. Receives honorary degree from Lincoln College, Springfield, Illinois. MOMA exhibition: *Photographs by Harry Callahan and Robert Frank.* Resignation as director of the department of photography at the Museum of Modern Art takes effect July 1. Becomes director emeritus. Exhibition *The Bitter Years: 1933–1941—Rural America as Seen by the Photographers of the Farm Security Administration* opens at Museum of Modern Art on October 15.

1963. On July 4, President John F. Kennedy announces award of Presidential Medal of Freedom to E.S. (Award presented on December 6 by President Lyndon Johnson.) *A Life in Photography* published (Doubleday and Company, New York). Undergoes cataract surgery. Receives plaque from U.S. Navy Photographic Center in recognition of outstanding contribution to naval photography, receives honorary diploma of the Federal Association of Photographers in Poland and awarded a U.S. Camera award presented at George Eastman House. A condensed version of *Steichen the Photographer* shown at Cologne and another at Zurich. Attends White House dinner in honor of H.R.H. Charlotte, Grand Duchess of Luxembourg, on April 30.

1964. Connecticut Yankee delphinium, introduced by E.S. and the Waller Flowerseed Company of Guadalupe, California, is an All-American Selections award winner. Edward Steichen Photography Center opens at MOMA on May 27. Receives certificate of award from the Governor's Council on the Arts, State of Wisconsin.

1965. Connecticut Yankee delphinium awarded Bronze Medal of the All-American Selections. E.S. receives Certificate of Award from Connecticut Professional Photographers Association. Filmed interview, "This Is Edward Steichen," airs on CBS television program *Eye on New York.* Attends President Lyndon Johnson's signing of the arts and humanities bill at the White House and the White House Festival of the Arts. Receives Lotos Club of New York Award of Merit and a citation from the National Council on the Arts and Government. Ten Steichen prints in exhibition *Photography in America, 1850–1965* at Yale University Art Gallery. Four prints in John Szarkowski's exhibition *Glamour Portraits.* Made Commander of the Order of Merit of the Grand Duchy of Luxembourg.

1966. Awarded honorary degree of doctor of science by the American International College at Springfield, Massachusetts, and honorary degree of doctor of humane letters from Bard College at Annandale-on-Hudson, New York. Guest of Grand Duchy of Luxembourg from July 21 to 26. Becomes a Grand Officer of the Order of Merit. Approves Clervaux Castle as site for permanent installation of *The Family of Man* (opened to the public in 1994). Travels in

France and visits Picasso at Notre-Dame-de-Vie in August. Edits and writes introduction for *Sandburg: Photographers View Carl Sandburg* (Harcourt, Brace and World). Receives Family of Man Award at the fourth annual dinner of the Society of the Family of Man, sponsored by the Protestant Council of the City of New York.

1967. Selects photographs for exhibition *The Navy in Vietnam . . . from Jets . . . to Junks* at the Newhouse Communications Center of Syracuse University. Painting, *Night Landscape,* acquired by the Whitney Museum of American Art, New York. E.S. photographs purchased by the Victoria and Albert Museum, London. Fairfield University, Fairfield, Connecticut, awards E.S. doctorate of fine arts. Receives the 1967 Progress Medal of the Photographic Society of America. One-man exhibition of ninety-nine Steichen photographs at the Exchange National Bank of Chicago.

1968. Receives Museum of Modern Art Special Award for Excellence and a special award from the White House News Photographers Association. The Edward Steichen Archive of the Museum of Modern Art is formally established on July 24. The Grand Duchy of Luxembourg accepts the exhibition *The Bitter Years* for permanent installation.

1969. Edward J. Steichen Collection established at United States Naval Academy Library, Annapolis. Ninetieth birthday party given at Plaza Hotel, New York, by Tom Maloney and Henry Allen Moe. E.S. photographs in exhibitions at Metropolitan Museum of Art, Parsons School of Design, Photo Expo 69 in New York, the Witkin Gallery, the Museum of Modern Art and the Library of Congress.

1970. E.S. photographs shown in exhibitions in Osaka, the University of California–Riverside, Museum of Modern Art, Milwaukee, Munich and London.

1971. Town of Redding, Connecticut, on third referendum, votes to buy 270 acres of Steichen's land for town recreation center. Redding Open Lands, Inc., buys another 117 acres and gives 43.16 acres to the Connecticut Audubon Society to be designated the Edward Steichen Memorial Wildlife Preserve. (Formally opens on August 25, 1973.) E.S. has a pacemaker installed in attempt to correct congestive heart failure. E.S. photograph of shadblow tree one of six posters produced by the Whitney Museum of American Art in an ecology campaign sold for the benefit of UNICEF.

1972. E.S. photographs in exhibitions at Metropolitan Museum of Art, the M. H. De Young Memorial Museum in San Francisco, the Hofstra Museum of Fine Arts, the Cologne Art Society, George Eastman House, the Royal Photographic Society of Great Britain and the Camden Arts Centre in London.

1973. Dies at 11:20 a.m. on Sunday, March 25, at Umpawaug Farm.

PHOTOGRAPHIC CREDITS

Except for those listed below, all the plates in this book were reproduced from original negatives, prints or copy negatives approved by Edward Steichen in the collection of Joanna Steichen. Black-and-white prints are silver bromide.

The following plates were reproduced from photogravures in original editions of *Camera Work:*

> 12, 15, 16, 26, 31, 32, 33, 48, 52, 53, 71, 84, 85, 116, 118, 119, 120, 125, 126, 127, 130, 133, 134, 135, 136, 143, 153, 155, 156, 170, 171, 273

The following plates were reproduced courtesy of the owners of the prints, as indicated:

> The Museum of Modern Art, New York, New York: 8, 10, 121, 152, 181, 238, 291, 292, 303
>
> The Royal Photographic Society, Bath, England: 44, 47, 50, 51, 117
>
> George Eastman House, Rochester, New York: 147, 179

The following plates were taken for the publications, agencies or organizations indicated:

> Copyright *Vanity Fair*/Condé Nast Publications, Inc.: 64, 65, 66, 73, 75, 79, 104, 106, 157, 159, 160, 162, 163, 164, 165, 168, 184, 186, 187, 188, 189–192, 198, 210, 211, 212, 213, 215, 216, 219, 224, 225, 242, 243, 246, 249, 250, 255, 259, 262, 275, 277, 278, 279, 281, 282, 283, 286
>
> Copyright *Vogue*/Condé Nast Publications, Inc.: 7, 73, 79, 82, 93, 94, 96, 97, 98, 101, 102, 103, 106, 222, 223, 276, 280, 284
>
> *Life:* 149
>
> *Harper's Bazaar:* 99
>
> *Everybody's Magazine:* 59, 60
>
> *Art et Décoration:* 88, 89, 90, 91
>
> Stehli Silks: 106, 107, 108, 109, 110, 111, 112, 113
>
> The J. Walter Thompson Agency: Gorham Silver: 100; Coty Lipstick: 221; Jergens Lotion: 241; Eastman Kodak Company "Snapshots": 251, 252, 253, 254; New York Eye, Ear and Throat Hospital: 257; Travelers' Aid Society: 258; National Broadcasting Company: 285
>
> *Walden* by Henry David Thoreau (Limited Editions Club, 1936): 263, 264
>
> The United States Navy: 177, 180

A NOTE ON THE TYPE

The text of this book was set in Centaur, designed by Bruce Rogers (1870–1957) in 1914 for the Metropolitan Museum of Art in New York. A celebrated penman, Rogers based his design on the roman face cut by Nicolas Jenson in 1470 for his Eusebius. Jenson's roman surpassed all of its forerunners and even today, in modern recuttings, remains relevant and vibrant.

The italic used to accompany Centaur is Arrighi, designed by another American, Frederic Warde, and based on the chancery face used by Lodovico degli Arrighi in 1524.

Composed by Stratford Publishing Services, Brattleboro, Vermont

Reproduction separations made by Robert J. Hennessey, Middletown, Connecticut

Printed and bound by Amilcare Pizzi, s.p.a., Milan, Italy